KU-537-152

Close Up Photography in Nature

John and Barbara Gerlach

Focal Press
Taylor & Francis Group

NEW YORK AND LONDON

First published 2015
by Focal Press
70 Blanchard Road, Suite 402, Burlington, MA 01803

and by Focal Press
2 Park Square, Milton Park, Abingdon, Oxon OX14 4RN

Focal Press is an imprint of the Taylor & Francis Group, an informa business

© 2015 Taylor & Francis

The right of John and Barbara Gerlach to be identified as authors of this
work has been asserted by them in accordance with sections 77 and 78
of the Copyright, Designs and Patents Act 1988.

All rights reserved. No part of this book may be reprinted or reproduced
or utilized in any form or by any electronic, mechanical, or other means,
now known or hereafter invented, including photocopying and recording,
or in any information storage or retrieval system, without permission in
writing from the publishers.

Notices
Knowledge and best practice in this field are constantly changing. As new
research and experience broaden our understanding, changes in research
methods, professional practices, or medical treatment may become necessary.

Practitioners and researchers must always rely on their own experience and
knowledge in evaluating and using any information, methods, compounds,
or experiments described herein. In using such information or methods they
should be mindful of their own safety and the safety of others, including
parties for whom they have a professional responsibility.

Product or corporate names may be trademarks or registered trademarks,
and are used only for identification and explanation without intent to infringe.

Library of Congress Cataloging in Publication Data
Gerlach, John.
 Close up photography in nature / by John and Barbara Gerlach.
 pages cm
 1. Nature photography. 2. Photography, Close-up. I. Gerlach, Barbara.
 II. Title.
 TR721.G47 2014
 778.9'3—dc23 2014006536

ISBN: 978-0-415-83589-3 (pbk)
ISBN: 978-0-203-50211-2 (ebk)

Typeset in Slimbach and Helvetica
By Keystroke, Station Road, Codsall, Wolverhampton

Printed and bound in China by 1010 Printing International ltd.

Bound to Create

You are a creator.

Whatever your form of expression — photography, filmmaking, animation, games, audio, media communication, web design, or theatre — you simply want to create without limitation. Bound by nothing except your own creativity and determination.

Focal Press can help.

For over 75 years Focal has published books that support your creative goals. Our founder, Andor Kraszna-Krausz, established Focal in 1938 so you could have access to leading-edge expert knowledge, techniques, and tools that allow you to create without constraint. We strive to create exceptional, engaging, and practical content that helps you master your passion.

Focal Press and you.

Bound to create.

We'd love to hear how we've helped you create. Share your experience:
www.focalpress.com/boundtocreate

Focal Press
Taylor & Francis Group

Table of Contents

Acknowledgments xi

Introduction 1

Chapter 1 Cameras and Lenses 11

Crop Factor vs. Full-frame Cameras 11

Features to Look for in a Camera 12

Taking Advantage of Camera Options 14

Lenses and Accessories 17

Final Thoughts 36

Chapter 2 Exposure Essentials 39

Avoiding Common Exposure Mistakes 40

The Averaging Histogram and Highlight Alert 40

JPEG and RAW Image Considerations 42

The Ideal JPEG Exposure 43

The Ideal RAW Exposure 44

The RGB Histogram 44

Clipping on the Left 45

How Images Lose Highlight Detail 46

Metering Modes 46

The Language of Stops 48

Exposure Modes 54

Exposure Modes and Metering Modes 55

Automatic Exposure Using Live View 59

Manual Exposure Techniques 60

Conclusion 64

Chapter 3 Shooting Sharp Images 67

Focus Properly—Manual Focus is Preferred 67

Reduce Camera Motion and Its Effects 68

Reduce Subject Motion and Its Effects 68

Use Focus Stacking 68

Tripods 68

Tripod Heads 71

Lens Plates 72

Dedicated L-brackets 72

Tripods, the Environment, and Camera Steadiness 73

Focusing 76

Optimum Apertures 79

Shoot a Little Looser 80

Subject Plane and Sensor Plane Should Be Parallel 80

Keep Still! 81

Ladies and Gentlemen: The Plamp! 81

Focus Stacking 84

Using Flash 84

Image Stabilization 85

Chapter 4 Light and Color 89

The Role of Light 91

Qualities of Light 92

Conclusion 108

Chapter 5 The Power of Flash 111

Ambient Light Defined 111

Advantages of Flash 112

Applications of Flash in Close-up Photography 112

How the Flash Works 116

Flash Basics 117

Close-up Flash Techniques 122

Specific Flash Techniques 123

Main Flash 127

Balanced Flash 134

Camera-mounted Flash 136

Should the Flash be Diffused? 138

Conclusion 138

Chapter 6 Photographing Flowers 141

Something Extra! 142

How Do You Photograph Flowers? 143

Focus Stacking Techniques 152

Chapter 7 Special Photo Techniques for Butterflies and Dragonflies 161

How to Find Butterflies and Dragonflies 163

Find the Optimum Subjects 165

A Successful Morning 166

What about the Dragonflies? 171

Attracting Butterflies with Flowers 174

Photographing Active Butterflies in the Wild 174

Butterfly Houses 176

Chapter 8 What's in Our Camera Bags? 183

Barbara's Bag 183

John's Bag 185

Why Do We Use This Gear? 185

Appendix: Resources 191

Custom Macro Accessories 191

Photography Workshops 192

Photo Stacking Software 192

Books 192

Web Sites 192

Magazines 192

Photographic Equipment 193

Index 195

Acknowledgments

The many thousands of photographers who have attended our classes over the past thirty-five years deserve our heartfelt appreciation for their probing questions, helpful hints, inadvertent mistakes made in the field that allowed all of us to learn, and their good humor about their mistakes and ours. There is no better way to learn photography than to live it day to day while teaching it to so many incredibly smart clients. Many of the most effective shooting strategies explained in this book come directly from student questions or observations. When we surround ourselves with many brilliant workshop participants, some of their wisdom manages to rub off on us. This back-and-forth sharing of knowledge helps us enormously to constantly expand the shooting system we use to make the art of quality nature photography easy, efficient, and fun. Special thanks goes to one of our brilliant clients and friends—Jason Steinle—who we travel with every year on our own private photo safaris. His good humor, keen observations, and "redemption dinners" are greatly appreciated.

The tremendous group of gifted biology instructors at Central Michigan University in the mid-1970s when I attended deserve special praise. During my early college years when I was mainly interested in birds and mammals, my professors taught with enthusiasm while encouraging me to develop a keen interest in all forms of life including insects and plants. Thanks for helping me learn that birds and mammals need the rest of nature's players to survive and thrive! It really is the ecosystem that is important—not just the individuals.

Professional nature photographers Larry West and John Shaw were instrumental in helping me effectively photograph small subjects. I first attended their weekend photo workshop at the Central Michigan University biological station when I was in college. Later that summer I enrolled in their week-long photo field workshop at Houghton Lake. Although I did not know it at the time, those experiences encouraged me to change my career path to nature photography. When I decided

to become a professional nature photographer in 1978, I drove to the southwest to photograph birds, butterflies, landscapes, amphibians, reptiles, and mammals that I had never seen before. To save money, I slept under the stars for several years. I enjoyed my homeless lifestyle and cherished the remote wild places where I spent so much time while learning the business. I worked my way north to Washington, Idaho, or Montana in the spring and followed a convoluted path south to southern Arizona or California for the winter. Eventually, it all worked out beyond my wildest expectations.

The late Mike Kirk, along with many others, was instrumental in my career. Mike was a skilled machinist who could make anything. I occasionally asked Mike to build flash brackets for me, or to modify them to help me achieve my photo goals. Eventually, Mike launched Kirk Enterprises, specializing in making equipment for photographers. Mike's proud tradition continues with his able son, Jeff, at the helm of the company today.

Producing a book is a huge undertaking. It takes far more time and effort than most people realize. Thanks to Deirdre Byrne of Taylor & Francis for her ongoing support and encouragement during this long process. I am not the easiest person to contact since I spend so much time in remote countries far away from internet and cell phone reception. Deirdre deserves a ton of credit for keeping me on schedule—no easy feat!

My four volunteer editors, Al Hart, Woodice Fuller, and David and Kim Stringer, all helped enormously in keeping the text both accurate and easy to understand. Typos and other errors creep into the text, no matter how careful I am. Although these errors are obvious when pointed out, there reaches a point where my brain simply passes over them. I need fresh eyes to spot the problems. My typo editors kept me busy fixing this and that, and we all appreciate that kind of attention to detail. From experience with past books, I know that no matter how many people edit the book, some typos somehow (perhaps mischievous bad elves) slip through. I hope you can

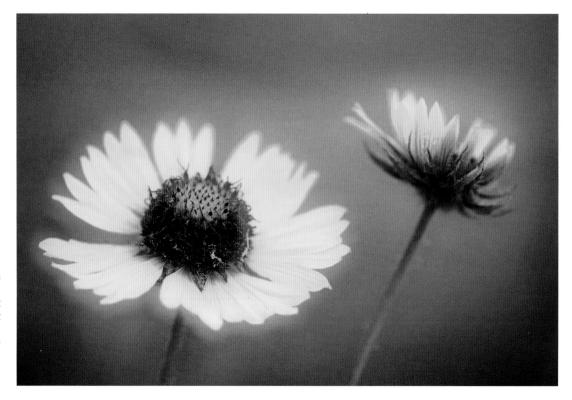

Barbara shot two exposures to create this artistic interpretation of a blanket flower. The flower is sharply focused for the first exposure. Then she made the flower out of focus and shot the second exposure. Both images are underexposed 1 stop to get the optimum exposure. Nikon D4, 200mm micro, 1/250, f/4.5, ISO 100, Cloudy, Aperture-priority.

forgive me if you find one. Thanks so much for each of you volunteering to edit this manuscript. You really help this "accidental author" make this book far better for everyone! I say I am an "accidental author" because I never had any desire to write a book and certainly not four of them! I feel compelled to write books to share the shooting strategies we use to capture pleasing images. At first, I thought the audience was mainly Americans and Canadians, but our books are sold all over the world, so the audience is far larger than I ever imagined.

My family deserves a huge round of applause for understanding why I must spend so much time working on books, shooting images while traveling the world, and figuring out new photo strategies. We don't get to interact as often as we all would like to. Barbara, especially, gets short-changed because early morning on bad weather days is such a perfect time for me to write when she would prefer to drink gourmet coffee with me. We enjoy our coffee a little bit later in the morning instead.

Mary Sue and Mike Nolan have been wonderful in allowing us to take over their Michigan Timber Ridge motel and guest lodge for six weeks every year over twenty-five years. They have let us do anything we needed to do and have taken care of our workshop clients while answering all of their questions. Alaska's Tom Walker—a top professional nature photographer—has helped us out tremendously in guiding us to great photo spots in Alaska, Japan, Mt. Evans, and numerous wonderful places. Your advice has been right on and we cherish your friendship. Thanks to good friends Ranger Les and his wonderful wife Laurie Brunton and all of the wonderful folks we meet on the trail every year!

And most of all, thanks to all of the folks who buy our books. Without you, there are no books. Publishers can't afford to produce books if they don't return a profit, and I can't afford the time allotment to write them unless I earn something to pay the endless enormous bills that steadily come our way. Thank you one and all!

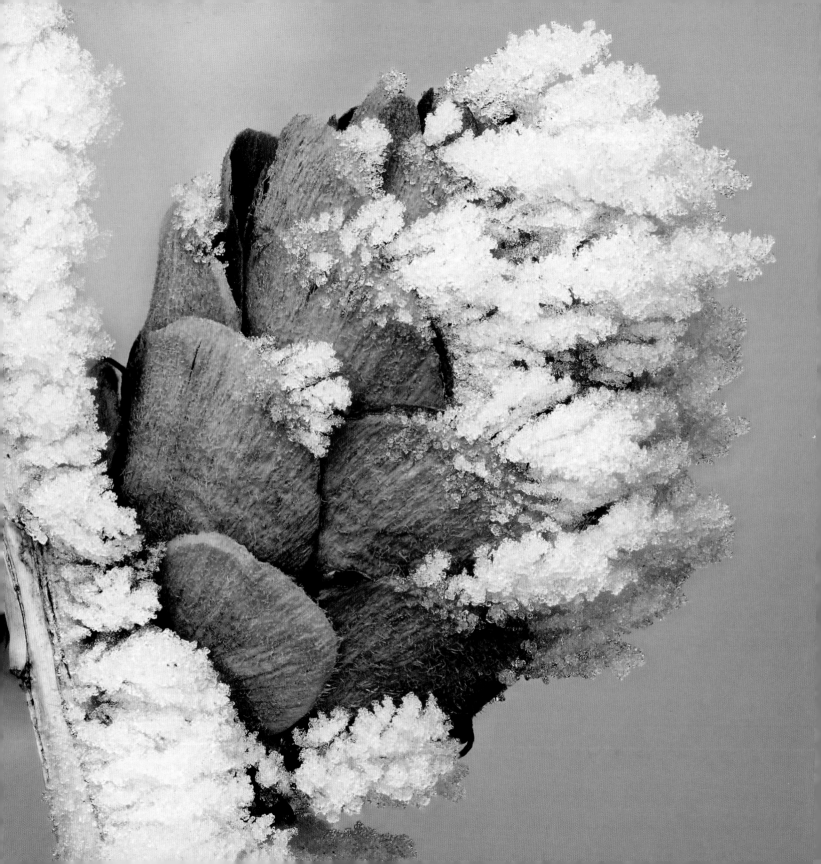

Introduction

This book describes a photographic shooting system for capturing enchanting close-up and macro images. Since I do all of the writing, I will write it using my preferred conversational style. I like to keep things fun and avoid unnecessary technical discussions, but still be able to explain technical concepts when absolutely necessary. Barbara is a huge part of this book, too. She offers many suggestions for the book, reviews the content and edits the text. She selects most of the images that are used in these pages.

All of the images you see here start as a RAW image. Barbara processes them using the most current version of Photoshop. Once the RAW images are processed, they are converted to JPEGs for publication in this book. My time is best spent in the field where I work to understand and use the latest features of the camera to develop new shooting strategies. This coincides with my natural interests and makes me a better instructor and photographer. Instructing others about capturing exceptional images using the new tactics that are learned is better than learning software and duplicating Barb's expertise. We take great pleasure in teaching the new strategies we learn to everyone through writing and public speaking. Barbara does that, too, and a whole lot more. Software use is necessary for developing RAW images. The images must be adjusted for color and contrast and finally sharpened at the end of the process. Nonetheless, our goal is to always capture the absolute best images we can while in the field. If software really is needed to rescue a seriously flawed image, then we have failed. Our failures are easy to edit. We select them and press delete!

Frost adds an interesting element to this tiny cone. The focus is changed slightly over twenty-four images. The stack is combined into a single image with incredible depth-of-field using Zerene Stacker software. Nikon D4, 200mm, 1/125, f/11, ISO 400, Auto WB.

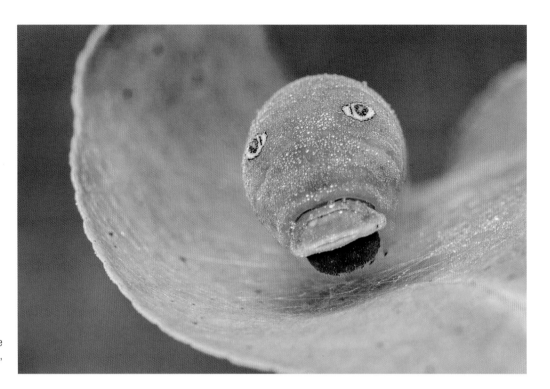

The false eyespots on this swallowtail larvae serve as a strong center of interest. Canon 5D Mark III, 180mm macro, 1/2, f/16, ISO 100, Cloudy.

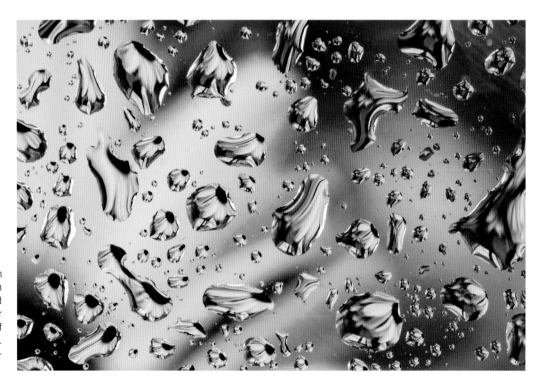

A bouquet of flowers is placed underneath a clean sheet of glass. The glass is then sprayed with Rain-X and wiped off. Next water is sprayed onto the glass which beads and creates water drops. Finally, reflections in the water drops of the blossom are focused precisely and carefully. Nikon D300, 200mm, 1/3, f/22, Cloudy, Aperture-priority.

We always had a passionate interest in small natural subjects. Both of us caught insects, toads, frogs, crayfish, minnows; Barbara avoided spiders, and we both ran from snakes in the rural towns in Michigan and Ohio where we grew up. Like most kids, we were attracted to animal life first. Later, we developed an intense interest in plants, especially wildflowers, and that continues to blossom to this day.

We began taking nature photos in our mid-teens and spent most of our photo efforts photographing small subjects. Birds and mammals were too wary for the short lenses we owned then. Cornfields and weedy meadows didn't offer many spectacular landscape possibilities. At the time, we never imagined being able to travel the world seeking out gorgeous landscapes and exotic wildlife. Those opportunities all came much later. We therefore concentrated on developing techniques for shooting superb close-up and macro subjects easily, efficiently, and consistently because these were the subjects that were most abundant around our homes.

The courses I attended to earn my B. S. Degree in wildlife biology from Central Michigan University have helped me immensely in identifying most of my close-up subjects. The physics and mathematics courses have helped me easily understand the numbers and science associated with photographing small subjects. Don't worry, you do not need to understand physics or math to become an accomplished photographer of small objects. I promise to keep the numbers and science to an absolute minimum.

The huge advantage close-up photography offers is that it doesn't matter where you live, there are unlimited subjects to photograph all year long. Weedy fields, marshes, ponds, and forests all offer numerous subjects that vary throughout the day and during the year. Even in winter when snow covers the landscape, berries frozen in ice or etched with frost, tracks in the snow and ice patterns all make outstanding close-up images. If you prefer to avoid the cold, it's simple enough to do indoor close-up photography. Photographing domestic

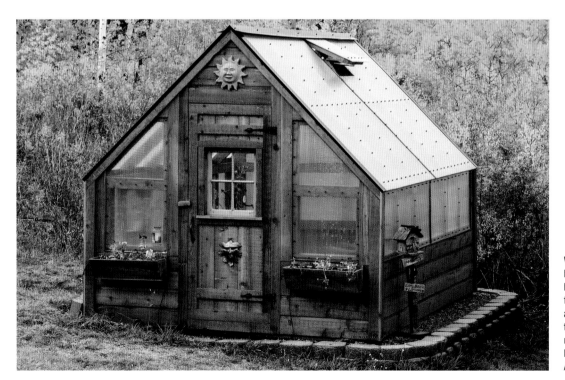

We installed this small greenhouse, built by www.frdmontana.com, near our Idaho home to enable us to completely control the light and wind. Otherwise, we are not able to shoot any close-up images most of the time due to a steady downward mountain breeze. Nikon D4, 70-200mm lens at 116mm, 1/4, f/16, Cloudy, Aperture-priority.

flowers like cultivated orchids or creating *bubble images* with Rain-X are excellent indoor close-up opportunities that will keep you busy all winter shooting creative images and helping you perfect your photo techniques. Even during the warmer months, unfavorable weather such as wind and rain often makes it virtually impossible to photograph outside. We don't like weather dictating when we can shoot images. Therefore, we installed a small 9 × 12 foot greenhouse to use to photograph in on our property. The greenhouse lets us completely control the light while keeping the air perfectly still to avoid moving our subject. Controlling both the breeze and the light enables us to effortlessly shoot well-illuminated and sharp images.

Flash is so frightening to many photographers that they avoid using it. If you fear flash, now is the time to master it. Using flash is crucial in close-up photography and easy to use well with digital cameras because you can see what it does right away. Mixing ambient light with flash is incredibly effective and simply done with the aid of the histogram. We use some flash for about 75 percent of our close-up images. We'll cover flash techniques in great detail later in Chapter 5.

Many of the close-up techniques we will explain only became available in the past few years. For example, Live View is invaluable in close-up photography, but it became a common camera feature only since around 2008. I will explain the shooting *workflow* we use to capture the images seen throughout this book. There is a lot to learn, but it is all quite simple and straightforward. Our goal, and we hope your goal, is to acquire a shooting workflow that produces superior quality images consistently and easily. We don't cut any corners when it comes to quality and hope you won't either. We emphasize the techniques and equipment we use to capture our images, but will suggest alternative ways of capturing close-up images for those who want other options. We realize not everyone can afford the long 180mm and 200mm macro lenses we cherish so much. Even if you can, perhaps you don't want to carry these weighty and bulky lenses. Fortunately, close-up photography offers you many options, and we'll explore the most widely used ones.

Writing a book is incredibly challenging. Do I write it for beginners or more experienced photographers? In this book, I assume you already have a considerable amount of experience because close-up photography is quite specialized. Most novices start out by photographing larger subjects. There is an incredible amount of equipment to choose from in order to capture splendid images of small objects. Do I cover everything I know about or only those things I can highly recommend? Of course, given the realities of word count maximums—books can only be so large—it is impossible to cover everything. Therefore, deciding what to include is an ongoing problem with which I must grapple. Some chapters, such as flash and exposure, could easily be expanded to be an entire book all by themselves—something that I am considering. To meet the needs of this book, I am forced to condense them down into rather long chapters on both counts.

I have decided to teach the same way Barbara and I approach close-up and macro photography. We see a wide variety of tripods, tripod heads, lenses, and other devices used for close-up photography in the many field workshops we teach. Much of the equipment we see is not made to be easily used by photographers. Therefore, we'll stress the equipment we use because we find it to be by far the most convenient for close-up photography. If new equipment becomes available that works better, we are happy to switch to it.

As with our three other books on nature photography, we won't get into image processing, which is an enormous topic that can easily fill an entire shelf of books all by itself. Space is limited, even in a book. We prefer to fill this book with photo techniques that work for both field and studio situations. You'll find close-up photography is fascinating, forces you to look closely and be creative, and will make you develop super shooting habits that work for all types of photography. Enjoy your close-up photography journey!

A DEWY MORNING

Before getting started with the nuts and bolts of close-up photography, let's describe a perfect close-up photo morning

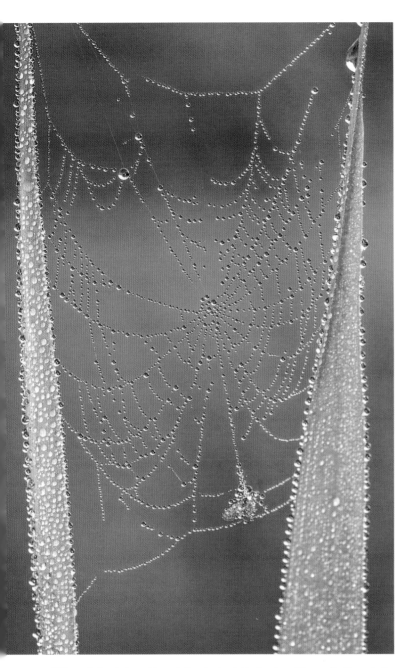

This small dew-laden spider web is only about 4 inches long. The smaller the web, the easier it is to sharply focus most of the dewdrops. Use Live View to detect slight movement caused by tiny air currents and shoot only when the web is perfectly still. Nikon D300, 200mm, 1/30, f/14, ISO 200, Shade.

in northern Michigan. I will share our thoughts and strategies with you as Barbara and I make the most of this fine morning. You don't need to understand everything that is mentioned here. We assure you it will be repeated again.

The weather guesser on the radio announces that tonight will be calm and clear with a morning low around 45 degrees Fahrenheit (F). We're excited to hear this forecast because we know if the forecast is accurate, it means a super close-up photo morning awaits us. We awaken the next morning at least 1.5 hours before sunrise to check out the weather. As forecast, the air is completely still, not a single leaf on the maple trees in the yard is trembling and the stars twinkle brightly overhead. Our camera bags are ready to go, all batteries in our cameras and flashes are fully charged, and the tripod and other accessories we use are already in the back of the car. We drive a few miles to a one-acre meadow that lies near two lakes and is surrounded by a tall beech-maple forest. We especially like this meadow for a couple of crucial reasons. First, two lakes are nearby, though not within sight of the meadow. Dragonflies are aquatic insects that spend most of their lives underwater in the lake. As adults, they emerge and fly about the meadow hunting for insect prey. Often they can be found roosting at dawn on top of the wildflowers, bushes, and grasses in this meadow. Many other types of insects are found here, too. On cool mornings, these subjects are covered with sparkling dewdrops and too cold to move, making them easy to photograph. Second, the meadow is tiny—less than an acre in size. Since it is surrounded by tall trees, it is more difficult for the sun to warm up the air and cause a breeze in this meadow. A breeze makes it almost impossible to capture sharp images. Third, the sun causes dewdrops to evaporate and warms up the subject, which starts to move around slowly. Fortunately, the tall trees that line the east side of this meadow prevent any sun from entering the meadow during the first two hours of the day. This extends the amount of time we get to photograph our dew-laden subjects.

We enter the meadow at first light, about 45 minutes before sunrise. It is too dark to photograph anything yet, but we want the extra time for finding subjects. As we look for dew-laden

Calm and bright overcast weather conditions are ideal for photographing wildflowers. John is looking at a magnified Live View image to make sure the flowers are **completely** still at the moment of exposure. Nikon D300, 28–70mm lens at 32mm, 1/500, f/4.5, ISO 1000, Cloudy.

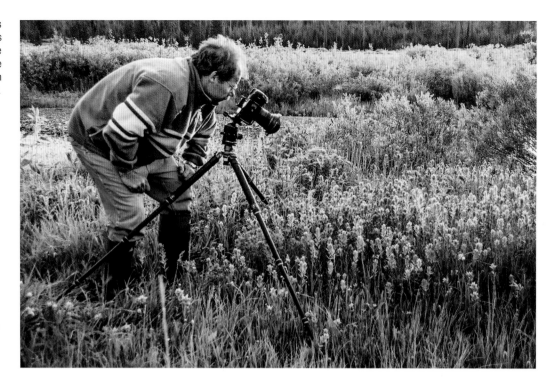

subjects on every plant, we carefully push a white plastic fence post into the ground to mark the most photogenic subjects we spot. We start on the west side of the meadow and look east. Even in the dim light, dewy subjects are softly backlit, making them easier to spot. We peer intently at the tops of the vegetation looking for bright spots. Often the bright spot is only a shiny leaf, but sometimes it is a gorgeous dew-laden dragonfly, butterfly, or spider web. As we find excellent subjects, we continue to mark each with a post. In 30 minutes, we find twelve potentially terrific subjects and many others that are promising. We won't have time to photograph all of them before the sun enters the meadow and the dew evaporates, so we photograph the best subjects first. If we each work a half dozen subjects over the next two hours, the morning is a huge success. It is always best to photograph the top ten subjects really well, than twenty-five subjects haphazardly.

We start photographing the very best subjects on the west side of the meadow because the sun will enter that part of the meadow first and quickly ruin the magical dewy situation. As the sun rises, we constantly move east to photograph the best subjects that are dew covered and completely motionless because they are in the cool shade. We use the Plamp (plant-clamp) to stabilize the subject without hurting it or the plant to which it is attached. Sometimes the shooting angle can be improved by changing the subject's position a bit. For example, instead of shooting down at the ground and getting a distracting background in the image, perhaps the angle can be changed to allow photographing the subject parallel to the ground to make the background much farther away. This produces a far more out-of-focus background at any given aperture. If the subject is a dew-laden dragonfly, for example, we attach the Plamp to the plant as close to the sleeping dragonfly as possible without allowing the Plamp to appear in the image.

We use a tripod to support the camera. This allows us to capture sharp images with shutter speeds in the typical 1/8 to 2-second range. We are careful to align the plane of the

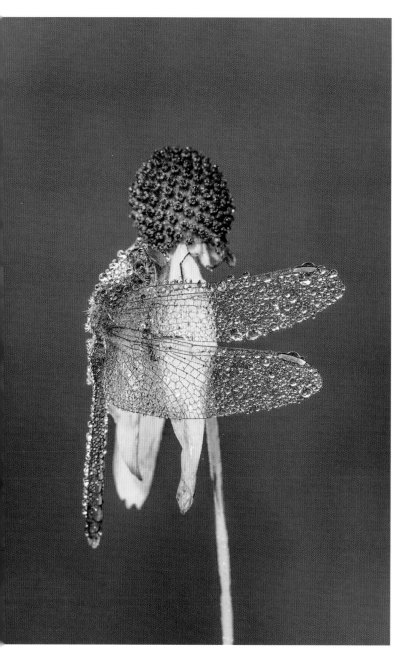

This dew-laden Red Meadow Dragonfly slept on the Gray-headed Coneflower blossom—a favorite and photogenic roosting spot for these insects. The ambient light is underexposed by about 1 stop to darken the background and flash is the main light on the dragonfly. Canon 5D Mark III, 180mm, 1/8, f/13, ISO 100, Manual exposure for the ambient light and automatic flash with a Canon 580 flash using a Canon ST-E2 wireless flash control.

sensor with the most important plane of the subject and shoot at f/16 to achieve sufficient depth-of-field and overall sharpness. Autofocus doesn't work well in close-up photography. Therefore, we use a magnified Live View image to manually focus on the most important part of the subject. We use ISO 100 or ISO 200 to capture the best image detail and use the RGB histogram to guide us to the optimum exposure. Our favorite lenses are the Canon 180mm macro and the Nikon 200mm micro. We have used versions of these lenses for at least twenty years and greatly favor these long macro lenses because they offer a narrow field of view, which makes it easy to capture a pleasing non-distracting background. These long macro lenses offer plenty of working distance, which allows us to stay back from the subject making it easier to work the tripod in without bumping the subject. Both macro lenses have a convenient built-in tripod collar, making it uncomplicated to change the composition from horizontal to vertical or anything in-between. We trip the camera with a cable release that is attached to the camera if it is necessary to wait for a slight breeze to stop. If everything is holding completely still and no breeze is present at all, then tripping the camera with the 2 second self-timer works fine. The white balance is set to the Shade preset because the light in the open shade with the blue sky above has a strong blue colorcast. The camera adds some yellow to mitigate the excess blue light with the Shade white balance.

The light illuminating the subject is crucial to attain superior images. At times, we use a gold-colored reflector to open up shadows and reduce the blue colorcast. However, the dim light in the shade makes it difficult for the reflector to reflect much light over any distance. Instead, we use light from a dedicated flash to open up shadows and reduce the contrast in the image. More often, we underexpose the natural light by a stop or two and use the histogram to guide us. Then we use flash to optimally expose the subject. The flash is the main light and the ambient light now serves as a fill light. This is effective for darkening the background, which emphasizes the brighter subject. We work fast, quietly, and efficiently because we know it's a race against the clock. Eventually, the rising sun will fill the meadow with warm sunshine and

create extremely high contrast. The sun evaporates the dew-drops and warms up our subjects. If it is an insect, it begins moving around. We are keenly aware that the warming air can make the breeze start blowing steadily and spoil the photo opportunities. If our luck holds out, we may get two hours of excellent photographic conditions for successful photography. Normally, a steady light wind, which we refer to as the *break-fast breeze*, finally brings our photo efforts to an end.

This description of how we work a dewy morning offers an insight into our photo strategies. I mentioned a number of tactics we use to successfully photograph the subjects. The remainder of this book will describe and explain these tactics in detail.

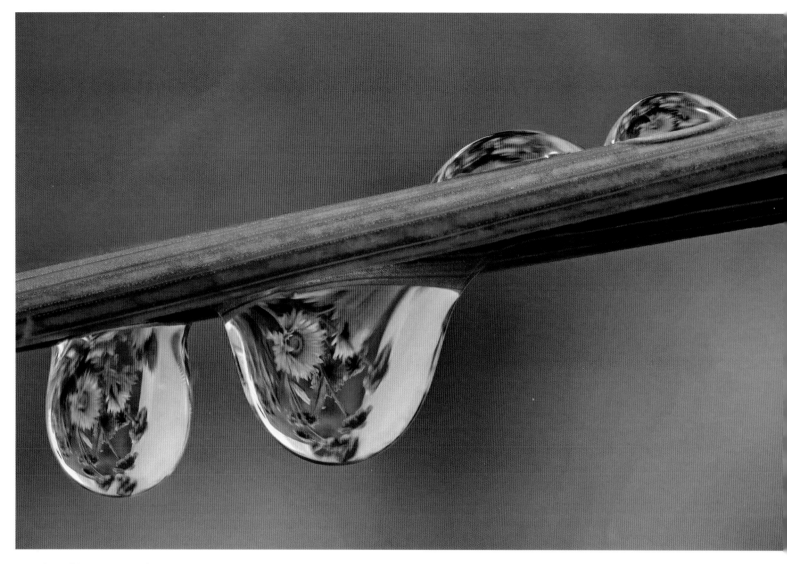

How is it possible to encapsulate flowers in water drops? Reflections in water drops necessitate an exceptional shooting technique that includes a tripod, focus rail, remote release, and quality macro lens. Barbara used an eyedropper to place the water drops on the blade of grass and shot the image indoors using soft window light. The depth between the grass and the flower reflection cannot be entirely captured with a single exposure. Stopping down to f/22 and focusing on the reflection does not sharply focus the grass. When you focus on the grass, the reflection is soft. Focus stacking is the only way to achieve sharp focus throughout the subject. Zerene Stacker software combined the thirteen images into the final composite. Canon 5D Mark III, Canon 65mm macro lens, ISO 500, f/8, 1.6 seconds, Cloudy WB

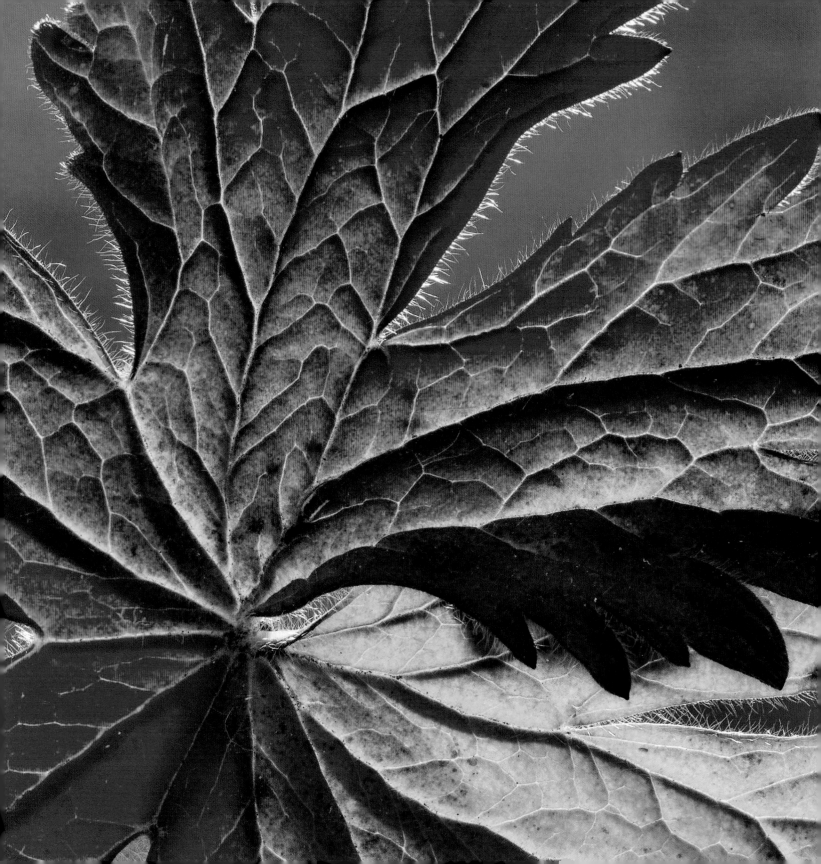

Cameras and Lenses

All modern digital cameras are fully capable of shooting excellent close-up and macro images if impeccable technique and a suitable lens are used. Nikon, Canon, Sigma, Sony, Olympus, Panasonic, and other camera makers all work perfectly fine for shooting close-ups. For the truly dedicated close-up photographer, make sure you are able to buy a long macro lens in the 180–200mm focal length range for your camera. This is important because some camera makers do not yet offer them.

CROP FACTOR VS. FULL-FRAME CAMERAS

To reduce the cost and the weight of both the cameras and lenses, most cameras offer an imaging sensor that is smaller than the normal 36 × 24mm full-frame version. Small sensor sizes vary among camera models. Cameras with small sensors are said to have a magnification factor. Typical magnification factors include 1.3x, 1.5x, 1.6x, and 2x. When you view the image through a camera that has a small sensor, it appears that you are getting more magnification and shooting through a longer lens. In reality, small sensor cameras do not truly offer more magnification. Any sensor smaller than 36 × 24mm merely crops the image that would have been captured if it were shot with a **full-frame** sensor-sized camera.

To see the crop factor differences, put a 100mm macro lens on a camera with a 1.6x crop factor, for example a Canon 7D or 60D, and that produces a field of view that would be equivalent to a 160mm lens on a full-sized sensor camera. This smaller field of view is highly beneficial because it makes it simple to capture diffused backgrounds that aren't

A 180mm macro lens nicely isolates the autumn Sticky Geranium leaf against a completely diffused background. A Canon 580 flash created the backlight. Canon 7D, 180mm, 1/6, f/18, ISO 100, Cloudy.

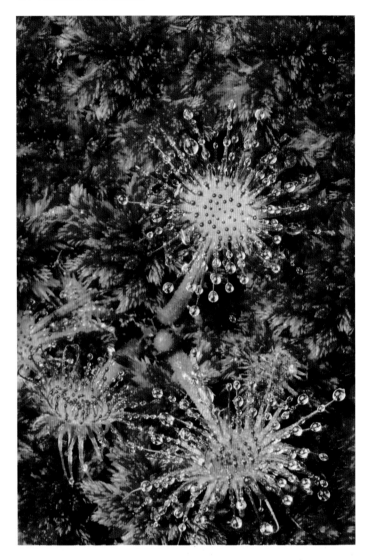

The sticky water drops on these tiny sundew leaves enable it to capture insects. Due to its small size, the image is cropped to fill the frame with this group of plants. Fortunately, the full-frame sensor of the Nikon D4 makes this easy to do because there are plenty of pixels in the sensor. Nikon D4, 105 micro, 2.5 seconds, f/22, ISO 200, Cloudy.

prints in the 20 × 24 inch range. If more pixels are crowded into a small sensor, they must be tinier, making them more likely to reveal noise because the signal-to-noise ratio is less favorable. Neither of these shortcomings is a valid reason to avoid small sensor cameras. They do a terrific job! In fact, we can easily capture the quality images we need with the bottom of the line Nikon and Canon DSLR cameras to produce this book and to conduct instructional photography programs worldwide. We simply prefer the higher end cameras with full-sized sensors because they offer more features and options.

FEATURES TO LOOK FOR IN A CAMERA

HIGH MEGAPIXEL COUNT

Most cameras offer plenty of megapixels today, so the number isn't likely to be a problem. If your camera is a 12MP camera or higher, you have enough for most purposes. Megapixels refer to the number of pixels that are built into the camera's imaging sensor. If you have eighteen million pixels, then it is an 18-megapixel camera. Not to confuse the issue, but the pixels that make up your sensor are designed to measure photons of light. These photons create a tiny electrical charge at the pixel. Using an on-board analog-to-digital converter, the electrical charge is measured and a number value is assigned to it.

BACK-BUTTON FOCUS

Most cameras have a button to the right of the viewfinder that is a designated autofocus button, or it can be changed to be used as the autofocus button. Using this capability is absolutely crucial because it is the best way to focus precisely on the subject in many situations. Unfortunately, most camera makers neither stress back-button focus in their camera manual nor call it anything recognizable. When you purchase the camera, ask the salesperson if it has a button on the rear of the camera for focusing control. Nearly all cameras have this important feature, and that especially includes Canon and Nikon. One of the few places back-button focusing is not

blemished by distractions. Using a small sensor camera still delivers super quality images while you enjoy the benefits of a less costly lighter camera. Two of the minor drawbacks to small sensor cameras include a reduction in the number and, more importantly, the size of the pixels. If the camera has more megapixels, it is more suitable for making large sharp

important is close-up and macro photography because it is better to use manual focus to get the sharpest possible focus. However, if your eyesight doesn't allow you to manually focus the lens, then back-button focusing becomes extremely crucial. Also, if you do any other kind of photography—sports, landscapes, animals, people—then using back-button focusing is the most efficient way to use autofocus. An article, "Back-button Focusing Benefits," is posted on our web site at www.gerlachnaturephoto.com.

RGB HISTOGRAM

All cameras offer a histogram that shows a graphic display of the tones contained in the image as exposed. Observing the histogram is the best and fastest way to determine when you've reached the optimum exposure. The default histogram display is referred to by different names. Typically, it is called the Averaging, Luminance, or Bright histogram. This histogram works okay, except anytime the subject has an abundance of one color over the others or light colorcasts or both, the averaging histogram most often does not prevent you from overexposing that dominant color. For example, a red leaf in the red light of dawn will quickly max out all of the pixels in the imaging sensor that measure red light, while the green-filtered and blue-filtered pixels measure much less light. The averaging histogram may indicate the image is optimally exposed even though the reds are severely overexposed. The RGB histogram display will show the red color channel is clipped.

This specific problem of one color dominating the others is easily solved by activating the RGB histogram color channels display. Make sure your camera provides it. We would not buy a camera that did not have it! The RGB histogram displays a separate histogram for each of the color channels. We'll discuss how to use it to achieve super exposures in Chapter Two.

LIVE VIEW

Automatic focusing systems do not work well and should not be used when shooting close-up images. Since the depth-of-field is shallow when shooting at higher magnification, even at f/16, it is important to focus carefully on the most important part of the subject. This could be the wings of a butterfly, the eyes of a bee, or the stamens of a flower. The best way to precisely focus the lens is to focus manually. Unfortunately, most folks over forty don't see fine details as well as we once did—even when wearing glasses. Therefore, the best way for most of us to focus on small objects is to use Live View. When this is activated, a live image appears on the camera's rear LCD display. There is a box on the display that can be scrolled about the live image. To sharply focus, move the square box over the most important spot and then magnify the image. At 10x, the point that must be sharply focused is obviously in focus—or not—at this magnification. Slowly focus the lens manually until the spot is as sharply focused as possible. If a breeze is blowing, wait patiently for the movement to subside momentarily. Press the shutter button with a cable or remote release as soon as the subject is completely still. If the subject is wiggling at all, the motion is easily detected in the magnified live image. Don't shoot until **all** motion has ceased!

LIVE HISTOGRAM

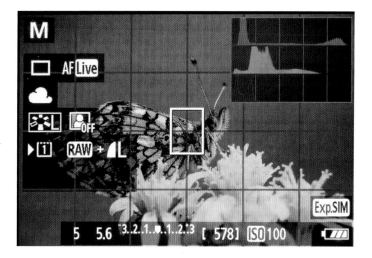

The Canon 5D Mark III can display a live histogram when using Live View. The live histogram is useful for quickly arriving at the optimum exposure. However, if the camera detects a flash is being used, the display turns gray to indicate it is no longer accurate because the camera does not know how much light from the flash will be added to the subject.

Some cameras provide a live histogram in Live View. This means you get to view the image's histogram and determine the ideal exposure before shooting the image! It is something to look for in a new camera. Hopefully, your present camera has this feature. Be sure to activate it. Using a live histogram will greatly decrease the time it takes you to arrive at the optimum exposure.

TAKING ADVANTAGE OF CAMERA OPTIONS

COLOR SPACE

Adobe RGB 1998 and sRGB are the two most prevalent color spaces offered on cameras. Adobe RGB 1998 offers a wider color gamut. This simply means that Adobe RGB more completely covers the range of colors that we can see with our eyes. Many cameras, however, especially Canons, display the images on the LCD more colorfully if the sRGB color space is selected. Also, most viewing accessories are really set up for the sRGB color space—the Internet—for example, and many companies that produce prints also are calibrated for the sRGB color space. There is no wrong answer, but we feel JPEG shooters should use the sRGB color space. If you shoot RAW images, then you do indeed need to decide to use a color space with a larger color gamut, so you might pick Adobe RGB 1998.

We routinely shoot both a large JPEG and a large RAW file for all of our close-up images. Shooting both files at once fills the memory card and the camera's buffer faster, but this is seldom a problem with the slower pace of close-up photography—unlike wildlife photography. By using the sRGB color space, our JPEGs look great when we view them on the back of the camera, projected, or on the web. We aren't giving up anything, though, as a larger color gamut can be selected when a RAW image is processed with the Photoshop or Lightroom RAW converter software without any loss of quality. Barbara is a student of a master printer—Charlie Cramer! Charlie and many other excellent printers select a color space with a broader color gamut called ProPhoto. This color space is not an option with any cameras that we know of, but is a common option in software that can process RAW images.

IMAGE SIZE ON THE LCD

Horizontal (landscape) images nicely fill the camera's LCD, making it much easier to see image detail. However, if you shoot a vertical, the camera will not be properly orientated when you view the LCD unless you turn the camera to the vertical. Therefore, your camera may offer you a menu choice to make vertical images appear vertical on the LCD when holding the camera horizontally. When this option is chosen the displayed images appear considerably smaller. It is more effective to turn the camera to the vertical to see a vertical image that occupies the entire LCD display. The cameras we use offer an important valuable option. We can set the camera to make vertical images fill the LCD by keeping them displayed horizontally, but when they are downloaded to a computer, the vertical images are displayed vertically, saving you time because you don't have to rotate each vertical image individually to properly view it on the computer monitor.

REVERSE THE EXPOSURE CONTROL DIALS

We nearly always use and recommend using Manual exposure in close-up photography. Once you learn to do everything manually it is quicker and faster to achieve optimum exposure than continually fussing with exposure dials or buttons to assist auto exposure modes in arriving at the optimum exposure.

We'll cover exposure in Chapter Two, but for now, it is helpful to have a camera that offers a separate dial for adjusting the shutter speed and the f/stop (aperture). When viewed from the back of the camera, it makes the most sense to turn the dials to the right (clockwise) to add light and to the left (counterclockwise) to subtract light. Adding light moves the histogram data to the right and vice-versa. Unfortunately, most camera default setups are the opposite. This means to add light and move the histogram data to the right, you must turn the dial to the left—the opposite way. Fortunately, many cameras now provide a way to reverse the dial direction with a menu choice (most Nikons) or a custom function (most Canon models). By way of an example, the Canon 5D Mark III dials can be reversed by going to the C.Fn2: Disp./ Operation menu. Then go to *Dial Direction during Tv/Av* and

set it to *Reverse Direction*. Now turning the main control dial on top of the Canon 5D Mark III to the right slows the shutter speed down and adds light. The histogram data moves right when the live histogram is activated. It can be seen and reviewed immediately. Turning the quick control dial on the back of the camera to the right opens up the aperture. This adds light and moves the histogram data to the right. Most photographers find it is more intuitive to turn the exposure control dials the same direction they want the histogram data to move. If you don't have a live histogram, shoot the image after you adjust an exposure dial. You'll see the histogram data move to the right when adding light and to the left when subtracting light.

REVERSE THE EXPOSURE INDICATOR INSIDE THE VIEWFINDER

Every camera we encounter has an exposure scale that can be viewed when looking in the viewfinder. Usually, the scale can be found at the bottom of the viewfinder, but it could be placed along the side. The exposure scale is quite simple. Though it depends on the camera model, a typical display shows a scale that represents plus or minus 2 stops of light in 1/2 or 1/3 stop increments. On Canon cameras and other brands, the plus side is on the right side of the scale. This is a convenient way for the scale to be set up. After all, if you wish to add light with Manual exposure, and your dials are set as such, turning them to the right (as viewed from the rear of the camera) does add light — it is only logical to have the metering scale set up the same way. Then, when the shutter speed dial or aperture dial is turned clockwise, the exposure indicator index line also moves to the right. However, some cameras, especially Nikons, have the positive side of the exposure indicator scale on the left side. Obviously, this is confusing to many photographers and makes absolutely no sense at all. Fortunately, many Nikon camera models, especially expensive ones, provide a menu selection to reverse the exposure scale. If your camera default is set up with the plus side of the exposure scale on the left, be sure to reverse the scale's direction if the camera allows this to be done.

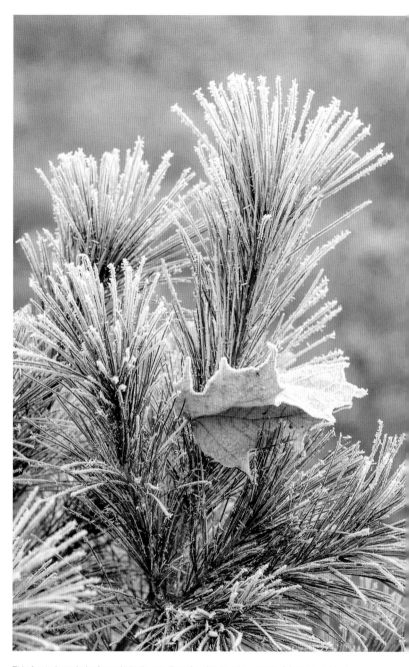

This frosted maple leaf caught in the needles of a pine tree is a wonderful macro subject. The air is absolutely still, but mirror lock-up must be used to obtain the maximum sharpness, especially at the 1/8 second shutter speed. Vibration caused by the movement of the mirror is especially troublesome in the 1/4 second to 1/30 second shutter speed range. Nikon D3, 200mm, 1/8, f/16, ISO 200, Sun.

MIRROR LOCK-UP

Even when shooting images on a sturdy tripod, the action of the mirror can cause the camera to shake a tiny bit, causing a slight loss of sharpness. This problem is most acute with shutter speeds in the 1/4 second to 1/30 second range. Select a camera that offers a way to lock the mirror in the upright position prior to the exposure. However, if you use Live View, then locking the mirror up prior to the exposure isn't necessary because the mirror is already up and out of the way to enable a live image.

BUILT-IN WIRELESS FLASH CONTROL

Being able to use electronic flash effortlessly is utterly crucial for close-up and macro photography. We regularly mix flash with natural light when photographing small subjects. It is a convenient bonus if your camera has a built-in pop-up flash that can be programmed to command an external flash. However, if your camera doesn't have a pop-up flash, then there are other ways to gain off-camera flash control.

TWO-SECOND SELF-TIMER

Any time you must shoot exposures of 1/60 second and longer on a tripod-mounted camera with natural light, be sure to avoid touching the camera or tripod during the exposure. Touching the equipment most likely will cause the camera to vibrate a tiny amount, which may produce a slightly soft image. Always use a remote release or cable release, or trip the camera by pushing the shutter button gently with your finger to activate a two-second self-timer. The camera counts down two-seconds before tripping the shutter, giving any vibrations that might be caused by pushing the shutter button with your finger time to dissipate.

CAMERA STRAP?

Almost certainly a camera strap came in the box with your new camera. Without giving it a thought, virtually all photographers automatically fasten the strap to their camera. Is it a good idea? It is true that a camera strap can support the

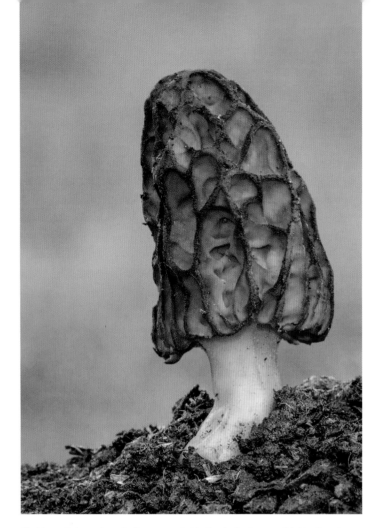

A cable or wireless release isn't necessary to trip the shutter because this Morel mushroom won't wiggle in a slight breeze. Using the two-second self-timer is a convenient and effective way to fire the camera. Nikon D300, 200mm, 2-seconds, f/20, ISO 200, Cloudy, fill-flash.

camera if the strap is wrapped around your neck. It could save your camera from a watery demise, sudden impact on granite, or some other tragedy should you accidentally drop it. However, in nearly all cases, the best quality close-up images must be shot on a solid tripod using impeccable technique. We almost never use a camera strap for any photography using a tripod, which is most of the time. This especially includes close-up and macro photography. Camera straps constantly get in the way and slow us down. All too often straps must be moved away from the LCD display on the rear of the camera to see the histogram or when manually

focusing the image using Live View or through the viewfinder. Sometimes the strap gets caught in the tripod legs. Since many close-up subjects are close to the ground, the camera strap occasionally dangles between the lens and the subject. The swinging strap may bump or spook the subject and ruin the shot. The camera strap slows you down, is a nuisance, and will cost you many fine images. Just because a camera strap is included with your camera does not mean you have to use it. My Canon 5 Mark III camera strap works just fine for supporting Zeiss binoculars around my neck, but never my camera.

We know many photographers are comforted by using a camera strap. Fine! Go ahead and use it if you insist, but please don't put the strap around your neck when shooting on a tripod. The idea of tying myself to the tripod gives me the heebie-jeebies. Especially for close-up photography, the camera strap around your neck is a horrible idea. Most close-up images benefit from some flash being used to the side or behind the subject. This means you must be able to get away from the tripod to position the flash correctly, which is made impossible if you are tied to the tripod with a short leash. We consider both camera straps and straps for most large lenses to be a nuisance and totally avoid them. Of course, when handheld photography is required, then camera straps are useful for supporting the camera. Wider camera straps work better than skinny ones because the weight of the camera is spread over a larger area so the strap doesn't so quickly wear a groove into your neck.

BATTERIES

Your camera probably came with a rechargeable battery and a charger. That's convenient and will save you a lot of money over the long run. Since modern rechargeable batteries work just fine if you charge them after each use, always do so. It is always wise to have at least one extra fully charged battery with you at all times. Nobody wants to be forced to quit shooting suddenly when the only battery they have quits. Therefore, buy at least one additional battery, and two is even better. If you go on an expensive photo vacation, consider having at least two extra batteries and one spare battery charger in case one charger fails.

Many camera systems offer a battery pack for your camera. This allows you to use two batteries at once to keep the camera running for a long time. While it might be worth doing this for wildlife photography when the action is furious, it is most likely unnecessary for close-up photography where the shooting pace tends to be much slower. We normally do not buy battery packs, but would do so if it would offer a convenience that we could not get any other way.

MEMORY CARDS

Your camera may use Compact Flash (CF), Secure Digital, or some other type of card on which to store images. Due to the slower and more deliberate shooting speed of close-up photography, card speed and capacity are not as crucial as they are in wildlife and sports photography. However, since we do all kinds of photography and love fast action, we tend to buy the faster memory cards with larger capacities.

We have used SanDisk Extreme CF cards without problems all of these years. Currently, we are using 16GB, 32GB, 64GB, and 128GB cards. Other quality memory card brands include Delkin, Lexar, and Kingston. Protect your memory cards in a plastic card wallet. To avoid corrupting the card, never turn the camera off when it is writing to the card. Always keep the card clean. When the images are successfully downloaded to your storage device (we use 1TB external hard drives), double-check to be sure it downloaded properly. Then format the memory card in the camera where it will be used next. This better prepares the card to receive more images, rather than erasing images off the card and reusing it. Remember, always format the card only in the camera!

LENSES AND ACCESSORIES

The photography of small subjects often requires lenses and accessories designed specifically for that task. Many options can serve the technical needs and budgets of the close-up photographer, but no one lens or no one accessory is best for

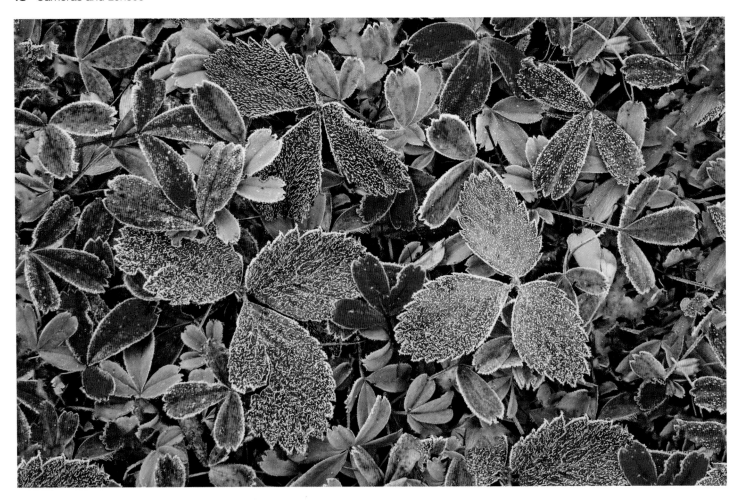

Since these frosted strawberry leaves will not move during the exposure, any shutter speed can be used if the camera is firmly supported on a tripod and the shutter is activated with the two-second self-timer. Nikon D3, 85mm, 1/2, f/22, ISO 200, Cloudy.

all users in all circumstances. Even experienced pros sometimes have heated discussions as to what's the best gear for this task or that. I will describe many of your possible choices along with their pros and cons and tell you exactly what equipment I use for what and the reason I use it.

MAGNIFICATION

We'll be talking a lot about magnification. It is a good idea to get a little grounding early on. Magnification, which we'll often refer to as m, is merely a comparison between the actual size of a subject and the size of its image on the camera's sensor. It's the ratio of those two sizes, or as the arithmetic geek might say, m = (image size) ÷ (subject size). So, if we photograph a dime, and the image of that dime on our sensor is exactly the size of the dime itself, i.e., life-size, then m = 1, or as we sometimes say, m = 1x. Sometimes magnification is called the reproduction ratio. For a subject photographed at half life-size, the reproduction ratio might be written as 1/2x or 1:2.

If we photograph a mosquito, and the image on the sensor is three times as large as the mosquito itself, then m = 3x. At least those 3x mosquito images don't bite! But, if we

photograph a silver dollar, a life-sized image probably will not fit on our sensor, so to quantify the magnification m, we'd still consider the size of the image that is on the sensor and divide it by the size of that portion of the silver dollar so represented. In this case, it might be something like m = 0.6x.

MACRO LENSES

Is it macro or is it not? Now that we've reviewed magnification, let's get one more confusing definition out of the way. It's no big deal, but there's close-up photography and there's that special case of close-up photography we call macro photography. The generally accepted practice is to refer to *close-up photography* when dealing with magnifications of less than 1x. It's bigger subjects and smaller images. Perhaps m = 1/2x where the image is only half the size of the subject or perhaps m = 1/4x or m = 1/10x etc. In the realm of big images and small subjects, specifically where m = 1x or larger, say, m = 2x, 3x, etc., we're discussing macro photography. All of that notwithstanding, we'll use the terms *close-up* and *macro* interchangeably unless we're making some specific technical point.

Macro lenses are designed to permit focusing closer to the subject than their non-macro cousins and to produce sharp images at those close distances and are optically corrected to produce super-sharp images across the entire frame with little sharpness falloff near the edges of the frame. It's by focusing closely that we achieve the larger magnifications of macro photography. All lenses have a minimum focusing distance (MFD), but non-macro lenses just don't get close enough. An extreme example is the Canon 800mm lens with an MFD approaching 20 feet! Most photographers at my age, or probably at any age, can't even see a mosquito at 20 feet away let alone photograph it! A less extreme example, but still quite unsuited for macro shooting, is a Nikon 50mm lens, a so-called *normal* focal length, but one with an MFD of about 3 feet. This is still way too far for a 1x image of that mosquito.

Close-up photography has become very popular in recent times, and lens makers offer a wide range of products. Looking at Canon's lenses, we see about six capable of 1x or greater, and Nikon products have a similar line-up. Camera manufacturers such as Olympus, Pentax, Sigma, Sony, and

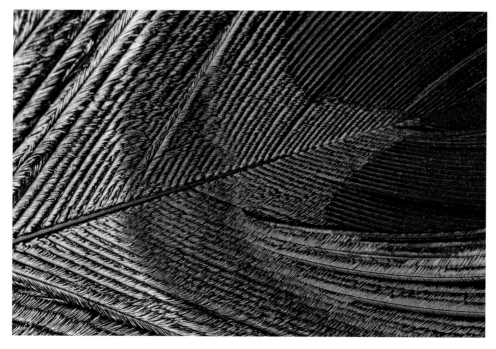

This peacock feather is photographed at precisely life-size (1:1 or 1x) magnification. The size of the focused image on the camera's sensor is exactly the same size as the subject. Nikon D4, 200mm, 1/13, f/22, ISO 320, Shade.

others, offer one or more macro lenses. The marketplace of macro lenses offers different focal lengths and different maximum apertures, different magnification abilities, prime lenses and zooms, expensive and not so. How's a poor photographer to choose? Oh, by the way, Nikon doesn't sell *macro* lenses. Nikon sells *micro* lenses. Not to worry, it's a difference in name only.

ANGLE OF VIEW

The angle of view of a macro lens has an enormous effect on the images it produces. The greater the angle of view, the more background information is included in the image. Too much background information is usually considered a distraction in macro shooting and thus detrimental to the image quality. Do you want an out-of-focus industrial warehouse

The angle of view of a 50mm lens is so wide that it makes it difficult to photograph the Twelve-spot Dragonfly without a distracting background. Canon 5D Mark III, 24–70 lens at 50mm, 1/10, f/14, ISO 200, Cloudy, fill-flash.

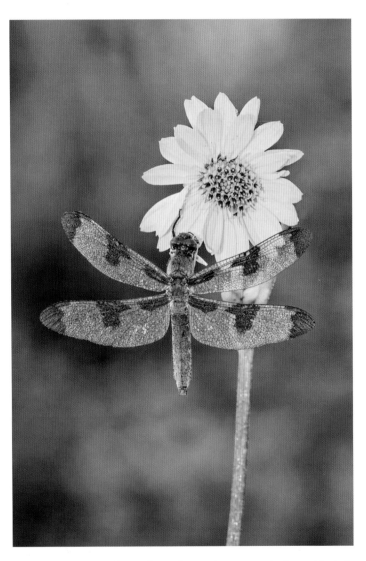

The Canon 180mm macro lens produces a far more homogeneous background due to its smaller angle of view. Canon 5D Mark III, 180mm, 1/10, f/13, ISO 200, Cloudy, fill-flash.

in the background of your otherwise lovely flower shot? Well, the longer the focal length of our macro lens, the narrower the field of view, and the less unwanted background material is included in the image. It's nearly impossible to get a nicely defocused and distraction free background with a 50mm lens, or with the misleadingly named *macro* position on an inexpensive short zoom lens.

With a long focal length lens, like Canon's or Sigma's 180mm macro lens or Nikon's 200mm micro lens, distracting backgrounds are minimized. By carefully selecting a shooting position and angle, you can easily avoid an unfavorably messy background. Background distraction is so important to excellent macro photography that the focal length of your lens is a major consideration, and, just like photography vacations, the longer the better.

WORKING DISTANCE

Another extremely important characteristic of a macro lens is its working distance. Suppose you're photographing an Acmon Blue butterfly, slightly less than 1 inch long. You're planning a composition with the butterfly at 1x and, luckily, your macro lens is easily capable of 1x.

Despite that, your macro lens achieves its 1x magnification at a working distance of 4 inches, so the lens must be that close to the butterfly to get it in focus. Not a chance! The critter suddenly vanishes—rightly terrified by the enormous glass and metal overcast suddenly looming a mere 4 inches away. How very frustrating. Every Acmon Blue you find promptly executes a fleet flit afar before you can get close enough to focus on it at 1x. The solution is a macro lens with a long working distance. Good examples are offered by Nikon, Sigma, and Canon, with working distances closer to 18 or 20 inches when focused to 1x.

Often these working distances are shown on the lens. For example, the Canon 180mm macro shows the working distance is exactly 1.56 feet when the lens is focused to 1x magnification. At .5x magnification (1:2x), the working distance is 2.15 feet.

Working distance always varies with the focal length of macro lenses. Canon's 180mm f/3.5 and Canon's 100mm f/2.8 both offer magnifications up to 1x, but when focused at m = 1x, the 100mm lens is 1 foot from the subject and the 180mm lens is 1.56 feet from the subject. The longer lens offers several inches of additional working distance.

Consider further the benefit of a long working distance as it relates to physically disturbing the subject. Practitioners of the macro shoot are invariably using tripods, especially under diffused light. The farther from the subject you can remain, the less likely a chance movement of the tripod will disturb the foliage or alarm the subject. Also, and slightly more esoteric, is the effect of your body heat. On a very calm and cool morning, an extremely fragile dewy spider web can easily be set in motion by the mere movement of nearby air caused by the shooter's body heat. Remember your physics—warm air rises and cooler air slides in to take its place. Nobody wants a wiggly macro subject—making you yearn once more for a lens with a long working distance.

THE TRIPOD COLLAR

Consider once again the short focal length macro lens. It attaches to the camera and the camera is attached to the tripod. Typically the arrangement provides for horizontal image orientation, and to shoot vertical images one must

A tripod collar on a lens makes it convenient and easy to change from a horizontal to a vertical composition or any angle in-between.

reconfigure the tripod head. Not only is that a nuisance, but the center of gravity and weight distribution of the gear keeps changing. Moreover, as the focal length of the lens increases, the lens size and weight increases. This adds potentially damaging stresses to the camera. Finally, when the lens is cantilevered off the camera, the *pendulum effect* causes an increased tendency for image-softening low-frequency vibration.

Camera makers have largely eliminated these problems by fitting longer lenses with a tripod collar. Now the camera and lens assembly is attached to the tripod head by the lens collar so that the camera is suspended from the rear of the lens. The weight distribution is better, the center of gravity of the system is better aligned with the center of the tripod footprint, and there is less mechanical stress on the camera's lens mount. Vibration effects are reduced, and another significant benefit is that both camera and lens are easily and conveniently rotated between horizontal to vertical in minimum time with minimum effort, with minimum change in the center of gravity, and with minimum photographer frustration. Barb and I hereby proclaim that tripod collars are incredible and wish all lenses had them!

KNOW YOUR LIMIT CONTROLS

One client complained that his new Canon 180mm macro lens—the one I had suggested he get—would not focus on small subjects. It turns out that some manufacturers have designed their lenses with two (the Sigma 180 macro has three) ranges of focus. For example, the Canon 180mm macro lens has a selectable choice of a focusing range from infinity down to 1.5 meters or a closer focusing range from infinity down to .48 meters. Using a focus limiter switch on the lens, two ranges are provided to allow users to select the range more suited for the upcoming shot. A restricted range reduces the amount of searching for correct focus that the lens must do and thus speeds up autofocusing. Faster focusing saves battery power, results in less lens wear and tear, and reduces that all-important photographer frustration. Use it to your advantage.

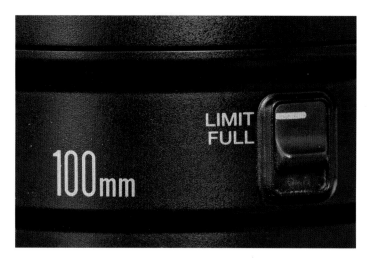

Many autofocus macro lenses provide a *Limit* switch. Be careful! This Limit switch confuses many photographers. If you unknowingly set it, you will have a problem. Pictured is the Limit switch on a Canon 100mm macro. If the lens is set to infinity focus, and then the switch is set to Limit, the lens cannot focus to the higher magnification range. If the lens is set to 1x, and the Limit switch is then set, the lens cannot focus on large objects. The Limit switch speeds up autofocus if you set it to cover the magnification range you are working in. However, we rarely use autofocus in close-up photography and always leave the switch set to Full.

Focusing ranges are offered on many lenses. Be certain you are aware whether or not your lens offers it, and learn to set it correctly. In the Canon 180mm macro example, setting the range from infinity to 1.5 meters—as my client had done— makes it impossible to autofocus to magnifications greater than about 1/5 life-size. Setting the focusing range to .48 meters to infinity allows magnifications all the way up to life-size (1x).

While you may be using the autofocus capability of your macro lens when using it for non-macro shooting, it's almost certain you will not use autofocus in macro work. Selection of the correct focus point in a macro subject is way too critical to be left up to a mere camera—the photographer needs to do it. Additional detailed discussion on this topic will be presented later.

THE EFFECT OF SENSOR SIZE

This topic relates more to the camera body than to lenses, but has a significant effect on our ongoing discussion of lenses, so here it is.

As I mentioned earlier, some cameras have a *full-size* or *full-frame* sensor, so-called because it's the same size as a frame of 35mm film which is 36mm × 24mm. Why is 35mm film, which some of us can't even remember, of any importance? Well, as a well-known fiddler once sang, *"It's tradition!"* And most of today's cameras have a smaller sensor. Nikon calls them *DX* cameras. The smaller size gives rise to a characteristic called a *crop factor* or occasionally a bit misleadingly called a *magnification factor*. We'll call it a crop factor. Irrespective of name, the effect is that a given image size on a smaller sensor is a larger portion of the sensor size than if the same image size were on a full-sized sensor. To get that image proportion on a full-frame sensor at the same subject distance, a longer lens must be used so the small sensor image thus appears to have been made by a longer lens.

Just for reference, the 36mm × 24mm full-frame sensor is 1.5 inches long and 1 inch high. A typical *DX* sensor is 0.9 inches long and 0.6 inches high. Let's do a life-size (1x) shot of a big beautiful busy bumble bee that's 1/2 inch long. It doesn't matter whether we use a long lens or short. It doesn't matter if the sensor is full-frame or smaller. If it's a 1x shot, the bee image on the sensor is always 1/2 inch long. On the small sensor camera, the bee image is a larger portion of the sensor size than on a full-frame camera and seemingly made by a longer lens. Yet the image was not made by a longer lens. Nothing has been magnified. It's merely that the smaller sensor crops the bee's surroundings more than the full-frame sensor does. "To bee or not . . ." Oh, never mind.

So the effect of the small sensor is that small sensor images appear to have been made by longer lenses. Even though focal length is focal length and lenses get no longer on a small sensor camera, we do enjoy the narrower field of view that a longer lens provides. A Canon Rebel has a crop factor of 1.6. This causes the field of view of a 100mm lens to be the same as that of a 160mm lens used on a full-sized sensor. The longer effective focal length gives better background control with its generally beneficial improvement in image quality. Just keep in mind that for any given subject, m is determined by image size, not by sensor size.

180MM AND 200MM MACRO LENSES

We've discussed the importance of having a narrow field of view, greater working distance, and a tripod collar, so Barbara and I have an easy choice of macro lenses. Barbara uses Nikon's 200mm f/4 AF Micro Nikkor lens while I use my Canon 180mm f/3.5 macro lens.

We've convinced many a student of the merits of these lenses, and each and every student who's acquired one has been happy with it. They're just superb for macro shooting. Despite that, they're costly, they're heavy, and they're bulky. If you seek convenience, get something else. But, if you want excellent macro images and have a supporting budget, they are the lenses of choice. A fine alternative is the Sigma 180mm f/2.8 macro, and this one has optical stabilization, a boon for shooting handheld while stalking butterflies and other fast-moving targets where a tripod would be problematic. I recently received this macro lens from Sigma to test during the spring and summer of 2013. It is an awesome lens, but alas, it is expensive!

100MM MACRO LENSES

These are fine lenses for most macro shooting, but like most choices a photographer makes, there are pluses and minuses. Let's look at both sides:

On the plus side:

- They are extremely effective macro lenses as long as one remembers the shorter working distance, and moves slowly and carefully so as not to disturb delicate or wary subjects.
- They are smaller, lighter, and far less costly than the longer macro lenses, and many shooters' priorities lie in these characteristics.

On the minus side:

- Shorter lenses generally have less working distance than longer lenses, although by moving slowly and carefully, you can approach most subjects closely enough for good images. This problem can be somewhat mitigated by small sensor cameras, which for a given subject size, will fill the frame at greater working distances.
- Shorter lenses also have a wider angle of view than the longer lenses, which is generally undesirable, although a careful selection of

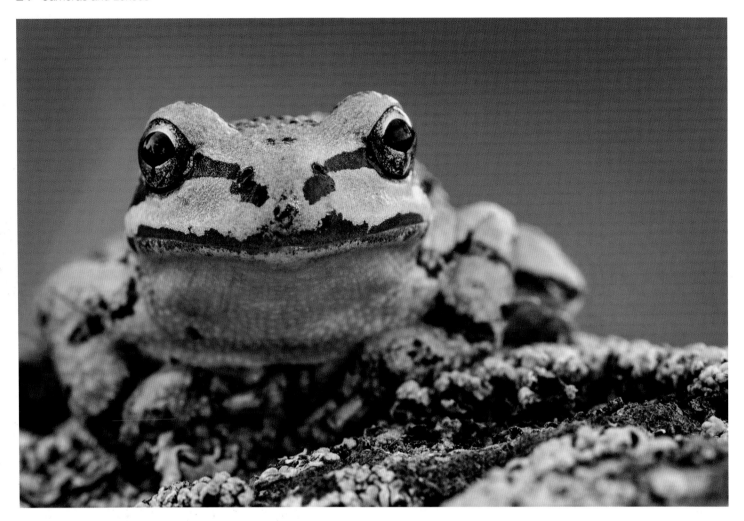

Pacific Chorus Frogs are wary of potential predators such as an approaching photographer. The long macro lenses we favor in the 180–200mm range offer considerably more working distance than shorter lenses, which makes it easier to get within adequate photo range. Nikon D4, 200mm micro, 1/2, f/22, ISO 100, Cloudy.

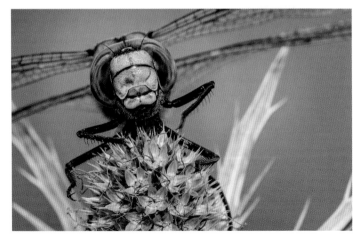

Dragonflies make great portraits! A Kenko 36mm extension tube is used on a 200mm lens to achieve greater magnification to fill the frame. Nikon D4, 200mm, 1/1.3, f/22, ISO 200, Cloudy.

shooting position can often achieve a satisfactorily non-distracting background.

- No tripod collar. This is a shortcoming of convenience; that is to say, it's a nuisance to switch back and forth between horizontal and vertical shots. Some macro shooters have image files that are 95 percent horizontal and 5 percent vertical only because it's such a pain to be changing formats without a tripod collar. Most of the inconvenience can be eliminated by using an L-bracket on the camera.

50MM MACROS

While 50mm macros are exceptional for in-studio and copy work, these lenses are just too short for serious in-the-field macro shooting. Their wide angle of view can encompass half the entire world as a background when you'd much rather prefer the highly constrained background of a very narrow field of view. The short macro has a working distance about the size of the insect you're photographing, and, without great care, the insect may be crawling on the front element of your lens! The extremely wide angle of view and miniscule working distance offered by 50mm lenses makes them difficult to use most of the time.

It's hard to hide our distaste for these lenses when used as in-field macro tools. Yet they can offer large magnifications when used with extension tubes. The mathematics of extension mean that extension tubes used on short lenses give lots of magnification. Therefore, they are suitable for high magnification images and studio work.

Barb and I will always work hard to help our students achieve the best possible results when they use short lenses, but we always recommend upgrading to a longer lens.

CANON MACRO PHOTO LENS MP-E 65MM F/2.8 1-5X

This unique lens permits extremely high magnifications. At a minimum, yes, a minimum, it gives m = 1x, meaning that you can handily shoot a life-sized image of a robber fly face. Turn the focusing mechanism of the lens a little and you get an astonishing 5x magnification. If you want a mosquito face or a spider eye image, this is the lens for you.

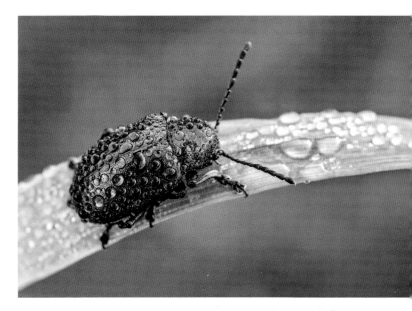

The iridescent colors in the beetle and the dewdrops are attractive. The specialized Canon 65mm macro lens that begins at life-size (1x) magnification and increases all the way to 5x is used to capture this image. Canon 5D Mark III, 65mm macro, 1/1.3, f/14, ISO 160, Cloudy.

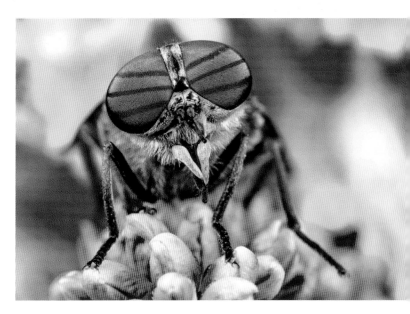

The fascinating pattern in the compound eyes of this horse fly is highly photogenic. Canon 5D Mark III, 65mm macro, 1/6, f/16, ISO 200, Cloudy.

A dedicated Canon lens without peer among other manufacturers, it features manual focusing with no autofocus capability, but that's acceptable for macro work. The wide field of view of a 65mm lens is somewhat mitigated by the extremely limited depth-of-field encountered at high magnifications. Backgrounds aren't distracting because they are so thoroughly out of focus at these high magnifications.

At high magnifications, especially at 2x and greater, all lenses become extremely critical to focus and incredibly susceptible to any movement or vibration of the subject or the camera. Moreover, the working distance is minimal—only about 4″ at 1x, falling to about 1.5″ at 5x. A good focusing rail is an essential accessory at these magnifications, and of course, so is a very sturdy tripod.

I've owned one of these lenses for several years and love shooting high-magnification images with it. I highly recommend it. That having been said, be aware that shooting at very high magnifications is much easier done in the studio than in the field. However, using a Plamp to hold the subject perfectly still in the field does make the 65mm macro easier to use.

PERSPECTIVE CONTROL (TILT-SHIFT) LENSES

These lenses have mechanical movements, allowing them, when mounted on a camera, to shift and to tilt. *Shift* is a lens movement up and down, or side to side, or on some intermediate angle, where the longitudinal axis of the lens, that is, the line through the center of the lens from front to back, remains perpendicular to the sensor. Stated another way, when shifting, the lens moves up and down, or side to side, or on some intermediate angle, where the planes of the glass elements remain parallel to the sensor. *Tilt* is a lens movement that changes the angle between the longitudinal axis of the lens and the plane of the sensor. Usually that angle is a right angle, 90 degrees, or we can say that the longitudinal axis is perpendicular to the sensor. When tilting, we adjust the lens for some different angle, causing the lens to point up, down, to one side or the other or some intermediate combination. It is important to realize that *tilt* and *shift* are two different controls that solve different problems. Of the two, *tilt* is far more useful in close-up photography.

Some lenses will only shift and some will both shift and tilt. Lenses that only shift are used, for example, in architectural photography, to keep vertical lines from converging, and, buildings from looking like they're falling over backwards. The nature shooter might like them for tall trees and tall waterfalls, but they're not very useful in close-up work. Lenses with tilt capability, however, are very useful to the close-up shooter. They allow extreme ranges of focus, such as when shooting a nearby flower and wanting both the flower and the distant mountain to be in focus. The tilt lens is superb for photographing the raindrops clustered on a leaf at an angle to the plane of the leaf to make the drops sparkle more. Likewise, it works for the angled upturned wings of a butterfly.

The best choices for close-up work are the Nikon 85mm f/2.8 PC-E Micro lens and the Canon 90mm f2.8 T/S lens. Both focus quite closely without accessories, and by using even short extension tubes, greater magnifications are easily achieved.

The ability of these lenses to give an extreme focus range even at very large apertures is best explained by the *Scheimpflug Principle*, the details of which are beyond the scope of this book and best left to your own research. However, one piece of geek speak might be helpful here: Tilt lenses do not, as often thought, increase depth-of-field. The depth-of-field is largely determined by aperture and magnification. What tilt lenses do is allow the photographer to change the *orientation* of the plane of focus, as best helps the image.

It's unfortunate that tilt-shift lenses aren't offered by other manufacturers, but they're expensive, and the limited markets of third-party makers don't warrant the engineering and production costs of adding them to the product line. Barbara and I find plenty of applications for them and wouldn't want to be without them. In any event, exceptional close-up photography is easily accomplished otherwise, so don't agonize if you don't have one! With the recent advances in focus stacking—to be discussed in the flower chapter—the need for owning a lens that can tilt has diminished.

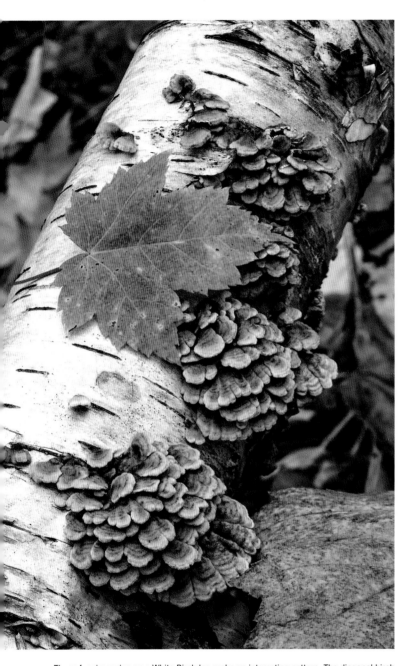

These fungi growing on a White Birch log make an interesting pattern. The diagonal birch log with the red maple leaf and fungi were shot at a 45 degree angle. To get the log, fungi, and maple leaf sharp, a Canon 90mm tilt and shift lens is used. The lens is tilted slightly down to make the plane of focus coincide with the plane of the log. Canon 5D Mark III, 90mm T/S lens, 1/4, f/18, ISO 100, Cloudy.

ZOOM MACROS

Some zoom lenses, particularly the lower cost so-called *consumer-grade* lenses, are occasionally advertised as having a macro mode. Yet many fall far short of m = 1x, a requirement of a true macro lens. Moreover, many offer close-up focusing only at the shorter focal lengths where the wider angle of view is decidedly unfavorable.

The big advantage of the zoom lens is the ability to adjust the compositional framing by adjusting lens focal length and not having to move a tripod around, or worse (many think), move the photographer around. That's an ability less needed in digital photography where one can *shoot loose* and crop later, but it's always a much better idea to maximize image detail by filling the frame nicely and not cropping during post-capture editing. One of the better zoom macros is the Sigma 70–300mm f/4-5.6 DL Macro Super II. At 300mm, this lens can be focused close enough to achieve a magnification of 1/2x. This doesn't reach the true macro range, but 1/2x fills the image with many small subjects.

NON-MACRO ZOOM LENSES

There's a plethora of zoom lenses on the market that themselves do not focus close enough to be useful for general close-up usage, but when augmented by certain accessories they can shoot excellent close-up images. If you already own a zoom lens that reaches out to say, 200 or ideally 300mm, you might consider adding a good quality close-up lens to your underlying zoom. Such lenses include the Canon 70–300mm and 100–400mm, Nikon 28–300mm and 70–200mm, and the Sigma 70–300mm.

CLOSE-UP LENSES

Close-up lenses, also known as *supplementary lenses* or *diopters*, are filter-like accessories that screw onto the filter thread of your lens. They enable the underlying lens to obtain greater magnification and can allow the photographer to fill their frame with a small subject. Consider the Canon 100–400 f/4.5-5.6 lens. Alone, it can achieve only m = 0.2x, meaning 1/5 life-size at a working distance of about 16 inches. If you

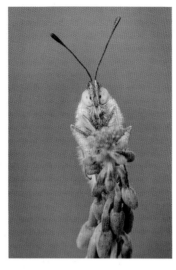

A close-up lens is attached to the front of a Canon 300mm lens to make it focus much closer. The close-up lens looks like a filter and screws on to the front of your regular lens. They are wonderful for reaching higher magnifications with fixed focal length and zoom lenses alike.

The portrait of a sulfur butterfly is captured by screwing a 62mm close-up lens on to the front of a 200mm micro lens. Nikon D4, 200mm micro, Nikon 5T close-up lens, 1/2.5, f/22, ISO 200, Cloudy, and with flash as the main light.

get the D model. Close-up lenses have a thread that mates with the filter thread of the underlying lens. Canon close-up lenses come in different magnification factors. The 250 series generates less magnification than the 500 series, so we always use the latter. Also, these lenses come with threads of 52mm, 58mm, 72mm, and 77mm to match (hopefully) the filter threads on the front of the lens that will be used with it. It would be nice to have one of those close-ups lenses for each lens you intend to use for close-up work, but a less expensive option is to get a single close-up lens for the largest of your underlying lenses and buy inexpensive adapter rings to use the large thread close-up lens with your smaller thread underlying lenses.

Actually, it's nearly always a good idea to use a close-up lens, or any filter at all for that matter, that's larger than the thread of the underlying lens. Use a simple and inexpensive step-up ring to mate the larger accessories to smaller lenses. The combination helps avoid darkening of image corners, you save the costs of buying close-up filters in different sizes, and the weight difference is not great.

Despite all of the advantages of using close-up lenses on a zoom, Barbara and I still prefer to use a long focal length macro lens. We must move our tripods around to get the compositions we want, but we're accustomed to doing it. This remains our preference, but we admit it isn't the best choice for everyone because price and weight and the convenience of zooming to compose are important to others.

One can also use close-up lenses on prime (non-zoom) underlying lenses. An avid close-up shooter frequently attending our Michigan workshops even puts a close-up lens on his long macro lens. His Nikon 200mm AF Micro lens gets m = 1x unaided, but he puts a good-quality Nikon 6T close-up lens on it and gets m = 1.8x, great for in-field dewy dragonfly heads and the like. When feeling photographically warlike and aggressive, he puts both a Nikon 6T and 5T on the same lens, and gets m = 2.2x. With both configurations, he enjoys a good working distance. Many outstanding photographers use close-up lenses successfully and without having to spend a great deal of money on their close-up photography.

add a 77mm Canon 500D close-up lens to the front of the zoom lens, the combination allows m = 0.8x—pretty close to life-size. While you benefit from a much narrower angle of view, you also get ample working distance, and you have a tripod collar as well. It's an efficient setup that delivers quality images!

Close-up lenses are relatively inexpensive, lightweight, compact, easy to use, and attenuate very little light. But, buyer beware! There are many poorly made inexpensive close-up lenses that produce poor quality images of degraded color, lowered contrast, and poor sharpness. Good close-up lenses, though, like the double-element Canon mentioned above and the double-element Nikon 5T and 6T offerings, can cost upwards of $100, but they produce first-rate quality images.

The Canon offerings include versions with and without a *D* as a part of the model number. The D designates the double-element close-up lens. The quality it produces is better than the non-D versions, so when you buy Canon, be sure to

OTHER FILTERS

The quality close-up lenses we've recommended notwithstanding, adding any glass in front of your camera lens risks some image degradation. So you should ignore the common advice to buy the high profit filter to protect your lens at the camera store. They're often of poor quality and will cause a loss of sharpness and will increase lens flare—doing considerably more harm than good. I've seen more than one lens irreparably dropped onto the rocks below, but in 40 years, Barb and I have never damaged a lens in a way that a filter would have helped. Therefore, we have never owned protection filters and do not recommend them. Instead, maximize your image quality by using reasonable care and rely on your lens hood for protection!

For a specific photographic purpose, though, some filters are valuable. A good quality polarizer is nearly always valuable in shooting foliage, anything wet, and of course, the sky. A blunder, though, is stacking your polarizer on top of a UV protection filter. That's a serious no-no practically guaranteed to degrade your images! When the positives of using a polarizer outweigh the miniscule loss of image sharpness, go ahead and use the filter!

EXTENSION TUBES

An extension tube is just a light-tight and glass-free empty spacer that moves a lens farther from the camera body. The lens being farther away allows closer focusing and thus greater magnification. Extension tubes are rugged, easy to carry, and fairly inexpensive. They are easy to use. Attach the extension tube to the camera and then the lens to the extension tube. Canon, Nikon, and independent manufacturer Kenko all offer extension tubes of excellent quality. They come in different lengths and can easily be combined for greater length. Canon offers 12mm and 25mm tubes.

I have a set of three Kenko tubes made for Canon that include a 12, 20, and 36 millimeter tube. I also have a Canon 12mm and two 25mm extension tubes. The Kenko extension tube set is an essential part of my camera bag. In a separate long-lens bag, I keep two Canon 25mm extension tubes to make my

A polarizing filter is necessary to subdue the glare from this attractive assemblage of seashells. Nikon D4, 200mm micro with polarizer, 1.3 seconds, f/22, ISO 200, Auto.

Without the polarizer, notice the glare that is hiding the color and detail in the shells. We normally don't use a polarizer when shooting close-ups because they absorb too much light, but they are helpful when glare is a serious problem. Nikon D4, 200mm micro with polarizer, 1/2, f/22, ISO 200, Auto.

The Canon 300/4 lens focuses down to a minimum focusing distance of 4.9 feet. At the closest focusing distance, this 3 inch long seashell is too small in the image. Canon 5D Mark III, 300mm, 1/3, f/16, ISO 100, Shade.

A Kenko 36mm extension tube is inserted between the camera and the 300mm lens. Extension tubes don't contain glass, but serve as a spacer to allow any lens to focus closer. Now the seashell can nicely fill the frame. Extension tubes are superb for achieving higher magnification. Canon 5D Mark III, 300mm, 1/2.5, f/16, ISO 100, Shade, Kenko 36mm extension tube.

500mm and 800mm lenses focus closer for small bird and mammal photography. Extension tubes are usually used one at a time, but they can be added together to achieve even greater magnification. Don't overdo it because it is possible to add too many and the whole system bows in the middle.

Barbara uses a Kenko set of tubes made for her Nikon system. Like Canon, Nikon builds their own extension tubes. They offer an 8mm, 14mm, 27.5mm, and the remarkable PN-11 52.5mm extension tube with a built-in rotatable tripod collar! That collar is an enormous boon when using lenses otherwise without one. One minor downside of the Nikon tubes is that they don't permit autofocus operation. But, as we've already pointed out, autofocus is not generally used in macro photography. However, if you want to use the tubes with longer lenses for wildlife photography, preserving autofocus is crucial. In that case, select the Kenko extension tube set for Nikon.

Regardless of brand, extension tubes offer many opportunities for use. As mentioned, I sometimes use one or two tubes on the back of my 500mm or 800mm lens to reduce its minimum focus distance, so I can capture larger images of small birds and mammals. Tubes are effective for reaching higher magnifications than otherwise would be possible. Put a set of Kenko tubes behind a 100mm macro lens, focus the lens to life-size, and the tubes will allow a magnification much higher than life-size.

I also use tubes to convert my 300mm prime lens into a great macro lens, thus acquiring a very narrow field of view and a long working distance—a combination that would bring smiles to most any close-up photographer. I do a lot of hummingbird and Black-capped chickadee photography, and that's a great combination! In fact, I've made some measurements, and my 300mm lens on a camera with a 1.6x crop factor gave these results:

300mm Lens on 1.6x Crop Factor Body	Subject Size that Fills the Frame	Apparent Magnification
Lens alone.	3.75 inches	0.24X
With a 12mm tube.	3.00 inches	0.30X
With a 20mm tube.	2.75 inches	0.33X
With a 36mm tube.	2.25 inches	0.40X
With stacked 20 and 36mm tubes (56mm total).	1.75 inches	0.51X
With stacked 12, 20, and 36mm, tubes (68mm total).	1.50 inches	0.60X

You can see that the 300mm lens with extension is capable of reaching quite reasonable magnifications. You can't fill the frame with a single dewdrop, but you can photograph many macro subjects well with a 300mm lens and extension tubes. Image quality is not compromised because there's no glass in the extension tubes to cause distortion, flare, or lack of sharpness. One obtains a very small angle of view, a very comfortable working distance, and a tripod collar to make tripod use more convenient.

At one time or another, Barbara and I have used tubes on nearly every lens we own, including macro, tilt-shift, zoom, wide-angle, and super-telephoto lenses. We have always found them to be very useful. Note that when using extension tubes, the ability to focus the lens at long distances is lost. It's a compromise that has confused many a workshop student trying an extension tube for the first time and finding that the tree a few feet away can't be brought into focus. I demonstrate what's happening by having them try to focus on my hand while I gradually bring it closer. If you're a newcomer to extension tubes, it'll take a short while for you to become accustomed to the changes brought about by the tubes.

It's often helpful to know what magnification to expect when using this tube or that. We tried to stick to our promise to hold down the arithmetic, but this simple formula might be useful:

m = extension tube length ÷ lens focal length

Example: with a lens focal length of 100mm, add a tube that's 50mm long.

m = 50/100 = 1/2x

So, with m = 1/2x, a butterfly that's 1 inch long will have an image size of 1/2 inch on the sensor, or half life-size. And if you instead use a Canon 25mm tube on a 100mm lens, m = 25 ÷ 100 = 1/4x, an image size one-fourth that of the subject.

To avoid the arithmetic, just approximate things. Precise numbers are not needed for most shooting. If your extension is about the same length as the focal length of the lens, you're going to get about 1x. If the extension is about half the focal length of the lens, you'll get about 1/2x, and so on. Do remember your lens has a built-in focusing range of its own. Focusing the lens to the closest focusing distance while using the extension tube will produce a magnification that is somewhat greater than the formula calculates. With practice, it doesn't take long to be able to accurately guess what extension tube size is needed to adequately magnify a subject with a favorite lens.

All is not peaches and cream, though. There's always some light loss when using tubes, but generally the loss is easily offset by ISO, aperture, or shutter speed adjustments. There are some arcane equations to calculate the loss of light, but the results aren't usually important in this day of RGB histograms and highlight alert exposure controls.

One more caveat—don't go wild in stacking multiple tubes. The mechanical stresses on the tubes, the lens and the camera may add up to a dangerous level causing mechanical or electrical failure. In the field, we rarely use much more than 50mm of extension.

To summarize, extension tubes are useful accessories for nearly all close-up shooters. Heck, we don't know how any photographer—even those who don't shoot close-ups—can get by without them. Buy either the tubes offered by your camera maker, or, alternatively, a set of the Kenko tubes configured for your camera body and lenses. Currently, Kenko offers tubes for Canon, Nikon, Olympus, Panasonic, and Sony Alpha.

TELECONVERTERS

Teleconverters, also known as tele-extenders, or TCs, are like extension tubes in that they fit between lens and camera body. But, unlike the completely hollow extension tubes, teleconverters contain internal glass optics that operate to multiply the focal length of the underlying lens on which they're used. Canon, Olympus, and Sony, all offer high-quality teleconverters for their own systems, in powers of 1.4x and 2.0x. Nikon has three, with powers of 1.4x, 1.7x, and 2.0x.

By the way, do not confuse the focal length multiplication factors above with image-magnification factors! A 2x teleconverter multiplies *focal length* by two times, but absent other information, says nothing about *m*, *the image magnification*. In simpler words, a 2x teleconverter doubles the focal length, but that does not mean the magnification is 2x.

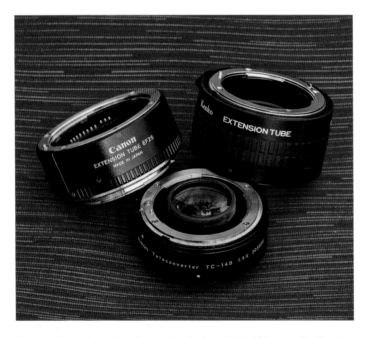

Teleconverters and extension tubes are effective for achieving higher magnifications than would otherwise be possible. A Canon 25mm extension tube is on the left. A Kenko 36mm extension tube is on the right. A Nikon 1.4x teleconverter is at the bottom. Only the teleconverter contains glass. Extension tubes work by enabling the lens to focus closer than otherwise possible. Teleconverters work by multiplying the magnification by the power of the converter.

Another less obvious way is that it's easy to degrade your images if using an optically unsuited combination of underlying lens and teleconverter. Good image quality, especially at higher magnifications, requires both lens and teleconverter to be of excellent quality. In fact, many writers and practitioners maintain that both products should be made by the same manufacturer, and we agree.

The close-up photographer finds that a teleconverter not only provides greater magnification, but has several other effects, not all of them are good. Contemplate the results of adding a 2x teleconverter to a 100mm f/2.8 macro lens:

- The focal length has doubled to 200mm.
- The linear magnification has doubled.
- The working distance has not diminished.
- The maximum aperture has dropped 2 stops from the original f/2.8 to f/5.6.
- Light is lost by the lowered maximum aperture. Focusing will be hindered due to the darker viewfinder making it more difficult to see.
- The loss of light may require changing your ISO or shutter speed needs to deal with wind on your subjects.
- The depth-of-field at any given image size and aperture remains the same, but at the small aperture end of the lens's f/stop scale, you gain 2 f/stops and hence additional DOF at the new f/stops. For example, it the aperture originally went down to f/22, it now goes to f/45, and the new aperture range will have commensurate depths-of-field. Watch out for diffraction-induced image softening at those miniscule f/stops!

COMBINE EXTENSION TUBES AND TELECONVERTERS (TC)

If a little is good, more is better, so they say. There are times when you may want more than a full-frame shot of a mosquito, you want a full-frame image of the mosquito's head. Here is a way to do it. You can savor a substantial boost in magnification by using extension tubes and teleconverters at the same time. Add a 2x teleconverter to your camera. Now add a 50mm extension tube, and finally mount a 100mm macro lens. When the lens is focused at life-size (1x), the 50mm extension tube will increase the magnification to

A Nikon 1.7x teleconverter is inserted behind a Nikon 200–400mm lens to fill the frame with this resting Whooper Swan in Japan. The extra working distance provided by the teleconverter makes it possible to photograph this bird without disrupting its pose. Nikon D3, 200–400mm, 1.7x teleconverter, 1/250, f/16, ISO 800, Sun.

This tiny cluster of blueberries encased in a spider web requires plenty of magnification. A 1.4x teleconverter is attached to the camera. Then a 25mm extension tube is attached to the teleconverter and mounted on a macro lens to achieve higher than life-size magnification. Canon 5D Mark III, Canon 100 macro, 1.4x teleconverter, 25mm extension tube, 2 seconds, f/16, ISO 200, Cloudy, fill-flash.

1.5x. The 2x teleconverter then doubles m to about 3x. Your mosquito-head image is imminent!

Two caveats:

- Be certain that the TC is on the camera and the extension tube is between the TC and the lens. Mounting them in reverse significantly reduces magnification.

- At these large magnifications, you need to think Rock of Gibraltar! Nothing can move, neither the camera nor the subject! Use only very sturdy and very rigid tripods—the $29 department store special is not in competition. Use solid tripod heads that lock down tightly and are designed for the weight of your camera and lens setup. Use mirror lock-up prior to the exposure to reduce vibration or the Live View option to get the mirror up ahead of time. Trip the camera with a remote or self-timer release. Shoot when the subject is absolutely motionless and stays still for the entire exposure. Even a teensy-weensy wiggle anywhere in the system will reduce the sharpness of your image.

If you can juggle all of those stability balls, you can fill your frame with a dewdrop using your 50mm macro augmented by a 50mm tube and a 2x teleconverter. Now your magnification is up to 4x! You also achieve a hard-to-focus very dark view-finder and a woefully short working distance, but if you're very careful and very patient, you can get decent results in the field or studio.

FOCUSING RAILS

It's difficult to focus precisely and reliably when shooting at 1x and greater. Generally, to achieve the highest magnifica-tion, you don't want to change the lens's focus. Instead, you

A focusing rail is beneficial to all close-up photographers. The rail makes it easy to move the camera forward and backward in tiny increments. Some focusing rails allow side-to-side movement.

want to move the camera back and forth a miniscule distance. Ouch! Have you ever tried to move your entire tripod and camera back and forth a tiny fraction of an inch or so, while the entire setup is all bogged in badly bouncing bushes or mired in miserable mucky mud? Meanwhile, try to do so without alarming the bashful black beetle.

A great solution is to use a focusing rail, sometimes called a *slider* or *macro slider*. It is a rack-and-pinion device mounted between the tripod head and the camera, or between the tripod head and the lens collar. It provides a knob that can precisely move the entire camera and lens assembly back and forth in small amounts, or, as needed, in amounts up to a few inches. There are even models that additionally allow small side-to-side movement for precise control of composition.

Our own focus rails are made by Kirk Enterprises of Angola, Indiana, but there are other models that work as well.

BELLOWS

In the good old days, Barb and I often used a bellows for our high magnification macro work. A bellows is a light-tight variable structure, as seen on the view cameras of yesteryear, mounting a lens at one end and a camera body at the other. This allows the distance between camera and lens to be changed by a small knob. It is essentially a variable length extension tube.

The variable camera-to-lens distance gives an adjustable magnification that is highly desirable in close-up work. However, a bellows is often heavy, generally fragile, bulky, prone to catching the breeze and causing vibration, and in some models, not as stable as one might like. In essence, bellows are not very convenient in the field and few are made. Today's photographers seem to prefer macro lenses, close-up lenses on zooms, solid extension tubes, or a combination of these devices.

STACKING LENSES

When I first learned to shoot high-magnification images way back in the 1970s, many shooters mounted a short focal

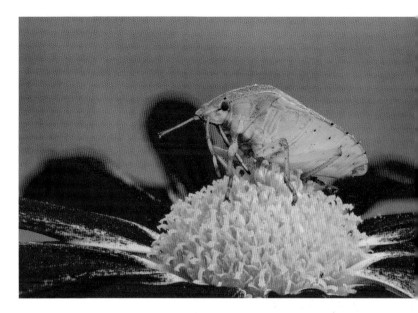

The Canon 1x–5x 65mm macro lens is terrific for shooting very high magnifications. If you commonly shoot higher than 1x magnification, consider getting this lens. Even Nikon, Sony, and other non-Canon users often buy an inexpensive Canon camera so they can use this lens. The green bug is captured in 29 images and merged into one single image with incredible depth-of-field and overall sharpness using the 65mm macro and Helicon Focus software. Canon 5D Mark III, 65mm macro, 1/15, f/10, ISO 400, Shade, 19 images combined with Helicon Focus.

length lens backwards onto the front of a longer focal length lens. By using a very inexpensive adapter ring, the lenses were mounted nose-to-nose, so to speak, that is, filter thread to filter thread, with the longer lens on the camera.

When the add-on lens was focused at infinity, the magnification achieved was the ratio of the focal lengths. If one were to mount a 200mm lens on the camera and reverse-mount a 50mm lens to the 200mm lens, the resulting magnification was 200 ÷ 50, a magnification of 4x. Lots of m, pretty easy to do, and often it didn't require any expenditure beyond the adapter ring. Now that zoom lenses rule, many observers thought that the system didn't provide the best image quality when using zoom lenses and thought there were better ways to preserve decent working distances, so this technique has fallen out of favor for most.

But, if you already have a 50mm and a 200mm prime lens, reversing the 50mm lens on the front of the 200mm lens still

works. For whatever reason, good or bad, today's shooters seem to prefer using macro lenses with various combinations of close-up diopters, teleconverters, and extension tubes to achieve the desired magnification.

FINAL THOUGHTS

Barbara and I continue to favor the use of long focal length macro lenses for the majority of our work. In fact, most of the images in this book were shot with either Barb's Nikon 200mm micro lens or my own Canon 180 macro lens. Both lenses do an exceptional job offering highly constrained fields of view for good background control while preserving excel-

lent working distances. The built-in tripod collar makes them a pleasure to use on a tripod.

However, we often recommend that our workshop students who already own a long zoom lens reaching 300mm (for example a 75–300mm) merely attach a high-quality close-up lens to the front of it. We also encourage using any of the good quality and widely available 100mm macro lenses, equipped as needed, with extension tubes and teleconverters.

There's many a way to reach 1x (and above), and more often than not, you can configure a satisfactory system at minimum expense by creatively using your existing lens or lenses with appropriate inexpensive accessories.

Paradoxically, even with all of the exotic animals at the San Diego Wildlife Safari Park, the unanimous crowd pleaser was a family of Mallard ducklings that briskly swam through the legs of a flock of flamingos. Barbara used a Wimberley Sidekick to convert her Kirk BH-1 ball head into a gimbal tripod head making it easy to pan with this dashing duckling. Barbara placed a single AF point on the head of the duckling, held down the back button focus control to activate continuous autofocus, and fired a rapid burst of images when it swam at the optimal angle for her to shoot. Barbara rapidly zoomed the lens to make a lovely composition. Nikon D4, Nikon 200–400mm at 400mm, ISO 1000, f/11, 1/640, Cloudy WB.

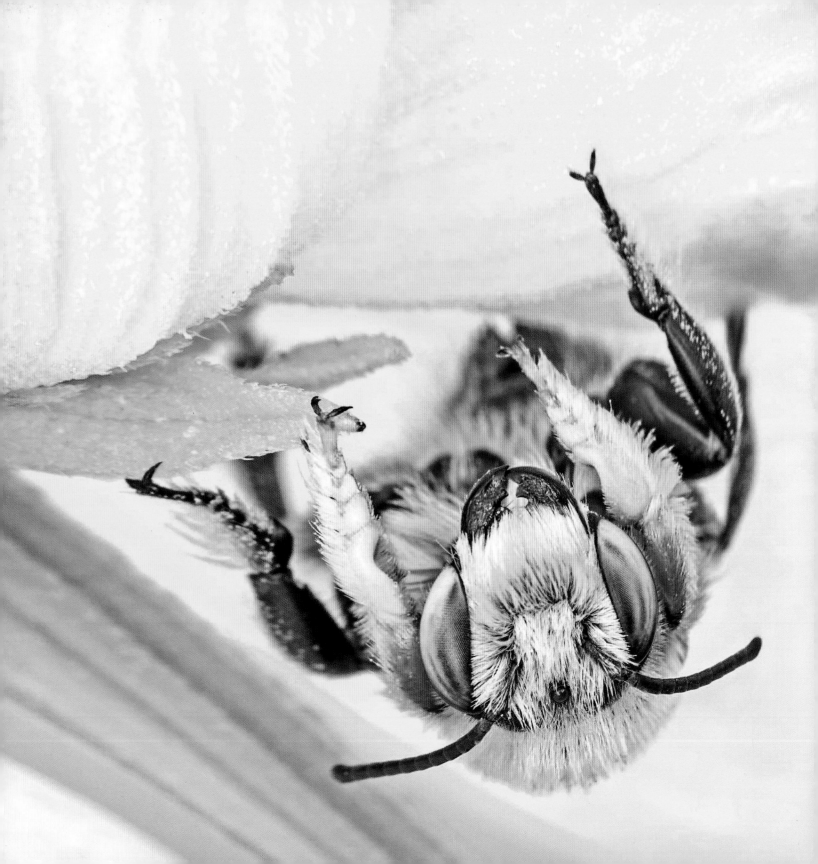

Exposure Essentials

We've long ago lost count of the books, articles, workshops, and bar conversations devoted entirely to the "Whatta ya shootin' at?" exposure question. Happily, today's digital technology rides in on its photographic white steed making it all very easy. A few simple guidelines guarantee your images are always perfectly exposed!

Cameras offer three major controls over image exposure. The first is the ISO setting, the image sensor's sensitivity to the incoming light. The second is the lens aperture, which we frequently, but not quite accurately, called the f/stop. And third is the shutter speed, which determines the length of time the incoming light is permitted to strike the sensor. You need only set these three simple controls correctly, and you maximize desirable detail in your image while minimizing unwanted *noise* in the shadow areas.

Explaining exposure, though, is not all that easy. As a photo instructor, I've been known to spout endless exposure minutiae on and on until I'm nearly hoarse. But relying on the magic of digital photography, I can now say much less and teach much more. So, in this book I'm going to avoid most of the mathematics of the digital camera. You don't need to know that information anyway, and you don't need to know precisely how the sensor measures light or exactly how the camera records colors. Instead, we'll cover just what you really need to know to make splendid close-up images.

Many insects roost on flowers at night. At dawn we always check flowers carefully to see who might be sleeping on them. This green-eyed bee remains perfectly still on a cool dewy Michigan morning. A Plamp is attached to the flower stem to hold it still. Nikon D3, 200mm, 1/1.3, f/22, ISO 200, Cloudy.

AVOIDING COMMON EXPOSURE MISTAKES

Many a new digital photographer tries to judge exposure by the brightness of the image displayed on the camera LCD monitor. No matter how tempting, and yes it is, don't do it! Okay, so Barbara and I both did it in the beginning, but we soon learned how wrong it was. The appearance of the image on the monitor is markedly affected by ambient light, so in bright daylight the image seems underexposed, yet in darker surroundings, the very same image seems overexposed. The user's viewing angle also affects image brightness. Moreover, the monitor display of many cameras can be made to look brighter or dimmer just by simple camera adjustment. But neither ambient light, viewing angle nor monitor brightness relates to the image's exposure. Knowing that the best exposure *collects the most data, preserves the most highlight detail,* and *minimizes image noise,* you need another way to detect exposure accuracy. *You cannot, cannot, cannot, accurately judge your exposure by looking at the LCD monitor.*

Likewise, don't judge exposure by how the image looks on your computer monitor or on your digital projector, where the same error factors are in play. The ambient light levels, instru-ment brightness settings, and user viewing angles all affect the image's appearance on those displays as well, effectively masking whether the exposure is good or bad.

So if you genuinely understand that you can't judge exposure by assessing the image on the camera's LCD monitor or on your computer monitor or projection screen, what's the poor bewildered photographer to do?

THE AVERAGING HISTOGRAM AND HIGHLIGHT ALERT

Overexposure is perhaps the photographer's most egregious blunder next to dropping his new camera onto the rocks. Luckily, many digital cameras allow the photographer to activate two accurate exposure aids. The histogram accurately tells whether the image is properly exposed, and if not, how to correct it. And where some overexposure is shown, the highlight alert feature reveals just what image portions are affected. When the highlight alert feature is activated, over-exposed image areas blink black and white, earning the photographer's buzzword *blinkies*. If the overexposed areas

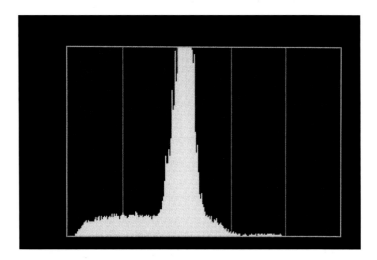

Many photographers still erroneously judge the exposure by how the image appears on the LCD display such as this butterfly on the back of my Canon 5D Mark III. Don't judge the exposure this way. The ambient light affects the appearance of the image too much and most LCD displays can be dimmed or brightened by the user making the LCD display inaccurate for judging the exposure.

Use your camera's histogram display to judge the exposure. The rightmost data of the histogram should be close to the right wall on the graph. In this image of a Canon 5D Mark III display, this Averaging histogram's rightmost data is about 1 stop from the right wall and indicates the image is underexposed.

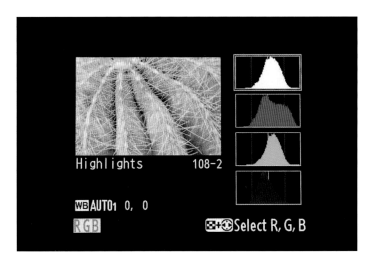

This Nikon D4 histogram display includes both the Averaging histogram at the top and the RGB histogram that shows a separate histogram for each of the three color channels—red, green, and blue. This histogram display shows the exposure is excellent as the rightmost data is nicely snuggled up to the right wall of the histogram.

are caused by *specular highlights*, like the sparkling water drops on a frog's back or dewdrops on a flower blossom, we don't need to capture detail in such highlights. It's okay to let them remain overexposed. By allowing those highlights to remain overexposed, we maximize detail captured in the remaining and important areas of the image.

If the histogram shows overexposure and blinkies reveal the overexposure occurs in important image areas where detail is wanted, it's time to reconsider our exposure!

Probably the most useful tool in digital photography, the histogram is a simple bar graph representing the different brightnesses in the image. The graph displays darker tones to the left and lighter tones to the right, with the height of the data showing the relative amounts of these darker and lighter tones. The actual numerical data is unimportant and not shown. Do recognize that there's no correct shape for all histograms. None. There's no such thing as an ideal histogram, and the shape of any histogram is peculiar to its own subject matter. Your white flower image will have an entirely different histogram shape from your brown toad image. What is definitely critical about the histogram is not its shape, but its placement within the graph space.

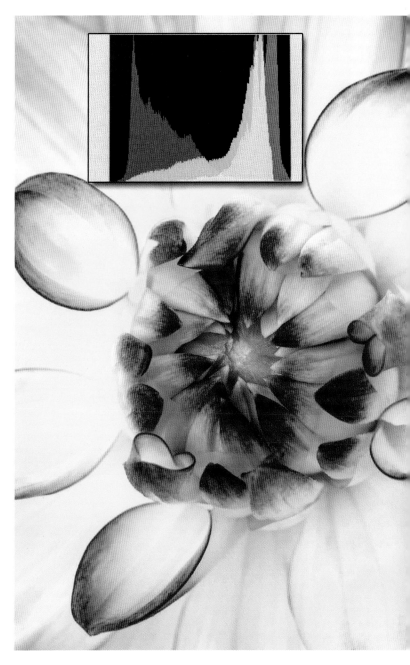

Dahlias are popular domesticated flowers. Overall, the flower is mostly light in tone. Notice the abundance of histogram data on the right side of the histogram chart. This data represents the lightest tones in the flower. Canon 5D Mark III, 180mm, 1/1.3, f/16, ISO 100, Shade.

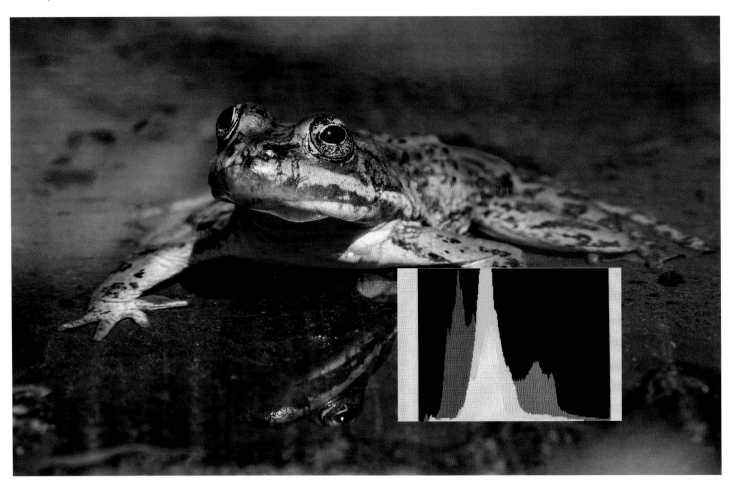

The Spotted Mountain Frog in this small pond is mostly made up of dark tones. Although you still want to Expose to the Right (ETTR), notice the bulk of the brightness values appear left of the center on the histogram. Canon 5D Mark III, 180mm, 1/100, f/16, ISO 320, Cloudy, fill-flash.

A proper exposure for any image will cause its rightmost histogram data, regardless of shape, to be as far to the right edge of the graph space as possible, within a couple of guidelines explained below.

JPEG AND RAW IMAGE CONSIDERATIONS

The largely unprocessed data taken directly from any camera's light sensor is called its RAW data. The sensor's millions of micro-sized pixels collect incoming light, distributed according to the light's color. The brightness of the light collected by each photosite is converted to a minute electrical signal. The tiny signal is *digitized* by an in-camera gadget called an analog-to-digital (A/D) converter to form the RAW image. If the camera provides RAW files as an output format, the digitized signal from the A/D converter is sent to the camera's memory card, essentially unchanged, as a RAW file.

Most cameras offer JPEG files as an output format. The photosite data goes through the same A/D conversion, but then undergoes extensive in-camera processing. The dictates of the camera designers and the options selected by the photographer as to color saturation, image size, resolution, sharpness,

and additional changes, are all applied before the image is delivered to the memory card as a JPEG file.

Summarizing briefly, JPEGs are more convenient ready-to-go files, but they offer less control to the photographer. Use JPEGs if you do not want to spend a lot of time editing and adjusting your photos on a computer. RAW files are more time consuming because they require more post-capture editing, but they offer much greater creative control and flexibility. Some cameras will allow an image to be delivered in both formats, a feature that may appeal to certain photographers. We always set our cameras to capture both a RAW file and a JPEG of every image we shoot. Then we can choose the file we want to work with later.

THE IDEAL JPEG EXPOSURE

The all-important guideline in JPEG exposure is that highlights in which detail is needed must absolutely not be overexposed.

The ideal JPEG exposure produces a histogram where the right-most histogram data does not quite touch the right edge of the graph space.

This Anise Swallowtail is basking on a cool afternoon. Using the RGB histogram display, notice the red color channel has data farthest to the right. The histogram in the upper left corner is an ideal exposure for a JPEG because the rightmost data of the red channel stops just shy of the right wall of the histogram, which ensures the highlights are not overexposed. The histogram display in the bottom left corner is better for a RAW exposure because the red channel's data actually touches the right wall. Nikon D4, 200mm, 1/5, f/22, ISO 200, Cloudy.

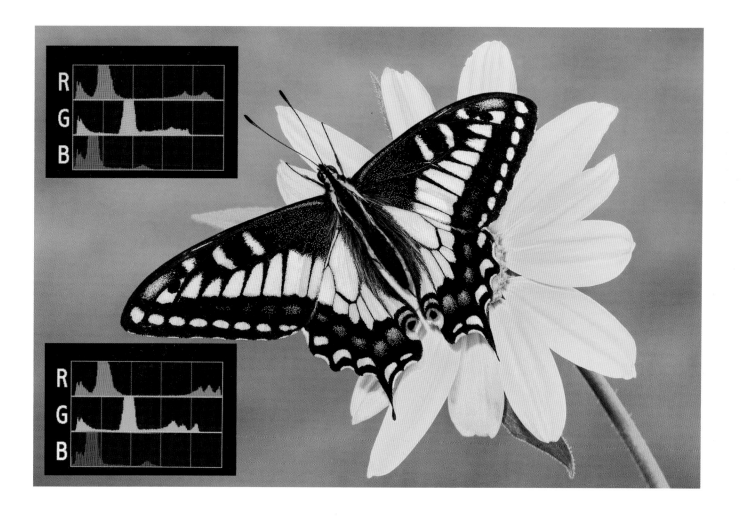

If you're interested in a bit of trivia, JPEG files are 8-bit files. That's because the JPEG format divides its subject matter into 256 different brightness levels, or tonalities, from 0 (pure black) up to 255 (pure white). Why are 256 different tonalities described mathematically? Because computer folks like to work with numbers expressed in *powers of 2* and 256 is equal to 2 raised to the 8th power.

THE IDEAL RAW EXPOSURE

Here's our guideline for proper exposure of RAW files:

The ideal RAW file exposure actually allows the rightmost edge of the histogram curve to touch the right edge of the graph space, as long as extensive climbing of the right edge of the graph space is avoided.

Each and every photo in our nature photography instructional books is exposed by the above guideline. A histogram actually touching the right edge of the graph space is **desirable** because it captures the maximum amount of image detail. It's **allowable** because a RAW histogram is derived from an embedded JPEG file, and the already mentioned internal processing of the JPEG file causes the RAW histogram to show highlight overexposure (clipping) before clipping actually occurs. So you can allow a RAW exposure perhaps up to a full stop over that which hits the right edge of the graph space and still not clip important highlights.

You may one day encounter good cause to deviate from the above JPEG and RAW exposure guidelines. If you can articulate a rational reason to do so, then have at it! Otherwise, using histograms and blinkies according to these guidelines has proven, over millions of exposures, to produce the finest images.

THE RGB HISTOGRAM

Many cameras offer a second form of histogram, called an RGB histogram. It's actually three separate histogram curves, one each for the camera's red data, blue data, and green data. It's a far more precise representation of your exposure. It is

very helpful in all photography and especially in close-up photography. Suppose you're photographing a bright red mushroom growing against a deep green moss background. The Averaging histogram, often called the Luminous his-

One of our workshop students found this tiny red mushroom growing in the moss during a 2013 fall color workshop. A long macro lens is used to isolate the mushroom against the green background. The entire mushroom is made sharp by shooting a series of ten images where the focus is varied slightly. All of the images are merged into a single image with tremendous overall sharpness using Helicon Focus. As expected, the inserted RGB histogram shows the red channel has data farthest to the right. Canon 5D Mark III, 180mm, 1/2.5, f/13, ISO 100, Cloudy, fill-flash.

This blue delphinium grows abundantly in our backyard. Anytime a single color dominates the image, you can expect the color channel that matches the color of the subject will show data farthest to the right. The inserted RGB histogram clearly shows that. Canon 5D Mark III, 180mm, 1/5, f/16, ISO 100, Shade.

togram, though Canon calls it the Bright histogram, is largely determined by the exposure of the large green background. The green moss can generate a good histogram even though the bright red mushroom might be badly overexposed with loss of detail in the reds.

The three-channel RGB histogram may initially appear intimidating, but it's easily mastered. After ensuring that the RGB histogram is activated in the camera menu, the shooter needs only to determine which of the three color-channel histograms has data farthest to the right and apply that histogram alone to our above exposure guidelines. Going back to the example of the bright red dragonfly on a green leaf, we'd see that the red channel histogram is farthest to the right. Ignoring the other channels, we merely expose so that the red channel histogram complies with our above rules. In conclusion:

If shooting JPEG files, we expose so the red-channel histogram data closely approaches, but does not touch, the right edge of the graph space.

If shooting RAW files, we expose so the red-channel histogram data touches, but does not extensively climb, the right edge of the graph space.

If our image of an appetizing bunch of blueberries resulted in the blue channel's data being farthest to the right, we just follow the same rules while using the blue channel.

You've probably noted we're always recommending an exposure causing certain histogram behavior on the right side of the graph space. Those rules have become known as *expose to the right* rules or by their acronym *ETTR*.

See? That's it! Perfect exposures every time, easy and right at your fingertips!

CLIPPING ON THE LEFT

So far we've addressed clipping on the right wall of the graph space. It's of no importance whatsoever if the data touches the top edge of the graph space as long as it is not climbing the far left or right wall, but we do want to address the left wall of the histogram. The left wall is where the darker tones of our image will lie, and if our image has a lot of dark tones, we'll see histogram data approaching, touching, or even climbing the left wall. If we've exposed according to our ETTR rules and our histogram curve is approaching or even just touching the left wall, we will have a fine exposure.

If, however, we've followed the ETTR rules and we have extensive climbing of the left wall of the graph space, then the

contrast of our subject matter exceeds the dynamic range of our camera sensor and we must do one or more of the following:

- Ignore the left-wall issue and accept whatever blocked up shadows and digital noise are present.
- Use HDR techniques to accommodate the excessively contrasty subject.
- Reduce subject contrast by lighting changes, for example by fill-flash or a diffusion cloth. High contrast can be somewhat mitigated by using software fixes, but it is always best to control the contrast problem at the moment of exposure if that is at all feasible.
- Come back tomorrow when the light is better.

HOW IMAGES LOSE HIGHLIGHT DETAIL

My inner self has never quite recovered from my college physics classes. I probably spend too much time wondering how and why things behave as they do. While leading a snowmobile photo tour in Yellowstone National Park some years ago, I was wondering how detail is lost in a digital image, and after a couple of sleepless nights, the answer dawned on me. I remembered my youthful high-speed snowmobiling and how I'd run at 100 mph, but only on sunny days, never when cloudy. I remembered how the shadows caused by sunlight on the snow revealed the dips and bumps in the snow so that I could prepare for them. On cloudy days there were no shadows, no dips and bumps were visible, and an invisible bump was hazardous indeed.

Losing detail in a digital image is similar. Suppose you're photographing an orange Great Spangled Fritillary. This butterfly has warm brown, red, and orange tones that vary in color and brightness. Consider an orange area of this butterfly. Because the camera sensor recognizes 256 different tonal levels for JPEGs, let's assume that properly exposed brown areas result in sensor pixels exposed to various levels near a tonal value of 220. Some pixels are at 224, some at 230, some at 218, and so on. It's the difference in these brightness levels that provides the detail in the orange areas of the image.

Now let's increase the exposure until all of the pixels making up the orange areas are raised from the levels around 220, and you keep raising and raising them. Eventually all the pixels of the orange areas reach the saturation level of 255. At that point, when all have reached saturation and every pixel looks like every other pixel, there's no detail left in that area of the image, and we say that the area is overexposed! Can you see any detail in looking at a sheet of pure white paper in bright light?

If a group of pixels are identical in color and brightness, one cannot see any detail among them.

METERING MODES

Today's DSLR cameras generally offer three or more metering modes. These metering modes affect the way the exposure meter operates and are not to be confused with *exposure modes* such as Manual, Aperture-priority, Program, etc. My Canon camera offers four metering modes, called Spot, Partial, Center-weighted, and Evaluative.

Spot-metering gives exposure information based only on the light reflected from a very tiny portion of the subject. Partial metering covers a larger area in the middle of the image, a larger spot so to speak. Center-weighted metering assesses the brightness of the entire image area, but places emphasis on the central area of the subject. Some cameras allow user selection of the area of emphasis. Nikon's Color Matrix metering, and Canon's Evaluative metering, and the multi-segment metering of other manufacturers, are surely the most sophisticated metering modes, assessing the entire image area and applying advanced software algorithms to reach their conclusions.

None of these metering modes is perfect. Some photographer-entered exposure compensation is needed most of the time, depending on the subject and lighting conditions. Luckily, all cameras offer some means to compensate the exposure, though how it is done can vary. Using the Manual exposure mode, you compensate by changing the shutter speed, ISO, or aperture while guided by the exposure scale in the viewfinder. In Aperture- or Shutter-priority, one changes an

Achieving the optimum exposure is important for top-quality images. Notice the wonderful detail in the white hairs on the moth's head, excellent overall color saturation, and detail in the yellow flower. A good exposure preserves highlight detail, captures the maximum amount of image data, and reduces noise in the shadows. Nikon D4, 200mm, 1/4, f/22, ISO 200, Cloudy, fill-flash.

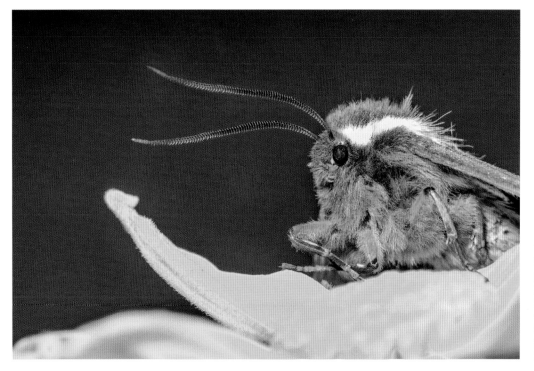

This image of the moth is seriously overexposed by at least 2 stops of light. The camera would warn you of this problem by showing the rightmost data bunched up and climbing the right wall of the histogram graph and the camera's highlight alert would blink off and on in all of the light areas. Notice the lack of detail in the flower and the white patch on the head. Nikon D4, 200mm, 1 sec, f/22, ISO 200, Cloudy, fill-flash.

exposure compensation dial whenever it is necessary to adjust the standard exposure the camera automatically sets.

WHY SPOT-METERING IS OBSOLETE

The camera designer is in a quandary when designing any exposure meter. The meter cannot tell whether a bright subject is bright because it has high reflectivity or because it's under bright light or some combination of each. He solves his quandary by making an assumption that all subject matter is of *average* tonality. Under that assumption, the meter can be thought to be measuring just the light falling on the subject. But it's not true that all subjects are of average tonality. Some subjects are bright (think white trillium) and some subjects are dark (think big black beetles). So, the only way the photographer can always get a proper exposure is to understand the meter idiosyncrasy, to be on constant alert for non-mid-toned subjects, and to override (compensate) the meter reading as necessary.

Over years of shooting finicky slide film with my top-of-the-line Nikon and Canon cameras, I used Spot-metering exclusively. I developed a metering strategy that worked perfectly for me. I Spot-metered something representative of the important parts of the image and added or subtracted light as demanded by the metered area's difference from average tonality. If the metered area was bright, I increased exposure by adding light. If dark, I reduced exposure by subtracting light. Yes, the compensation direction is counter-intuitive, but trust me, it is correct!

The system worked perfectly. Barbara and I taught it to thousands of our workshop students over twenty-five years. In fact many photographers attended our workshops just to learn that system that they'd heard so much about. But, woe is me! This exposure system, some of my most innovative ideas, is now antiquated and obsolete. With today's digital cameras, you need only use your Evaluative or Matrix metering, check your histogram to ensure ETTR appropriate for your JPEG or RAW usage, compensate according to your RGB histogram and blinkies, and it's an optimal exposure every time!

BE WILLING TO CHANGE

Although I invested zillions of hours in developing good Spot-metering strategies for use with slide film, I quickly abandoned the method when I realized it was unnecessary using digital cameras. Barbara and I make it a habit of questioning how we do things with our cameras. We find that it helps to occasionally try things we haven't done before.

As an example, we're not big fans of the Aperture-priority exposure mode, but Barbara uses it occasionally for wildlife photography, and I use Shutter-priority frequently for wildlife when it is the best exposure mode for the photographic problem at hand. Shutter-priority can be a big help on some occasions, such as when the light is changing so fast that I manually can't keep up with it when photographing animals. We use it in those circumstances. So, do try new things. Don't stay in the rut of old techniques when there are often new and better approaches to achieving your photographic goals. For close-up photography, however, we find little use for either mode. Should changing levels of ambient light be a problem, then the Aperture-priority exposure mode, which, unlike Manual exposure, monitors changing ambient light, is a logical choice to use, since depth-of-field is critical most of the time.

THE LANGUAGE OF STOPS

The idea of stops is a simple and precise means of thinking about controlling light in photography. The concept applies perfectly to ISO settings, to lens f/stops, to shutter speeds, and to flash output. You're now reading a book on close-up photography, and that probably means that you're already familiar with the stop concept, but for those who need a refresher, we'll review it briefly.

ISO

An ISO number is a measure of the camera sensor's sensitivity to light. The higher the ISO rating, the less light needed to form a properly exposed image. Every sensor has a *native* ISO rating, an ISO that will cause the sensor data to be used

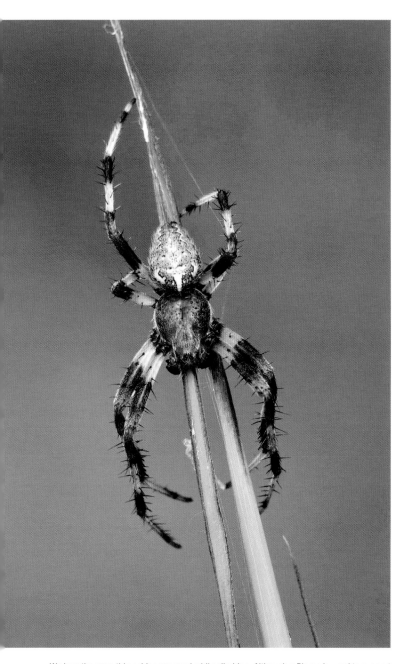

We love the pose this spider assumed while climbing. Although a Plamp is used to support the grass below the spider, a slight breeze gently wiggled the spider. To counteract the breeze, a higher than normal ISO is used to allow a faster shutter speed. Canon 5D Mark III, 180mm, 1/30, f/18, ISO 640, Shade, fill-flash.

without electronic manipulation of the data. In most cameras the native ISO rating is either 100 or 200. Other ISO ratings can be achieved by electronic amplification of the sensor data, and by so doing the camera becomes much more versatile. However, a price is paid in greater image noise that appears as random specks of colors or brightnesses where they should not be. Noise tends to make the image appear less sharp.

Image noise may be meaningless or unacceptable, depending on the ISO used, the characteristics of the camera, the nature of the subject matter, and the intended use of the image. Noise reduction software can be utilized in post-processing to reduce the harmful effects of noise.

A camera with a native ISO of 100, for example, might offer additional ISO *standard settings* of 50, 200, 400, 800, 1600, 3200, 6400, 12,800, and even much higher. Note the numbers are doubles or halves of the adjacent number. That means that each ISO standard setting is either twice as sensitive to light as the next one, or half as sensitive as the next one, depending on which way you are looking. As with shutter speeds and apertures, each doubling or halving of the light is a change of 1 stop.

ISO 1600 is 1 stop more sensitive than ISO 800. If ISO 800 gives correct exposure, then ISO 1600 will give correct exposure with only one-half of the light. If ISO 1600 is needed to give correct exposure, then images shot at ISO 400 will be 2 stops underexposed, assuming, of course, the shutter speed and the f/stop remain the same. That doubling and halving of light is the crux of stops theory, and we'll be talking lots more about it. And while we'll be talking about ISO changes in terms of stops, be aware that most cameras offer the opportunity to change ISO numbers in increments smaller than 1 stop, and offer in-between ISO settings of 1/3 stop increments.

Although the native ISO always gives the best image quality, sometimes we must use a different ISO because of other considerations. We may be in dim light, or may need a high shutter speed to arrest subject motion, and so we need to compromise. With many modern cameras, shooting at ISO ratings modestly above the native ISO compromises image quality so very little that it's wise to do so.

Bracken ferns wiggle if any air moves. This leaf has two Plamps attached to it, one on the right and one on the left to help it remain still. Even with two Plamps, it still trembled from time to time. Therefore, the shutter speed is increased by increasing the ISO to allow it. Nikon D3, 200mm, 1/15, f/22, ISO 400, Cloudy.

In close-up photography, the native ISO is preferred. Yet if a combination of native ISO of 100 and a small aperture needed for depth-of-field results in a shutter speed of 1 second, and 1 second is too long for the wind-blown flower, then now's the time to hike up that ISO and increase the shutter speed. Raise the ISO by 3 stops, going from ISO 100 to ISO 800, and you can now raise the shutter speed by the same 3 stops, going from 1 second to 1/8 second. At 1/8 second your battle against the wind is much improved if you wait for a temporary lull!

SHUTTER SPEED

The shutter speed is the length of time that the shutter remains open and allows light to strike the sensor. The faster the shutter speed, the less light is received. So, while we use fast shutter speeds to arrest both subject motion and camera motion, we must deal with the exposure implications of less light. When we use long (slow) shutter speeds to capture a lot of light, we must deal with the motion issues.

A typical camera offers shutter speeds ranging from 30 seconds to 1/8000 of a second in 1 stop increments. The sequence might be, in seconds:

30, 15, 8, 4, 2, 1, 1/2, 1/4, 1/8, 1/15, 1/30, 1/60, 1/125, 1/250, 1/500, 1/1000, 1/2000, 1/4000, 1/8000

Notice that the sequence is in stops. Each shutter speed is half or double the one next to it, so that a shutter speed change of 1 stop either doubles or halves the amount of light passed. As with f/stop settings, smaller increments of 1/2 stop or 1/3 stop are often available.

There is frequently an additional setting, called *B* or *Bulb*. The Bulb setting allows you to open the shutter on demand, and then close it on demand. It's used for shutter openings longer than 30 seconds, and while handy for such long exposure projects as shooting fireworks and star trails, it has little use in close-up photography.

One additional consideration is the minimum shutter speed usable while handholding the camera. A common rule of thumb for handholding is the slowest shutter speed usable while handholding is the reciprocal of the lens focal length. So when using a 200mm lens, always use a shutter speed of 1/200 second or faster. Perfectionists among us and users of electronically stabilized lenses may modify the rule. Whenever possible, use a tripod. Most of your close-up shooting will be on a tripod, not only to arrest camera motion but, importantly, to allow careful image composition and precise focus.

In close-up photography, shutter speed control is particularly important. You should memorize the different shutter speeds offered by your camera and know how to change light by the number of stops you need. A slower shutter speed offering more light will cause histogram data to move right, and conversely, a faster shutter speed moves it to the left. Most of your close-up shooting will be on a tripod, not only to arrest

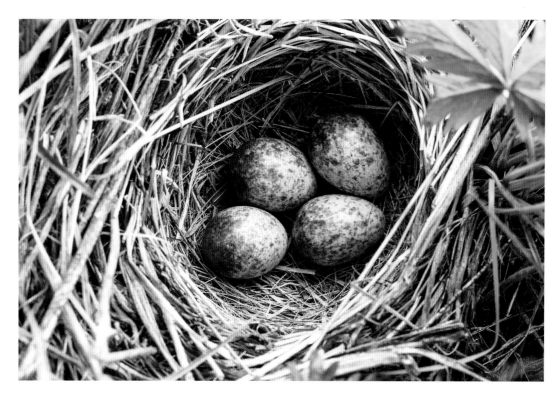

While photographing wildflowers along a high mountain stream, a White-crowned Sparrow flushed nearby. I quickly noticed the four eggs in the ground nest. I switched to ISO 800 which gave me enough shutter speed to handhold the camera—something we rarely do. I photographed the eggs in less than 1 minute and left the area to allow the bird to return. Canon 5D Mark III, 180mm, 1/125 second, f/11, ISO 640, Cloudy.

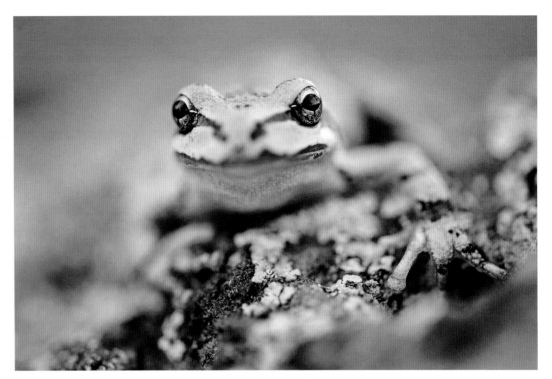

Depth-of-field is the zone of acceptable sharpness. It is primarily determined by subject magnification and the aperture. Notice how small the zone of sharpness is on this Pacific Chorus Frog. Nikon D4, 200mm, 1/60, f/5.6, ISO 100, Cloudy.

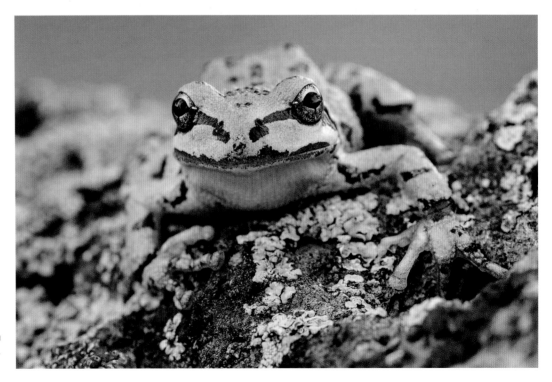

The zone of sharpness is much greater when the frog is photographed at f/22. Nikon D4, 200mm, 1/2.5, f/22, ISO 100, Cloudy.

camera motion but equally importantly to allow careful image composition and precise focus. You will often be using a small aperture such as f/16 or f/22 because of your need for a relatively large depth-of-field. You will also want to use the lower ISO settings because of the better image quality. With all of those parameters limited, you need the flexibility of the wide range of shutter speeds to control exposure.

DEPTH-OF-FIELD

When a camera is focused at any given distance, only objects at that distance are truly sharp, but objects a bit closer and a bit farther may be acceptably sharp because of the characteristics of the human eye and brain. The distance between the nearest acceptably sharp objects and the farthest acceptably sharp objects is called the depth-of-field (DOF).

Several factors affect DOF, but subject magnification and lens aperture (f/stop) are the major considerations in most close-up work. Greater magnifications reduce DOF and larger apertures reduce DOF as well. Magnification is generally dictated by the size of the subject and by the desired image, so aperture remains as the primary DOF control parameter. The smaller the aperture, the greater the DOF, so a great deal of close-up work is done at f/16 and f/22. Don't forget to use the ISO as an aid in selecting a suitable aperture! A higher ISO will allow you to shoot with a smaller aperture.

F/STOP AND APERTURE

A lens's aperture and its f/stop are not precisely the same thing, but the two are intimately related. Nonetheless, many photographers use the term interchangeably, as I do. Technically, aperture refers to the size of the adjustable iris hole through which the light passes, and it can be user adjusted from its design maximum to its design minimum.

The f/stop precisely describes the math relationship between the lens focal length and the size to which the aperture has been adjusted. It's the ratio of lens focal length to aperture diameter. As an example, a 55mm lens adjusted to an iris diameter of 5mm is set to an f/stop of f/11 (55mm divided by

5mm). Ignoring the technical distinction, most photographers will simply say that the above lens is set to an aperture—rather than an f/stop—of f/11.

Although smaller and smaller apertures give greater DOF, there's a problem. As the aperture's iris gets smaller and smaller, a greater percentage of the total light passing through the aperture strikes the edges of the fine blades of the iris. In so doing they are bent, or diffracted, from their original path, resulting in image softness. The effect is called diffraction. Putting it in perspective, a 20mm lens at f/32 has an aperture of 0.625mm or only 0.025 inches—the thickness of a matchbook cover. Through such a small aperture, so much light is diffracted that the image softness is unacceptable. That's why short focal length lenses, like the 20mm lens, rarely offer such small aperture choices as f/32. Using such a small f/32 aperture yields great depth-of-field, but little is sharp due to the deleterious effects of diffraction. For this reason, we tend to avoid even f/22 with our macro lenses, and normally use f/16 or f/18 when we seek the maximum depth-of-field.

The f/stops or f-numbers to which one can set a lens, just like ISO settings and shutter speed settings, run in stops. The standard f/stop numbers are:

1　1.4　2　2.8　4　5.6　8　11　16　22　32　45　64

A fast glance shows that these numbers are not halves and doubles like ISO and shutter speed numbers. Why not? Well, to double and halve the amount of light passing through, we must double or halve the *area* of the aperture circle, not its diameter. The area of the aperture is not linearly related to its diameter, so we get these funny numbers. Nevertheless, changing an aperture from f/5.6 to f/2.8, a change of 2 stops, does indeed quadruple the amount of light passing through, and changing the aperture from f/11 to f/16 cuts the light in half. Like the shutter speed settings, the lens f/stops are often adjustable in 1/2 stop and 1/3 stop increments.

Remember that the small apertures are those with the big numbers like f/16, and large apertures are those with small numbers, like f/4. Here's a question: If your 200mm lens is

set to f/22 and your 20mm lens is set to f/22, which lens has the larger aperture? The arithmetic above shows that although both lenses at these settings pass the same amount of light to the sensor, the aperture in the 20mm lens is much smaller, thus creating more diffraction-induced softness at f/22.

THE LAW OF RECIPROCITY

Wow! The very name sounds complicated, eh? Well, not so, now that we can speak in stops. Let's look at it. Assume that at some ISO, we have a good exposure at 1/60 of a second and f/8. We need additional depth-of-field, however, and would like to use f/16. We recognize that we'd be reducing the light by 2 stops, so we merely cause the shutter to be open 2 additional stops from 1/60 of a second to 1/15 of a second. The exposure of 1/60 second and f/8 gives the same amount of light as an exposure of 1/15 second and f/16. The two exposures are reciprocal exposures. Let's try one more.

Say we have a good exposure at 1/125 second and f/11, but our fast-moving butterfly wings are blurred. We need a faster shutter speed. We can increase the shutter speed to 1/1000 second, a light lowering change of 3 stops. To maintain the correct exposure, we just open the aperture by the same 3 stops, going from f/11 to f4. F/11 at 1/125 second and f/4 at 1/1000 second give the same exposures because they are reciprocal exposures.

Likewise, changes in ISO expressed in stops have the same effect as changes in shutter speed and/or apertures. Suppose that on an overcast day we're shooting a wiggly caterpillar using ISO 100, 1/8 second, and f/16. The caterpillar is moving around a bit and we'd like to use a higher shutter speed, say 1/125 second. That reduces the light by a full 4 stops. To compensate by changing the aperture, we'd have to open the aperture by 4 stops, to f/4 but at f/4 we'd have inadequate depth-of-field to keep the entire caterpillar in sharp focus. But wait! We're not done! We can increase the shutter speed by the necessary 4 stops, leave the aperture at the f/16 we need for good DOF and just compensate for the higher shutter speed by raising the ISO 4 stops from 100 to 1600. At ISO 1600 we might get a little noise in our image, but at least we'd have

a sharp caterpillar! Thinking in stops makes it all easy! Admittedly, if stops are new to you, then it will take some time and effort to become comfortable with them. There is little choice here for you must learn to speak the language of stops to gain complete control over exposure.

EXPOSURE MODES

PROGRAM (P)

Program (P) is a fully automatic exposure mode commonly used by beginners who either don't understand the camera or by those who don't want to be bothered by having to control their camera. In this mode, the camera meter assesses subject brightness and the camera's software uses a set of not necessarily true assumptions to reach an ISO setting, aperture setting, and shutter speed setting that will make a *good* exposure. Some camera makers, Canon for example, use the term *standard exposure* instead of *good exposure*. Unfortunately, the software doesn't know how fast the subject is moving, how much DOF the photographer desires, whether the user is handholding or using a tripod, or the all-important tonality of the subject. So the Program mode can give a good result much of the time, but gives less than optimum results lots of times. It's not commonly used by serious photographers, though some outstanding photographers find it useful. We sometimes use it to photograph our small party after we have had a little too much wine. When I don't want to or can't think too clearly, I use it to make the decisions for me. Perhaps P stands for the *party* mode!

SHUTTER-PRIORITY (S OR TV)

This is a semi-automatic exposure mode that requires the user to manually select the ISO and the preferred shutter speed. Then, based on the metered subject matter, the camera automatically selects the correct aperture to make a *good* exposure. Again we're faced with the fact that the camera cannot compensate for subject matter tonalities far from average, so the shooter, as always, must remain alert to the need for exposure compensation.

Shutter-priority is not an effective mode when shooting close-ups on a tripod because the aperture will be changing around with subject brightness, and in those circumstances we generally want the aperture to be controlled for DOF purposes. Sometimes, though, Shutter-priority will make sense, such as when handholding and you need to maintain a certain shutter speed to arrest camera motion. Most camera makers use the letter *S* on the controls to identify this mode, although Canon uses *Tv* for *time value*. It would be helpful if the photo community standardized their terms and icons.

APERTURE-PRIORITY (A OR AV)

This semi-automatic exposure mode requires the user to manually select the aperture and the ISO. Then, based on the metered subject matter, the camera automatically selects the correct shutter speed for a *good* exposure. Once again, the photographer must compensate for non-average subject tonality or exposure problems caused by contrasty light. We'll later expand on that and some other problems of using automatic exposure modes.

Most cameras designate this mode on their controls by the letter *A*, but Canon uses *Av* for *aperture value*. Many outstanding close-up photographers actually use this mode, but read on to consider some of the problems.

MANUAL EXPOSURE (M)

Barbara with her Nikons and I with my Canons use Manual exposure for the vast majority of our close-up, landscape, and wildlife photography. We manually choose ISO settings, shutter speeds, and apertures, completely controlling our cameras and leaving nothing to unknown software mavens making unspecified assumptions and unidentified compromises. We regularly achieve superbly exposed images using the meter's exposure indicator scale that appears in the viewfinder along with the RGB histogram and the highlight alert. We'll shortly expand on these methods.

EXPOSURE MODES AND METERING MODES

We've already addressed this, but modes are important enough to review. The term *metering modes* refers only to how the meter operates, and the viewing patterns it uses to determine the recommended exposure data. The common metering modes are Spot-metering, Partial Metering, Center-weighted Metering, and Evaluative or Matrix Metering. The term *exposure modes*, however, refers to how the camera uses metered exposure data in such automated exposure modes as Program, Aperture-priority, or Shutter-priority, or by the photographer using the Manual exposure mode. Some cameras offer a few additional automatic modes for specialized subjects like flowers, sports, landscapes, and others, but we find little reason to use them. Nevertheless, the Manual and Aperture-priority exposure modes remain the most useful choices for close-up photography.

THE TROUBLE WITH AUTOMATIC EXPOSURE MODES

We've already touched on the metering problem, but let's look at it in more detail. It's important because a thorough understanding of the meter's behavior allows a much easier mastery of exposure. It gets back to the problem of designing an exposure meter because two variables affect the light reflected from the subject.

One variable is the intensity of the light falling on the subject. It's called the incident light. Strong incident light, bright sunlight for instance, can make dark objects look bright and bright objects even brighter. Weak incident light makes bright objects look dark and dark objects even darker. The second variable is the reflectance of the subject, which determines the percentage of the light falling on the subject that's reflected. Dark objects like a Mourning Cloak butterfly have low reflectance and reflect a small portion of the light falling on them. Bright objects like the white petals of a flower have higher reflectance and reflect a larger portion of the light falling on them.

The Mourning Cloak butterfly is dark overall. Nevertheless, still expose to make the rightmost data closely approach the right wall of the histogram. Do not clip the highlights by climbing the right wall. Nikon D4, 200mm, 1/40, f/22, ISO 200, Sun.

Here's the fundamental question: When a camera meter measures a certain amount of light reflected from the subject, is it because of the subject's reflectance or because of the intensity of the incident light? A little of this and a little of that? More of the other? The meter can't tell. But, if it doesn't know, it can't provide the proper exposure.

To resolve the matter, the meter engineer makes a big assumption! The engineer assumes that all subject matter is of medium reflectance. He ignores white flowers, he ignores black Mourning Cloak butterflies, and he assumes that all subjects reflect about 18 percent of the incident light falling on them. He picks that 18 percent number because over the years most people interested in the matter have concluded that on average, the world we live in reflects that amount of light. For us close-up photographers, though, many wonderful subjects deviate considerably from 18 percent reflectance, so the meter often fails us.

An object of any color that reflects about 18 percent of the light that falls on it is said to be a *mid-toned* object, or to have middle tonality. Clear blue skies in mid-afternoon are approximately mid-toned blue. So are your blue jeans. General foliage, on average, on an overcast day, is about mid-toned

green. The palm of your hand is about 1 stop brighter than mid-toned, that is to say, twice as bright.

By assuming everything reflects exactly 18 percent of the incident light, then the light reflected from any subject can be a measure of the incident light. Now, the meter can give us some answers. But wait! What if the subject isn't mid-toned? What about dark leaves? What about white petals? Black butterflies? Now we have a new problem. The engineer's assumption results in meter readings making all images turn out mid-toned. Our meter reading of the black butterfly will produce an image of a mid-toned gray butterfly. Our meter reading from the white flower will give an image of a mid-toned gray flower.

This time it's up to the photographer to solve the problem. The competent shooter must know what mid-toned subjects look like, and when the subject is not mid-toned, compensate for the meter's wrongful assumption.

When metering the black butterfly, the photographer needs to reduce the light a bit to avoid an image of a gray butterfly and get an image of a black butterfly. Here, minus a stop or so should do the job.

When metering the white flower, the photographer needs to increase the light a little to avoid an image of a gray flower and get an image of a white flower. Here, plus a stop or perhaps 2 stops should do the job.

The above concepts apply not only to black and white subjects, but apply equally to all colors, be they light, dark, or mid-toned.

The knowledgeable photographer using an automatic exposure mode adjusts the camera's *exposure compensation* control to override the meter's recommendation. Be careful here. Your camera also has a *flash exposure compensation* control, usually denoted with a plus and minus symbol and a zigzag arrow. We'll say more about this in Chapter 5. Be sure to use the ambient light exposure compensation control.

The knowledgeable photographer, using the Manual exposure mode, adjusts ISO, shutter speed, or aperture, or some combination, to override the meter's recommendation.

Here's the icon for adjusting the ambient light exposure when using an automatic exposure mode. It represents the Exposure Compensation (EC) control.

An icon that includes a plus and minus symbol and a zigzag arrow (think lightning bolt) indicates the flash exposure compensation (FEC) control.

By all means make certain you understand the information in this section, and if not read it over and over until you do. To a high degree, a good *gut feel* for these concepts separates the skilled photographers from the snapshot takers.

LIGHT THROUGH THE VIEWFINDER

Throughout the first thirty years of my career, I used Manual exposure exclusively. When I switched to digital cameras in 2003, I tried some Aperture-priority shooting because of the convenience of the histogram and highlight alerts. I was photographing one day in a Michigan bog where I'd found a tiny carnivorous sundew plant. Using a Canon 65mm macro lens at more than twice life-size, I filled the frame with a tight image of the leaf with its shiny dewdrops, and I shot in Aperture-priority. My histogram showed nearly 2 stops of underexposure. I instinctively added a couple of stops of light by setting the exposure compensation control to the plus 2 stops of light position and shot again. Again, an underexposed histogram. Huh? Why should an additional 2 stops of light still give an underexposed image? I couldn't understand that. I switched to the Manual exposure mode and that made every-thing work just fine. It became clear there was some problem with the camera's Aperture-priority mode. Luckily, before shipping the camera back to Canon, I remembered that the instruction manual had mentioned something about a little plastic gizmo to be attached to the viewfinder when in auto-matic modes. I'd long lost the little plastic shield, but the thought was enough to give me a clue to help me understand what had happened.

When in any of the automatic modes, Aperture-priority, Shutter-priority, Program, or any other, the metered data from the subject is measured through the lens and delivered directly to the camera to form the exposure. *However, an uncovered viewfinder allows light to enter the viewfinder opening and mix with the light coming through the lens, thus seriously corrupt-ing the meter reading.*

After writing the above paragraph, I tried it with my present gear just to make sure I'd written about it correctly. I set up a test using Aperture-priority and pointed the camera at a dark subject in the shade while bright sunlight shone on the view-finder eyepiece. I added a polarizing filter and a Kenko 36mm extension tube to the optical path. I shielded and unshielded the viewfinder opening, and allowing it to remain unshielded resulted in an astonishing 6 stops of underexposure! I had set

up a worst case scenario. Pointing the camera lens at a dark subject in the shade, adding a polarizer and extension tube, and letting the bright sun strike the unclosed viewfinder all served to make the *light through the viewfinder* problem more severe. I could have made it worse, though, by adding a 2x teleconverter to the camera. Try this yourself to help you fully understand this enormous problem that you run into fre-quently when shooting close-ups.

Some cameras, as mentioned, provide a plastic shield to cover the viewfinder, and some cameras have a built-in shutter curtain to cover the viewfinder. *When using any automatic mode with your eye away from the viewfinder, use your hat or your hand or your viewfinder shields, but always make sure your viewfinder opening is covered.*

In concluding this topic, here's a final thought. The viewfinder problem is generally considered an issue peculiar to automatic modes. However, a student of mine tells of a time when his Nikon was in **Manual** exposure mode on a tripod. My (he says luckless, I say careless) student and close friend were standing alongside the tripod *viewing his metering scale on the top LCD panel and not through his viewfinder*, thus leaving his view-finder uncovered. This caused him to set an exposure that was too dark.

CHANGES IN SUBJECT SIZE

A beautiful white flower growing among rich green leaves cries out to be photographed. Using an automatic exposure mode, you put on your macro lens and make a lovely com-position in which the flower petals fill about a third of the frame. The meter makes a reading based on a 30–70 percent mix of white and green and delivers that information to the camera. You remember to cover your viewfinder and you shoot. With the very white flower, that 30–70 percent mix might just average out to be around mid-tone, and your result-ing picture is splendid. It's so good that you want to shoot another image with the flower even bigger!

Remaining in Aperture-priority, you move closer to the flower, which now fills 90 percent of the image frame. You shoot

again. Now, the 90 percent white image, only 10 percent green, averages out to be much brighter—perhaps at least a stop above mid-tone. You shoot. The meter, required by its very heritage to produce mid-toned images, delivers appropriate exposure data to the camera, the shutter speed is increased, and you get a very sad appearing gray flower. This is simply one more reason to consider using Manual exposure to avoid having the camera change the exposure without your permission.

DIFFICULT OPERATING CONDITIONS

It's dark. It's frigid. Your fingers are cold. You're shivering. You're wearing gloves. You're getting more and more frustrated. The outstanding photograph is unfolding right in front of you, and any or all of these conditions are making it really tough to smoothly use the camera's controls. Many photographers, having experienced such conditions, conclude that it's much easier simply to further turn a shutter speed dial or an aperture dial that they're manipulating anyway, rather than to seek out and fiddle with a separate Exposure Compensation dial. That alone convinces many shooters to stick with Manual exposure.

A THIRD HAND

Good close-up technique often requires use of a remote release to trip the shutter so that camera motion is eliminated. If one hand is thus occupied, and the other hand is busy holding the flash, your reflector or diffuser, which hand will you use to block the viewfinder? Using Manual exposure and determining the exposure while looking through the viewfinder to block extraneous light ingress will always eliminate the viewfinder problem. While it is true that most photographers who use any of the other automatic exposure modes also look through the viewfinder and block the light, the problem arises when they remove their eye to shoot the image with a remote release or 2 second self-timer, allowing the camera to automatically change the exposure unfavorably.

AUTOMATIC EXPOSURE USING LIVE VIEW

Another way to get along with automatic exposure modes is available if your camera offers a Live View mode and live histogram. The live histogram shows exposure data for the image about to be made while the shutter is open and the

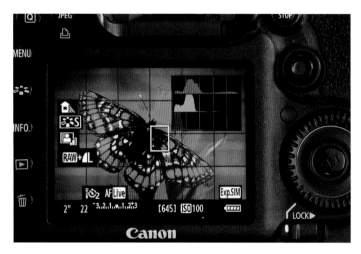

Some cameras provide a live histogram when using the Live View mode. It offers a quick way to get close to the optimum exposure. However, once the image is shot, be sure to check the actual histogram the image generates.

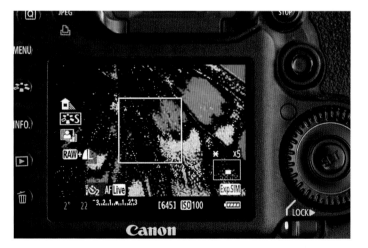

Magnifying the Live View Image is the best way to sharply focus the lens on the most important part of the subject when using manual focus. In the interest of full disclosure, we seldom use the live histogram for exposure, but nearly always use a magnified Live View image for focusing and for detecting subject movement.

mirror is up, forming the Live View image. The mirror being up prevents any viewfinder light ingress. So you merely set the desired aperture or shutter speed according to your preferred mode, adjust the other parameter with the exposure compensation control to achieve a good histogram as we've discussed, shoot, and enjoy your well-exposed image!

A downside to the method is that the Live View shooting consumes lots of power and your battery won't thank you. So it's a good idea to minimize Live View usage, or perhaps a better idea to carry one or two extra fully charged camera batteries. Please ensure that batteries are carried safely! If the unprotected terminals of the battery in your pants pocket are accidentally shorted out by your car keys, you're going to get a quick, but unhappy, introduction to hot pockets!

Yet another downside to the Live View scheme is that in much of our close-up work, we use flash to open shadows, to reveal texture, to improve color, or to control background tonality. When flash is in use, the cameras we use deactivate the live histogram, depriving us of that feature. The live histogram display on my Canon cameras turns gray when a flash is attached to the camera and turned on, telling me it cannot give an accurate reading because it does not know how much light will be added to the image from the flash. Barbara and I use flash for more than 75 percent of our close-up work, so the Live View technique for metering usually isn't that valuable to us. Of course, the flash could be turned off, the live histogram used to get the ambient light exposure, and then the flash could be turned back on. That does work, though it is a cumbersome and messy way to do it. We use Live View to manually focus and then turn it off.

MANUAL EXPOSURE TECHNIQUES

Barbara and I use Manual exposure modes for the vast majority of our shooting. Lest we seem in a technical rut, and before expanding on Manual exposure considerations, let me say that in our wildlife shooting, we use Aperture-priority a little and Shutter-priority frequently. We use them when the ambient light is changing so fast that we just can't keep up with the changes. Having said that, rapidly changing ambient light is a minor and infrequent problem in our close-up work.

In Aperture-priority and in Shutter-priority, the photographer sets two control parameters and the camera automatically sets the third. The photographer using Manual exposure sets all three. Yes, one more control to set, but the problems of the automatic modes are largely wiped out.

This is a point I need to emphasize to so many beginners, so important that I hope you'll indulge my doing it again here and now:

When the camera is in Aperture-priority or Shutter-priority, the meter's data is delivered to the camera, and the camera sets the third parameter.

When the camera is in Manual exposure, the meter's data is delivered not to the camera, but to the photographer, and the photographer sets all three parameters—the ISO, shutter speed, and aperture (f/stop).

In either automatic or Manual modes, good photography more often than not requires the photographer to compensate the exposure, but it's generally easier and faster using Manual exposure.

Absent photographer intervention, there is absolutely no exposure difference in the resulting images. None! This is not well understood, so let me explain. Using Manual to adjust the exposure to make the indicator align with the zero position on the exposure scale in the camera's viewfinder is exactly what the camera does automatically when using Shutter-priority, Program, or Aperture-priority if the exposure compensation control is set to zero.

Reader, do get used to Manual exposure. Once you're used to it, you'll find it to be both fast and accurate, and you'll probably relegate auto modes only to special occasions. To become comfortably fast with manual methods, memorize the standard set of f/stops, the standard set of shutter speeds, and the standard set of ISO settings. Ensure you're fluent in thinking in stops. With a little study and practice you can quickly change exposures this way and that doing nothing

but counting clicks when the shutter speed or aperture dial is turned without even bothering to look at the camera!

Accomplished close-up photographers tend to work in favorably low contrast light of adequate intensity to give a proper exposure with camera settings appropriate to the image. Using the proper settings means a preference for the native ISO to ensure minimal image noise, a preference for a small enough aperture to ensure adequate depth-of-field, and a high enough shutter speed to ensure arresting any subject or camera movement.

Incidentally, another good reason to use the camera's native ISO, when possible, is that generally the camera's dynamic range is greatest at the native ISO and the maximum amount of subject contrast can be captured in the image without loss of highlight or shadow detail.

Let's photograph a pink flower. I set the ISO to the native 100 of my Canon 5D Mark III camera. I want to have as much of the flower in sharp focus as reasonably possible, so I choose f/16 to maximize depth-of-field. On this bright overcast day, my meter suggests a shutter speed of 1/8 second, and I shoot. Drat! My lovely pink flower is rendered a dark and dingy pink. There's that meter again, making everything mid-toned! I check the RGB histogram that appears on the LCD after the first image is shot, and because the pink flower is predominately colored by reds, I find that the data of the red-channel histogram is farthest to the right, but not nearly far enough. I need to add some light. Okay, I just decrease my shutter speed three clicks to 1/4 second, a +1 stop change in the light, and now I have my nice flower image. I double-check the RGB histogram, and now I find that the rightmost part of the red channel histogram is touching the right wall of the graph space.

By the way, in my camera menu I've chosen the 1/3 stop option for my control increments. Every click on my ISO, aperture, and shutter speed dials changes the setting by 1/3 stop and every three clicks changes the setting by a whole stop. By counting clicks as I turn my exposure control dials, I know my camera settings without even looking at the camera.

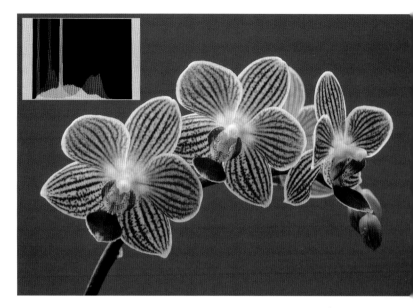

We photographed this domestic orchid in our greenhouse on a cloudy and windy morning. This image is 1 stop underexposed. This creates more noise in the shadows, less overall detail, and a reduction in color tones. Notice the rightmost red data is quite far from the histogram's right wall. Canon 5D Mark III, 180mm, 1/6, f/18, ISO 250, Shade, fill-flash.

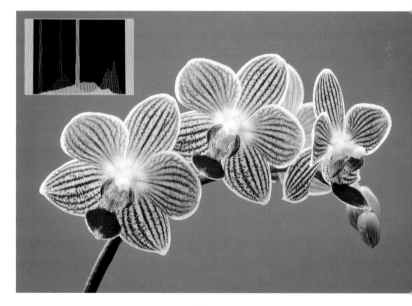

The orchid is properly exposed in this example. The histogram graph shows a better overall distribution of tones and the rightmost red data is snuggled up to the right wall of the histogram. Canon 5D Mark III, 180mm, 1/3, f/18, ISO 250, Shade, fill-flash.

SPEEDING UP THE MANUAL EXPOSURE PROCESS

Here's the view of the back of John's Canon 5D Mark III camera. The top right main control dial (A) adjusts the shutter speed. Turning this dial clockwise slows the shutter speed down which adds light to the exposure. Please know that Manual exposure is being used. Turning the main control dial counterclockwise does the opposite. The control dial (B) on the back of the camera adjusts the aperture. Turning it clockwise opens the aperture which adds light to the exposure. Turning it counterclockwise stops the lens down more and reduces the exposure. It is crucial to know where your shutter speed and aperture controls are without looking at the camera and you should instantly know which way to turn the dial to add or subtract light to make exposure simple and fast. Note: A custom function is set to make both of these dials reverse direction to make it more logical.

It makes for efficient camera usage to know exactly where a specific control is on your camera body. Cameras are different, so memorize the location of your ISO control, your aperture control, and your shutter speed control. Sometimes cameras have more than one knob or dial available to assign an exposure control to it. One of them may be more convenient than the other. Also, some cameras have one or more programmable controls that can be made to do a user-chosen duty. Memorize your control locations! It's extremely convenient to be able to manage your camera, especially the shutter speed and the aperture, when not even looking at it! Memorize it with your hands!

THE EXPOSURE SCALE

In any exposure mode you will see an exposure scale appearing somewhere, probably inside the viewfinder, usually at the bottom. Here's an example:

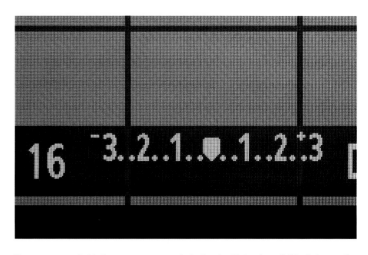

Your camera probably has an exposure scale in the viewfinder, in an LCD window on the camera, or both. Take the time to understand and know your scale. This Canon 5D Mark III scale that appears in the Live View image and in the viewfinder shows plus and minus 3 stops of light in 1/3 stop increments. Adding light (+) is on the right side of the scale and subtracting light (−) is on the left side.

The sample exposure scale shown covers a range from −3 stops on the left through zero and then up to +3 stops on the right, in increments of 1/3 stop. However, some cameras have scales from −2 stops to +2 stops instead, and most of today's DSLRs allow user selection of increments of 1/2 stop or 1/3 stop, although most photographers select the more precise 1/3 stop increments. My own Canon 5D Mark III has a +/− 3 stop scale in 1/3 stop increments, and so does Barbara's Nikon D4.

It's not uncommon for some new shooters trying Manual exposure to become frustrated when nothing happens on the exposure scale as they twist and turn the dials for ISO, aperture, and shutter speed. Almost always the reason is that the exposure indicator (pointer) is off the scale. If, for example, the meter is recommending f/4 but the lens setting is f/22, the pointer is trying to show a 5 stop underexposure. However, with a scale that only goes to −3 stops, the pointer won't even get on the scale until the lens setting is closer to the meter info. Many cameras provide a flashing signal or small arrow to aid the shooter in recognizing the condition and to point in which direction to correct the exposure. Watch out! This always happens when you're handling the camera with its lens cap on!

REVERSING THE EXPOSURE DIALS

During a 2007 Michigan photo workshop, one clever student quickly came to appreciate the many merits of Manual exposure and promptly adopted it. One day he asked me in exasperation, "Why do I have to turn my shutter speed or aperture dial to the left to add light and move the histogram data to the right?" It was confusing him and seemed counter-intuitive. Me too! His irritation brought to mind that buried in the camera menus (he was using the same Canon 5D Mark II camera as I) was an option to reverse the direction of the control dials. One could change the shutter speed dial and the aperture dial to make turning them to the right (as viewed from the rear of the camera) add light and move the histogram data to the right. Of course, to decrease the exposure, turn the dials to the left, the same direction you want the histogram data to move. In my Canon menus I found the correct custom function. It is called *Dial Direction during Tv/Av*. Although not said, this custom function works with Manual exposure, too. After making the changes, the histogram moved back and forth in the more intuitive manner when turning the control dials. Both student and teacher smiled at how much more expedient the camera became.

Some Nikons offer another nice feature. They allow the user, via the Custom Functions menu, to reverse the direction of the exposure indicator scale, too. The default Nikon scale has the (+) end of the exposure scale on the left end and the (–) end of the scale on the right end. (The Canon exposure scale is made with the plus side on the right.) This is often confusing to some, but it's easy to reverse the scale and get it into the more logical orientation. Although not all cameras offer the flexibility of reversible dials and reversible exposure scales, if your camera does, be sure to take the time to set it up and maximize your personal comfort. It will make working with the camera's exposure controls much easier.

CALIBRATING THE HISTOGRAM DISPLAY

When looking at histogram data that you'd like to move within its graph space, it's very convenient to know just how much light change is needed to move the data a desired

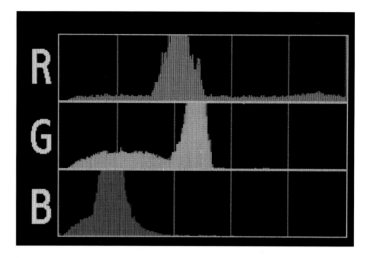

Calibrate your histogram display because it makes arriving at the optimum exposure quicker. Notice the left and right walls of this Canon histogram display. Also notice the extra four vertical lines within the walls. Photograph a white piece of paper to determine how much light must be added or subtracted to move the histogram data one entire vertical line. Adjust the exposure from the white paper to make the histogram spike coincide with the line immediately to the left of the right wall. Now add light in 1/3 stop increments until the data spike aligns with the right wall. The amount of stops it takes to do this is the increment value. With my Canon 5D Mark III, I must add about 1.3 stops of light to move the histogram data from one vertical line to the next one on the right.

The Nikon D4 histogram display has one less vertical line between the histogram walls. It takes about 1.7 stops of light to move the histogram data from one vertical line to the next.

amount. The histogram graph spaces of most cameras have fine vertical lines dividing the graph space into segments. You can make your exposure changes much more efficiently if you know just how much exposure change is needed to move the histogram data from one line to another.

Here's how to learn. Shoot a plain white sheet of paper in even light, with the paper filling the frame. Since all tones of the image are the same white, the resulting histogram will approximate a thin vertical line. Now take additional shots at different exposures to make the histogram move around in the graph space until the column of histogram data is over one of the fine vertical lines. Use one of the lines near the center. Now increase the exposure in 1/3 stop clicks until the histogram data coincides with the next vertical line to the right of the one you started with. The change in exposure to move the histogram from one vertical line to the other is what you want to know.

Now, whenever you look at your histogram and see that your histogram should be moved this far or that, you need only note how far in terms of the vertical lines of the graph space, and you can make the correction in probably only one jump. It eliminates a lot of the time-consuming guesswork of zeroing in on the correct exposure when I learned that my Canon camera has vertical graph space lines about 1 stop and a tiny bit more apart. That's close enough to 1 stop for my purposes. Suppose the rightmost data of my histogram is about 2/3 of the way from the right wall of the graph space. Thinking

ETTR, I recognize that as being about 2/3 stop underexposed. I merely change one of my 1/3 stop exposure controls by two clicks toward more light, and without so much as looking at a knob, I've got a perfect exposure! Incidentally, while Canon cameras typically have six vertical graph space lines (including the left and right wall of the histogram graph) and in my camera they're about 1 stop apart, Barb's Nikons have five vertical graph space lines about 1 2/3 stops apart between the left and right wall of the histogram. So one needs to do a slightly different calculation with the Nikons, but it nonetheless significantly speeds up exposure changes.

CONCLUSION

I hope you've concluded that Barbara and I vastly prefer using Manual exposure in most of our photography, but especially in our close-up and macro work. By teaching literally thousands of students in our workshops, we've consistently seen that most quickly learn the techniques, learn to expose quickly and correctly, and never look back.

In spite of our preferences though, for those who do choose to use automatic exposure modes, know that Aperture-priority makes the most sense in changing light because of the importance of depth-of-field control in close-up work. Besides, as we've said, Aperture-priority is particularly useful in conjunction with Live View and the live histogram.

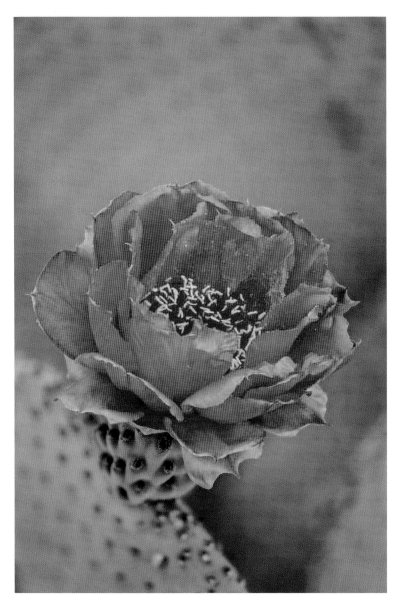

Beavertail cactus bloom during March in Tucson, Arizona. Barbara focused the entire blossom sharply while keeping the cactus pads behind it out of focus using focus stacking. She shot six images in which the focus was changed slightly from the front of the blossom to the back of it. To keep the background out of focus, she used f/4.5 to keep the depth of field shallow. Although focus stacking is typically a way to optimally focus everything in the image, Barbara uses it here to selectively focus only the blossom while keeping everything else out of focus. As you might surmise, the red channel histogram with the magenta blossom had data recorded farthest to the right. The six images shot to capture the depth in the blossom were combined with Zerene Stacker. Nikon D4, 200 micro, ISO 100, f/4.5, 1.6 seconds, Cloudy WB.

3

Shooting Sharp Images

The wonderful magic of close-up photography is largely due to the vast array of colorful and interesting subjects so readily available and so willing to pose for you. You can easily find great subjects in gardens, fields, wooded areas, lakes and streams, and in lovely wet meadows on calm and dewy mornings. The possible subjects are innumerable.

Most subjects allow you to approach within camera range without being disturbed, but it can still be challenging to shoot sharp close-up images because one's camera handling techniques must be nearly flawless. Why, you ask, is it so important? The image-psychology experts tell us that a viewer's eye is first irresistibly drawn to the brightest and highest contrast areas of an image, but is next drawn to the areas of sharpness. If the subject isn't sharp, the viewer's eyes will not see the subject as you intended it to be seen. For most images to be effective, sharpness is critical. To ensure that your image is as sharp as you can make it, you should:

FOCUS PROPERLY—MANUAL FOCUS IS PREFERRED

- Carefully select the correct plane of focus for the chosen subject.
- Focus with care and precision, perhaps employing a magnified Live View image to help manually focus accurately.
- Ensure adequate depth-of-field by choosing a proper aperture.
- If available, use a tilt lens.

Barbara isn't a big fan of spiders, but she tolerates jumping spiders. On a cool morning, we enticed this jumping spider to perch on a stone while Barbara varied the focus and shot 24 images. She ran the images through Zerene Stacker to merge all of them into one sharp photo. Nikon D4, 200mm, 1/4, f/11, ISO 200, Cloudy.

REDUCE CAMERA MOTION AND ITS EFFECTS

- Securely mount the camera on a *very sturdy* tripod.
- Use mirror lock-up.
- Use a remote release or the self-timer to trip the shutter.
- Use a sufficient shutter speed.
- Use a short-duration burst of flash as the (main) key light.

REDUCE SUBJECT MOTION AND ITS EFFECTS

- Use a fast enough shutter speed.
- Use a short-duration burst of flash as the main light.
- Have enough patience to wait for the wind to die down.
- Have ample patience to wait for the subject to settle.

USE FOCUS STACKING

- Employ this sophisticated but easy shooting and post-capture processing system to achieve very large depths-of-field.

Wow! So much to remember! Not to worry, though, as we are going to expand on all of these techniques. One day they will be a routine part of your shooting workflow and just come naturally whenever you shoot. You'll be rewarded by images every bit as sharp as your best lens can produce. Another great benefit is that when the mechanics of sharp images have become second nature, your mind will be free to think about finding more of those splendid subjects!

TRIPODS

WHY BOTHER WITH A TRIPOD ANYWAY?

Many photographers, newbies and oldies alike, insist they have no need for a tripod because they can handhold much better than ordinary people! That claim is probably way off base for most overconfident shooters. It's an incredibly bad idea for those doing close-up work, and it ignores the important ability to use the tripod as an aid to composition. More than one photographic educator has written that a good tripod is the most important accessory a photographer can own, and

A sturdy tripod is enormously important for the majority of close-up images, such as this section of a Goat's Beard seedhead. The small apertures that are required to obtain adequate depth-of-field and the light loss that is inherent in close-up lenses and accessories usually forces the use of shutter speeds that are far too slow for handheld shooting. Nikon D70, 200mm, 1/30, f/22, ISO 200, Auto.

we agree. So, let's explore the ins and outs and the whys and wherefores of tripods and tripod usage.

HIGH MAGNIFICATION

Good close-up photography often involves high magnification. At high image magnifications, the image-softening effect of

camera movement is magnified, too. In close-up work, the slightest camera movement can cause unsharp images.

When magnification is increased, depth-of-field declines markedly. At a magnification of 1x or life-size magnification, the DOF may be only a few millimeters. That's true even at f/16. A millimeter is only about 1/25 of an inch, the mere thickness of a matchbook cover. In close-up work, limited DOF can cause unsharp images because the available DOF cannot adequately cover the depth of the subject.

Small apertures are necessary to obtain more depth-of-field. These small apertures demand longer shutter speeds. Apertures of f/16 and f/22 may involve shutter speeds as slow as 4 seconds and possibly longer. This is especially true if you are working under the soft light of a cloudy day, or using a diffuser, or shooting in the shade. These longer shutter speeds make your situation more susceptible to any movement of subject or camera, whether wind-induced or self-induced. In close-up work, increased DOF can indirectly cause unsharp images due to diffraction when small apertures are used.

LOCK IN THE COMPOSITION

Close-up images require a careful and thoughtful composition. Even a miniscule bit of wobble while shooting handheld will radically change the composition from shot to shot because the magnification makes the subject bounce all over the viewfinder.

A THIRD HAND

The most expert close-up and macro shooters working today regularly rely on light-modifying devices—diffusers, reflectors, flash—to skillfully improve the light on their small subjects. If one hand is needed to trip the shutter with a remote release and the other must hold the light-modifying device, then no hand is available to hold the camera.

AN AID TO MANUAL FOCUSING

The best and most precise way to focus on most close-up subjects is to do it manually. While it is tempting to look through the viewfinder to achieve sharp focus while the focus ring is slowly and manually turned, it really is more efficient to use Live View and magnify the specific part of the subject where the sharpest focus is desired in order to achieve the best focus. This is especially true for shooters over forty years old!

TRIPOD REQUIREMENTS AND POPULAR BRANDS

If you look through our tripod references in this book, and for that matter in all of our books, you will see we are always talking about *good* tripods and *sturdy* tripods. Those are not merely casual references, but important suggestions that are worthy of an explanation. Here they are:

The tripod must solidly support the camera and lens. A 200mm Nikon micro lens or a zoom lens mounted on a camera is a heavy combination. Make certain the tripod is properly rated for that load. Everybody yearns for a light tripod, but a tiny cheapie tripod that is too light and has wiggly legs, wobbly joints, and a plastic head is worthless for shooting sharp images. If you have one, use it to hold a flash, reflector, or Plamp instead, but certainly not your camera.

With legs extended, the tripod should be tall enough to put the camera viewfinder at or above eye level. It's tough to spend a day bending over to see through your viewfinder. Lots of nice macro subjects are tall and you certainly don't want to be extending a center column that merely converts your sturdy tripod into a far less stable monopod. Barb and I much prefer tripods characterized as a "set of legs" with no center column whatever. Of course, a very short center column of a few inches might be handy for fine-tuning your composition.

Countless enchanting macro subjects are very close to the ground. Your tripod must have legs that splay out flat to the ground. Generally, you want to shoot *horizontally at* the subject, not *down* at it. A tripod suitable for ground level operations, without using a cantilevered beam, is virtually essential for close-up nature photography. And, do ignore the oft-stated but absolutely useless suggestion that you mount your camera upside down on an inverted center column! I could do it that way when I was twenty, but seeing anyone do it now makes my neck ache.

Barbara's tripod legs are spread out to get low to the ground to photograph this Alpine Sunflower. She uses the 2 second self-timer to trip the shutter and a wireless main flash to enhance the colors in the blossoms and separate the flower from the background. Canon 5D Mark III, 24-70mm lens at 55mm, 1/10, f/18, ISO 200, Cloudy.

Tripods typically have three or four leg sections. All other factors, such as overall height, being equal, I much prefer the three-section legs because they are so much easier and quicker to set up and take down. Oblivious to my advice, Barbara selects four-section legs because they collapse to a shorter overall length, are easier to pack, and most elevate the camera higher. There is no wrong answer here as it's a matter of personal preference.

Fine tripods are manufactured by Benbo, Gitzo, Induro, Really Right Stuff, and other companies. Everyone has their favorite model, and arguments are common. We use Gitzo tripods exclusively and have for many years. Gitzos are not inexpensive, but for decades they have been the "gold standard" tripods for outdoor and nature photographers. We recommend the carbon-fiber tripods because they are lighter and strangely sturdier than their aluminum counterparts. Aluminum tripods are less costly and perfectly satisfactory, too. So, our favorite tripod is a carbon-fiber Gitzo with no center column, collapsible to about 27 inches and able to reach about 59 inches when

Here's the Alpine Sunflower Barbara is shooting in the previous image. She focused a 24mm lens close to the flowers to make them large in the image while also capturing the background. Nikon D4, 24mm, 1/20, f/16, ISO 200, Cloudy, +1/3 flash compensation.

extended. The models we use—#1325 and GT3541LS—are no longer made, but plenty of upgraded versions are available. For a similar version, look at Gitzo's Systematic line of tripods such as the GT4330LS and the GT3330LS.

TRIPOD HEADS

Every tripod must be topped by a head. It is the head that provides the smooth and easy adjustment of camera directions and angles that allows your desired composition. An easy to operate head that securely locks your camera and lens into the most favorable position is essential to convenient close-up photography. I promised you honesty, so here is a bit of it: There are a zillion different tripod heads on the market ranging from dreadful plastic grip heads to shabby one-way adjustment heads. However, there are only two suitable for close-up photography. They are the ball head and the one called a "pan-tilt head" or "three-way head."

THE THREE-WAY PAN-TILT HEAD

This head has pros and cons. The pro is that it has independent handles for vertical, horizontal, and angular movements, which airplane pilots call pitch, yaw, and roll. The pan-tilt head allows greater precision of adjustment than the ball head. You can more easily adjust the camera in one direction without accidentally disturbing the other directions. But! The pan-tilt head has two cons. One is that having to wrap your mind around three controls instead of the one control of the ball head is awkward to many users. A second problem for us and many others is the three handles are always in the way and poking us in the eye. We know users who like them, but most nature and close-up shooters avoid them. In fact, Al Hart, our consistently intractable rebellious student, steadfastly touted and used pan-tilt heads for decades while haughtily citing their greater precision. Nonetheless, just this past year, he finally saw the light and switched to ball heads and is glad he finally did so.

BALL HEADS

Ball heads are efficient to use with only one main control knob. The other smaller knobs are used less often. Ball heads have no long handles poking you in the eye, either! There are many makers of ball heads. As with most things, cheap ones are cheap and good ones are expensive. You get what you pay for. Barbara and I have for years used the excellent ball heads made by Kirk Enterprises (www.kirkphoto.com). Kirk makes the larger BH-1 and a smaller BH-3. They are well-suited for close-up work, and we have used both successfully. Fine ball heads are also offered by other manufacturers, and RRS (www.reallyrightstuff.com) offers several splendid heads, the largest being the BH-55, and many outdoor shooters swear by it. There are other ball heads, but we rarely see them and therefore won't comment on them.

The ball heads made by Kirk, RRS, and some others feature a built-in clamp to accept the camera plates and lens plates commonly used these days. These clamps and plates are of the "Arca-Swiss" type, the present-day gold standard of camera mounting systems. Several manufacturers offer camera-mounting and lens mounting plates that are compatible with

For twenty years, we have used Kirk ball heads exclusively and remain perfectly thrilled with them. They are easy to use, reliable, and sturdy. The Kirk BH-3 ($285) is the smaller one on the left. The larger one is the BH-1 ($385). For close-ups, the smaller ball head is fine. However, if you wish to use larger lenses on the ball head—500mm f/4 lens for example—then you need the larger Kirk BH-1.

the Arca system, which remains by far the most popular among serious photographers.

There is another advantage to the Arca system that is especially handy for close-up shooters. One can equip a camera or a lens with an especially long Arca mounting plate. They can then slide the camera and lens back and forth within a slightly loosened Arca clamp to use the Arca parts as a miniature focusing rail. Compositions and ease of focusing are greatly improved at no additional cost!

LENS PLATES

Some lenses, including the Canon and Sigma 180mm macros and the Nikon 200mm micro, have a built-in tripod collar to which you can easily attach an Arca lens plate. The camera is attached to the lens, but the lens and not the camera is attached to the tripod—an arrangement with many pluses:

Important: The camera and lens are better balanced on the tripod, reducing camera movement.

Also important: The load on the camera's lens mount surface is greatly reduced, lessening the potential for camera damage.

A biggie: The entire camera and lens can be rotated between horizontal and vertical vastly more easily than by any other means. Going back and forth is quick and easy. It is equally easy to shoot at any angle in between horizontal and vertical, too. Easy changes in composition make for many better images!

A caveat: There are some "universal" camera and lens plates available. They fit everything, but often poorly. We don't recommend any of them. A poor quality camera or lens plate not properly gripped by the Arca clamp can mean a camera and lens shattered on the rocks below!

A recommendation: The camera and lens plates made by Kirk Enterprises, RRS, and Wimberley feature perfect Arca-system compatibility, superb machining, and are competitively priced with each other. A phone call to any will get you excellent advice.

DEDICATED L-BRACKETS

A dedicated L-bracket is designed especially for a particular camera. Most popular cameras have one made for it. This accessory should be attached to every camera that is used on

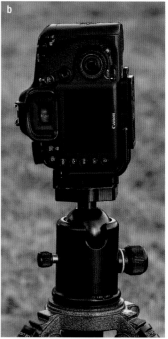

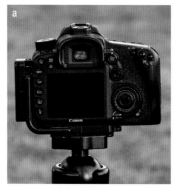

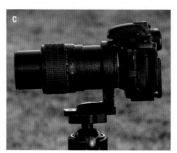

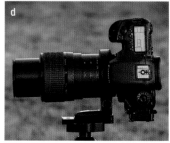

No matter what tripod head you use, make sure it can accept the Arca-Swiss style plates because many manufacturers make accessories for this style which provides plenty of choices. It is far easier to shoot close-ups if you do not have to flop the camera over to the side to shoot a vertical composition. All cameras benefit from the addition of an L-bracket. This screws into the bottom of the camera and provides a quick-release plate on two sides. In part a, the camera is attached to the tripod head horizontally with the L-bracket. In part b, the camera is mounted to shoot a vertical (portrait) composition by attaching the camera to the tripod head with the other quick-release plate on the L-bracket. L-brackets work incredibly well when shooting with lenses that don't have a tripod collar. If your lens has a tripod collar, then attach the collar to the tripod head with a quick-release plate and shoot horizontally (part c), vertically (part d), or any angle in-between by simply loosening the tripod collar, rotating the lens to the desired angle, and tightening the collar.

a tripod. The L-bracket attaches to the camera's bottom by a screw that engages the camera's tripod socket. It provides an Arca-style plate on both the camera bottom and the camera side, while the dedicated design allows convenient battery and cable access.

The purpose of the L-bracket is to allow quick and easy changing between horizontal and vertical shooting with lenses that aren't equipped with tripod collars, such as the very popular 100mm macro lenses. Yes, very convenient for those macro shooters, but equally convenient with any lens whatsoever without a tripod collar. Not only providing convenience, the dedicated L-bracket allows switching between vertical and horizontal shots with no need to twist the tripod head into vibration prone unstable configurations that misplace the center of gravity, and there is no need to lower the viewfinder into a position needing a lot of bending over. Macro shooters have plenty of headaches—no need for backaches, too. A dedicated L-bracket is a splendid accessory. Get one forthwith!

TRIPODS, THE ENVIRONMENT, AND CAMERA STEADINESS

Absolute camera steadiness being so crucial in macro shooting, Barbara and I always counsel our students to use a good tripod with a good ball head whenever possible, to use an L-bracket, and to use a lens plate on appropriate lenses. Yet, in spite of these precautions, trouble is possible. Trouble in the form of image-destructive camera shake can come from:

1. Wind
2. Water
3. Soft ground
4. Firing the camera

Let's look at each.

WIND

Winds of 10 mph or more will surely cause vibration of the tripod legs that will be transmitted to the camera itself. The fix is to await calm conditions, a temporary lull in the wind, or perhaps to move to the downwind side of a hill, cliff, boulder, forest edge, nearby vehicle, or some other wind-obstructing obstacle. Perhaps even a large reflector or diffuser will help, used not to modify light but to block the breeze.

High winds, heck, even gentle breezes are particularly nettlesome when shooting close-ups. Even slight breezes can be ruinous, and in over forty years of macro shooting, I have capitulated to a steady breeze on thousands of potentially memorable images. Wind is the most common and persistent obstacle Barbara and I face each time we photograph.

We live amid high mountain slopes near Yellowstone National Park. Even on calm weather days when there is little wind, air tends to slide up and down the mountain slopes. Still air doesn't happen often enough at our home. Rather than wait for perfectly calm conditions to occur, we have built a small greenhouse on our property. When all of the doors and windows are closed, the air is always still inside the greenhouse. Now we can shoot sharp close-up images of the plants we grow anytime we want to.

The greenhouse not only blocks all wind, but allows easy manipulation of the light, keeps mosquitoes at bay, provides handy shelves for our photo gear, and comforts us against rain. Barbara and I enjoy the many benefits of the small greenhouse we had installed at our home. If the wind allows, we often open a window and shoot our macro subjects against the lovely green backgrounds of surrounding meadows. Although an expensive addition ($2000 to $5000), it can surely be a boon to the serious shooter. We regret not having done it years ago. Relatively inexpensive portable versions may be just what you need.

WATER

The wonderful waterfall shot made from the middle of the stream subjects the tripod legs and hence the camera to the considerable vibration brought on by the action of the running water. It is better if you can set the tripod feet behind rocks or logs which obstruct the water's vibrating flow. In a pinch, use your own foot to block the flow.

Are we crying wolf? Check us out by setting your tripod and camera in a flowing stream. Use a 5x or 10x magnified Live

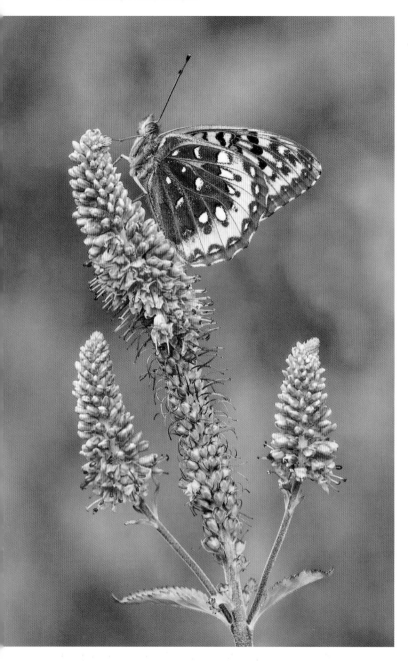

This handsome male Great Spangled Fritillary is in excellent condition. The butterfly perching quietly on this flower is a great subject. The situation is perfect with the soft early morning light, a cooperative subject, and no breeze. While using superb technique, I quickly shot a pleasing image before the butterfly crawled to an unfavorable spot on the flower. Here's the key to shooting excellent images consistently. Find an **excellent subject** in an **excellent situation** and use **excellent technique**. Canon 5D Mark III, 180mm, 1/25, f/11, ISO 200, Cloudy, and a weak main flash.

View to look at the subject. If the flowing water is vibrating the tripod at all, the subject will be gyrating around like it is in a severe earthquake.

SOFT GROUND

Sand, mud, and snow will bog down your car, and the same elements can be the ruination of close-up shooters. If the ground moves so much as a silly millimeter, a macro subject can go significantly out of focus. So when shooting a frog in a foggy soggy bog, remain very still and don't even move your feet. Don't shift your own weight, and be alert for wiggly wobbling nearby persons walking past who can shake the ground from afar.

FIRING THE CAMERA

Consistently sharp images require precise focusing and completely motionless subjects and cameras!

Make certain you not only understand the above sentence, but are willing to do everything you possibly can to make it your rule for every shot! It's especially true when not getting the benefit of the short flash duration of an electronic flash. Unfortunately, a high percentage of beginning and even advanced shooters will shoot when the subject is nearly still, but not completely still, or the camera is permitted to move. Let's discuss the shooting habits that deliver sharp images time after time.

USE A REMOTE RELEASE

In the old days of mechanical cameras, we called them *cable releases*. In today's world of electronic cameras, they are better called *electrical releases* or *remote releases*. The purpose of a remote release is to allow shutter activation without causing camera motion that would be created if you pressed the shutter button with your finger. There are several types of releases. The simplest and least expensive is merely a push-button switch attached by an electrical wire to a connector that fits into the camera. The camera is mechanically isolated from the push of the button by the flexibility of the wire. Another

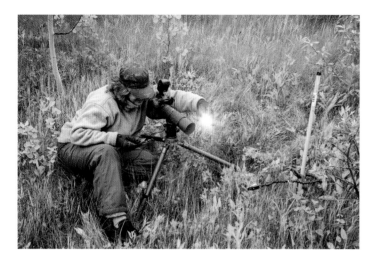

Barbara uses a cable release to trip the camera's shutter. When shooting close-up images, never trip the camera with your finger—unless using the 2 second self-timer—to separate your quivering finger from the camera to achieve the ultimate in sharpness. Notice the Nikon wireless flash controller that is mounted in the camera's hotshoe. The Plamp is being used to stabilize the lily without harming it. Canon 5D Mark III, 24-70 zoom at 47mm, 1/6, f/18, ISO 100, Shade.

Here's the lily Barbara is photographing. Notice how the distant background is rendered nicely out of focus even when stopped down to f/16. Barbara used a magnified Live View image to manually focus on the protruding stamens. Nikon D4, 200mm, 1/3, f/22, ISO 100, Cloudy, fill-flash.

inexpensive type is a small pendant that sends an infrared beam to an infrared sensor with which some cameras are equipped. Isolation here is by the absence of a mechanical connection between the shutter release button and the camera.

Complete mechanical isolation is also accomplished wirelessly by a radio link system. Radio links are especially good for activating the camera from a great distance, around corners, or behind obstacles. Typically, a radio system includes a remote transmitter and a local receiver that is attached to the camera by a short cable. A few years ago, we began using radio systems manufactured by Pocket Wizard. Though not inexpensive, they are highly regarded by the professional photographer community for being very effective and reliable. However, during the last year, I have abandoned the Pocket Wizards in favor of my radio-controlled Canon 600 EX-RT when used with the ST-E3-RT hotshoe controller. It works terrifically well! I enjoy being able to fire my camera from a distance by pressing the release button on the flash.

Be careful, though, when using any system with a lock that provides continuous shooting. Should the lock be inadvertently set, a situation that we encounter at least once a day in a photo workshop with one of our clients, control of the camera is temporarily lost. It isn't a big deal with digital once you discover the release is locked, but in the film days, many a hapless victim suffered the loss of a complete roll of expensive film before reacting to shut it off!

SELF-TIMER

Another effective way to fire the camera with reduced camera motion is to use the built-in self-timer. Generally, the default setting for the camera's self-timer is a time delay of 8 or 10 seconds. This allows the photographer to fire the camera and then run around and get into the picture. However, this much time is altogether too much delay for merely isolating the camera from any vibration the camera might have when the shutter button is pushed with a finger. So, if your camera permits (and most do), change the self-timer to 2 seconds or so. Then fire the camera, no, not by pushing the shutter

button, but instead by carefully rolling your finger over the shutter button. *A rolling finger motion induces less camera vibration than an abrupt jab of the finger and should always be used when directly firing the camera.*

If the subject is in motion, such as a flower in a breeze, the 2 second timer method fails because there is no way to accurately predict that the flower will be motionless 2 seconds later. Here, a remote release is more effective. If you forgot your remote release, you could try multiple attempts at catching the *peak of stillness* with the 2 second delay. Better yet, don't forget the remote release, especially if your luck is similar to mine.

MIRROR LOCK-UP

Mirror vibration can also be a cause of fuzzy images, but I have covered the gist of it back in Chapter One. I won't bore you with going over the same ground again, but I will nag you to the extent of reminding you about the critically important issue of camera stillness when shooting macro images. Be sure to use mirror lock-up whenever appropriate!

LIVE VIEW

Like mirror lock-up, Live View was covered in Chapter One. Nonetheless, like mirror lock-up, Live View is another very valuable tool in ensuring the sharpest possible image when shooting close-ups. If your camera supports Live View, make sure it is prominent in your sharp shooting toolbox!

FOCUSING

Talented close-up photographers are successful only if they've adopted exemplary shooting habits—especially focusing. Remember that the depth-of-field of a medium focal length lens shooting at macro distances, say a Canon 65mm macro or a Nikon 60mm micro, can be, for example, as little as 2mm, which is less than 1/10 of 1 inch! With the depth-of-field so limited, it's essential that the lens be precisely focused on the correct plane of focus. Be aware that unlike photography for larger objects where the depth-of-field falls roughly 1/3 in front of the object and 2/3 behind it, the DOF in close-up

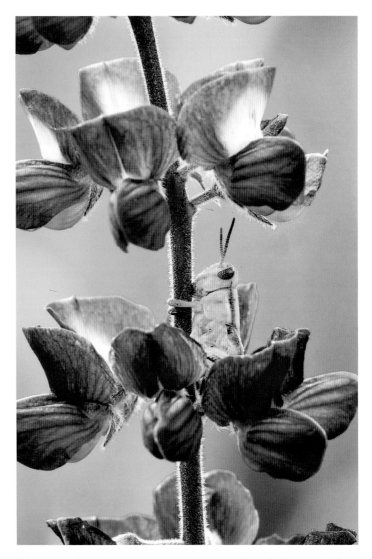

This yellow grasshopper is attempting to hide in the midst of the lupine blossom. This flower could not be stabilized with a Plamp because that would scare the grasshopper. By carefully watching the live image on the LCD display, the image is shot when everything is perfectly still. Nikon D3, 200mm, 1/3, f/22, ISO 200, Auto.

shooting is closer to 50/50 in front of and behind the plane of focus. Let's see how to consistently obtain sharp focus.

AUTOFOCUS

Barbara and I use autofocus extensively in our landscape and wildlife photography, but rarely for close-up work. When

autofocus is used, though, it is made far more useful by configuring the camera for "back-button focusing," a technique we have touted extensively in all of our books, that we consistently teach at our seminars and workshops, and that is detailed at our web site www.gerlachnaturephoto.com in the articles section. Back-button focusing allows much greater freedom to select and use a convenient focus point and then recompose to produce and shoot the best image without unwanted refocusing. We heartily recommend that you visit our web site, read the details, and if your camera accommodates back-button focusing (most likely), do it forthwith! It occasionally takes a few shots to get used to it, but new users that quickly get used to it often wonder how they ever got along without it.

Even when using back-button activation, autofocus may not work well when doing close-up work. The subject may be closer than the minimum distance at which the autofocus will work, which is also a problem for manual focus as well. The biggest problem is the desired focus point may have inadequate contrast for the autofocus system to operate accurately. This causes the system to continuously search back and forth without finding proper focus. Also, the extremely limited DOF in close-up work requires you to precisely focus on the most important part of the subject. Most of the time, no single AF point corresponds to the exact spot where the sharpest focus is desired.

MANUAL FOCUS

We wish it were otherwise, but autofocus just isn't terribly useful for close-up work. Luckily, it's easy to ignore autofocus and just manually turn the lens's focus ring slowly while looking through the viewfinder and rocking the focus back and forth to see the point of best focus. Manual focus may be more difficult for those of you over forty (Barb and I are still thirty-nine—we wish), but practice does help.

The spring chickens among you and even you old timers with a zillion shots under your belt may encounter focusing difficulty when the viewfinder image darkens. Here, size does matter—at least the maximum size of the aperture. Viewfinder

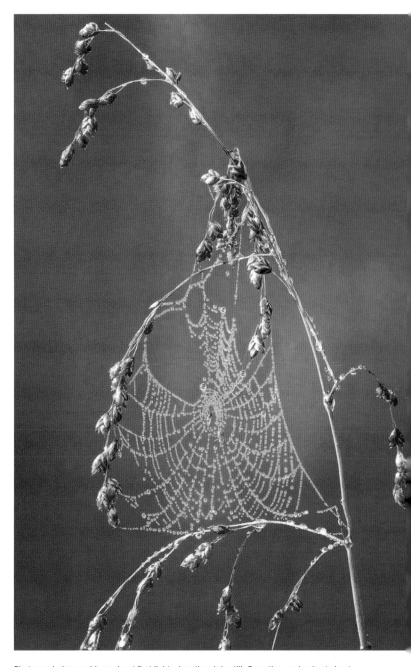

Photograph dewy spider webs at first light when the air is still. Once the sun begins to heat the atmosphere, moving air makes it impossible to capture a sharp image of this exquisite subject. Nikon D4, 200mm, 1/15, f/10, ISO 100, Shade, twenty-three images were merged into one image using Zerene Stacker to achieve incredible depth-of-field.

brightness is determined by the maximum aperture, not the shooting aperture, and the image from an f/2.8 lens is twice as bright as that from an f/4 lens. Extension tubes also cut down on the light, as do teleconverters and polarizing filters.

One good method of dealing with dark viewfinder images is to use Live View if it is offered by your camera. I discussed Live View in Chapter One. Now we'll just add a few details.

LIVE VIEW FOCUSING TECHNIQUES

Many newer cameras offer a Live View capability where the camera's mirror is raised and the shutter is opened, so the image is seen on the camera's rear LCD panel. Here, the composition and especially the focusing can be seen with great precision.

Additionally, the Live View image on many cameras can be magnified such that only a very small part of the image—the part where precise focus is wanted—can be selected and studied until it is in perfect focus. This feature provides even greater precision of focusing, a boon to all photographers and a super boon for us more mature folks! Moreover, our generally new gadget resistant rebellious student is nearing 80, and even he loves Live View for his macro work. He couldn't do without it!

Like everything in photography, Live View offers many a benefit, but at a price. You pay for its precision and ease of focusing in reduced battery life, but carrying a couple of extra batteries with you solves that problem. Some say that the sensor's temperature rise because of Live View usage will increase digital noise in the image shadows. One more problem is seeing the LCD image in bright sunlight. However, if you use a "Hoodloupe" (www.hoodmanusa.com), you will avoid the sunlight problem and probably never want to be without that gadget again!

Here's how to use Live View:

1. Set your lens to manual focus.
2. Activate Live View.
3. Notice the scrollable box appearing on the LCD screen.
4. Move the box over that part of the image needing most critical focus.
5. Magnify the image as desired.
6. Carefully rock the lens's focus ring back and forth for best focus.

Marvel at how easily you can get perfect focus!

If that seems like a lot of steps to remember, don't worry, you won't have to. Once you've done it a couple of times, it will merely be a simple sequence of things you naturally do when you want precise focus.

Not only can you get the best possible focus and hence the sharpest possible image with Live View, but you can easily see even the slightest movement of the subject. You can view your dandelion blossom or spider web in the Live View mode, watch the LCD, and release the shutter as soon as you see that your dancing subject has stopped wiggling in the breeze!

FOCUSING RAILS

This accessory is tremendously helpful when shooting magnifications at life-size and greater. In some circumstances, it may indeed be a necessity. The focusing rail is a device mounted between the tripod and the camera, or perhaps between the tripod and the lens—if the lens has a tripod collar. (If the lens does, be sure to use it!) The focusing rail uses mechanical gearing to move the entire camera and lens assembly forward and backward in very small incremental movements. Having achieved approximate focus by adjustments of tripod position and lens, the focusing rail is adjusted for the last little very precise achievement of perfect focus. Some focusing rails also offer side-to-side adjustability, which is sometimes an aid to very careful composition, though the Kirk rail we use only moves forward and backward. We recommend that if you do buy a focusing rail, don't skimp on the quality. Only precision machining will do the job without annoying looseness or rough movements.

The focusing rail is incredibly useful for shooting sets of images where the focus between images is varied a tiny amount. The sets of images are combined into one final image where everything is sharp from foreground to background. This technique is called focus stacking.

OPTIMUM APERTURES

The lens aperture can have a significant effect on sharpness. Lenses that are wide open can suffer from various optical aberrations, and lenses that are stopped down too far suffer from others. To obtain the best sharpness, you should avoid using either extreme of aperture. In fact, most lenses offer maximally sharp images when stopped down about 2 stops from wide open. Your f/2.8 lens is probably sharpest at f/5.6 and your f/4 lens at f/8.

However, you can't always shoot at f/5.6 or f/8 or any other given aperture. Sometimes, if not most of the time, you must use a smaller aperture—f/16 for example—that provides more depth-of-field. On the flip side, to isolate a subject against a background, you may need a very wide aperture such as f/4. In either case, do use that smaller or larger aperture, as the difference in sharpness by deviating from the optimum aperture is minimal. Smaller apertures are more problematic to use than the widest apertures. Often in shooting macro one needs to use a smaller aperture to achieve a needed depth-of-field. As one makes the aperture smaller and smaller to get that DOF, the lens aberration called "diffraction" becomes more and more prevalent and softens the entire image. Diffraction is caused by the bending of light as it goes through an aperture. The smaller the hole, the greater the diffraction. It's a compromise between diffraction and DOF, but try to avoid the two smallest apertures of your lens. For example, if your lens stops down to f/32, then avoid both f/32 and f/22 and you won't suffer much from diffraction-induced softening.

Focal length influences diffraction, too. The f/stop is a relationship between the focal length of the lens and the diameter of the aperture. A 200mm lens that is shot at f/22 has a larger physical aperture than f/22 with any shorter focal length. For example, my Canon 200mm macro will stop down to f/32, but my Canon 65mm macro only goes down to f/16. Neither lens offers any smaller apertures because diffraction would produce such soft images that everyone would complain. Regardless of the focal length of the lens, beware of using the extremely small apertures in the f/22 to f/45 range.

John photographed the lichen specifically to demonstrate diffraction for this book. He used f/11 because it is a very sharp aperture on his Canon 180mm macro lens. Four images are shot where the focus is changed slightly and then this small stack of images is combined into a single image with Helicon Focus to simultaneously achieve both superb sharpness and plenty of depth-of-field. Canon 5D Mark III, 180mm, 1/4, f/11, ISO 100, Shade.

In part a, a highly magnified portion of the lichen is greatly blown up to clearly reveal the excellent sharpness. In part b, the enlargement is from a single image where f/11 is used. Notice some portions of the lichen are not sharp because the depth-of-field is inadequate at f/11. In part c, the overall depth-of-field is significantly improved by stopping down to f/32, but the overall sharpness suffers from increased diffraction at this tiny aperture. Prior to shooting this test, we would use f/18 to shoot the lichen in one shot. This is a compromise between more depth-of-field than f/11 delivers and far less diffraction at f/32. Now, we would use f/11 and shoot a series of images to be combined with focus stacking software to arrive at the super sharp result you see in the figure on page 79.

SHOOT A LITTLE LOOSER

Depth-of-field is *inversely proportional* to magnification. What on earth does that mean? Only that the greater the magnification, the less the DOF. If we shoot from a bit farther away, the lower magnification gives a greater DOF that may be just enough to make the subject sharp from front to rear. Later on in post-capture editing, we can magnify the subject by cropping it to the desired composition. Make sure you don't carry this too far. Too much post-capture magnification and too few camera sensor pixels will cause a loss of adequate picture detail.

SUBJECT PLANE AND SENSOR PLANE SHOULD BE PARALLEL

The very shallow depth-of-field encountered in high-magnification shooting often makes it necessary to ensure that the most important plane of the subject is absolutely parallel with the camera's image sensor. Although a crucial consideration, and one that is simple sounding, we find that many shooters either don't appreciate its importance or somehow fail to make it happen.

Suppose we're tramping through the flowery meadow early on a very cold summer morning. We spot a gorgeous specimen of a Great Spangled Fritillary perched on a flower, and this lethargic creature is so cold it's totally dormant. It has spectacularly colorful wings that are neatly folded over its back. After a short study of how the wings are tilted, we carefully align the camera in a seemingly parallel position. But, are we perfectly parallel with the first attempt? Probably not!

If you were in those circumstances, how could you tell? Here's how. Using a magnified Live View image of the wings, focus first on the wing at its point of attachment to the thorax. Then, move the Live View's scrolling box to study the opposite edge of the wing. Is it also in focus? If not, you probably have a problem of non-parallel alignment, so readjust the camera position until both fore and aft of the wing are sharp. Continue to readjust the camera's position in tiny increments until all parts of the wing, including the top and bottom edges, are all in good focus. Now you have a sensor parallel to the subject's most important plane—the wings!

All that does seem burdensome, but having the sensor plane parallel to the subject's most important plane truly does make

The Great Spangled Fritillary wings aren't even close to being parallel with the camera's sensor. The wings go out of focus rapidly at f/13. Canon 5D Mark III, 180mm, 1/20, f/13, ISO 160, Cloudy, fill-flash.

By repositioning the camera to make the sensor plane parallel to the plane of the wings, the depth-of-field easily covers this cooperative butterfly. Canon 5D Mark III, 180mm, f/13, 1/20, ISO 160, Cloudy, fill-flash.

the image significantly sharper. Although we described a simple subject like a butterfly, there are cases where the subject has no obvious plane of needed sharpness. The subject may even have multiple interesting planes, and you must decide which plane is most important. Focus as we just discussed, stop down to f/16 or f/18, and shoot! If the subject is perfectly still for minutes at a time, the focus stacking techniques will let you capture multiple planes in exquisitely sharp focus.

KEEP STILL!

Trying to get a sharp image of a wildflower defiantly dancing in a baffling breeze can generally drive the most laid-back photographer into involuntary utterances of impolite language. Sure, one can up the ISO to 1600, set the aperture to f/4, hope for a lull in the gale, and perhaps get a sharp image. But, the image will likely suffer from insufficient depth-of-field and increased digital noise. Perhaps it is better to come back early tomorrow morning when there is no wind—hopefully!

Wildflower shooters favor calm air and bright overcast days. The overcast offers soft light, and the calm conditions are essential when shooting at slow shutter speeds, say 1/30 second and slower. In those conditions, you always should have:

LADIES AND GENTLEMEN: THE PLAMP!

Years ago, okay, decades ago, I employed a stiff wire with a clothespin attached to each end of the wire to brace my wavering and wiggling subjects. Yes, it was effective, but very crude and easily broken. I struggled with it for years until Clay Wimberley at (www.tripodhead.com) invented the Plamp. What on earth is a Plamp, you ask? The name is a contraction of "plant clamp," and this $40 device is worth its cost many times over. It's a sturdy and flexible photo tool about 22 inches long that holds its shape, but is easily bent. Each end has a spring-loaded clamp. It sounds simple, but it has a gratifying abundance of handy uses for the close-up shooter. The Plamp can be used to:

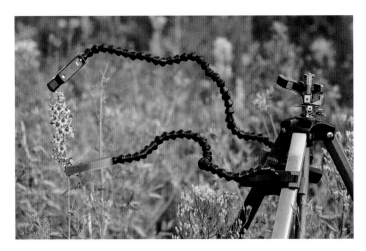

Using a tripod lawn sprinkler for support, two Plamps are attached to it and used to stabilize this delphinium wildflower by attaching one Plamp below the part of the flower that will be photographed and the other above it. We frequently use two Plamps at the same time to steady the subject. Plamps are so important to obtaining sharp images that we wonder why most close-up photographers don't avail themselves of their enormous benefits. Canon 5D Mark III, 180mm, 1/4, f/11, ISO 100, Cloudy, fill-flash.

1. Clamp one end to a stake and the other to a plant to hold the plant still.
2. Hold and position a small reflector or diffuser.
3. Hold something in front of, or behind, the subject to improve the composition.
4. Tilt the subject to improve the composition.
5. Reposition the subject to achieve a better background.

Barb and I heartily endorse the Plamp and recommend that all close-up shooters have at least one, while two is better still. We each have three!

HOW TO HOLD A FLOWER STILL

Consider the larkspur. It's a common mountain wildflower growing up to 3 feet tall and bearing blossoms up and down its tough stem. To shoot a sharp image of the blossoms, even in a slight breeze, attach a Plamp just above the blossoms to be shot and another Plamp just below. The other ends of the two Plamps are attached to a separate nearby tripod or to a stake pushed into the ground. We happen to favor plastic electric fence supports although any old stake will do. In a reasonable breeze, that clamping will permit sharp images

Careful placement of the Plamps prevents them from appearing in this image. Canon 5D Mark III, 180mm, 1/1.6, f/22, ISO 100, Cloudy, fill-flash.

even at very slow shutter speeds, although there is obviously still some limit on just how much breeze can be tolerated.

PLAMPS, DIFFUSERS, AND REFLECTORS

The Plamp isn't enormously strong, but can very easily hold small reflectors and diffusers, and larger ones too if one edge of the reflector or diffuser rests on the ground or some other support. If you run across a small group of flowers or mushrooms growing close to the ground and in bright sunlight, you can place your spare tripod or your friend's tripod nearby and Plamp the diffuser to it. Absent a tripod, a simple stake will do. The diffuser is held in place by the Plamp and softens the sunlight, which lowers the contrast to produce a pleasing image. Moreover, you have both hands free to fire the shutter, hold the flash, slap a pesky mosquito, or scratch your nose—always itchiest when you're busiest.

HOLDING AN OBJECT BEHIND OR IN FRONT OF THE SUBJECT

Creative close-up photographers like to occasionally mix and match colors in their images. Suppose you are shooting a bright yellow wildflower. Rather than having other yellow flowers making up your background, you would like to include that nearby but not quite in the frame purple flower. Without cutting the purple flower, perhaps you can attach one of your two Plamps to it and pull it over enough to be included in your composition without harming it. This is all possible because you know of the pleasing complementation of yellow and purple and because you had Plamps in your camera bag!

Here's another thought. Wildflowers, the frequent subjects of many close-up photographers, are generally protected. Picking them deprives others from enjoying the beauty of the lost flowers, and because so many flowers depend on seed production to propagate, picking disrupts future generations. Wild orchids are especially fragile and very sensitive to human disturbance. Spotted knapweed, on the other hand, is an invasive alien weed that covers vast tracts of otherwise pretty northern Michigan acreage where Barb and I like to do a lot

of wildflower photography. Those flowers you can pick all you want. But, and this is important, if you're unsure whether a flower is a native wildflower or an unwanted invasive or noxious weed, please don't pick it.

TILTING THE SUBJECT FOR A BETTER BACKGROUND

Your Plamps can be employed to change the viewpoint just by tilting a flower. Perhaps you want to shoot up at your flower against a blue sky background. Use the Plamp to tilt the flower forward to enable you to shoot up at it just a bit. Or tilt the flower back to have nicer flowers in the background. The Plamp lightly grasps the stem of the plant to avoid injuring it. For flowers with extremely fragile stems, the holes in the clamping end can be used to stabilize the flower without putting any pressure on the stem at all. Use your Plamps to help you modify the shooting angle without hurting the subject! We do it routinely.

You may think that our seemingly incessant rambling about Plamps suggests some personal interest in them. Okay. We admit to a personal interest. We admit that we're so thoroughly enamored with their extreme usefulness in so many aspects of close-up photography that we had to cover them in great detail here just as we do at our lectures, seminars, and workshops. We really don't understand how you can be a productive close-up photographer without using them!

ENVIRONMENTAL FRIENDLINESS

You spot a sleeping caterpillar on a twig in the middle of a small leatherleaf bush. Due to the densely interconnected branches, it is exceedingly difficult to get a tripod in close enough to frame the caterpillar without disturbing the subject and without having a distractingly busy background. The caterpillar photographs much better if you clip the twig and move the twig bearing the caterpillar to the open and attach it to a Plamp. This allows selecting the most favorable side of the caterpillar, the best shooting angle, and it makes the now far more distant background record pleasingly out of focus. Since the photography takes place a few yards away,

It's fun to capture a macro scene where you fill the frame with a small subject, but use a wide-angle lens to capture the background behind it. The mushrooms are focused in the first image and the waterfall is focused on in the second image. This image is made from combining the two images with Zerene Stacker. Nikon D300, 18mm, 1/4, f/22, ISO 500, Shade, fill-flash.

it prevents the bush from being trampled. After the photos are shot, the caterpillar is gently and safely returned to the wild by laying the twig back on the original bush to allow the unharmed insect to continue with its life.

FOCUS STACKING

Focus stacking is a technique in which multiple shots are taken along the length of a subject because depth-of-field alone could not get it all in sharp focus in a single shot. The multiple shots are then combined into a single image that is sharp throughout using special software in post-capture editing. The process can be carried out in some versions of Photoshop, or in specialized focus stacking software published by Helicon Focus at www.heliconsoft.com, or by Zerene Stacker at www.zerenesystems.com. Enormous depths-of-field are skillfully obtained this way. It opens up an entire new world of opportunities for the close-up photographer.

USING FLASH

Your flash can be a big help to obtain image sharpness. The benefit of flash is its very short duration burst of light. Depending on the power output and whether set manually or automatically, the light burst may range from a long 1/700 second (this is long?) to as little as 1/20,000 of a second (wow!). Such extremely short flash duration times easily freeze wind-blown subjects and arrest camera movement and vibration. Images are sharp! The downside is that depending on ambient light and your shooting parameters, the backgrounds might turn out unflatteringly black.

Over our decades of close-up photography, the idea of hand-holding a camera was belittled as not allowing properly studied compositions, not allowing careful focus, and not allowing small enough apertures to give sufficient depth-of-field. Nowadays, however, it may be okay to handhold when the camera has some combination of image stabilization and substantial light available, whether from ambient, from flash, or both at the same time. Nonetheless, using a tripod is highly recommended anytime its use is possible.

IMAGE STABILIZATION

Image stabilization is one of the recent electronics wonders favoring photographers. It comes in two flavors—systems that manipulate the lens or the sensor, called "optical stabilization", and systems that manipulate the electronic image, called "digital stabilization." Most camera systems commonly used by the close-up crowd will use optical stabilization, that Canon oddly enough calls "IS" for "Image Stabilization," that Nikon calls "VR" for "Vibration Reduction," and that others call by various names.

Those systems that are already good and rapidly getting better offer a few stops of improvement in motion stopping capability. For example, the latest Nikon VR systems claim a 4 stop improvement. Recall the rule of thumb that the slowest shutter speed suitable for handholding your system is the reciprocal of the focal length, i.e., if shooting a 100mm lens, you may handhold only at shutter speeds down to 1/100 second. But, if your stabilization system allows a 4 stop improvement, then you can shoot the 100mm lens handheld at any shutter speed down to 1/6 second!

Marketing hype being what it is, it's probably a good idea for all photographers to individually test their personal handholding capabilities. Point your camera at a target with fine detail—perhaps a newspaper tacked to a wall, or a postage stamp, or a dollar bill, and shoot at various shutter speeds. Critically examine the results on your computer at 100 percent magnification and determine your own limit of sharpness. Then, for safety, add 1 stop of shutter speed to that number for your own guideline.

I tested Sigma's new 180mm f/2.8 macro with optical stabilization while writing this book, and it performed well. I was able to get acceptably sharp images handheld at 1/100 second and consistently shot crisp images at 1/200 second. I could not capture sharp images at slower shutter speeds. This isn't surprising! Although many non-macro lenses enable sharp images when shot with a shutter speed that is only about one-quarter of the focal length, it doesn't work with macro lenses. Why? Consider a 24mm lens. The handheld guideline suggests one should be able to shoot sharp images at 1/24 second. Your camera doesn't offer that exact shutter speed, so round it off to 1/30 second. If the optical stabilization is available and activated, then it may still produce sharp images with one-half second shutter speeds. It can do this because the picture elements in the image are not highly magnified and are moving over a much smaller percentage of the image real estate. Conversely, in macro photography, the subject is highly magnified and the picture elements are gyrating over far more of the imaging sensor—making it more difficult for the optical stabilization system to keep everything sharp. Currently, you can only hope for a couple of stops of usable slower shutter speeds in close-up photography—though, these systems will steadily improve in the years to come.

Warning! *Do not activate optical or electronic stabilization (if you have it) when shooting on a tripod.* When the camera is perfectly still on a solid tripod, the stabilization system on many lenses or in the camera will activate in its hunt for vibration. If the lens isn't vibrating because it is on a tripod, the system may create its own vibration while hunting for non-existent lens movement and cause soft images. We see this happen often in field workshops. Anytime a student complains nothing is sharp in the image and we know it isn't a case of missed focus, more likely the stabilization system is activated. However, some systems are able to detect when the camera is supported on a tripod and the system is automatically deactivated.

Handheld shooting, which we have all been cautioned against, is sometimes unavoidable. Although it limits the ease of careful composition, the bugaboo of camera movement can be somewhat mitigated by:

- Using a higher than usual ISO.
- Activating image stabilization.
- Using an aperture that allows a satisfactory DOF and a high shutter speed.
- Using flash to provide a short burst of light that freezes all motion.
- Being certain to focus precisely.
- Being as steady as possible when shooting by assuming a stable stance, holding your breath, and being gentle with the shutter release.
- Shooting numerous images to increase the odds of getting sharp ones.

- Remembering exposure reciprocity and knowing that if your exposure is 1/125 second at f/11, you can also shoot at 1/1000 second and f/4. You sacrifice some DOF and gain a lot of shutter speed!

So, there you are. The viewing world seeks tack-sharp images. How do you know? Just read all of the ads for lenses and the user reviews. Sharpness makes up a large percentage of those texts—perhaps the largest. Sharpness is a key goal most of the time. You have just read our techniques to make your images razor sharp. Remember, nothing in photography is very complicated. You just need to remember a multitude of simple things. Well, now you may have even a few more things to remember, but if you make the effort to learn and apply them, you will be thrilled with your results!

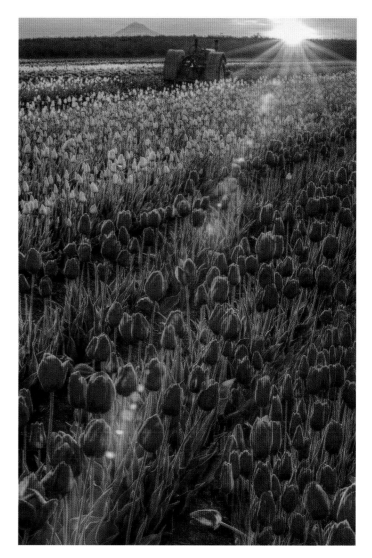

Frost is the best way to make Teasel attractive. Frost only develops when the air is still. Nevertheless, I attached a Plamp to the stem to hold it perfectly motionless. Thirteen images were assimilated into one image using Helicon Focus software in order to achieve the ultimate in sharpness. Notice f/11 was used because it is one of the sharpest apertures on the lens. There is absolutely no reason to stop down more because the depth of field is fully covered in the stack of images. Canon 5D Mark III, 180mm macro, ISO 200, f/11, 1/30, Cloudy WB.

Sunrise is spectacular at the Wooden Shoe tulip field near Woodburn, Oregon. Because Barbara is especially imaginative, she decided to use diffraction in a uniquely beneficial way to produce a sunrise starburst. To get the starburst, Barbara stopped the lens down to f/22 and included the sun in the image. Even though the diffraction at f/22 reduces the overall sharpness of the image, using a small aperture was necessary to attain the starburst. Had it not been for wanting the starburst, Barbara would have focus stacked the image. The contrast between the dark foreground and the sun was extreme, so four different exposures were shot to cover the contrast in the scene. The shutter speed was changed by one stop for each exposure and all four images were combined into one using Photomatix Pro HDR software. Nikon D4, 70mm, ISO 400, f/22, 1/10, Sun WB.

Light and Color

"John, what happens when you shoot images using mid-day bright sunshine?" I was asked this simple question by well-known Michigan nature photographer Larry West while I was a student at his 1977 summer field workshop.

Hoping to impress my very knowledgeable instructor, I began: "The high-contrast light makes it hard to capture color and detail everywhere in the image. Mid-day sun is a harsh light and creates dark shadows because the overhead sun is high in the sky. These are distracting shadows that are unflattering and often conceal important shadow detail. Moreover, while the shadows are too black, the highlights may be 'blown out,' thus destroying important detail in the highlight areas. Additionally, bright sun has a very neutral color and many of my outdoor subjects are enhanced by the warm golden colors of early and late day when the sun is low in the sky. And besides . . ."

At that point, Larry just smiled and interrupted my answer, which obviously would never end, by quietly saying: "Bad light makes bad pictures!"

And how correct Larry was!

My lengthy and not-so-insightful answer merely described the "mechanical" effects of unflatteringly bad light on the image. Larry did a much more effective right-brain summary of the issue by implicitly suggesting that a serious photographer is wasting time by shooting in lousy light.

Goat's Beard seed heads offer a wonderful opportunity for shooting enchanting patterns. The soft overcast light prevents excessive contrast. Barbara shot nineteen images and changed the focus slightly between shots to create her stack. Zerene Stacker is used to merge all of the images together to create a single image with tremendous overall depth-of-field that isn't possible with a single capture. Nikon D4, 200mm, 2 seconds, f/11, ISO 100, Cloudy.

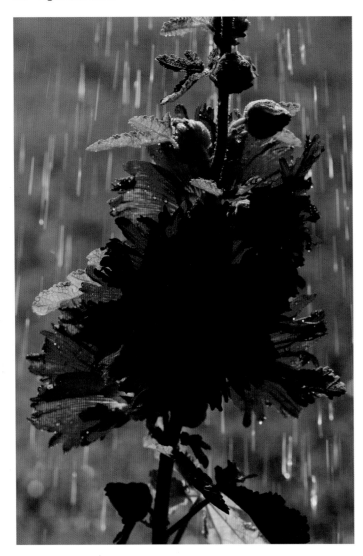

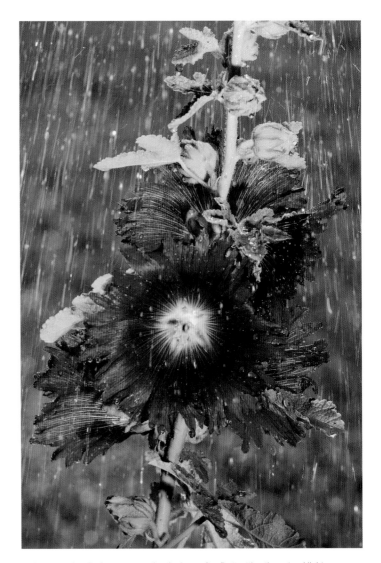

Hollyhocks grow in our garden. To add interest, we showered the flowers with a handheld sprinkler. The water drops show up best when the early morning sun backlights them. Unfortunately, the dense flowers block the sun too much, creating black shadows. Nikon D4, 200mm, f/13, 1/160, ISO 100, Cloudy.

Barbara uses her flash to open up the shadows after first setting the natural light exposure. The short flash duration freezes some of the water drops. Nikon D4, 200mm, f/13, 1/160, ISO 100, Cloudy, automatic flash with the Nikon SB-800 using the SU-800 Wireless Flash Commander.

I have come to realize that to be a successful photographer, one must first learn to see the light. If I use my time, effort, and resources to shoot only when the light is favorable, I dramatically raise my percentage of "keepers," enhance my professional credentials, utilize my time and money more wisely, improve my artistic self-satisfaction immensely, and most important of all, my students learn much more. Even as I write this, while leading a photo tour at Kenya's Samburu National Park, I continue to follow Larry's advice. Here, I counsel my students to shoot intensely during the first two hours of morning light and the last two hours of the day, when the sun is low in the sky and the light is golden. For the little

shooting I do here for myself, and for any of my own shooting for that matter, I won't even bother to shoot any images in lousy light.

After all, they would promptly be dumped into the computer's insatiable "bit bucket" depository of discarded images, so why bother taking them? This may be even more important for our students. Barb and I have conducted nearly forty African photo tours, and we'll hopefully teach more. Most of our students are here for a one-time event, so Barb and I are duty-bound to do everything we can to help them capture exceptional images during their limited time. As Larry West knew so well, fine images are made most easily in superb light.

Okay, let's get down to brass tacks. I promised earlier to be honest in this book, so here goes: Many photographers believe that they can see the light. Their feelings are honest, but unfortunately, many are naive. What they see is only whether there is enough quantity of light to shoot—not whether the quality of that light is worth a hoot. And light that is not worth a hoot doesn't even make good images of owls! However, even some pro photographers occasionally attempt to make images in poor light. Today's computerized darkroom can help improve many lackluster images, but the process is wearisome, often technically problematic, and sometimes not aesthetically wonderful. Doesn't it make better sense to simply shoot the same subjects, but only when the light is splendid? Let's look at some of the factors important to outstanding light shooting.

THE ROLE OF LIGHT

Think of a gorgeous orange Great Spangled Fritillary butterfly gracefully posing on a colorful flower. Can your close-up shot be accomplished without light? Hardly! Some shooters argue to use only "naturally occurring ambient or available light," but can you make an image with unavailable light? Neither can I. Only the light illuminating your butterfly can be focused by your lens and captured by the millions of pixels of your camera's sensor. And that light has important—no, not just

Calm and bright overcast is an ideal time to photograph large groups of flowers like this colony of Indian Paintbrush. Calm is crucial because there is no way to stabilize each of these blossoms with Plamps. Canon 5D Mark III, Canon 17-40mm lens at 20mm, 1/4, f/16, ISO 200, Cloudy.

important, but critical characteristics. One crucial parameter is color. Did your high-school science instructor teach you about Roy G. Biv, a mnemonic for the color spectrum of visible light? The sequence, from low color frequency to high, is Red, Orange, Yellow, Green, Blue, Indigo, and Violet. These colors of light impinge on the camera's sensor to form the millions of tiny reservoirs of electrical charge that record the butterfly's colors and send them through the camera's inner workings. After much electronic manipulation, the light ultimately forms your image. If the colors of the light reflected from your butterfly are drab, you will get a drab butterfly image. If the colors, intensities, direction, and contrast of the reflected light are lovely, then your butterfly image might just become a prize-winner! Paraphrasing a perhaps not too diplomatic former U.S. president who said, "It's the light, stupid!"

QUALITIES OF LIGHT

Color is but one of the four important qualities of light. Collectively, they are:

- Intensity
- Color
- Direction
- Contrast

Let's explore them one by one, and in some detail.

INTENSITY

A fancy word describing the quantity of light or how much is available. The amount of light, whether ambient light, light supplied by the photographer such as a flash, or a combination of the two, determines what can be photographed at the desired ISO settings, the desired shutter speeds, and the desired apertures. On an overcast morning, the dim light can be problematic when shutter speeds must be lowered to the point of introducing wind-blown subject movement, when the aperture must be opened to some lesser and undesirable depth-of-field, or when the ISO must be raised into a high noise region. If, for example, you must lower your shutter speed to, say, 2 seconds, it can be tough to anticipate a 2 second period when the prevailing wind will not wiggle your flower and blur your image. The odds are against you. But if the dim light brightens by just 3 or 4 stops, a faster shutter speed can be used and your luck improves. Obviously, the dim light makes for dim viewfinder images and difficult focusing, but when you have enough light, you can happily use the aperture you need for your desired depth-of-field, the shutter speed you want for arresting subject motion, and a low enough ISO to avoid visible noise in your image shadows. Adequate light is happiness!

COLOR

Returning to the subject of color, have you ever wondered why the sky is blue? The answer lies in the different ways in which different colors of light are affected as light rays travel at various angles through the earth's atmosphere. Light has different colors because of differences in what's called "wavelength." Let it be said, though, that blue light has a different wavelength and therefore has a different behavior than red light. As the sun changes its position in the sky, its light travels through the air at different angles, and the various colors of light are differently affected. One result is a blue sky because the atmosphere tends to reflect the shorter wavelengths of blue light rather than the longer wavelengths of red, orange, yellow, and green light.

The light conscious photographer is acutely aware of blue sky. While the blue skies can surely be pretty, the blue light falling on the earth can be a photographer's headache. Let's consider what we call "open shade." Open shade exists when our subject is in the shade, but under an open blue sky. The blue light falling on the subject gives a blue cast to all of the colors of the subject. That blue cast degrades all the warm colors—the yellows, oranges, reds, and browns. In blue light, our orange butterfly is less orange and our yellow flower is less yellow. The blue light compromises the warm colors. Even otherwise neutral colors will take on a blue colorcast.

If the subject is not under open blue skies but is under white clouds, the blue colorcast is less pronounced, though it's still present and generally an irritant to photographers. Often

Auto white balance doesn't work well in close-up photography because the subject often fills the frame. This orange tulip doesn't appear anywhere near its proper color because Auto white balance is unsuccessfully compensating for the preponderance of orange light reflecting from the tulip. If you shoot RAW, the colors are easily adjusted later with software. But, if you want good-looking in-camera JPEGs, then Auto white balance often fails. Nikon D3, Nikon 200mm, 1/50, f/20, ISO 200, Auto.

We both shoot Large JPEG plus Large RAW files for all of our close-up images. Therefore, Barbara uses the Cloudy white balance to compensate for the excess blue light in the overcast light to keep her orange tulip warm in color. All shooting data is the same as above, except the Cloudy WB is used rather than Auto white balance.

the alert photographer can compensate for the blue light by careful selection of white balance settings in the camera, or especially if shooting RAW files, by adjustments in post-capture RAW conversion. Moreover, when in a shaded setting in a forest, the blue light from the sky and the green light reflected from the trees and grass can mix to a distinct blue-green color. Generally such complex light colors can be controlled by using the Custom white balance capabilities of the camera or perhaps by post-capture editing which is possible to some degree with JPEG files and to nearly any degree with RAW files.

Most cameras, and perhaps all cameras commonly used by serious shooters, offer several presets of white balance selections along with a few variable selections. The presets of the Canon 5D Mark III include Daylight, Cloudy, Shade, Flash, Tungsten, and White Fluorescent Light. The variable choices include Auto, Color Temperature, and Custom. Your camera may offer different choices, but most likely they are similar ones that merely go by a different name. We will look at the choices most likely to be used by the close-up photographer.

White Balance Setting: Automatic

If a subject has a colorcast to it because of the color of the prevailing light, the Automatic white balance (AWB) selection will attempt to remove that colorcast and render the image as if it were shot under white light. Sometimes the Automatic white balance system can't cope with a complex mix of light colors. A common example is the blue light of the sky mixing with the green light reflected from trees. The AWB system doesn't compensate well for both, leaving the image with an unwanted colorcast.

Photographers shooting RAW files have a decided edge here. JPEG files come out of the camera ready to go, but they only allow minor color correction in post-capture editing. RAW files allow far more color optimization. RAW files come straight out of the camera and may appear dull and flat. They become usable images after a software editing process called "RAW conversion" has been used. One shooter I know, whose name I won't mention, was thoroughly alarmed by his first new results using his new expensive first digital camera. He was very close to tearfully shipping it back to the vendor and going back to film, before he came to understand the characteristic of RAW files! During RAW conversion, the data contained in the RAW file is converted into one or more of several standard image formats, and in the process can be edited easily in many ways, including changing the colorcast, or white balance, to suit the photographer's aesthetic desires. So much latitude is offered the RAW file user that some shooters operate with complete disdain for white balance control because they know they can change it at will in post-capture edits. Ignoring white balance admittedly removes one more item from the list of things we have to think about when shooting, but Barb and I counsel otherwise, believing that one should always do the best possible job with the camera and thus minimize computer editing.

Incidentally, a RAW file itself cannot present a visible image. It's solely a bunch of digital numbers capable of being converted into an image. Thus, when a RAW file is "viewed," either on the back of a camera or in a computer, it's only because the RAW file contains an embedded JPEG file that is used for viewing.

Barb and I don't use Automatic white balance, preferring to choose a white balance setting appropriate to the color of the prevailing (dominant) light. By selecting the optimum white balance choice, the image looks more colorful on the back of the camera and on our computer. Since we shoot large RAW files and large JPEGs simultaneously, using the appropriate white balance choice reduces the need to edit the JPEG files, making them easy to use quickly for slide programs. In John's case, he sets his Canon cameras to the Landscape picture style, which instructs the camera to increase the color saturation and the sharpness of the JPEG files, making them better for immediate use without additional software tweaking. Admittedly, doing this affects the histogram display slightly. The histogram's rightmost data will touch the right wall of the histogram a tiny bit sooner than if a Standard or Neutral picture style is used, but the difference is small.

While RAW file shooters can comfortably use Automatic white balance most of the time, both JPEG shooters and RAW shooters must take care when doing close-ups. The reason is that so often when shooting close-ups we largely fill the image frame with a single color. For example, if a bright red flower occupies most of the frame, the poor camera doesn't recognize a red subject, and assumes it's a neutral-colored flower basking in strong red light. The Automatic white balance system will try to compensate for that assumed bright red light and will produce a spoiled oddly colored image.

Aside from our close-up concerns, many a beginner has been disappointed by sunrise and sunset images when they forget

to move the camera off the AWB mode. In AWB, the camera decides that the red subject means illumination by red light, and the camera removes the colorcast, much to the irritation of the forlorn photographer.

White Balance Setting: Sun or Daylight

The color of the mid-day sun is well-known. It's a neutral light that reveals colors more accurately than any other light and usually provides pleasing colors. However, the neutral color of sunlight is limited to mid-day. At dawn and dusk the sunlight is red. Why red, you ask? Honestly, not only does the sunlight get red at the extremes of the day, it gets red also at extremes of latitude, such as the northern hemisphere's Alaska and the southern hemisphere's Falkland Islands. Sunlight gets red at those times and places because the sun hovers low in the sky. This means the sunlight must travel a greater distance through the lower atmosphere before reaching our eyes than does sunlight coming from above us. It so happens that as sunlight passes through the atmosphere, the dust particles and moisture molecules attenuate the higher frequencies (shorter wavelengths) of the sunlight—the cooler blues, indigos, violets, and greens. When those cooler frequencies are more attenuated, the residual sunlight reaching our eyes has a greater percentage of the warmer colors remaining—the reds, oranges, and yellows. The sunlight thus exhibits the strong red–orange cast that gets so many photographers out of bed before dawn and keeps them out way past dinner!

Yes, golden-red sunlight can make beautiful images. JPEG shooters, however, must remember to turn off AWB and use a fixed white balance. Additionally if your camera allows custom WB settings, something very high, like 10,000K, will enhance the warmer colors and can produce dramatic sunrises and sunsets. Returning to our close-up pursuits, Barbara and I find that backlighting with the sun's warm colors can produce terrific results!

Irrespective of the gorgeous sunrise/sunset images frequently available, sunlight isn't always the optimum light. Sunlight from a mid-day clear sky is a very harsh high-contrast light that can cause offensive black shadows in our pictures unless the subjects are front-lit so that the shadows fall directly behind and are invisible to the camera.

White Balance Setting: Cloudy

Whenever the sky is mostly covered by clouds, we routinely recommend the Cloudy white balance preset. An extensive but reasonably thin cloud layer gives the bright overcast that is sometimes considered "God's Diffuser." This can be the ideal lighting for many subjects because of the absence of undesirable shadows when the light is coming from every which way at once. Through clouds thick or thin, the light is scattered by water droplets and takes on a significant bluish color. The Cloudy white balance setting of the camera will add some yellow to the image and reduce or cancel the undesirable blue light. Keep in mind that the Cloudy white balance is probably the most versatile single setting for outdoor close-up work. We use it more often than any other.

White Balance Setting: Shade

On a sunny day, whenever you are photographing in the soft light of shade, the light has a strong blue color. This occurs when clouds block the sun or other obstacles such as trees, mountains, or perhaps a tall building. Much of the light when shooting in shaded conditions is blue because the subject is illuminated by the scattered blue light from the sky. To compensate for this excess of blue light, use the Shade white balance setting, which adds yellow to the image and mitigates the preponderance of blue light. Nature photographers commonly shoot under shady conditions, so this white balance choice will be one that is used frequently.

White Balance Setting: Flash

Flash generally produces a color of light that is similar to that of the mid-day sun, but it may have a slightly blue color. Some flashes are made with a little yellow filtering over the flash tube to reduce the blue cast. The behavior of the Flash white balance setting is much like that of the Cloudy white balance setting in that a little yellow is added to the image to mitigate

Grasshoppers can be photographed on cool mornings when they are sluggish, if you move slowly, and use a longer focal length lens for more working distance. This grasshopper is in the shade with an indigo blue sky above it. Open shade is excessively high in blue light, which is not suitable for this warm-colored subject. Canon 7D, 180mm, 1/2, f/16, ISO 100, Sun.

Compensate for the excess blue light created by the blue sky by setting the Shade white balance. The camera adds yellow to the image and thereby reduces the blue colorcast.

whatever blue may be present. So, when flash is the major source of light, be sure to use the camera's Flash white balance setting.

If you are using a mix of ambient light, with a lesser amount of flash, perhaps when using flash as a fill light, then the better white balance would be that which compensates for the major ambient light source. A good example would be shooting a flower growing in a shaded area and using fill-flash to open up the shadows. If the ambient light, the light of the shaded area, is the main light, then Shade white balance is the way to go. And moreover, don't get too fixated on the nuances of white balance. As we've said before, JPEG users can always

make limited white balance changes in post-processing editing and RAW users have total flexibility over the white balance effects (the color) of the final image.

White Balance Setting: Custom

Here's an option that critical shooters can use to accommodate complex multi-colored lighting. Remember, though, that it's useful mostly to the JPEG shooter with limited post-capture editing capability and to those RAW shooters who want to do everything in the camera and not in post-capture editing. Other RAW shooters depend on the RAW file's extremely wide flexibility for post-capture color control.

Consider a white flower growing in a green forest on a cloudy day. The light coming from the clouds has a high blue content, giving everything a blue cast. If that were all, you would set your WB to Cloudy, which would add some blue-canceling yellow to the image. The problem, though, is that the light also passes through, or reflects from, the green chlorophyll-filled leaves, which adds a green cast. The yellow added by the Cloudy WB setting would not itself compensate for the green cast, but it will affect the apparent color of the greens by making them more yellow–green. If, however, one were to set the Custom WB properly, the multi-colored cast can be largely neutralized.

To describe the process of setting Custom WB, I'll use a Canon 5D Mark III, although virtually all serious DSLR cameras offer a similar methodology. If you're going to use Custom WB, be sure to read your camera manual carefully. Here's how I use it with the Canon 5D Mark III.

- Place a sheet of unlined white paper in the same light as the subject.
- Fill the center region of the viewfinder with the paper. Add 2 stops of exposure compensation to make certain the white paper comes out white and shoot the image.
- On the *Shooting 2* menu tab, highlight *Custom white balance* and press the *Set* button. The image of the white paper is displayed on the rear LCD, and in the upper left corner the *Custom* icon appears.
- Press the *Set* button. A confirmation screen asks whether you want to use the white balance data from this image of the white paper.

These iridescent Ring-necked Pheasant feathers make wonderful patterns. This taxidermy mount is placed in the shade to avoid the contrast of bright sun. This creates a witch's brew of multiple colorcasts. The feathers are predominately red–orange in color and the light is high in blue content. When you have multiple colorcasts, the best way to handle it is to shoot RAW and adjust the colors with software or use Custom white balance because it can neutralize more than one colorcast at a time. Auto white balance does a poor job. Canon 5D Mark III, Canon 100mm, f/18, 2 seconds, ISO 100, Auto.

The Custom white balance produces far more realistic colors. I photographed a white piece of paper in the same light as the pheasant. Then I selected the image of the white paper and set Custom white balance. The camera "looks" at the image of the white piece of paper and creates a custom white balance to compensate for all colorcasts. The shooting data is the same. Only the white balance changes between images. Instead of Auto WB, Custom WB is used.

Select *OKAY* and press *Set*. Unless the camera is already set to *Custom WB*, a second screen reminds you to do so.

- Press *Set* and then press the shutter button half-way to dismiss the menu. The camera will use the white balance data from the white paper to neutralize any colorcasts in subsequent shooting until you change the WB setting.
- Be sure to remember that the camera is now compensating for the color of the light that illuminated the white test paper. If subsequent shooting involves a change in lighting, the white balance will be inaccurate. Shoot another shot of the white paper that is illuminated by the light to create the new Custom WB for the light conditions.

The above procedure might seem to be complex, but it really isn't. It'll become second nature after you have done it a few times. However, I seldom use it, and Barbara rarely uses her Nikon's equivalent system. Why? We routinely capture both a high quality JPEG and RAW version of every image we shoot. It's more efficient to select the closest non-custom WB setting and make final corrections later. JPEGs easily handle minor color corrections. If a large color correction is required, then we use the RAW file and convert it using the RAW conversion software in Photoshop. Even my free Canon Digital Photo Professional software works fine for converting RAW images.

However, we still do advise those who shoot only JPEGs to use the Custom WB most of the time to capture superb color in their images that require little or no color adjustments later. We would do this, too, if we shot only JPEGs and didn't have the RAW file to work with when needed.

White Balance Setting: Color Temperature

This white balance setting allows the shooter to tailor the camera's white balance setting for any specific color of ambient light, even some light not accommodated by the routine white balance settings. The use of this setting is problematic in the sense that it requires the use of an expensive color temperature meter. Barbara and I see no call for this capability in close-up work. In landscape photography, however, we do sometimes set our cameras to 10,000K to produce dramatic red sunset or sunrise images.

White Balance Setting: White Fluorescent

Subjects illuminated by fluorescent lighting are often difficult to shoot because of the unpleasant green cast of that light, and the additional problem that the light's color changes with the aging of the lamps. We recommend that where feasible, you shoot those subjects under window light or with flash, or with a mix of both. In other words, avoid using this type of light unless there is no other option.

White Balance Setting: Tungsten

Tungsten lamps are the common incandescent lamps that emit light with a strong red cast. This white balance setting attempts to compensate for that red cast, although as with fluorescent lighting, it's much better if you can use window light or flash, or a mix of both.

The Most Useful White Balance Settings

We have already mentioned the blue light of a bright cloudy day. However, the bright low contrast light of that cloudy day is generally excellent for close-up photography. The use of the Cloudy WB setting will add yellow to the image to compensate for the blue. If the subject is in the shade, then using the Shade WB setting will add even more yellow to compensate. Early or late in the day, when the low sunlight is high in red, orange, and yellow content, the Sun or Daylight white balance will better match the light.

Thus, the Cloudy, Daylight, Flash, and Shade white balance settings are by far the most useful for close-up photographers when shooting outdoor images where JPEGs or RAW and JPEGs are captured. For those who shoot only RAW files, Auto WB works fine with the understanding the colors will be optimized later when the image is processed.

THE DIRECTION OF LIGHT

Having rambled on over the color of light, let us look at one of the other important light parameters—the direction. Front lighting, side lighting, back lighting, and diffused lighting each have a major effect on our photographic goals.

Light direction is crucial in close-up photography. Front light is probably the most used light direction, but often it isn't the best. This delicate Western White butterfly displays its attractive pattern nicely with front light, but the texture in the wings is missing. Canon 5D Mark III, 180mm, f/18, 1 second, ISO 100, Sun.

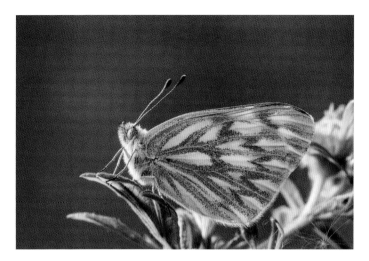

The Canon 600 EX-RT flash is held above and behind the butterfly to rim it with light to better reveal its shape. See how the flash nicely highlights the tiny backlit hairs on the butterfly and some of the leaves. Though many photographers love front light, side light and back light generally produce more interesting images. Canon 5D Mark III, 180mm, f/18, 1-second, ISO 100, Sun, Canon 600 flash to light the butterfly from behind.

The natural light exposure is darkened by 1/3 stop. A Canon 600 EX-RT flash is held above the butterfly to skim the light across the wings. This weak side light creates soft shadows that emphasize the texture in the wings. Canon 5D Mark III, 180mm, f/18, .8 second, ISO 100, Sun, Canon 600 flash.

Front Light

Front light is light that shines most brightly on that part of the subject facing the camera. Photographers of a century ago were often constrained by low film sensitivity to shoot only when the sun was over their shoulder, thus producing front lighting. Even today, more images are shot using front light than any other. Front light is good for revealing color and detail in the subject and good for causing objectionable shadows to disappear because they fall behind the subject. Front light also illuminates a subject with often desirable low contrast light. Although front light is frequently effective, we believe it is used far too often because side lighting and back lighting often produce more interesting images.

We've already paraphrased a well-known politician by saying, "It's the light, stupid!" It's the light that displays the shape of the subject, the texture of the subject, the color of the subject, the different tonalities of the subject, and everything else about it. In frontal lighting, shadows are few and subjects can appear two-dimensional. Their shape is hidden. Shadows are important to show shape in many subjects, flowers being a good example. Moreover, frontal lighting hides texture.

The scaling on the butterfly's wings is far less visible when obscured by low-contrast front light. Whether a novice or more advanced shooter, you'd be wise to always consider the direction of the light.

Side Light

Side light is the best light to use if you wish to reveal the texture of a subject. Subjects like feathers, leaves, butterfly wings, and many other flat surfaces that have considerable texture can be dramatically portrayed by using side lighting. Yet side light does not work so well with subjects having considerable depth. A frog, mushroom, or tulip may all cast harsh and distracting shadows when using side light. Of course, such shadows can be easily mitigated by diffusing the light with a reflector or by fill-flash.

Back Light

Dew-laden spider webs and dragonflies, a yellow aspen leaf or fern leaf, frost on the windowpane, delicate flowers, and the thin wings of butterflies, all produce splendid and dramatic images when illuminated from the back. Back lighting is terrific when illuminating any subject with small hairs because the lighting makes the hairs glow, and that highlights the shape of the subject. It's also the best lighting for translucent subjects of all types because of the way the back lighting highlights subject details. It will take some thought and a good deal of practice to achieve these dramatic results.

Light coming from behind the subject is often high in contrast. If a subject is not translucent, then the camera's view of the subject may be in deep shadow with little detail. It's also important to remain alert for objectionable lens flare and the resulting fogginess that can occur from a light source in front of the camera. Prudent aiming of the camera or use of the "hat trick" might eliminate or at least reduce flare, but if using the hat trick or some variant thereof, make sure the hat is not in the frame! Hat trick? Just hold your hat out in front of the camera to block the sun from directly entering the lens.

We have noticed that many beginning photographers shy away from back lighting, or perhaps just have never added the idea to their kit of photo tools, but don't avoid back light. You will find your image collection markedly improved when you use it in those situations where it without a doubt works well. Take the time to experiment!

Diffused Light

Most of us have at one time or another been irritated by unwanted harsh light. Its high contrast with dark and detail-hiding shadows is troublesome. Sometimes we can diffuse the light with a portable diffuser, or we can move our subject into the diffused light of shade, or even generate some shade. Portable fold-up diffusers are readily and inexpensively available. At times, a wide and cooperative friend comes in handy to shade flowers, insects, and other small subjects. Sometimes one can just sit, wait, and enjoy the outdoors until a helpful cloud wanders under the sun.

Low contrast diffused light is excellent for subjects with lots of depth because it comes from all directions and "wraps around" the subject. It's good for flowers, frogs, mushrooms, insects, and lots of other subjects, especially when the sunlight is bright, but still highly diffused by clouds. Diffused light is easy to manage, and its effects may be optimized by adding some shadowing with electronic flash or inexpensive fold-up reflectors. As with any light, or for that matter any technique, just beware of overusing it to the point your image collection is in a proverbial rut.

Modifying the Light Direction

By way of illustration, let us talk about butterflies. Bronze Coppers, Monarchs, Black Swallowtails, and other species sleep on the vegetation in weedy meadows. The early morning golden sunshine finds many a photographer using front lighting when shooting these insects. When they use excellent technique, they certainly capture pleasing images, but often a little deviation from the ordinary can significantly improve those images. Again, consider back light. When shooting the

Alpine Spring Beauty bloom near the top of Colorado's Mt. Evans in late June. Like most alpine flowers, they grow close to the ground to avoid the freezing effects of the cold wind. The bright sun creates harsh shadows that are distracting and hide the flower's color and detail. Canon 5D Mark III, 180mm, f/18, 1/80, ISO 200, Cloudy.

John blocked the sun from hitting the flower. Shading the subject is a simple and highly effective way to control excessive contrast. Shading does change the color of the light by making it bluer and increases the exposure time—in this case by 1.7 stops. Canon 5D Mark III, 180mm, 1/25, f/18, ISO 200, Cloudy.

butterfly from its shaded side, being cognizant of lens flare of course, the back light will highlight the rim of the butterfly's wings and its body, and perhaps light up the translucency of the vegetation upon which the insect is resting. But, it's likely that the shaded side is too dark and needs a bit more light. This is easy to do! You can use a white or silver fold-up reflector, or even better at this time of day, a gold fold-up reflector. Holding the reflector at this angle or that will give you complete control over the light.

If you aren't carrying reflectors with you or are all out of hands to hold everything, a little flash illumination can do the job. Just use appropriate flash exposure compensation when in an auto flash mode, or appropriate power level ratio when in manual flash mode, to satisfactorily illuminate the dark side of the butterfly. And if you attach a light-yellow gel over your flash to better match the early morning sunlight, you are a clever photographer indeed!

Using back lighting to highlight rim detail and translucency while adding light to the shadowed sections of the subject is an effective lighting technique we call crosslighting. The back light comes from behind the subject. The light we add to fill in the shadows created by the back light comes from the opposite direction. These two light sources essentially cross at the subject location. Be sure to use it!

Finally, this: I've extolled the many virtues of back lighting at length, and while I shun "rules" in photography, preferring to call them guidelines, there may be one thing that truly deserves to be a rule: *If it's translucent, back light it!*

Shadows Reveal Shape

Diffuse light does a fine job of preventing harsh shadows in a subject, but some shadowing is generally necessary to show the shape of a three-dimensional subject. Yes, we can easily shoot a wildflower with the virtually shadowless diffuse light of a very cloudy day, but sometimes a little shadow can add some pizzazz to the image. It's easy to do, too. Just use a reflector to slightly brighten one side of the flower and expose to retain the detail on the brighter side. The opposite,

or darker, side now has some soft shadowing that helps to emphasize the shape and suggests three-dimensional depth. Reflectors do a good job here.

Another approach is to light one side of the flower with flash. With the flash exposure compensation control (our preferred method), or with power ratio control of the flash in manual mode, add about 1 stop of light to one side of the flower. While reflectors are okay, flash offers considerably greater control of the lighting ratio. We'll be covering flash more extensively in Chapter Five, but here are some elements of the contrast enhancing procedure:

- Set an exposure to underexpose the flower by about 1 stop. That means that the brighter tones of a trial histogram will be a stop or so to the *left* of the right-hand edge (sometimes called the wall) of the graph space.
- Set the flash exposure, using as we've discussed either the flash exposure compensation feature with automatic flash or a power ratio controlled manual flash to increase the exposure by a stop. This will now move the histogram data to the right, i.e., to the preferred ETTR position.

CONTRAST

In any ordinary scene and its image there are two major kinds of contrast, color contrast and tonality contrast. Color contrast is the difference between colors, for example, blue and yellow, but it is tonality contrast that interests us here. Tonality contrast is a measure of the difference between brightnesses of a hue, for example, between light gray and dark gray, between white and nearly white, nearly white and not so nearly white, light green and dark green, dark magenta and light magenta, and so on.

Though the elements of a subject themselves have a contrast between the lower-tonality (darker) areas and the higher-tonality (lighter) areas, different lighting conditions can greatly modify the contrast. Consider a mushroom. The contrast of that mushroom under very diffuse light is quite low. The lightest part of the mushroom may be only a stop different from the darkest part, so the subject contrast, sometimes called its "dynamic range," is only 1 stop. Now, however, let's

put the same mushroom into the mid-day sun. The harsh sunlight brightly illuminates the crown of the mushroom while casting a black shadow onto its background and under the mushroom's cap. The tonality difference between the brilliantly lit crown and the deep dark shadow may now be 5 stops or more, a significant problem for the mushroom shooter!

Along with ruinous high winds, excessive contrast can spoil a close-up photographer's day, but we have already mentioned a couple of controls we can use to address the problem. Let's take a look in more detail!

Controlling Contrast

Reflectors

A wildflower illuminated by harsh sunlight coming from one side will have dark shadows on the other side. The contrast between bright and dark areas can easily exceed 3 stops of light. This may not be enough to make the shadows completely black because the blue light of the sky can operate as a fill light, but 3 stops is certainly enough to make unpleasantly harsh shadows with loss of detail.

One of our controls is the reflector. In adequate ambient light, a simple reflector can bounce enough light onto the subject to not only mitigate contrast but to actually rim-light a subject. Reflectors are convenient and inexpensive tools that we used for a large amount of our work for years, although the recent evolution of sophisticated wireless flash technology has made flash more and more important in contrast control.

Reflectors are offered by many sources. We successfully use those by Photoflex, although one of our more rebellious students happens to prefer Lastolite reflectors because of the convenient handles on some models. Either way, these are the so-called pop-up reflectors that are contained in a small zippered bag, erected for use, then folded back up to store. They come in several sizes, selected according to the size of the largest subject you are likely to use them for. They also come in several surfaces, white, silver, gold, soft-gold, and others. Barb and I generally use a 32 inch Photoflex combination system called a MultiDisc 5-in-1 reflector. It has gold,

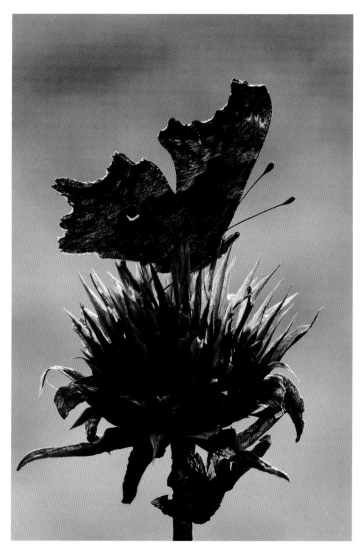

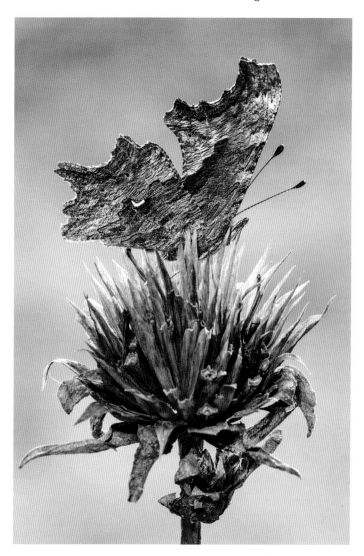

The golden early morning sunshine backlights this Hoary Comma, but creates some harsh shadows. Canon 5D Mark III, 180mm, 1/4, f/20, ISO 100, Sun.

Using a reflector, the sunlight is bounced back to the butterfly. We call this *crosslighting* because the sunlight comes from one direction and the bounced light strikes the butterfly from the opposite direction. Light crosses at the subject's location—giving a nice backlit effect while keeping the shadows from going too dark. Shooting data is the same as the image to the left. The only difference is the light that is added with a reflector to minimize the shadows.

silver, white, soft-gold surfaces and a diffuser all in one package. The soft-gold is great in the early morning or late day sun, the white is best at mid-day to avoid any colorcast, and the silver gives a crisper brighter light. We find the solid gold surface can make our images too gold in color.

Since they say you can't get something for nothing, I'll reveal some of the negatives of reflectors:

- When the ambient light is low, a reflector may not have enough oomph to do the job.
- It's one more accessory to remember to bring and to carry. Some

Contrast problems nearly always plague mushrooms because their caps act like a hat to create dark shadows. You can use flash, or in this case, a reflector to bounce light under the cap of the mushroom to reduce the dark shadows and reveal more color and gill detail. Canon 5D Mark II, 180mm, 2 seconds, f/18, ISO 250, Shade.

A gold-toned reflector easily bounces light under the cap of this mushroom to lower the contrast. Canon 5D Mark II, 180mm, 2 seconds, f/18, ISO 250, Shade.

shooters carry folded-up aluminum foil of various colors while some glue aluminum foil to the back of stiff cardboard. These home-made reflectors work fine.

- Branches, grass, stones, tripod legs, etc., often interfere with the best placement for achieving the desired lighting effect.
- It must be held in place, often necessitating some kind of clamping, support, or that most expensive of all photographic accessories, a spouse (kidding—sort of).
- It must be held still to avoid movement of the lighting and movement of the still air. Moving a reflector even a little will stir the air and cause delicate or wary subjects themselves to move, resulting in unsharp images.

Diffusers

My interest in photographing nature arose while attending college over forty years ago—but who's counting. I was shooting wildflowers for a biology class project when I discovered that the bright ugly sunlight was vastly improved by passing it through a bed sheet. I learned that a nearby military surplus store sold white nylon parachutes about 9 feet in diameter. They were called *motorcycle covers*. Not only were they perfect as diffusers for my own project, my entrepreneurial instincts also impelled me to buy them for $10 each and sell them to other nature photographers for $20 each, a quick doubling of my money. The store soon discovered my gold mine, and changed their description from *motorcycle cover* to "photographic diffuser." They raised the price to $50, effectively terminating my profitable business endeavors.

I used those parachutes often for shooting wildflowers and mushrooms when photographing toward the ground. It was a setup where I threw the parachute over me, over my tripod, over my camera, and hence over my subject. It diffused light, blocked wind, and held determined biting insects at bay. The parachute offered multi-purpose benefits, but one day working at roadside, I was interrupted by the local authorities. They reasoned that anybody hiding under a white sheet in the field was clearly a person of interest. I defended my 4th Amendment rights by explaining that I was merely photographing flowers. The cops concluded anybody that crazy can't be dangerous, and so they wandered off. I can still hear them snickering as they left.

The overhead sheet gambit fails when shooting parallel to the ground as the sheet tends to wander into the frame. However, a couple of stakes or light stands will sort out that problem. Ensure that the sheet or parachute diffuses the light on both the subject and the background to avoid excessive contrast. If you're lucky, you might find that your background is in shade and only your foreground must be diffused. Also remember that while the sheet will certainly diffuse the light, it will also attenuate the light, often causing as much as 3 stops of light loss if the sheet is thick enough.

Some shooters go so far as to use a white tent of the appropriate size. They remove the bottom of the tent and place if over the subject, providing a highly diffuse light on both foreground and background. Even if the light is already diffuse on a cloudy day, they use the tent anyway. It blocks wind and keeps the mosquitoes away.

Diffusers, like reflectors, are available in many sizes, shapes, and makes. We prefer Photoflex diffusers just as we prefer their reflectors. Review the market for what is best for you—don't be limited by our choices.

For a wrap-up, let me say that diffusers and reflectors are inexpensive, convenient, and very effective for small subjects. Every close-up photographer should be adequately equipped with each.

Shading

We've already mentioned using some object (or person) to cast a shadow over a harshly illuminated subject. Let's now discuss it in greater detail. Selecting a camera position that properly composes the subject while still allowing the shooter's body to completely shade the subject is very effective. A minor problem to the JPEC shooter is that the light thus shadowed is slightly blue, but that is quite inconsequential to the RAW file shooter.

Instead of bringing shade to the subject, it's often possible to move the subject into the shade. Barb and I frequently

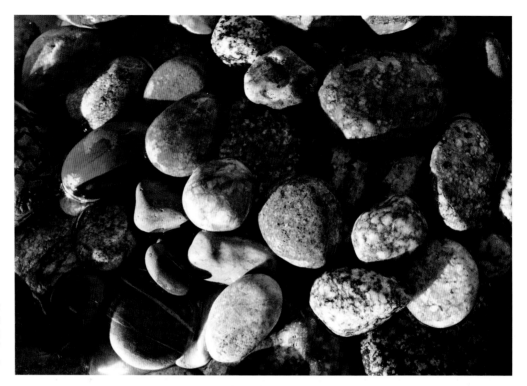

This attractive pattern of multi-colored stones lies on the beach of Pictured Rocks National Lakeshore. The bright sun, though, creates extreme contrast among the rocks and tends to dry them off which hides their true colors. Canon 5D Mark III, 100mm macro, 1/10, f/16, ISO 100, Sun.

Solve the contrast problem easily and quickly by shading all of the stones in the image. Use a handy cup of water to wet the stones to keep them colorful. Shading these stones increases the exposure time by 1.3 stops—no problem on a tripod—and the Shade WB is set to compensate for the bluer light. Canon 5D Mark III, 100mm macro, 1/4, f/16, ISO 100, Shade.

Sally Lightfoot crabs are colorful residents of the Galapagos Islands. Bright sunshine creates ugly shadows on the sand underneath it. Canon 7D, 300mm with a 25mm extension tube to make the lens focus closer, 1/250, f/10, ISO 320, Sun.

This Sally Lightfoot crab is hunting for food on a cloudy day. The light has inherently less contrast when diffused by overhead clouds. Canon 7D, 300mm with a 25mm extension tube to make the lens focus closer, 1/200, f/4.5, ISO 400, Cloudy.

erect a stake or an electric fence post in a shaded area, very carefully clip the blade of grass or twig on which our cold-immobilized subject is perched, and move the subject into the shaded area. The blade of grass or twig is held by a "flexible grab-it" tool, the well-known Wimberley Plamp, of which we have several.

Often, we are photographing our insect subjects in an early morning meadow, and we gravitate toward the eastern edge of the meadow. Why east? The eastern edge is last to receive the warming rays of the rising sun, thus lengthening the time our insects remain lethargically chilled. Not only is the light diffused by the trees to the east, they can do a good job of blocking the wind.

Barbara and I always endeavor to be kind to our subjects. We ask our students to do the same. Even our generally rebellious student, Al Hart, who is helping to edit this book, agrees with us on this one. When done photographing butterflies and dragonflies, move them back into the sunshine so they can warm up, become active, and get on with their lives. With caterpillars and spiders and other insect life that doesn't fly, be sure to return them to the plants from which they came.

Many insects eat only certain species of plant life and will perish if not returned to their required food source. *__All subjects deserve to be unharmed and released in their natural environment ASAP!__*

CONCLUSION

Once again, we paraphrase that famous former politician by reiterating, "It's the light, stupid!" Not that Barbara or I are stupid, and our readers are not, and you're certainly not, and even our rebellious student isn't. Indeed, any photographer who knowingly and deliberately becomes aware of the light to take advantage of its color, its harshness or contrast, its direction, and its cumulative helpful effect on the image is certainly one smart photographer.

Remember, the art of *seeing the light* is more than knowing when there is enough light in which to shoot. Photographers who really see the light are able to instantly decide how to mix light direction, color, and contrast to enhance the beauty of their subject and capture enchanting images.

The Wooden Shoe Tulip field is tremendously photogenic at the peak bloom in mid-April. This splendid group of blossoms was growing in a display box with the flowers planted tightly together. The bright overcast and perfectly calm weather conditions at dawn provided the opportunity to sharply focus all of these tulips. The closest blossom was only a few inches from the lens. To get all of them sharp, a series of images was taken in which the focus was slightly changed between shots. Helicon Focus software combined sixteen images into one final composite. Canon 5D Mark III, 16–35mm at 35mm, ISO 400, f/8, 1/30, Cloudy WB.

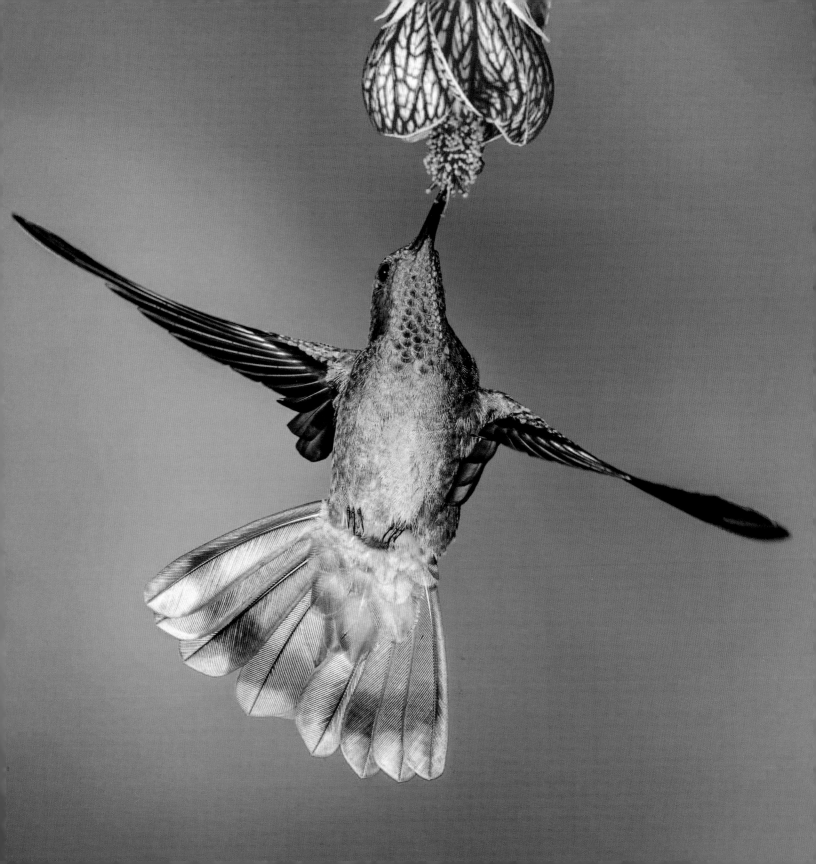

The Power of Flash

Our close-up subjects can be illuminated by many natural light sources, but modifying those sources with flash is nearly always effective at dramatically improving the photographic lighting situation. The qualities of the light on the subject are such major contributors to the quality of our images that flash augmentation can be an enormous benefit to most of our close-up images. This happy situation is generally not found in landscape photography because of the size and distance of the usual subjects, but all accomplished close-up and macro shooters must master the art and science of mixing flash with various natural light sources.

AMBIENT LIGHT DEFINED

We'll frequently use the term *ambient light*, so let's make sure we're all on the same page when we write about it. Ambient light is sometimes called natural light or available light. I often get a chuckle from that last term, as I've never yet been able to make an image with unavailable light! Ambient light refers to the light that illuminates the subject, but not supplied by the photographer. It might arise from the bright sun, from overcast clouds, from a streetlight, from a lamp in a room, a moonlit sky, and so on. Moreover, it is often some combination of more than one source. *Flash, however, is a light source introduced by the photographer.*

Ecuador boasts over 150 species of hummingbirds, including this Green Violetear photographed with flash at the Tandayapa Bird Lodge near Quito. Barbara uses her Nikon 200–400mm lens at the closest focusing distance to fill the frame with this acrobatic small bird. Nikon D3, 200–400mm at 260mm, 1/250, f/20, ISO 200, Flash WB, four Nikon SB-800 flashes set manually at 1/16 power.

ADVANTAGES OF FLASH

Close-up photographers accused of flashing are generally found innocent when even the judge comes to appreciate the splendid quality of light, the ease of creative control, and the remarkable improvement in close-up images that the modern flash can offer. The court will generally advise those close-up photographers only to keep their flash batteries well charged, to use their flashes often, and to read this book carefully and frequently.

Oh, while I think of it, we'll be using the term *flash* two ways. One refers to a burst of light and the other refers to the hardware gizmos that generate that light. The photography literature over the years has used terms like *flashgun*, *speed-light*, and *strobe-lite*, and undoubtedly a few more, but not to worry, it's all the same thing. We'll stay consistent with much of the world and use the term *flash* for both the light and the hardware, relying on context to reveal the meaning.

One quality of the light emitted by a flash is its color. It's generally the color of mid-day sunlight, although we might sometimes creatively change it with colored filters. We describe the color of light by its color temperature. Another quality of the light on our subject is its direction, and our typical flashes are small and easily directed as we wish. Some of today's flashes offer a zoom feature to allow control of the width of the beam of light.

APPLICATIONS OF FLASH IN CLOSE-UP PHOTOGRAPHY

FILL-FLASH TO REDUCE CONTRAST

Barbara is carefully watching the Live View display to make sure this Common Whitetail Dragonfly is perfectly still when she fires the camera. Canon 7D, 24–70mm lens at 60mm, 1/2, f/20, ISO 100, Cloudy, fill-flash.

The Common Whitetail in part b makes a fine image, but no flash is used. In part c, a little fill-flash adds some sparkle to the wings, opens up some shadows, and brightens the white abdomen. Nikon D3, 200mm, 1/2.5, f/22, ISO 200, Cloudy, fill-flash.

Fill-flash is the term used when a correct exposure is achieved by the ambient light, but we add additional light to the dark areas (shadow areas) of the subject. By augmenting the ambient light with flash, we reduce the overall contrast of the subject and capture greater detail throughout the image. *Fill-flash is the most common use of flash in close-up photography.*

FILL-FLASH TO IMPROVE COLOR

Consider a wildflower growing in a green forest. The ambient light has two colorcasts—the blue light from the sky and the green light reflected from the leaves on the trees. This is a photographically unpalatable witch's brew of light, but a strong flash burst, having the color of sunlight, can reduce or

This lovely wildflower is saddled with a terrible name—Bracted Lousewort. This is a fine natural light version of it, but the yellow flowers blend into the light green background too much. Canon 5D Mark III, 180mm, 1/2, f/10, ISO 100, Cloudy.

The natural light is underexposed 1 stop by increasing the shutter speed to 1/4 second. This darkened both the flower and the background. Main flash is used to properly expose the yellow flower while the background remains 1 stop darker. Canon 5D Mark III, 180mm, 1/4, f/10, ISO 100, Cloudy.

even overcome the undesirable colorcasts. And although we can make some colorcast corrections in post-capture editing, it's hard to do with mixed light and generally best to get it right in the camera.

MAIN FLASH

Fill-flash is used when the basic exposure is by ambient light, and flash is applied only to *open up* the shadows. *The exposure would be correct even without using the flash!* We've already said that, but it's important enough to repeat. Now, let's discuss using flash as the main light, or as it is sometimes called, the key light. Here, the basic exposure is via the flash, and it's the ambient light that serves to *fill* in the subject's shadow areas. *The image would be underexposed without using the flash!* When the flash is used as the main light, it is easy to darken the background a little to make the subject more prominent in the image. If the light is too low in contrast, main flash is the key to increasing the contrast, especially when the flash is used to side light or back light it. Main flash is an incredibly valuable technique largely unknown among close-up nature photographers, and it's a goal of this book to shed some light on the subject.

BALANCED FLASH

This occurs when flash is used to light a portion of the image, usually the foreground and not the background, though the reverse is also possible. Ambient light is used to light the other portion of the image.

Contemplate a dew-laden dragonfly sleeping on a wildflower in dim shade, but having a green meadow or blue sky background brightly illuminated by sunlight. A very contrasty subject—so much so that our camera is unable to record detail in both shadow and highlight areas. Here's a technique: Set an exposure that will result in the background being as you wish it, and then use your flash and the flash exposure compensation (FEC) control to properly expose the dragonfly roosting on the flower. The background is entirely exposed by the ambient light, and the dragonfly is exposed mostly by the flash.

The reverse happens, too. Photograph an uncommon white Indian Paintbrush wildflower. Two feet behind the white flower are normal deep magenta Paintbrush flowers. When the white flower is optimally exposed, the dark maroon flowers behind it appear too dark in the image. Put a wireless flash near the magenta flowers to properly expose them with the flash by adjusting the flash exposure compensation

We like the gray clouds behind this Weidemeyer's Admiral and the view from underneath the butterfly, but the light is too dim underneath it. Nikon D4, 200mm, 1/20, f/22, ISO 200, Cloudy.

A Nikon SB-800 flash effectively adds light to the butterfly to better highlight it against the gray sky. This is an example of balanced flash where the background is nicely exposed with ambient light only and the dark butterfly is well exposed primarily with flash to balance out the huge difference in the ambient light on the subject and the background. Nikon D4, 200mm, 1/20, f/22, ISO 200, Cloudy, one flash with +.7 FEC.

control (FEC). The white flower in the foreground is nicely exposed with ambient light. The background flowers are nicely exposed with some ambient light and much more light from the flash. Now the white flower and the dark flowers behind it are all nicely exposed. You capture plenty of detail because the contrast in the light between the foreground and background is much less. The flash balances the darker background with the light foreground flower.

FILL-FLASH, MAIN FLASH, AND BALANCED FLASH

Many of our workshop students confuse these terms. If they're new to you, be certain to read the descriptions above until you fully understand the three uses of flash. Remember that the ambient light is the primary light with fill-flash and the light from the flash is the weaker or secondary light. Main flash is the opposite. When using main flash, the flash is the primary light and the ambient light serves as the fill light. Balanced flash means one portion of the image is illuminated with flash and the rest is lit with ambient light. Generally, flash and ambient light are not used to light the same area in the image.

FREEZE CAMERA AND SUBJECT MOVEMENT

It's probably safe to assume that your flash system doesn't use magnesium flash powder and, luckily, modern electronic flash guns have adjustable output. Note, though, that the light output is not controlled by changing its intensity, it's controlled by changing the length of time—the duration—of the light burst. When used in automatic modes, the duration of a modern flash may range from about 1/1000 of a second all the way down to about 1/27,000 of a second. The shorter the flash duration, the greater the likelihood of freezing the motions of the camera and the subject and getting a sharp image. But where we do encounter subject or camera movement, we must be careful about *ghost images* in balancing flash and shutter speed. Suppose we're using a shutter speed of 1/60 second and suppose the light, the ISO, and the aperture all allow discernable exposure. When the shutter opens, the flash fires, but it may be gone in 1/1000 of a second. That

short burst of light renders a sharp image on the sensor, but if the shutter stays open for the full 1/60 second, there will be additional exposure of the subject from the ambient light. Should the subject or camera move after the flash has extinguished but before the shutter closes, we get the ghost image. The secret is to use a fast enough shutter speed to eliminate exposure by the ambient light and let the flash do the work!

HOW THE FLASH WORKS

You don't need to know the intricacies of the internal workings of a flash, but knowing a few tidbits might be helpful. The key components are the battery, the voltage converter, the storage capacitor, and the flash tube. Some flashes can operate from household power, but most operate from batteries. Either way, the voltage converter changes the low voltage of the batteries or the house power up to a much higher voltage, maybe around 300 volts or even more. Electrical energy at that higher voltage is stored in the capacitor awaiting a signal to fire the flash. When the camera, or the operator, gives the signal, the stored energy flows out of the capacitor and into a glass tube filled with xenon gas. The ignited gas causes the brilliant flash of light that we want! Once the gas has been ignited, we cannot control the intensity of its light, but we can control the duration of the light by electrically extinguishing the ignited gas.

BATTERY TIPS

The recycle time of a flash is the time necessary to recharge the capacitor and illuminate its ready-light, showing it's able to make another flash. Recycle times may vary from a fraction of a second to several seconds, but like recovery from a nasty cold, the faster the better. Well-charged batteries help lower recycle times. We find good quality and well-charged rechargeable batteries do the job best.

Rechargeable batteries cost more initially but amortize well over the long term and avoid the toxic waste of disposal of one time only use batteries. The rechargeable batteries that work well for us include Eneloop, Powerex, and Sanyo 2700.

We make it a habit to recharge them after each photo session and immediately before beginning another photo session.

SYNCHRONIZATION (SYNC) SPEED

*The **sync speed** of a camera is the fastest shutter speed that will allow proper exposure by the flash.* In virtually all of our modern DSLR cameras, shutter operation involves a movement of two shutter curtains best described separately for slower (lower) shutter speeds and faster (higher) shutter speeds.

At slower shutter speeds, the first curtain opens, allowing light to hit the sensor, and then the second curtain covers the sensor, shutting off the light. The short time when the first curtain is fully open but the second hasn't yet begun to close is our opportunity to fire a flash and expose the entire sensor.

At faster shutter speeds, the first curtain starts moving, but before it fully opens, the second curtain begins following it. The effect is that of a traveling slit, which does expose the whole sensor with continuous ambient light, but not all at once. There's no one time when the entire sensor can be seen by the incoming light and hence no one time we can fire a flash that exposes the entire sensor.

The *maximum* shutter speed at which we can fire a flash and expose the entire sensor is called the synchronization speed, or sync speed, sometimes called the x-sync speed. Depending on the camera, it's generally between 1/200 second and 1/320 second. If we use a conventional flash at any higher shutter speed, part of our image will not see the flash and will be underexposed. *The sync speed itself and all slower speeds will be okay.*

You can find your camera's sync speed from the manual. Most of today's clever cameras are smart enough to somehow warn you if you attempt to use a pop-up or hotshoe mounted flash at shutter speeds above the sync speed. Indeed, the camera may do more than warn you. Typically, the camera will automatically change the shutter speed to the sync speed. This does not mean it is impossible to accidently shoot with a shutter speed faster than sync speed. If you attach a simple

PC cord to the flash and the camera, the camera will fire the flash without knowing it is there and you can certainly shoot faster than the sync speed. Of course, depending on the shutter speed, only a portion of the image will be exposed and the rest remains unexposed.

HIGH-SPEED SYNC

Having so carefully explained why you can't use a shutter speed above the camera's sync speed, let me explain how this sometimes isn't true. It's probably part of a vast worldwide conspiracy to make me look foolish—not hard to do. Remember the traveling slit of faster shutter speeds? If your camera offers a high-speed sync mode, the clever camera breaks up the flash burst into several shorter duration bursts and fires them sequentially as the slit travels across the sensor. The good news is that all segments of the sensor receive light from the flash. The bad news is that the capacitor energy is not applied to a single flash burst, but is dissipated in multiple short bursts, each of lesser energy than the full flash, so the effective exposing power of the flash is reduced. In other words, the flash is considerably weaker, perhaps 2 or more stops, and the subject must be much closer to expose properly.

High-speed sync is a wonderful feature when you must, absolutely must, shoot with a fast shutter speed, but luckily that's pretty rare in close-up photography. When handholding at large apertures (f/2.8 or f/4.0) in bright sun, it could be pretty handy.

FLASH BASICS

POP-UP FLASH

Many cameras offer a convenient pop-up flash built into the top of the camera. Pop-ups have their uses, but close-up photography isn't one of them. Here's a laundry list of why you shouldn't illuminate your close-up subjects with the pop-up flash:

- The flash, being very small, emits a harsh light generally not very flattering to the subject.

This Wine Cup blossom will soon be fully opened. Using a shallow depth-of-field to completely throw the background out of focus, and a weak fill-flash to open up the shadows a little, Barbara uses high-speed sync to allow the flash to work with a shutter speed that is higher than the sync speed for the camera. Shooting with big apertures (f/2.8 to f/5.6) while using flash will often require the use of high-speed sync because the shutter speed is fast. Nikon D3, 200mm, 1/320, f/5, ISO 200, Cloudy, Manual exposure for the ambient and automatic flash for the fill-flash.

- The pop-up flash is relatively weak and often can't adequately illuminate a distant background.
- The mounting location occasionally causes part of the flash beam to be obscured by lenses and lens hoods, throwing a dark shadow on the subject.

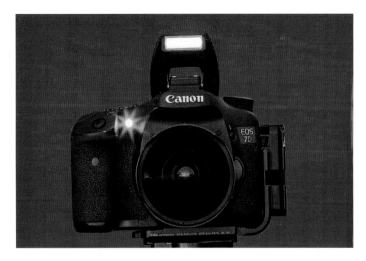

Using the flash off the camera is crucial in close-up photography. The pop-up flash on many cameras can be set to send signals to a Remote (Slave) flash, allowing wireless control of the flash. It works well!

- The direction of the light is in a straight line from camera to subject with no side light component, thus masking texture, detail, and shape.
- Adding back light to the close-up subject is usually incredibly effective, but not possible with a flash mounted on the camera.

On the other hand, some pop-up flashes can be effectively used in a *Commander* or *Master* mode. The pop-up flash is not used to illuminate the subject, but is used just to transmit commands from the camera to Remote flashes being used off-camera. Note: Some setups allow the pop-up flash to transmit the commands to the Remote flash and contribute light to the subject simultaneously.

OFF-CAMERA FLASH

Many benefits accrue when the flash is not mounted on the camera, but instead is used remotely. Old-fashioned manual techniques such as PC cords and photoelectric slaves still work for firing Remote flashes, but they're cumbersome and thoroughly made obsolete by modern dedicated flash systems that provide camera and flash intercommunication via infrared beams of light, light pulses, or radio. We'll describe some of the available choices.

DEDICATED FLASH CABLES

The least expensive camera-to-flash communications path is via a dedicated cable connecting the camera to the flash. Cables come in various lengths including stretchable curly cords, with connectors appropriate to the camera and flash for which they're designed. At the camera end they connect to the camera hotshoe. These cables preserve the same communications systems as if the flash were mounted directly on the camera's hotshoe. For example, a Canon 430 EX II or 580 EX II flash can be connected to any Canon EOS camera with an OC-E3 (Off-Camera Shoe Cord) for about $70. Nikon users can use an SC-28 or SC-29, or their predecessor, the SC-17. When buying flash cables, be careful to verify that your selection is compatible with your camera and flash. Cables offered by your camera's manufacturer ensure compatibility.

Dedicated flash cables are troublesome when using the flash as the main light and you need a longer cable to reach the subject areas needing illumination. Trying to stretch the cable, especially in cold weather, can pull on the camera causing blurred subjects, or worse, toppling it over. A work-around, sometimes, is to join two or more cables to attain additional

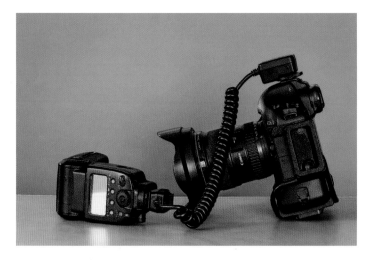

Using a dedicated cord to connect the flash to the camera does work. However, the limitations include: it only works with one flash at a time, the cord may not be long enough for back lighting, the cord may accidently touch the subject and ruin the image, you have to buy the flash cable and carry it with you, and it takes time to connect it to both the camera and the flash.

length. Cables are better in fill-flash applications where the flash is closer to the lens/subject axis, and so the typical 3 foot cable length is more than adequate.

One downside to using cables for a Remote flash with a tripod-mounted camera is the awkwardness of moving it all when changing composition. One never has quite enough hands to manage the camera, the tripod, and one or more Remote flashes. You can't put the flash in your pocket easily without disconnecting the cable and then reconnecting it later. I suppose you can let one dangle from the tripod, but none of these is a good solution. The best setup is to scrap the dedicated cable and use a sophisticated wireless control of the Remote flash. That's what Barbara and I use. To move our gear when recomposing, we quickly tuck the flash into our pocket, and with both hands unencumbered, we're unhampered by an entangling cable.

Dedicated flash cables provide an inexpensive means of controlling Remote flashes, but it's far more convenient to use either an infrared optical link, a radio link, or some other wireless signal. If you already have one or more cables, certainly keep them as a guard against failure of your more sophisticated control system or its batteries suddenly dying.

WIRELESS FLASH

It was new technology only a few years ago, but every camera system we've recently seen includes a wireless flash capability. These systems work amazingly well and greatly simplify the formerly arcane flash techniques so much that practically all camera makers offer them. It is in your best interest to use them!

TERMINOLOGY

When a pop-up flash or a flash mounted in the hotshoe is used to control other flashes, some maker-specific terminology comes into play. The flash doing the controlling is called the *Commander* by Nikon and flashes being controlled are called *Remotes*. For the same items, Canon refers to *Master* and *Slaves*. We've always thought the Canon terms are uncomfortable, but we do use them to avoid confusing our many Canon-bearing students. We much prefer Nikon's *Commander* and *Remote* nomenclature, and we'd be pleased if all camera makers were to adopt it.

PROGRAM THE POP-UP FLASH

If your camera has a pop-up flash that can be used as a Commander flash, or Master flash, this choice is selected somewhere in the camera's menu system. The feature implicitly requires that the Remote or Slave flashes are of the same system, that is, a compatible Nikon flash for use with Nikon Commander pop-up flashes and a compatible Canon flash for use with Canon Master pop-up flashes. Other camera makers use similar systems.

When a pop-up flash is programmed as a controller, it generally outputs only enough light to communicate with its Remote units, and not enough light to illuminate the subject. However, there are systems that can configure the pop-up to do both simultaneously. Beware! If you program the pop-up flash to transmit signals to a Remote flash and forget later you have done that, you may run into a confusing problem. If you later decide to use the pop-up flash to light the subject, it may fire a burst of light, but nothing is illuminated. If this happens, immediately check to see if the pop-up flash is still set to the Commander or Master selection. Choose the default setting for the pop-up flash and it should work as expected.

DEDICATED FLASH CONTROLLER

What if your camera has no pop-up flash? Canon has offered its $225.00 *ST-E2 Speedlite Transmitter* for many years. It's an optical device that communicates with other Canon flashes and usually mounts to the camera's hotshoe, although it can be mounted remotely and connected by a dedicated flash cable. I've done that myself when shooting with my 500mm lens peeping out through an opening in a wildlife blind. I found that the ST-E2 mounted on the camera inside the blind had no optical path to the Remote flashes outside the blind and would not fire the Remote flashes. I solved the problem by using a dedicated flash cable to reposition the ST-E2 from the camera hotshoe to a new position duct-taped to the lens

Wireless flash control systems are by far the most convenient way to use flash. Many systems are available. Pictured here from left to right are the Nikon Wireless Speedlight Commander SU-800, PocketWizard Plus III (two are needed), and the Canon Speedlite Transmitter ST-E3-RT.

hood that was outside the blind. There, the ST-E2 easily communicated with the Remote flashes. Nikon's equally effective optical flash controller is the $250.00 SU-800 Commander.

The flash controllers we use offer more than one channel on which the communications occur. It's an important feature. I once advised a group of students to purchase Canon 580II EX flashes and ST-E2 controllers preparatory to a workshop. During the workshop, I overheard three students excitedly talking about flash problems, and I discovered that each of them was experiencing seemingly random flashes not triggered by the student. In fact, I caught one student curiously staring into his flash wondering what was wrong. My shouted warning came just a wee bit too late to save him from a full-face blast of light. It turned out, of course, that all three students had set their systems to use Channel #1, and whenever one student pushed the shutter button, all three of their flashes fired. It didn't take long to change each student's equipment to a different channel. Their ST-E2 controllers offer four selectable channels, so it's a good thing that we didn't have five shooters in that group!

USING THE FLASH AS A CONTROLLER

The Canon 580EX II and the Nikon SB-910, and others of today's more advanced flashes, can be configured to serve either as a Remote flash or as a Commander. Then, using it as a Commander, compatible flashes can be set to supply additional light in multi-light applications. Most non-pop-up flashes used as Commanders can be programmed to emit light to help with the exposure when it is desirable.

OPTICAL COMMUNICATIONS

Both Nikon and Canon systems provide control of Remote flashes by short pulses of light sent by the controllers. They are sent just before the main burst of light intended to illuminate the subject. They happen so fast that you can't discern them by eye. Commander or Master controllers can easily manage several Remote flashes at once, up to about 30 feet away, but there must be an unobstructed line-of-sight path between them. For most photographers, optical communications are reliable and relatively inexpensive. Barb and I have regularly used these systems for years.

THIRD-PARTY RADIO CONTROLS

As we've noted, the optical flash-control systems have shortcomings in range and in line-of-sight requirements, but both shortcomings are overcome by radio-based control systems. A small radio transmitter-receiver is mounted on the camera or connected by cable, and it communicates via radio with other transmitter-receivers located at the Remote flashes. These systems are reliable and feature a long range of 100 yards or more. They have no line-of-sight requirement and happily communicate around corners and while inside non-metallic enclosures.

Several companies offer radio-based flash control systems, but perhaps the best known system is the highly reputed *PocketWizard*. It and its competition are relatively expensive, but they're widely used by serious photographers. I've used them only rarely myself because I've owned and relied on the ST-E2 for many years. That notwithstanding, one of my students wanted to place a flash behind the water of

Scott Falls, a small Michigan waterfall, to backlight the water. He could never make it work with optical flash control because of the distance involved and because the falling water heavily attenuated the optical signal from the optical controller. The PocketWizard's radio signal did the job just fine!

But buyer beware! Online auction sites offer many radio control systems at small fractions of the price of "serious equipment." Generally, these controls do a bare bones firing of a Remote flash without permitting through-the-lens (TTL) metering of the flash and without permitting any control over the output of the Remote flashes. Since TTL metering is essential for close-up photography, if you plan to buy an inexpensive system, be sure to understand its limitations.

Most wireless flash controllers use optical signals to control the Remote flash. These usually work fine, but the signal can be blocked by an object, so line-of-sight between the transmitter and the flash is important. When using a photo blind to photograph this Common Flicker, optical controllers may not work because the blind material blocks the signal. Fortunately, radio controllers are available for such situations. The Canon ST-E3-RT sends radio signals (it cannot send optical signals) which makes it terrific for blind work when used with the new Canon 600EX-RT speedlite. Canon 5D Mark III, 500mm with 25mm extension tube, 1/200, f/9, ISO 200, Flash WB, Manual exposure for the ambient light and automatic flash for the bird, Canon ST-E3-RT radio controller with the Canon 600EX-RT speedlite.

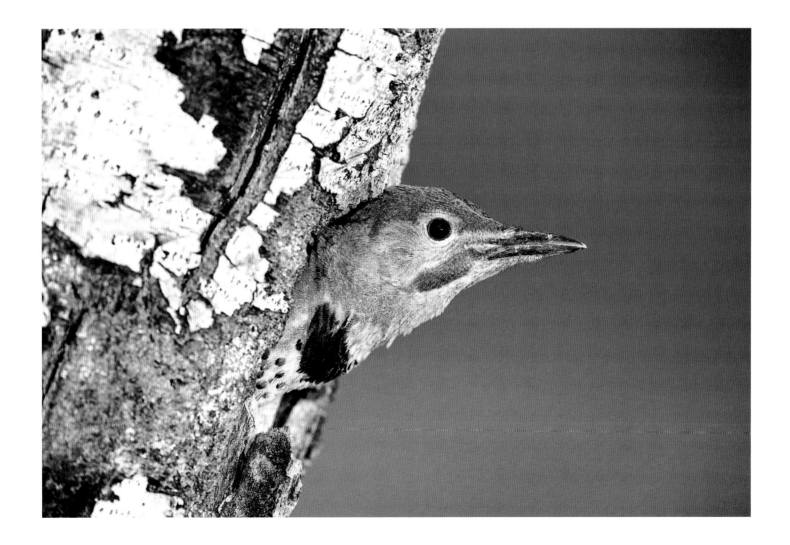

RADIO TRANSMISSION

Radio controllers work beautifully over long distances and independent of line-of-sight. Nonetheless, I've encountered a problem with radio-based flash controllers. I was using the Canon system for close-ups of butterflies. My system comprised the 600EX-RT flash and the ST-E3-RT flash controller, both recently introduced. It all worked gratifyingly well—perhaps too well. Why too well? Because it *always* worked! When I needed to inhibit the flash to shoot an ambient light only image for comparison with the flash image, I couldn't just hold my hand over the controller, put it behind my back, or stuff it into my pocket. The silly thing just unabashedly kept on firing its Remote. To disable it, I had to either turn the controller off or the flash off. You may think that's a pretty feeble objection, but to Barb and me, efficiency is everything. Having to turn the flash on and off 122 times during a close-up photo session is monotonous and tiring. For this reason, we prefer optical systems for close-up photography so we can easily block the wireless signal with our bodies whenever we want to.

However, shortly before sending this manuscript to the publisher, I discovered the release button (REL) on my new Canon 600 flash. Pressing the REL button on the flash fires the camera with a radio signal. This enormous convenience makes it worthwhile to use the radio-controlled flash.

CLOSE-UP FLASH TECHNIQUES

Yuck! Did I really make that horrible image? Have you occasionally asked that question? All too many photographers shun flash photography because of the many ugly images they've shot in the past or that they've seen made by others. More often than not, the "yuckiest" of flash shots can be traced to a single flash used as the sole light source and a resultant high-contrast image with a black background. If one adjusts exposure settings to properly expose a flash-illuminated full-frame flower, it's not uncommon that the background, assuming it's a couple feet or more away, will be a few stops underexposed and be black. Readily accepted by the nature

photographers of forty years ago, such images are today widely considered passé.

There are several ways to avoid the pitfall. One way is to use additional flashes, so that one flash illuminates the close-up subject, perhaps our delicate flower, and another flash (or flashes) illuminates the flower's background. A simpler way is to shoot with a mix of ambient light and flash. It sounds complicated, but it's not. That last sentence reminds me of a friend who is helping edit this book. Al often intones *Hart's Law of Photography*, a maxim stating that nothing in photography is especially complicated—photography is made up of very simple things—you just have to remember a million (okay, plenty) of them! He's certainly right in this case—it really isn't complicated. Years ago, before itsy-bitsy microcomputers infested our photo gear like ants at a picnic, yes it was awkward. Nowadays, though, automatic flash control and regular reliance on the RGB histogram, highlight alerts, and image preview make the mixing of ambient light and flash the proverbial piece of cake. Let's take a look at just how to do it.

SET THE AMBIENT LIGHT EXPOSURE FIRST

The secret (now unclassified) of a good mix of ambient light and flash light is to first decide the part to be played by the ambient light. Let's say we are relying on it to light the background. Do we want the background to be normally exposed, that is to say, of about the same brightness as the foreground flower will be? Do we want the background to be slightly subdued, say a stop or so underexposed? Do we want it 2 stops underexposed? Upon answering that question, we merely (1) meter our scene and set an exposure for the desired background and (2) rely on through-the-lens flash metering and the flash exposure compensation control (FEC) to set the flash to properly expose our flower. Not to worry—we'll be expanding on how to do this.

SHOOT ON A TRIPOD

It has often been written that the most important accessory a photographer can own is a good tripod. *Good* in this case

should preclude the $29 garage sale bargain. Be prepared for a significant expenditure. But a good tripod is well worth it. Professional photographers in the close-up world very strongly appreciate the indispensable nature of a sturdy tripod. Some spend nearly as much for their tripod and its head as they do for their camera! All too many shooters think of the tripod solely as a means to hold the camera steady, and so it does. But they may not appreciate the vastly greater importance of camera steadiness when doing macro photography. At higher magnification, any camera movement causes the subject to shimmer over a larger portion of the sensor and significantly reduces image sharpness. Moreover, beyond camera support and steadiness, the tripod frees up your hands for holding a flash, tripping the shutter, blocking light from viewfinder ingress, and holding your hat to shield the lens from sunlight.

But, and here's one great big but! (I can say that if I use only one "t".) Maybe every bit as important, or even more so, is the ability of the tripod to give you time to carefully study your image. When you're handholding, there's a natural inclination to push the button right now and be finished with it. With the camera on a tripod, you can be perfectly comfortable in taking time to study your composition, to be sure half your butterfly's wing is not out of the frame, to ensure no ugly brown leaf is intruding into the image, to check whether changing the camera angle a little would improve the image, and on and on. Having unhurried time to do a little composition study can vastly improve your images. It's an extremely important feature of tripod use!

SPECIFIC FLASH TECHNIQUES

FILL-FLASH PROCEDURES

The most common use of flash in close-up photography is for fill purposes. Even in heavily diffused light such as that which is present on a heavily overcast day, one can find objectionable shadows in a close-up subject. Sometimes these shadows can be satisfactorily reduced or even eliminated by judicious placement of one of those often puzzling springy little fold-up reflectors, but it's generally much easier just to point a flash

at the offending shadows. The flash successfully adds light to the shadows and lowers the subject contrast. Let's describe two of the most effective ways to mix ambient and flash illumination.

MANUAL EXPOSURE FOR THE AMBIENT LIGHT AND USE OF FILL-FLASH

First, set up a proper exposure for only the ambient light. Let's say your subject needs considerable depth-of-field, so set your aperture to f/16 or f/18. If not already there, set your ISO to the setting of best image quality, that is, the native ISO, typically 100 or 200. It gives minimum noise in the shadow areas. Next adjust the shutter speed to get a proper exposure. Use your RGB histogram and your highlight alerts to confirm the exposure.

Now you've easily found the perfect exposure for the ambient light, but you'll often still see objectionably deep shadows hiding the natural color and detail. You want to be a real photographer and not merely a snapshot grabber, so you'll take the time needed to eliminate or reduce those shadows. Here's how: With the flash set to its ETTL metering mode, use the flash exposure compensation (FEC) control, and for a starting point, dial in –1 or maybe –1.3 stops or so. If you're using off-camera flash, hold it near the front of the lens, but behind the front, and point it at the subject. Shoot an image and check the image you shot in your LCD monitor to see how you now like the shadow areas. Still too dark? Okay, change your FEC to –.7 stops and make another test. If the previous exposure used an FEC of –1.3 stops, using –.7 stop FEC (minus 2/3 of a stop) will add more light to the shadows. Continue adjusting the FEC until you have a pleasing balance between the ambient light exposure and the flash exposure. The goal is to reveal more color and detail in the shadows without completely eliminating them.

Don't worry about minor changes in flash position when you're handholding your flash because the camera's TTL flash-metering system automatically compensates for position changes you make. In other words, if the flash is held a few inches closer or farther away from one shot to the next, the

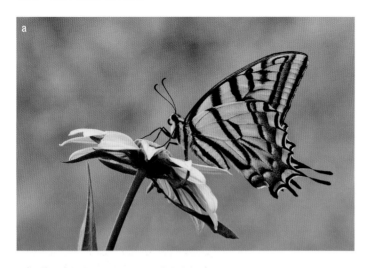

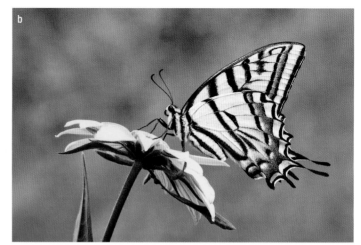

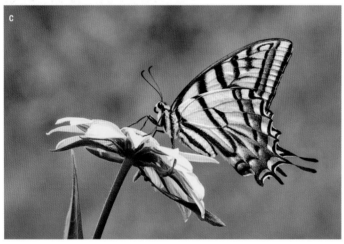

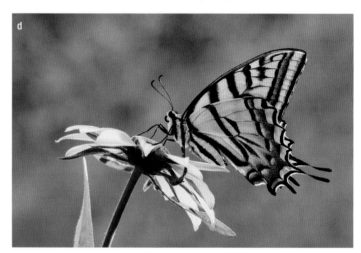

One of America's largest butterflies, the Two-tailed Swallowtail occasionally wanders into our backyard garden where it seeks flowers for nectar. In part a, the butterfly is photographed using natural light exclusively. Part b shows the desirable effect of underexposing the butterfly by about 1/3 stop and then adding direct frontal flash. The butterfly separates nicely from the background. Even better, though, is to raise the flash above the butterfly to almost directly overhead and skim the light from the flash across the butterfly's wings as seen in part c. The skimming light creates texture in the wings. Finally, in part d, the flash is held above and behind the butterfly to produce a lovely back light effect. Picture data for part as follows: Nikon D4, 200mm, 1/6, f/22, ISO 200, Cloudy. In the other three images, the shutter speed is increased to 1/8 second to darken the ambient light and an SB-800 flash is used.

automatic flash will adjust its output for minor distance changes and you need not worry about it. Do note, though, that movement of the flash causes exposure changes in accordance with the so-called Inverse Square Law. So, be alert when using your flash in a *manual mode* where the system does not automatically control flash output. For this reason, it's best to avoid manual flash in close-up photography.

FLASH ANGLE FOR FILL-FLASH

Inexperienced flash users often tend to get too fancy with positioning their flash. Sometimes they point it at various angles that don't do a good job of filling shadows. Not to dissuade you from creative experimentation, but be aware that merely filling shadows is generally best done by having the flash close to the lens and pointed at the subject. It is important to fill in the shadows being captured by the camera.

FILL TO TASTE

A couple of paragraphs earlier, we recommended that you experiment with flash fill by using the FEC control and then judging the appearance of the result by its appearance on the LCD display. You may recall (we hope) that in Chapter Two, Barbara and I condemned, in the strongest publishable terms, using the LCD to judge exposure. Why are we recommending it now? We're not! We did recommend that your ambient light exposure be established, as always, by your RGB histogram and highlight alerts. We're just saying that, in this case, you must use the LCD to judge the extent of your flash fill because the histogram is already close to the right wall of the histogram due to using ETTR techniques with the ambient exposure.

APERTURE-PRIORITY AND FILL-FLASH

In the previous example of fill-flash, the exposure for ambient light was determined by Manual exposure methods to achieve a proper RGB histogram. You then set the flash exposure by the FEC control to achieve pleasant shadow fill.

Now, however, we're going to explore using fill-flash when using Aperture-priority for the ambient light. Continue to keep in mind that the camera system that measures ambient light exposure and the system that measures and controls flash exposure, the TTL system, are two different and independent systems. Therefore, you use the camera's exposure compensation (EC) control to adjust the ambient light exposure and a different control, the flash exposure compensation (FEC) control to adjust the amount of fill-flash. We advise that you

absolutely understand the difference, recognize when you need one and the other, and know where on the camera to find them. Do keep in mind that some flashes (Canon's for example) offer a more convenient FEC on the flash—the one I use—that is not buried in the camera's menus.

Here is the logical order in which to make a picture! With the flash turned off, or otherwise disabled, set your camera to Aperture-priority, generally A or Av on your camera controls. Then, thinking of the depth-of-field (DOF) that you want in this image, enter an aperture (f/stop). Often in nature close-up work, you'll use f/16, f/18, or f/20 to get a large DOF, although for a more planar subject where less DOF is needed, you might select a larger aperture, knowing that your lenses give better performance at the larger apertures around f/8 to f/11. Also, for best quality, set your ISO to your camera's native ISO setting. *Be sure to cover the viewfinder eyepiece before shooting to avoid spoiling the exposure because of the ingress of stray light.* Then take a test shot. In Aperture-priority, your camera will select and use the presumably proper shutter speed. Consult your RGB histogram and your highlight alerts to see whether the exposure is consistent with the ETTR rules we've suggested in Chapter Two. If not, correct the exposure with your exposure compensation control and take another test shot. Continue the process until you have the optimum exposure for the ambient light as shown by the histogram where the rightmost data nearly touches the right wall of the histogram. Now for the flash!

Turn the flash on, position it near the lens but slightly behind the front of the lens and pointed toward the subject. Set your FEC to −1 stop or so (more about that later), and take a test shot using the flash. Evaluate the fill light by studying the image shadows on your LCD monitor and if necessary, change the FEC up or down until you like the shadow appearance on your LCD. You have filled to taste, and having done it a few times, you'll have seen just how easy it really is. Note: Although it is usually best to hold the flash slightly behind the lens hood, it is permissible to hold the flash between the lens hood and the subject as long as the flash unit does not appear in the image.

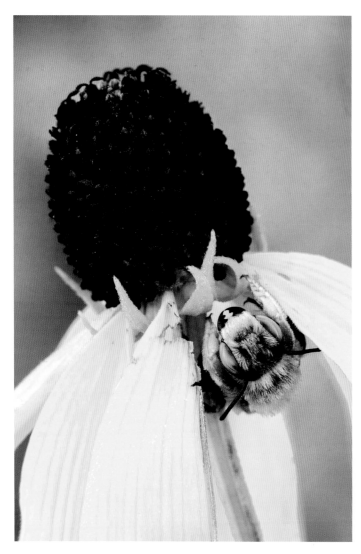

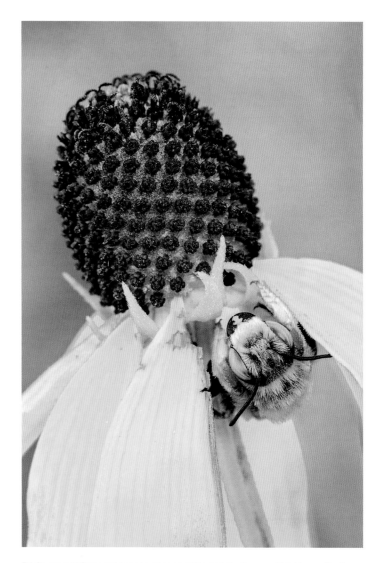

Bees commonly sleep on wildflowers. This fine specimen is photographed for more than 15 minutes while it snoozes quietly. Here's the natural light version. Nikon D3, 200mm, 1/1.6, f/22, ISO 200, Cloudy.

Fill-flash (-1 FEC) is used to open up some of the soft shadows and brighten up the flower which helps to separate both the bee and the flower from the background. The color temperature of the flash is similar to bright sun. A little light from the flash counteracts the excess blue in the overcast light and makes the flower and the bee more yellow in color. Nikon D3, 200mm, 1/1.6, f/22, ISO 200, Cloudy, fill-flash from a Nikon SB-800.

HOW MUCH FILL DO YOU NEED?

Your call—not mine. The right answer is whatever floats your boat, and it'll surely vary from image to image. For a given image, some shooters like lots of contrast and let the shadows remain deeper. Others prefer less contrast and brighten the shadows more. Now let's talk a little more about the flash exposure. The camera's TTL system measures the light reflected from the subject and controls the flash duration. Yet the TTL system is burdened by the very same problem that plagued the meter designer. When shooting flowers, we have those with the bright petals and those with the dark petals. If the reflected light is bright, is it because the flash was bright

or because the flower was bright? Perhaps both? The camera doesn't know and must just assume your close-up subject is mid-toned reflectance. So you've got to think about that when setting your flash. If the subject is bright, use the FEC to add some light. If the subject is dark, subtract some light. Yeah, we know it sounds backward, but it's true. The TTL flash exposure metering system behaves the very same way as we explained the basic camera meter, or to say it in fancier words, it's counterintuitive! For example, we said above to make the initial test shot at about −1 stop. But, if the subject is very bright, you might start with your FEC set to zero compensation, and if very dark, you might start with your FEC set to −2 stops or so. Either way, review your image on the LCD for shadow detail that pleases you, and if necessary, change the FEC and make additional test shots until you have your perfect image!

MAIN FLASH

We've already explored fill-flash, where the main exposure is via ambient light and flash is used to fill in shadow detail. Now let's look into using the flash itself to provide the main exposure while the ambient light provides the shadow fill. The flash is now the main light, or, as sometimes called, the key light. Using flash as the main light is critically important to good close-up work, and practitioners should strive to appreciate its artful benefits and master its techniques. We'll try to help.

Barb and I started seeing opportunities to beneficially use flash as a main light about twenty years ago, although we surely did not invent it. We got the idea from a book on portrait photography, in which the author described *killing the ambient* to make a flash-illuminated person stand out from the background. Then, and now, it's a technique well-known in portraiture, and Barb and I were happy to adopt (okay, copy) the idea for our nature photography with gratifying results. Sadly, this powerful technique remains largely unknown to the majority of nature and outdoor photographers. Let's change that from this day forward.

WHEN TO USE MAIN FLASH

Imagine a calm and overcast early summer morning in a meadow full of wildflowers. Your eyes fall on a gorgeous yellow flower, and you see that it's in pristine condition. With your camera securely mounted to your rock-steady tripod, you carefully compose a nice image. Using the techniques we've described, you determine the perfect ambient exposure. The image on your LCD monitor looks satisfactory, but just seems to lack that certain something. The flower seems to fade into a vaguely yellow background and doesn't jump out at the viewer, or as we sometimes say, the subject lacks *pop*. So how do you make the subject pop?

One way would be to darken the background without darkening the flower. The flower would appear more prominent. I suppose you could have a patient friend hold up a large dark blanket to shield the background from the ambient light, but you probably have enough to think about without having to cope with the vocal grousing of an overstressed shooting companion. I love to be of help to Barb whenever I can, but let me tell you, standing still while holding up a large diffuser not only makes for sore arms, it can be the ultimate in boring! Watching grass grow is way more exciting! Is there a better way?

MAIN FLASH PROCEDURES

As always, determine the optimum ambient exposure as we just recommended above. Now darken the background's response to the ambient light by deliberate underexposure, perhaps by 1 stop or so. For example, let's say the optimum ambient light exposure using ETTR is 1/4 second at f/16 and ISO 200. Using Manual exposure, you could underexpose 1 stop by changing any of the control settings to reduce the light by 1 stop. You could change the shutter speed to 1/8 second, the aperture to f/22, or the ISO to 100. However, in this case you might opt to maintain the present DOF by not changing the aperture. You might want to leave the ISO at the camera's native setting to minimize image noise. After considering the three possibilities, you opt to change the shutter speed. A new test shot using a shutter speed of 1/8 second shows a darker

This Variegated Fritillary is wonderfully back lit by soft early morning sunshine. Canon 7D, 180mm, 1/6, f/14, ISO 100, Shade.

We like this image better because the ambient light back lighting continues to nicely rim the butterfly, but the detail in the wings of the butterfly facing the camera is improved when the flash brightens it. We call this important lighting technique *crosslighting* because the ambient light comes from behind the butterfly and the flash comes from the opposite direction. Canon 7D, 180mm, 1/10, f/14, ISO 100, Shade, fill-flash.

background and an RGB histogram that has moved to the left, including the rightmost data which retreats from the right wall of the histogram by 1 stop. Not the ideal ETTR histogram, but as they say over in the prosecutor's office, you're making a "knowing, willing, and intelligent," decision to underexpose the background.

Now everything in the image is darker than our optimum ETTR exposure, including the colors and tonalities of the subject flower. Let's add flash just to the poor underexposed

flower. It's a yellow flower of fairly high tonality (brightness), perhaps a stop or so above mid-toned yellow, so the TTL flash metering system is going to underexpose the flower, too. Hah! We're clever photographers and we recognize that, so we use our FEC control to dial in +1 stop of flash compensation. Add light to bright! We take test shots at various FEC settings, changing a third of a stop here and a third of a stop there until

we find the flower exposure we like best—the one that makes the target flower *pop* but doesn't actually overexpose it. How do we know the flower isn't overexposed? There are no *blinkies* on the flower, and the rightmost data isn't climbing the right wall of the histogram. A note, incidentally, about FEC controls: some cameras have them and some flashes have them and sometimes both have them. Be sure to consult both your camera manual and your flash manual to see which is the correct way or the more convenient way for you to change flash exposure. I know I'm nagging, but I'm just sayin', the flash compensation system and its controls and the camera's ambient compensation system and its controls are two fully independent systems, and contrary to the old song about love and marriage, here you can have one without the other. With my Canon systems, I change FEC on the flash and Barb's Nikon systems let her make FEC adjustments on her camera.

There's another caveat. In our recommendations on flash fill, we suggested that you position your flash near the front of the lens, albeit far enough back to prevent light from the flash from directly entering the lens, and to keep the flash unit out of the image. We also suggested that you point the flash along the camera–subject line for the most pleasing fill of the shadows. Now, however, with the flash being used as the main light and not fill, we're changing our story. Now you can experiment with the positioning of the flash, and try a little side lighting, try the other side, try a little top lighting or even back lighting. Whenever you find a nice lighting direction, you can then fiddle with the exact exposure using test shots as suggested above. Changes to flash exposure will have a negligible effect on the background exposure because of the different distances from flash to subject and flash to background. As you run through a series of test shots looking for the absolutely finest image, don't forget to always wait for your flash ready-light to okay the next shot.

These techniques will produce close-up images where the main subject is properly exposed against a background that's a bit darker. The subjects always nicely separate from the darker background. The methods may seem complex in the initial reading, but after a little practice will become second nature. You'll never begrudge the little work needed to

become comfortable with the technique, because your close-up subjects will take on a whole new level of visual drama!

FOR APERTURE-PRIORITY FANS

You can easily use Aperture-priority to achieve effective images where the main subject stands out from a more muted

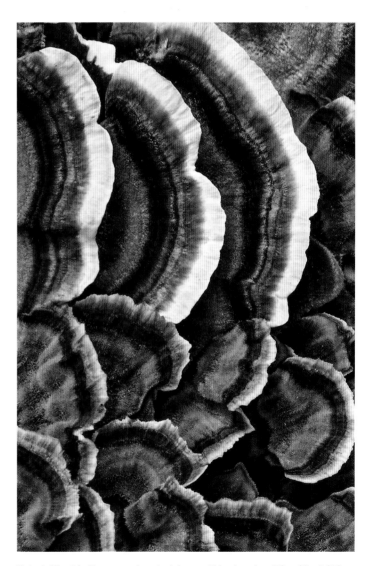

Turkeytail fungi don't move even in a steady breeze. All fungi can benefit by adding light from a flash. The flash is set to −1.3 stops using the flash exposure compensation control (FEC) on the camera. The close distances in close-up photography demand using the flash on automatic and adjusting the output with the FEC. Nikon D300, 200mm, 1/2, f/22, ISO 200, Cloudy.

background. Select an aperture, let's say f/11, to strike a good balance between the needed DOF and diffraction considerations, and a high enough shutter speed to combat the breeze wiggling the flower. As always when using an automatic mode, ensure that the viewfinder eyepiece is closed off to prevent stray light from entering and causing underexposure. Use the camera's ambient light compensation control to add or subtract light as appropriate. Suppose that for a bright background you end up having dialed in +2/3 stop of compensation, and now have a well-exposed background. But you want a darker background, so reduce the exposure 1 stop by changing the compensation to –1/3 stop. If the background is not now at the brightness you want, take additional test shots at different compensation levels until the background brightness is pleasing. Now introduce the flash and vary the flash angle routinely, using different FEC levels until you get a high-impact, high "wow factor" image—a perfectly exposed flower leaping out from a slightly darker but not black background!

THE INVERSE SQUARE LAW

No, it has nothing to do with the legalities of a backwards nerd. It's a fundamental law of physics that's used to describe, among other things, the way the light from a flash is distributed and spreads out depending on the subject's distance from the flash. I did promise in Chapter Two not to dump a bunch of theory on the reader, but permit me a little slack here because it's important enough to be worthy of exploring. One way to express it goes: *The intensity of light from a point source falling on a subject is inversely proportional to the square of the distance from the source.* Did that clear it up? Maybe not. I know that in my physics classes it took me some time to really understand it. It has to do with the way the light spreads as it travels away from the flash. The farther it goes, the greater the area it illuminates and the dimmer it gets. If a flash (not a true point source, but who cares?) lights up a flower at a distance of 1 foot and lights up the background at a distance of 2 feet, the background will have a lower light intensity falling on it than did the flower. According to the law, if the flash to background distance is twice as great as the flash to flower distance, then the background will receive only 1/4 as much light as the flower. We multiplied the distance times 2, and squared 2 to get 4. Then we took the inverse of 4, to get 1/4. Whew! Stated in user friendlier terms, the background receives 2 stops less light than the flower.

Here's another example: Suppose the flower is 1 foot from the flash, but the background is now 4 feet from the flash. We square the 4 to get 16 and take the inverse to see that this background only gets 1/16 of the light as on the flower. The background in the first example was twice as far from the flash as was the subject and was illuminated at –2 stops below the flower. The background in this example is twice as far as the first background and is 4 stops below the flower.

So, the rule to remember is that whenever we double the distance to a background, it gets only 1/4 as much light and we lose 2 stops. Conversely, if we cut the distance to the background to half of what it was, it gets 4 times as much light or gains +2 stops.

The Inverse Square Law explains why light from our flash falls off so quickly as distance increases and why it's so easy to purposefully or inadvertently have a purely black background in our images. When we use flash as the main light and shoot at a high shutter speed, say the sync speed of 1/250 second, the background is very dark. Use the language of stops to think about it. Say the normal exposure for the background required a shutter speed of 1/4 second. Going from 1/4 to 1/8 to 1/15 to 1/30 to 1/60 to 1/125 to 1/250 is a movement of 6 stops! Our background is 6 stops underexposed! That's dark. Real dark. Black, in fact.

In the Manual exposure mode, use your selection of shutter speed, and in Aperture-priority use your ambient exposure compensation control, to set the background as you see fit. Student pilots are frequently cautioned by their instructors: "Fly the airplane, don't let the airplane fly you." It applies to your close-up photography just as well—fly the camera—make it do what you want it to do! In other words, take control.

Again, taking a lesson so to speak from students, law students are incessantly taught to "apply the law to the facts" when

analyzing a case. Here again, we too can learn. We'll get splendid close-up images if we *apply the equipment we have and the methods we know to the results we want.*

ADD CONTRAST WITH FLASH

Outdoor photographers know well that the low contrast light on a cloudy day is ideal for many close-up subjects and especially for flowers. Untold thousands of superb flower images are made every year under these splendid light conditions. Yet sometimes just a little more contrast adds a great deal to the image as it brings out more of the shape, texture, and detail. Flash is the perfect tool for adding a tiny sprinkle of light to enhance the contrast.

As we've done before, determine the optimum exposure for the ambient light. We'll say it again for emphasis—use either Manual exposure or Aperture-priority with the RGB histogram

Shaggy Mane mushrooms grow in damp spots during the autumn. They make fine subjects for photography and these two are especially handsome on a rainy day. The image is okay as it is, but sometimes a little contrast can improve their appearance and make them look more three-dimensional. Canon 5D Mark III, 180mm, 1/15, f/18, ISO 200, Cloudy. In part b, a Canon 580 Speedlite is held on the left side and above the mushrooms to create sidelight.

and highlight alerts for a good ETTR exposure. Now under-expose the ambient light exposure a little—perhaps 2/3s of a stop. Set the flash at zero compensation and position the flash to one side of the main subject. Try to the left. Try to the right. Try up. Now try down. Try placing the flash somewhat behind the subject to get a little of that dramatic rim-lighting, but be sure to keep the flash itself out of the frame. Back lighting will highlight tiny details along the edges of the subject and should the subject be at all translucent, back lighting can produce a lovely glow.

Irrespective of where you place the flash, if you like the result at all, then experiment with the *amount* of flash, using your FEC control to do test shots at different levels of flash between, let's say, +1 stop and –1 stop. Barb and I have found that when the ambient light is diffuse, adding just a pinch of light to slightly increase the contrast is highly effective when from the side or from above or behind. Don't overdo it, though!

SHUTTER SPEED CONTROLS THE AMBIENT EXPOSURE

Once more, we're repeating a concept because it's important —and because beginners often have trouble understanding why fiddling with the shutter speed changes the background exposure and not the flower exposure. Using automatic through-the-lens flash metering, the flash output is adjusted using the flash exposure compensation control (FEC). The FEC is set to pleasingly expose the subject with the chosen camera settings—perhaps ISO 100, f/16, and a shutter speed of 1/30 of a second. Once the optimum flash exposure for the subject is determined in the usual way with the histogram and highlight alert, the shutter speed is irrelevant for the flash exposure. It's because the duration of the flash burst is on the order of 1/1000 of a second or even less in a lot of close-up work due to the closeness of the subject. The flash burst comes and goes so fast, that when the flash is the main light, the exposure on the flower is determined by the flash metering system irrespective of the shutter speed as long as the shutter speed is fast enough to prevent exposure by the ambient light.

The flash provides the main light on the flower, but usually it can't light up the more distant background due to the Inverse Square Law. Therefore, when using Manual exposure, selecting a faster shutter speed reduces the ambient light exposure of the background. Slowing the shutter speed—changing from 1/4 second to 1/2 second—increases the background brightness. Neither changes the flash exposure on the subject because it is controlled by the FEC.

APERTURE-PRIORITY EXPOSURE OR MANUAL EXPOSURE?

Both modes work well in close-up photography. It's up to the user. Aperture-priority is good for those who struggle with the concepts of shutter speeds and lens openings or the language of stops. Just set the f/stop most suitable for your desired DOF and the camera will select the shutter speed for an average exposure. If the shooter needs to adjust the exposure because the subject is not average tonality, but is brighter or dimmer, or they wish to alter the brightness of the background, then the shooter uses the camera's exposure compensation control to add or subtract light. Again, for the umpteenth time, remember the necessity to shield the viewfinder eyepiece from allowing light entry. Barb uses this method consistently by using one hand to shield the viewfinder eyepiece (not actually touching the camera) and the same hand holds her remote release and fires the camera. Her other hand holds the flash. It works well for her.

While I have little control over Barbara's methods, I at least can define my own. I much prefer to use the Manual exposure mode because I can so easily and quickly juggle my controls by this many stops or that. Stop-think (the language of stops) is so ingrained in me that I don't have to agonize over this many stops or that while I'm working with them. That's why I so strongly urge my students to use stop-think over and over until it is second nature.

It is efficient to set up a camera to offer the most natural and fastest presentation of dial direction and exposure indicator direction. I've done that, and I suggest you do, too. I've set all of my controls to operate in 1/3 stop increments. As a

result, I can add or subtract whatever light the subject demands merely by counting the clicks of my dials. If I need to subtract 1 2/3 stops of light without even taking my eye from the camera, I just rotate the shutter speed dial in the correct direction to increase the shutter speed a total of five clicks and there I am! My eye is to the viewfinder when I'm working, thus blocking ingress of stray light, so I don't have that to worry about. Finally, if I need to compensate an exposure, I don't have to bother finding and operating a separate exposure compensation dial. I'm already managing shutter speed and aperture by watching the exposure meter indicator, so all I need to do is set the indicator to a different reading—a little this way or a little that way—with the controls I'm already using. My Canon exposure scale has the plus side on the right and the minus side on the left, which makes perfect sense if you consider the histogram. Plus, I used a custom function that Canon calls Dial Direction during TV/AV—to reverse my dial direction, so adding light, either with the shutter speed or aperture dial, is simply done by turning the dial to the right (clockwise) as viewed from the camera rear. It's all so very simple—so very fast—so very intuitive—it is puzzling why everyone isn't doing it. It only takes a little practice!

SIDE LIGHTING AND BACK LIGHTING

Using flash as a main light is the best way to add strong side light, or perhaps strong back light, to a subject. Sometimes with flat subjects, like leaves, feathers, and butterflies, a stop or so of ambient underexposure along with a proper side lighting flash exposure is terrific for revealing texture and other surface detail. Even with only one flash, the contrast isn't too high because of the ambient exposure that serves as the fill light.

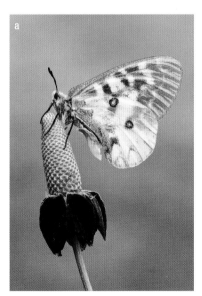

Let's do a light study with this cooperative Rocky Mountain Parnassian. In part a, only natural light is used. It is okay, but we feel the image is stronger by using main flash to light it as shown in part b. Even better, use the main flash behind and above the butterfly to back light it as seen in part c. Some photographers like black backgrounds, but we don't. It is easy to do as you see in part d. Simply increase the shutter speed enough to underexpose the ambient light by at least 5 stops of light and then properly light the butterfly with flash. If the background is a couple of feet behind the subject, the light fall off from the flash produces a very dark or totally black background. We prefer color in the background and don't like the harsh light created by a single flash when used as the only light source. We also don't care for the dark areas of the subject—antennae and legs—merging into the black background. Flash is such a valuable photo tool that we use it for a portion of the light in at least 75 percent of our close-up images. Canon 5D Mark III, 180mm, 1/5, f/20, ISO 200, Cloudy. Flash is used to shoot parts b, c, and d. The only exposure control that changed happened in part a when the shutter speed is made faster to underexpose the ambient light by 1 stop of light and in part d when the shutter speed is increased from 1/5 second to 1/160—a change of – 5 stops of ambient light, but has no effect on the flash output.

Back light can bring a dramatic and lustrous glow to some subjects. Occasionally it doesn't work well on opaque subjects, although even there it can produce nice rim light. But if the subject is at all translucent, back light does a terrific job of revealing detail while making the subject itself appear like a light source. Many close-up workers would benefit from using back light more than they do. It's a superb technique for lethargic butterflies that in the early morning are too cold to fly away. Look for them in a dewy meadow early in the morning anytime the ambient temperature is below 55 degrees Fahrenheit (F).

BALANCED FLASH

The term *balanced flash* is used to describe a situation where a portion of an image is illuminated mainly by ambient light and another portion of the image is illuminated mainly by flash. A good example might be found in a meadow early on an August morning. Imagine encountering a dew-laden dragonfly in the shade of a tree, but with a background of sunlit blue sky. You're fluent in stop-think, so your very first thought is not about being late for your wedding scheduled in a couple of hours, it's that the light on the dragonfly is several stops under the bright blue sky background. It's a high contrast scene that just might exceed the dynamic range of your sensor. Your impending honeymoon probably means that waiting for an overcast day isn't on the cards, so you need a more immediate means of lowering the scene contrast. Enter balanced flash!

You can't think of an easy way to darken the sun, so you opt to brighten the dragonfly. It's not very complicated. Set your camera up for either Manual exposure or Aperture-priority. As you've done many times, use your RGB histogram and your highlight alert blinkies to find a good exposure for the sky. Choose an exposure that produces a pretty blue sky. Since the sky has little contrast or detail, it does not need to be exposed according to the ETTR exposure guidelines—it can be darker.

Now that you have a pleasing blue sky background, you'll notice the dragonfly in the shade is severely underexposed.

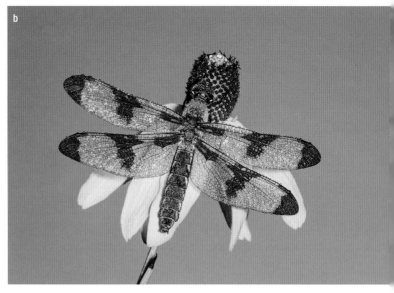

This is a good time to use balanced flash. The sleeping Twelve-spot Dragonfly is still in the shade on a cool morning. The background is the much brighter sunlit blue sky. Expose for the sky and the dragonfly is severely underexposed as shown in Part a. Expose for the dragonfly and the blue sky is hopelessly overexposed. There is no way to expose both well with ambient light unless the sun also lights the dragonfly. Remembering the sun in our camera bag—the flash—we set the ambient exposure for the sky and then use automatic flash and the FEC control to properly light the dragonfly. Part b shows how the flash balances out the difference in light between the dragonfly and the sky. It is a powerful technique that all close-up shooters must master! Part a: Nikon D3, 200mm, 1/100, f/22, ISO 200, Cloudy. Part b: the only change is the light being added with a Nikon SB-800 and + .7 FEC.

That's easy to fix! Turn on your flash with the FEC control set to zero, point the flash at the dragonfly and shoot a test image. Use the histogram and highlight alert to expose the dragonfly according to the ETTR guidelines. Study the image on the LCD monitor to see how the dragonfly compares to the background. If too dark, add +1 or so with the FEC, or if too bright, then try −1 stop or so with the FEC. Try another test shot, and, if necessary, continue until you like the balance between the dragonfly and the sky.

If you're using Aperture-priority, be sure to compose the subject well before starting the procedure. If you change composition between making the background exposure and the dragonfly exposure, the underlying exposure may change, thus corrupting your test shots. This is not a problem in the

Balanced flash is usually used to light a dark subject in the foreground because the background is bright. This white morph Indian Paintbrush is the opposite situation. When the white flower is properly exposed to retain detail, the darker red flowers in the background become nearly all black as you see in part a. Use wireless flash (part b) and hold it close to the Paintbrush in the background to light them up and balance the white blossom with the dark red ones behind it. Part a: Canon 5D Mark III, 180mm, 1/80, f/14, ISO 100, Cloudy. Part b: the only change is flash is used to light the background and the FEC is set to +1.

Manual exposure mode. It is just one more reason why Barb and I so often prefer the Manual exposure mode.

To summarize, in the dragonfly example we used our LCD display to view the image after it was shot to make the background a pretty blue while ignoring the exposure of the insect. Then we caused the insect to be properly exposed by adding flash and by adjusting the flash exposure with our FEC control until we were satisfied with the balance between subject and background.

COMPENSATING FOR DARK BACKGROUNDS

Suppose that instead of the bright background we just discussed, we find the opposite—a background a few or more stops below the dragonfly, butterfly, caterpillar, or whatever. The exact nature of the main subject is unimportant. What's important is how to achieve a balance between the subject and a darker background. We concluded before that we couldn't darken the sun, so it's logical to realize we probably can't brighten it either. Nor, generally, can we brighten the background with flash or other photographer-supplied light because the backgrounds are too large, or too far away, or both. And yet, sometimes you rule! Suppose you come across a fine looking group of light-colored fungi growing on a tree trunk. The background is another tree, about 6 feet beyond the subject fungi, and that tree has a dark bark. To properly expose the fungi, you use the ambient light, with or without a fill-flash to fill the shadows. Then, you put a flash in position to illuminate the dark tree in the background. Use the FEC control to adjust the background exposure for a pleasing balance with the fungi. Having your ever-patient shooting companion hold that second flash, or perhaps employing a light stand while using optical or radio wireless flash makes it all very easy.

CAMERA-MOUNTED FLASH

Many a close-up photographer has acquired a flash bracket to attach the flash to the camera, or has acquired a lens-mounted macro flash system. These latter systems hold one or two flashes arranged near the front of the lens. These flash setups typically allow the flash heads to be positioned at different angles, allowing more lighting options than a hotshoe-mounted flash.

We own and use two different lens-mounted flash systems. I've had success with Canon's Macro Twin Lite MC-24EX, and Barbara does equally well using her Nikon R1C1 wireless optical close-up system. Although we prefer handholding the flash so we can move it to different positions as quickly as possible, handholding the flash requires that the camera be supported on a tripod. We have seen people handhold both the flash and the camera, but it looks awkward and unappealing. I did try it once and discovered I could not point the flash perfectly while holding the camera, too.

If you are determined to shoot handheld, then one sort or another of on-camera flash mounting is the way to go. Handholding with dedicated lens-mounted macro flash setups is certainly more convenient when stalking leaping grasshoppers and flitting butterflies.

Bracket-mounted flash setups are also very effective when you can't use a tripod. Many butterfly houses showcasing exotic specimens are adamant in banning tripods because everyone is in close quarters and the tripods are at least an impediment if not a downright hazard. Beyond that, some subjects are too active to stalk with a clumsy tripod-mounted rig. Handholding is not a good idea when using ambient light because the generally long shutter speeds engender soft images. But, if using flash as a main light where the bulk of the illumination comes from the flash, the very short flash duration of 1/1000 second or so, a mere millisecond, will effectively freeze the subject's motion and minor camera movement to give sharp images. Even when shooting at a sync speed of 1/200 second or so, it's the flash that's doing the lighting. Moreover, if additional flashes are used, then the burst duration of each of them is reduced, and they may be firing at an extremely short 1/5000 second or even less. Regardless of the exact flash duration, when the motion of a photogenic but wriggly-wiggly bug is frozen by a high-speed flash burst, Barb and I always sing a couple of celebratory choruses of "Freeze a jolly good fellow!"

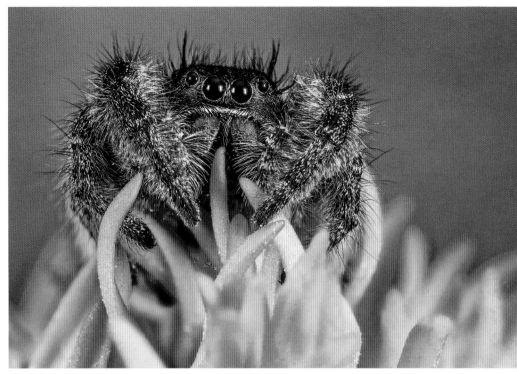

Many camera systems offer a macro flash setup like the Canon Macro Twin Lite MT-24EX or the Nikon R1C1. The Canon MT-24EX pictured here has two small lights that can rotate around the circular flash holder and they can tilt in or out to change the lighting angle. The light output from each flash can be varied to provide lighting ratios. We use the Nikon and Canon system and they work fine. They are especially good at high magnification and when it is necessary to shoot handheld.

The dual flash setup nicely lights the jumping spider. While using a tripod, thirteen images are shot where the focus is varied slightly between them. These images are combined with Helicon Focus to achieve extreme depth-of-field that is not possible in any other way. Canon 5D Mark III, 65mm macro, 1/8, f/11, ISO 400, Flash WB, flash from the Canon Macro Twin Lite MT-24EX.

There are some serious considerations involved in handholding a camera with either a lens-mounted or bracket-mounted outfit. Sharp images require that practically all of the light stimulating the sensor must come from the flash to reap the benefit of the flash's speed. Too much ambient light, even at the high sync speed of 1/200 or so, can often cause ghost images or lack of sharpness. Where the ambient light is low, and where the background is somewhat behind the main subject, our old nemesis, the Inverse Square Law, can easily cause a black or very underexposed background. Most practitioners find black backgrounds to be undesirable, especially for subjects usually found in daylight, like butterflies.

Occasionally that's not a problem. Consider a beetle strolling along on the light-colored sand. The sand is so close to the subject that light falloff is negligible, and both subject and background can be properly exposed.

It's hard to focus during handheld shooting because of the very limited depth-of-field characteristically encountered in close-up work. Focusing handheld is nearly impossible when shooting at magnification ratios higher than life-size. Due to that DOF issue, it can be critically important to get a precisely parallel alignment of the subject plane and the sensor plane to minimize the DOF requirement, and that's hard enough to do on a tripod, let alone by handholding!

One nice attribute of flash brackets is the possibility of mounting two flashes on them, which then allows you to vary the

light ratio between them to get a more attractive lighting. For example, if you have two flashes, one on each side of the camera, and you set one flash a stop down from the other, you get a lighting ratio that introduces soft shadows helping to reveal subject shape. Flash brackets, regardless of mounting, are nowhere as fast to use as a flash held in your hand.

What if you want to back light a nice fuzzy milkweed? Flash brackets generally permit some movement of the flash, but to my knowledge none readily permits back lighting, always easier to do when the flash is not camera-mounted!

Barb and I don't often use our dedicated flash brackets, but they're sure a lot better than nothing in circumstances where the tripod is banned, too awkward to use, or where its bulk alarms wary subjects. Many beginning close-up shooters shun tripods because they're heavy, they're expensive, they're awkward, they're ugly, etc. etc. etc., but as I've said in an earlier chapter, tripods are often described as photography's most important accessory. We believe that, and hope that either you do, or you quickly come to believe it.

SHOULD THE FLASH BE DIFFUSED?

A single flash can produce a very harsh, high-contrast light. Size and distance are two influencing factors. All else being equal, large lights produce softer light than small lights. Closer flashes produce softer light because the closer the light, the larger it is relative to the subject. A small camera-mounted flash can be large indeed, especially when positioned only a few inches from a little spider.

Sometimes photographers soften their flash output by attaching a diffuser, or a soft-box, to their flash. Whether you do that, too, depends on whether the flash is a main light or fill light, what exposure is being allowed by the ambient light, the size of the flash lens, the flash to subject distance, and of course, what you want the image to convey to the viewer. You'll get better and better at those decisions as you become more experienced. Any diffusion device will attenuate the light from the flash to some extent, but the camera's automatic TTL system will easily compensate for it. That said, we seldom diffuse the flash because we nearly always mix ambient light and flash together and may use more than one flash at the same time. These multiple light sources make it easy to control the contrast without diffusing the flash.

CONCLUSION

About 75 percent of our close-up images are made with some flash, and we use it, albeit less often, in both wildlife and landscape work. I hope you've gleaned from this chapter that we consider it enormously important to us and, in turn, to our students. It's especially valuable in close-up work. The effective use of flash takes some understanding and practice, but it is well worth both. Done well, flash illumination will considerably improve most, if not all, of your close-up images. The versatility that flash can bring to your close-up photography is probably greater than you presently realize, but as you use it more and more, you'll even hit upon new and effective ways to use it. Enjoy the journey!

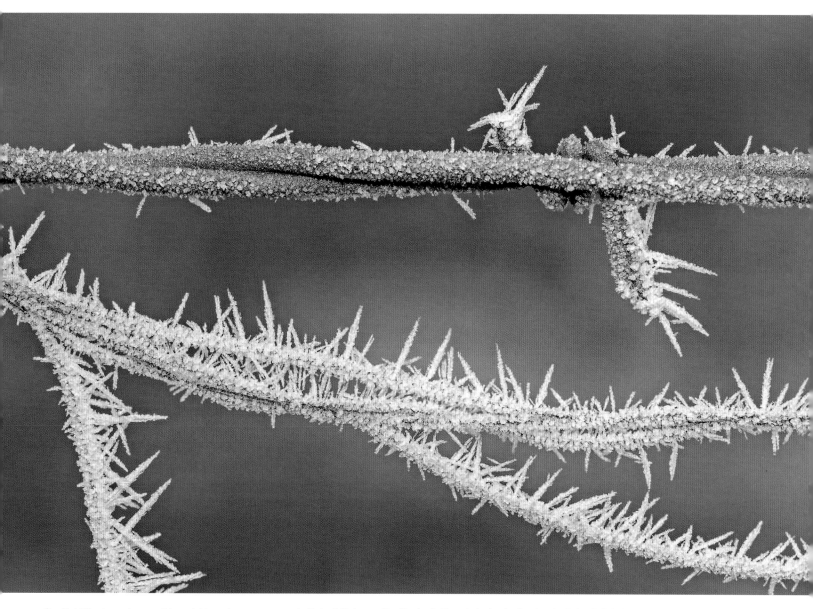

One frigid March morning everything outside our home was covered with frost. Barbara noticed the frosted horsehair adorning the strands of wire. A slight, but persistent breeze was blowing, so Barbara had to capture the subject in a single image during a lull. The ambient light was underexposed by two-thirds of a stop to darken the background. Electronic flash provided the main light to properly expose the frosty fence and the hair while not brightening the background. Nikon D4, 200mm micro, ISO 640, f/18, 1/100, Cloudy WB.

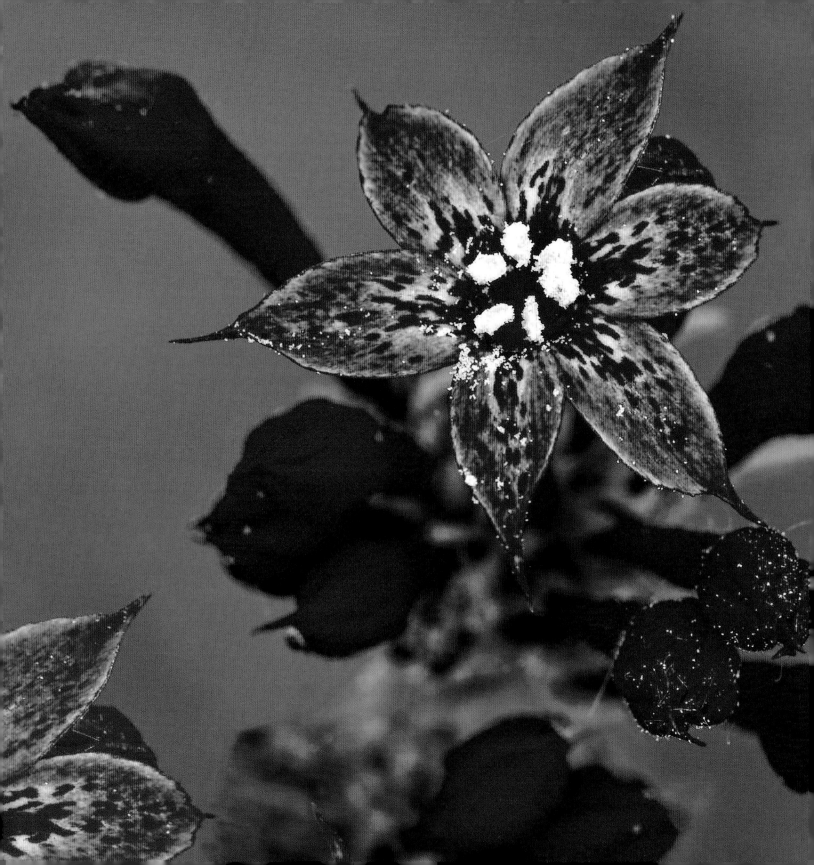

6

Photographing Flowers

Flowers may entice more shutterbugs into the magical world of close-up and macro photography than any other subject. Both cultivated and wildflowers offer endless opportunities for producing images with their kaleidoscope of colors and appealing shapes. They are readily available during all seasons of the year. Even during winter when the snow halts the growing season, potted flowers readily thrive indoors where they are easy to photograph using diffused window light, reflectors or flash, and artificial backgrounds made from photo prints or colored matte boards.

Wildflowers are especially fun to discover and photograph. While many species are abundant for long periods of time, other "shy" wildflowers—especially wild orchids—grow in extremely restricted habitats and bloom in small numbers for short periods of time. They are challenging to find because their unique habitat of acid bogs and swamps where many species thrive is often hidden from casual observation. It is such a thrill to finally discover a small colony of Arethusa, Showy Lady's-slipper, Yellow Lady's-slipper, Ram's-head Lady-slipper, Grass-pink, Rose Pogonia, or Calypso orchids. All are incredibly photogenic.

One convenient aspect of wildflower photography is that once you find them, usually they can be found year after year in the same spot at the same time of the year. For example, over the July 4th weekend we know places in Michigan's Upper Peninsula where small colonies of the magnificent Showy Lady's-slippers thrive. Some wildflowers, however, vary their blooming time. I remember exploring a thriving colony of rarely seen Painted Trilliums in eastern Michigan near Port Huron on

The Plamp is attached to the long stem of this Scarlet Gilia to hold it still. Canon 7D, 180mm, 1/1.7, f/14, ISO 100, Cloudy, fill-flash.

Tulips make pleasing images and photographing them helps you perfect your close-up photo skills. Nikon D3, 200mm, 1/5, f/22, ISO 200, Cloudy, Aperture-priority.

Michigan Nature Association property that were blooming in mid-May. When I returned the following year at the same time, the trilliums were still in tight bud. Apparently, a colder than normal spring delayed their blooming time by two weeks!

Over thirty-five years of doing nature photography as a profession, the common advice we heard was "don't bother with wildflowers because everyone does them. The market for wildflower images is saturated and you simply can't sell enough images to make it worth your time and expense." However, we found images of wildflowers were tremendously profitable and worthy of our time. Besides, we love looking at and photographing flowers. It never mattered if their images earned us a paycheck or not, for we find them fun and challenging to photograph, and so we seek them out. In fact, we have never photographed anything simply to make money. We always follow our passion and photograph what interests us. The income from these efforts is more like a fringe benefit. Perhaps, if you photograph what really interests you, the images are naturally better because you expend more effort and thought to do them well.

SOMETHING EXTRA!

Everyone can "sneak" up on a wildflower and most of us have no trouble finding them. Although wildflowers are relatively easy to find and approach, they are not necessarily easy subjects to photograph successfully. Wildflowers and cultivated flowers both demand superb photography technique, a creative eye with a knack for composition, and the ability to find *something extra* in the flower.

What is *something extra*? A pristine flower blossom is richly colored and nicely shaped. No tears, dirt, insect bites, or decayed parts mar the blossom. It makes a lovely image—true—but it does not have that *something extra* that is so vital to a truly fine image. Here's a short list of flower shots that have something extra.

- A grasshopper perched on the flower
- A bumblebee sleeping under the petals

- Dew or raindrops sprinkled all over the flower
- A yellow crab spider hiding in the blossom waiting for prey
- Frost on the flower
- The red ball of the rising sun behind the flower
- Complementary colors from other flowers in the foreground or the background

All of these examples provide that added boost that can make a truly compelling flower image.

HOW DO YOU PHOTOGRAPH FLOWERS?

Let's describe how not to do it first. Take a 50mm macro lens and shoot handheld on a breezy day in bright sun. Photograph as many blossoms as you can as quickly as possible while using Aperture-priority or the Program shooting mode. You will capture plenty of images this way. Your friends may say your photos are wonderful (they are just being kind or don't have the eye for quality images), but the quality of the images is dismal. The pictures suffer from severe lack of sharpness (blurs are great at times, but not all of the time), the light is unappealing with too much contrast, the exposures vary from too light to too dark, the background is chaotic and unappealing, and the composition is underwhelming.

Instead, use a shooting strategy that consistently guarantees quality images. Let's outline the one we use, but feel free to modify it to fit your budget or shooting style. Our *shooting strategy* has been modified over the decades as new techniques become available and continues to gradually evolve as we constantly gain experience. Sometimes one of our gifted workshop clients says something that becomes tremendously helpful and leads us down a new path. As full-time photography instructors, we welcome the opportunity to learn from our clients while teaching them—a win-win for everyone.

VISIT THE WILDFLOWERS WHEN THE WEATHER IS FAVORABLE

There is little point traveling to the wildflower meadow when you know the wind is blowing hard and the bright sun is creating too much contrast, unless, of course, you are merely

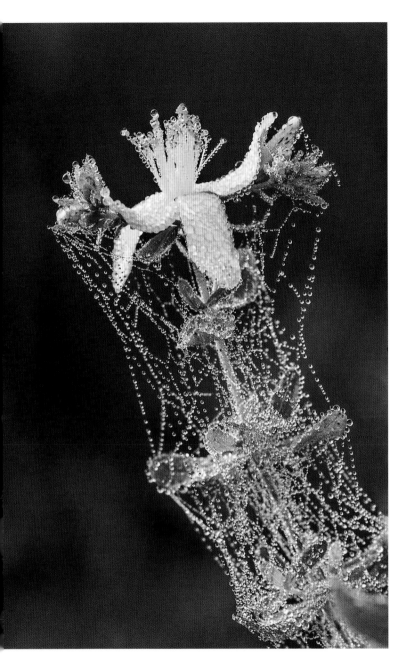

The spider web that is being supported by the Common St. Johnswort is a lovely "something extra" that makes this flower even more appealing. Nikon D3, 200mm, 1/15, f/13, ISO 100, Cloudy.

We dislike this image because the light is far too high in contrast and the badly lit yard in the background is distracting. How do we make this flower look better? Nikon D4, 200mm, 1/200, f/16, ISO 400, Cloudy.

Let's move the potted poppy to make it easier to isolate against the sunlit lawn and bring the camera closer to the subject to reduce the amount of background. Finally, a sprinkler adds "rain" to create more interest in the image. Nikon D4, 200mm, 1/160, f/16, ISO 400, Cloudy.

scouting for potential subjects. Plan to visit during calm periods—usually early or late in the day. A bright overcast day, however, can be calm and may offer terrific light all day long. Early morning or late evening red sunshine works well, too. If the sun is shining brightly in the meadow, be aware there is a one- or two-hour period before sunset where the flowers may be illuminated by soft light because trees or perhaps a nearby hill blocks the bright sun.

PHOTOGRAPH THE BEST SUBJECTS

Spend some time looking for the most attractive flower blossom or the best group of flowers. Also, key in on any *something extra* possibilities. If an insect, water drops, frost, or a "cute" spider happens to be perched on the flower, so much the better. Perhaps a certain blossom is found in a spot where the background is especially attractive or easy to completely blur to remove all distractions.

SELECT THE VIEWPOINT

Select a viewpoint (shooting angle) that allows a fine composition of the subject. Consider the foreground and the especially important uncluttered background. Make sure there is a clear shot in the foreground without obstacles being in the way—unless selective focus is desired—and the background is not distracting. Sometimes the direction of the light suggests the best shooting direction. For example, if you plan to highlight the translucent parts of the flower, you must use back light and shoot toward the light. Remember flash can be used easily to create back light any time you want it to.

USE A LONG FOCAL LENGTH LENS

We use Canon 180mm and Nikon 200mm macro lenses on a tripod nearly 100 percent of the time for photographing single-flower blossoms. As previously stated, the advantages of long focal length lenses are worth repeating. These long lenses have a narrow angle of view for simplifying the background, much more working distance than shorter lenses, and each

LEFT: Always look for multiple compositions when you find an attractive subject. This backlit close-up of a tulip has pleasing lines and shapes. Nikon D3, 200mm, 1/30, f/22, ISO 200, Cloudy.

TOP: It is effective to isolate a single blossom against others of its kind such as this tulip. Nikon D3, 200mm, 1/400, f/8, ISO 200, Cloudy.

lens has a built-in tripod collar that balances them better on a tripod and makes vertical images easier to shoot. By the way, some photographers use the terms *working distance* and *focusing distance* interchangeably. They are not the same. We consider the working distance to be the distance between the subject and the front of the lens hood. Focusing distance is always a greater distance because it is the distance between the subject and the camera's sensor when the subject is precisely focused.

USE A TRIPOD

Support the camera and lens on a sturdy tripod. The tripod allows the use of all shutter speeds, especially the commonly used ones in the 4 seconds to 1/15 of a second range. The tripod locks in the composition, allowing you to wait for the subject to become motionless if a persistent breeze is challenging you. Since the tripod supports the equipment, the photographer's hands are conveniently freed up from this duty. Now a flash, reflector, or diffuser can be held in position with one hand. The other hand can trip the shutter using a remote release while simultaneously shading the viewfinder to eliminate the light through the viewfinder problem when using any automatic exposure mode. Shielding the viewfinder isn't necessary when using Manual exposure.

Study Barbara's flower technique closely. She is using a small shovel that is pushed into the ground to hold the Plamp that is gently stabilizing the orchid. She trips the shutter using a cable release with her right hand and holds the wireless controlled flash in the proper position with her left hand to photograph the orchid. Canon 5D Mark III, 24-70mm at 58mm, 1/8, f/20, ISO 100, Shade.

We looked at several individuals before deciding this is the best looking Northern Bog Orchid growing in the roadside ditch. Nikon D4, 200mm, 1/8, f/22, ISO 100, Cloudy, −1 fill-flash.

ATTACH A PLAMP TO THE FLOWER STEM

Even when the air is totally still, it doesn't take much to make the air move enough to cause an unsharp image when using slow shutter speeds of 1/60 of a second or slower. Even moving your arm stirs the air, which can make a motionless flower suddenly begin to sway ever so slightly. Use a plastic electric fence post (about $3), small tripod, or flash stand to support the Plamp, and put it close to the subject. With one end of the Plamp attached to the stand support, attach the other end of the Plamp to the flower stem as close to the blossom as

possible, but keep the Plamp out of the image. Be cautious, though, as some flowers have delicate stems that are easily crushed. In that case, there are holes in the Plamp's flower clamp for the stem to go into to avoid crushing it. With especially delicate flowers, it is highly effective to push the Plamp's clamp up against the stem to apply some pressure to it without actually gripping the stem. Anyone who damages a flower with a Plamp isn't using it correctly!

USE MANUAL EXPOSURE

Set f/18 to obtain adequate depth-of-field, ISO 100 or ISO 200 to avoid digital noise in the image, and manually adjust the shutter speed control to the zero point on the exposure scale that appears in the camera's viewfinder. Shoot the image and check the RGB histogram to see if any of the color channels are touching the right wall of the histogram. If not, add more light by slowing the shutter speed and shoot new images to view the histogram until it does. If the histogram data is climbing the right wall, it means some highlights may be clipped and highlight detail might be lost. Reduce the exposure by increasing the shutter speed and shoot another image to check the new histogram. Remember, the goal as a RAW shooter is to snuggle the rightmost histogram data up to the right wall and even climb it a tiny bit. For JPEG shooters, make sure the rightmost histogram data stops a little shy of the right wall.

PRECISELY FOCUS THE FLOWER

Focus accurately by looking through the viewfinder, or better yet, use Live View and scroll the focusing box over to include the most important part of the subject and magnify that area. Usually an important spot on the front of the flower is selected. Now manually focus the lens. When you shoot the image, the lens stops down to produce more depth-of-field in front of and behind the focus point than you see in the viewfinder or LCD display. This makes the flower look acceptably sharp. If the subject is completely still and will remain so for a minute or two, then the awesome focus stacking technique can produce superb sharpness that completely covers the entire depth in the flower. We will discuss focus stacking shortly.

The frost nicely edges this larkspur on a cold June morning. The yellow sun figure shows precisely where we manually focused the lens using a magnified Live View image. This image is taken in 2010. Today we would use f/11 and shoot a focus stack of images. Canon 7D, 180mm, 1/6, f/16, ISO 100, Cloudy, fill-flash.

USE A FLASH

Even when the light is thoroughly diffused, some shadows underneath the blossom may still be unacceptably dark. Once you determine the optimum exposure for the ambient light, set the flash compensation control to –1.3 stops. Hold the flash close to the front of the lens, point it directly at the flower, and shoot the image. If the shadow detail looks fine, shoot some additional images. Vary the angle of the flash to the subject slightly to get different lighting effects. If the shadows are too dark, add more light with the flash by setting the flash exposure compensation to put out more light—perhaps –2/3 stop. This will open up the shadows by two-thirds of a stop. If the shadows are too light in the initial exposure, then set less flash exposure compensation (FEC), perhaps –2 stops of light. Continue to adjust the FEC amount until you arrive at the desired shadow density. Be certain that adding light with the flash doesn't overexpose any flower highlights by monitoring the histogram and the highlight alert!

Flash is effective for highlighting the flower while darkening its surroundings quite easily. It is a technique that we call *main flash*. Set the ambient light exposure to be 1 stop underexposed as shown by the histogram where the rightmost data retreats from the right wall by 1 stop of light. Now use positive (usually) flash exposure compensation—perhaps +1 stop—to properly expose the flower. You know when you have it perfect because no blinkies appear in the flower and the rightmost histogram data moves close to the right wall. Now the flash is the main light illuminating the flower and the background is 1 stop darker. To perfectly light the flower, be sure to monitor the histogram's rightmost data. Through-the-

This garden Dahlia is nicely isolated against the lawn. Canon 5D Mark III, 180mm, 1/3, f/16, ISO 100, Shade.

While the previous image is satisfactory, completely shadowless light can be boring. This version benefits from using a flash to nicely back light the Dahlia. Canon 5D Mark III, 180mm, 1/5, f/16, ISO 100, Shade, Canon 600EX flash.

lens flash can be a bit tricky if you try to use the same flash exposure compensation all of the time because the amount that is needed varies greatly as subject reflectance, the size of the subject, metering modes (Spot or Evaluative, for example), and the distance to the background come into play. Just this morning I did some main flash on flowers where I had to use –1 stop flash compensation—and the flash was the main light. Apparently, the distant background caused the flash to emit too much light when a positive flash exposure compensation was set. The flash was trying to light up the background and overexposed the delicate light blossoms in the foreground. I monitored the histogram to arrive at the proper –1 FEC setting.

If the ambient light is already sufficiently diffused and doesn't produce shadows, flash can be easily and quickly used to slightly and pleasingly increase the contrast. Underexpose the ambient light a little—perhaps by two-thirds of a stop— and use flash to produce a highlight and proper exposure on one side of the flower. Try pointing the flash at the rear of the flower to highlight it with light from behind. This is an incredibly effective technique that we use frequently. Using flash offers many creative choices and you'll get better at seeing the possibilities as you gain experience with its use. For most close-up and macro images, it is desirable to mix flash and ambient light together to avoid the flash look and to produce beautifully illuminated images. We do this for the vast majority of our close-up images.

WORK THE SUBJECT

Shoot as many stunning compositions of the subject as you can. Can the flower be leaned forward or backward to allow another background to be used? Can you select another viewpoint to allow the use of a different foreground or background? Can you add a splash of color to the foreground or background to complement the colors in the flower? Can you use a mister to add water drops to the blossom for added interest? Is the subject still enough to employ focus stacking to achieve maximum sharpness? Did you discover the best blossom that has *something extra*?

While back light is incredibly effective for all translucent subjects like this lily, it doesn't work well if the contrast is excessive. Canon 5D Mark III, 180mm, 1/400, f/16, ISO 400, Shade.

Flash nicely lights the flower while the natural sun back lighting continues to highlight the water drops. Only the addition of adding light with a Canon 600 EX flash is different.

Don't forget about the light. Does the subject need to be shaded or the light illuminating it diffused to lower the contrast? Should flash be used to fill in the shadows or create shadows? Does the subject stand out more if the ambient light is used as fill light and flash is the main light? Should ambient light be the main light, but flash be used behind the subject to add some backlit highlights? There are always many possibilities besides the obvious ones. As you gain experience, you will learn to see the ways you can modify things and do it quickly.

Have fun and be creative. Barbara set her camera to AutoGain to keep a good exposure and set the camera to multiple exposure. Using the collar on the lens, she focused on the flowers, took a shot, then rotated the lens within the collar and shot another image, and did it again for a total of five shots. Nikon D3, 80-200mm lens at 130mm, 1/60, f/20, ISO 200, Cloudy, Aperture-priority.

Barbara focused on the pink tulip. Once again she used AutoGain and set the camera to multiple exposure. She shot the pink tulip and then zoomed the lens to a longer focal length. She recomposed to keep the pink tulip in about the same spot and shot another and kept this up for several shots. Nikon D3, 200mm, 1/10, f/22, ISO 200, Cloudy, Aperture-priority.

BE KIND TO THE FLOWER

When you finish photographing, always unclamp the Plamp from the subject first. If the Plamp is still attached and you grab the Plamp support, you will surely damage the flower. Grab the tripod and carefully back away from the flower. During the entire photography process, always be aware of delicate plants that may be growing nearby. Be careful to avoid them. While most of us see the blossoms, look for plants that have yet to bloom. Don't trample them. We all must work to let our native wildflowers go to seed to produce a new generation for future viewers and photographers and to fulfill their role in the natural environment.

CONTROL THE BREEZE AND THE LIGHT

While we enjoy the wildlife and gorgeous natural views at our Idaho mountain home, living on a fairly steep mountain slope means the air is seldom completely still. Cooling air tends to

flow down the hillside, gently quivering our flowers. At times we can find completely still air by putting our potted flowers on the downhill side of our huge garage. The building blocks the flowing air. Sometimes this works perfectly and sometimes it does not. Not wishing to allow our flower photography on our property to be at the mercy of the weather, we decided to find a way to shoot close-up images anytime we want. It became crucial to find a way to effortlessly stop all breezes and modify the light.

We routinely use our small greenhouse to photograph potted flowers and other close-up subjects. When the door and all of the windows are closed, the air is completely still. White sheets completely diffuse the light producing an ideal environment for photography that is especially suited to focus stacking techniques. We use photos of out of focus natural scenes as backgrounds in the greenhouse, although at times, it is possible to open one of the windows or the door to use the forest or meadow behind it as the background. We have only had a greenhouse for a couple of years, but wished we had used them sooner.

FOCUS STACKING TECHNIQUES

WHAT IT DOES

Focus stacking software programs such as the hugely popular Helicon Focus and Zerene Stacker allow the capture of unlimited depth-of-field when the subject is perfectly still and remains still over a minute or two, the time needed to shoot the series of images. It is incredibly useful in close-up photography for mushrooms, flowers, frogs, berries, insects, water drops, and most other subjects. Although not the focus (pun intended) of this book, it is becoming widely used in landscape photography, too.

As you know, even at f/22, when you are photographing at the higher magnifications, the depth-of-field is very shallow and may only extend over a fraction of an inch. If the depth of the flower is 1 inch, there is no way to sharply focus every portion of the flower because the depth-of-field is simply too shallow, even at f/22. However, focus stacking allows you to sharply focus everything. It seems like magic, especially to photographers who have struggled with the limitations imposed by inadequate depth-of-field over the years. Now the impossible is easily possible. Shoot a series of images where the focus is varied a small amount in each image. Every part of the subject must be in sharp focus in at least one of the images. Load the entire set of images into a software program. When you run the program, it selects the most sharply focused parts of each image and combines them to produce a final image where everything appears in sharp focus!

HOW TO SHOOT SETS OF IMAGES FOR FOCUS STACKING

Select the Appropriate Subject

Since many images (often twenty or more) must be shot to cover the focus between the front and the back portions of the subject, it is crucial that the subject remain completely still. A motionless flower, dew-laden dragonfly, mushroom, and frog all work. A flower wiggling in the breeze or a caterpillar slowly crawling up a plant stem doesn't work.

Use Manual Exposure

The exposure must not change while shooting the sequence of images. Automatic exposure modes may change the exposure as you change the focus from shot to shot. Therefore, use Manual exposure to lock in the exposure. If you must shoot twenty images—for example—make sure the light doesn't change during this process. If it does, reshoot the series of images when the light remains steady. Determine the optimum Manual exposure in the usual way. To refresh your memory, use the histogram to guide you and set the exposure to make the histogram's rightmost data snuggle up to the right wall of the histogram if shooting RAW. If shooting JPEGs, then let the rightmost data approach the histogram's right wall, but not touch it.

Use f/11 Depth-of-field

Throughout this book, when maximum depth-of-field has been sought we have suggested you use f/16, f/18, and f/20. We encourage you to avoid stopping down any more than f/20 because the optical problem of diffraction becomes too detrimental with such small apertures, especially with lenses shorter than 200mm. Remember, diffraction is what happens to light as it passes through a tiny hole. Due to the wave nature of light, it bends or *diffracts* when light grazes an object. Diffraction happens at all apertures, but it is especially noticeable and therefore deleterious at tiny apertures, such as f/22 and f/32, because a high percentage of the light passing through the tiny hole is diffracted. Using f/16 to f/20 is a happy compromise between getting the maximum depth-of-field while still avoiding much of the diffraction problem—though not all of it.

The typical lens delivers the sharpest images when the lens is stopped down 2 to 3 stops from the wide-open aperture. If you have a 200mm f/4 macro lens, then f/8 to f/11 are superbly sharp apertures to use with that lens. Since running a stack of images through Helicon Focus, Zerene Stacker, or another focus stacking software program provides maximum sharpness for the subject, it is not necessary to use f/16 to f/20.

The frost on the Purple Coneflower is a pleasing bonus. At this magnification, it is impossible to get every part of the flower sharp unless one uses a wonderful relatively new technique called focus stacking. This final image is a result of combining twenty-three images with Helicon Focus. Canon 5D Mark III, 180mm, 1/2, f/11, ISO 100, Shade.

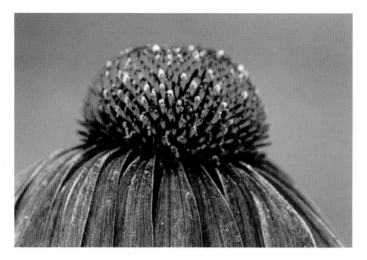

The focus is on the closest part of the blossom at the bottom of the image. This is the first image in the stack of twenty-three images.

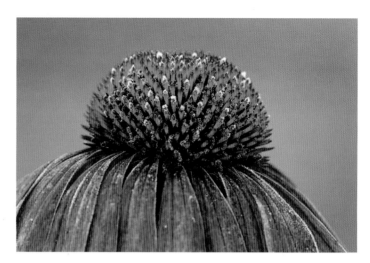

This is image #8 in the focus stack. The middle of the blossom is focused and both the front and rear of the flower remain out of focus.

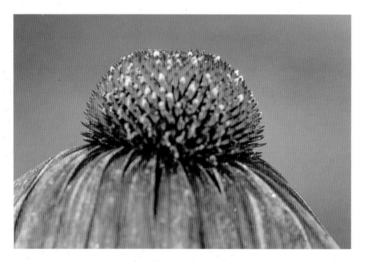

This is the last image in the stack where only the furthest part of the flower is in focus. Remember, in addition to the three images shown here, twenty other images are in the stack. Each image is focused on a slightly different part of the flower. Using a focus rail, or manually changing the focus on the lens, start at the front of the subject and keep changing the focus in tiny increments until the rear of the subject is finally in focus. Then combine the images into one with tremendous depth-of-field. It is easier to do than it sounds!

The image will be sharper if you select f/11, shoot a series of images (called a stack) that cover the area you wish to render perfectly sharp and then combine all of these images with the software to produce an ultra-sharp image.

FOCUSING THE SUBJECT

Use Manual Focus

Do not use autofocus. The focus must be controlled manually and adjusted from one shot to the next in very small increments. Begin by focusing on the closest spot where sharp focus is desired and shoot the image. Then focus a tiny bit farther into the subject and shoot another image by turning the focus ring on the lens a wee bit until you see the focus change a little. Keep doing this until the furthest spot where sharp focus is desirable is achieved and shoot this final image. In most cases in close-up photography, every part of the subject should be in sharp focus, but not the background. Landscape photographers often want everything from the near foreground to the distant background in sharp focus, so they might need to focus on the background. We find it works best to focus on the closest point where sharp focus is desirable and shoot our way to the rear of the subject because it is easier to see if the closest point is in sharp focus. Some may prefer to do the opposite and shoot the stack by focusing on the rear of the subject and shoot their way to the front of the subject. Either way works!

Turning the Focusing Ring

Focus on the closest part of the image that must be in sharp focus. Shoot the image. Turn the focusing ring the correct direction to focus the lens at a slightly greater distance and shoot another image. Do the focusing gently to avoid jarring the camera and tripod too much. Remember to keep the focusing increment small between shots. Turn the focus ring just enough to see the focus shift slightly past the previous image. Continue this process until the last shot taken is focused precisely on the part of the image that is furthest away where sharp focus is desired. To find these focus stacks quickly, it is wise to photograph your hand (doesn't need to be in focus) to mark the beginning and end of the stack of images. While it is easy to notice a set of images that are destined for focus stacking if you shoot only one series, it is much easier to find the end points when you shoot several series of images in a row by marking the end points with out-of-focus images of your hand. Obviously, all images between the two images of your hand are meant to be part of one focus stack.

Focus Rail

Another way to easily adjust the focus in small increments is to use a focus rail. This is a device that attaches to the tripod and then the camera is attached to it. The focus rail can be moved forward and backward over a span of several inches, depending on the model, in very tiny increments. When shooting a focus stack, simply adjust the focus rail in small increments to enable you to shoot a stack of images that cover every portion of the subject where sharp focus is desired. Some focus rails allow you to shift the camera from side to side, though this isn't useful when actually shooting the focused stack of images. Of course, side-to-side movement can initially help you obtain a desirable composition. However, we have little trouble setting the exact composition desired by adjusting the ball head that supports the focusing rail and the camera. Compose the image while setting the focusing rail close to the beginning of its focusing range. Focus on the closest spot in the image where sharp focus is desired.

Barbara sprayed Rain-X on a pane of glass and then wiped it off. Rain-X is sold at auto supply stores because it is used on windshields to make water bead up. Then she sprayed tiny drops of water on the glass which promptly beaded up and put a rose underneath the glass. She manually focused on the rose reflection in the water drops using a magnified live image and a Kirk focusing rail. Nikon D4, 200mm, 5 seconds, f/22, ISO 100, Sunny.

Shoot the image. Now turn the control on the focusing rail to make the camera move slightly (perhaps a millimeter or two) closer to the subject and shoot another image. Continue this process until the spot farthest away in the image where sharp focus is desired is captured. Using the focusing rail does change the perspective slightly because the camera moves closer or farther away from the subject. The software is able to compensate for these slight changes. However, focus stacking software can handle huge numbers of images—even more than fifty. The number of images that must be shot varies greatly. Larger subjects with a lot of depth require more images to be shot and so do subjects shot at higher magnifications.

DOWNLOAD

Move the images off the camera's memory card and download them to your computer's hard drive or an external hard drive (our preference). Select the images that make up a specific stack and transfer them to a folder that is titled *Focus Stacks*.

PROCESS

Using Helicon Focus

Open the Helicon Focus software program and open up File. Now press Load Project and a window opens up to allow this to be done. Look at the window on the right side of the screen that lets you find the images you wish to merge. When the file with the appropriate images is opened, check each image that you want to include in the stack. If you check one by mistake, simply uncheck it by clicking on the check box again.

Run

When all of the images are checked that you wish to include, press the Run button. The program begins to merge the images together. Depending on the number of images in the stack, the amount of time will take a minute or up to several minutes. When all of the images are merged, the final result will appear. You will be amazed by the amount of overall sharpness in the subject! Focus stacking is much better, in most cases, than stopping the lens down to the f/22–f/32 range for three important reasons:

1. Since you can use an aperture of f/8 or f/11, the image will be inherently sharper as these apertures are typically the sharpest ones on the lens because optical defects that are most problematic when shooting wide open or stopped down are minimized, though not completely eliminated, at the intermediate apertures of f/8 and f/11.
2. Every portion of the subject can be recorded in sharp focus. Using any aperture in a single image always means some parts of the subject with depth are less sharp than others, unless the subject is completely flat and the camera's sensor is perfectly parallel to the subject.
3. Shooting sets of images at f/11 to cover the subject still allows the background to be completely out of focus, which minimizes or eliminates background distractions. This is much better than stopping the lens down to f/22, which tends to reveal more background distractions.

Zerene Stacker

This is another outstanding focus stacking software program. It is especially effective at handling large sets of images. Tutorials describing how to use it are available on their web site.

Using stacking software to maximize the sharpness is an awesome new tool for all photographers and is especially useful in close-up and macro photography. Go to the web sites of the companies that offer stacking software and download their free trial software. The web sites for Helicon Focus and Zerene Stacker are listed in the Resources section of this book. You'll find that running a focus stack of images is quite easy to do. Even I was able to do it shortly after I downloaded the free trial version of Helicon Focus, and I am not the most computer literate person.

STACKING SOFTWARE OFFERS A HUGE NEW OPPORTUNITY

Sharply recording all parts of a subject has been desirable since the beginning of photography and impossible to achieve most of the time, especially for subjects that have significant depth and require magnification around one half life-size and greater. Stopping the lens down to f/22 or f/32 still won't sharply record all portions of a tulip, rose, frog, lizard, mushroom, or dewy dragonfly. When photographing at magnifications greater than 1/10 life-size, depth-of-field quickly becomes too small to fully cover the subject. Plus, keep in mind that the only area that is truly sharp is exactly where the lens is focused, areas of the subject that are only millimeters in front of or behind the plane of sharp focus are actually not quite as sharp, though they may look sharp to us due to the limitations of our vision. And remember that small apertures (f/22 to f/32 especially) lose sharpness because a high percentage of the light passing through a small hole is diffracted.

In the discussion on lenses, we talk about how tilt and shift lenses can change the plane of focus to coincide with the most important plane of the subject. The subject plane does not have to be parallel to the plane of the camera's imaging sensor. This capability does offer huge advantages at times, but it still does not let you record every part of a subject in sharp focus. Consider a field of flowers on a completely still afternoon with absolutely no breeze, and tilt the lens to make the plane of focus perfectly align with the plane of the flower blossoms across the field. Shifting the plane of focus by tilting the lens down makes it easier to sharply record the blossoms, but most subjects have other planes that should be sharp as well. Shifting the plane of focus on the field of flowers makes the blossoms sharper, but the vertical stems become less sharp because they are standing at close to right angles to the plane of focus. Wildflower photographers are willing to accept flower stems that are somewhat out of focus if the blossoms are sharp. Still, some portions of the subject remain soft.

This same field of flowers can be sharply photographed using the focus stacking technique. Of course, the flowers must be motionless for this to work perfectly. If you are being challenged with a steady breeze, the tilt-shift lens remains the best option by far because it allows you to align the focusing plane with the plane of the blossoms and a single image does the trick. A faster shutter speed helps to arrest slight movement caused by a light breeze because it isn't necessary to stop down as much—f/11 instead of f/22—for sharp results.

Photo stacking techniques are the only way to truly render everything sharp in the image. When you properly shoot a series of images of a still subject, every part of the subject, no matter how many planes exist in the subject, is rendered sharp. Only recently has photo stacking become widely known. Your authors heard of it a few years ago, but we did not look at it seriously until a few of our always brilliant workshop clients showed us their results during our 2012 Michigan summer workshops. Although we have taught these macro and landscape workshops since 1987, they showed us an entirely new way of doing things and created stunning images that we had thought impossible. We immediately began shooting sets of images to be combined and downloaded the software during the winter when we had time to work with it. The results were spectacular! We are now able to capture exquisite detail and sharpness everywhere in the subject, a feat previously not possible. The new digital tools that provide a way to do things that were never thought possible continue to open up new ways of seeing and capturing images.

Photo stacking software offers endless opportunities, if only we can see the possibilities. These opportunities multiply quickly, especially when you combine it with a couple of other magnificent digital tools—HDR and panoramic images. Imagine a close-up scene of a dense colony of mushrooms growing along a foot-long section of a decaying woodland log. Perhaps it takes five overlapping images—a panorama—to fully capture the entire row of mushrooms because they are depth-of-field hogs. Can you envision the opportunity of shooting five different overlapping images to make a panorama with many images in a single stack that are all focused slightly differently? Run each set of images through

photo stacking software. Then take the final result of each set of stacked images and stitch them together with panoramic software. Now you have captured the entire group of perfectly sharp mushrooms in a long horizontal image. Should there be a lot of contrast in the mushroom image—perhaps dark green moss on the log and white caps on the mushrooms—it might be necessary to shoot sets of images where the exposure varies to capture detail in all portions of the image to use with high dynamic range software (HDR) such as Photomatix Pro. It is

Bergamot is a small flower with a wonderful pattern (about 1x) in the middle of the blossom. Nikon D300, 200mm and close-up lens, 1/4, f/22, ISO 200, Shade, fill-flash.

possible to use HDR, panoramas, and photo stacking techniques together to make a single image. HDR handles the contrast problem, pan techniques let you capture a wide or tall subject, and focus stacking lets you achieve maximum sharpness. The possibilities and opportunities are endless. It is a whole new world for the close-up specialist!

Flowers are a delight to photograph and new technology has made capturing the exquisite colors and shapes of flowers far easier to do. Superb results will soon be yours if you have mastered the technology and have the patience to put it into practice. Enjoy your flower explorations!

Special Photo Techniques for Butterflies and Dragonflies

I've already mentioned some generalities of shooting butterflies and dragonflies, but let's supply considerably more detail now. I developed an intense interest in these insects while studying entomology—the study of insects—at Central Michigan University in 1975. That was four decades ago, but my interest in those fascinating flying flowers and delightfully dashing dragons continues to grow.

While butterflies and dragonflies can be quite challenging to success-fully photograph, they are at the same time interesting and fun. Both can make stunning images, and both are easy to find in their favored habitat during the warmer months. Insect species have distinctive life cycles. Some require specific habitats, others need specific plants or food, and some species need both. Some fly only a week or two, giving a narrow window of opportunity for photographers. Others, such as the Monarch and Mourning Cloak, live for several months over a wide range of habitats, so they're much less challenging to find.

One difficulty making butterflies challenging photographic targets is that they are most active when ambient temperatures are warmer than 60 degrees Fahrenheit (F). When temperatures are warm, many are wary, elusive, skittish, and hard to approach. Another downside to their favored flight times of mid-day hours is that the bright sun creates harsh shadows and hard-to-tame contrast. This may force the use of flash, as

Weidemeyer's Admiral rests on a blossom in our garden. Nikon D4, 200mm, 1/5, f/20, ISO 200, Sun, Aperture-priority, fill-flash.

reflectors are difficult if not impossible to employ on a fast-flitting and fluttering butterfly. Also during those hours, breezes commonly make the butterfly's fragile roosts and perches wiggle and wobble. This complicates the task of getting sharp images, especially when the shooter is striving to achieve fairly parallel alignment of the butterfly wings and camera sensor.

Have I discouraged you? I hope not, because we will reveal many strategies that will actually make butterfly photography enjoyable as well as productive.

I grew up in the beautiful state of Michigan, which abounds with over 125 species of butterflies. Many species are plentiful during their flight season, especially in the northern portions of the state where light farming results in lower insecticide use. Therefore, butterfly populations are more robust. Some butterflies such as the Green Comma that overwinter as adults in brush piles begin to appear in Michigan during March, and some are still flying on chilly October days. Yet most species have more limited flight tenures of around a month, while still others fly a mere couple of weeks. As the year moves from spring through summer and into fall, the serious butterfly photographer must constantly look for new species.

Like many butterflies, this Green Comma is basking on rocks to warm up on a cool morning. Canon 5D Mark III, 180mm, 1/30, f/22, ISO 250, Cloudy.

Michigan is blessed with innumerable small inland lakes and surrounded by Lake Superior, Lake Michigan, and Lake Huron—each known as one of the Great Lakes for a very good reason. From the vast and chilly Lake Superior to the state's tiniest pond, their collective addition to Michigan's atmospheric moisture, combined with the commonly cool nighttime temperatures of Michigan's northern latitudes, often generates very heavy formations of dew. It's in the dew-laden meadows where plentiful specimens of some butterflies—Monarchs, Black Swallowtails, Bronze Coppers, Orange Sulfurs—and many other species roost at night.

A cold butterfly is a photographable butterfly! Butterflies, dragonflies, and other insects are cold blooded. Most are inactive at temperatures below 60 degrees F, and especially when heavily coated with large drops of dew. Incidentally, dew occurs when the air is calm and the air temperature drops to or below the dew point, which is the temperature at which air of a given humidity becomes saturated. Under those conditions, the lethargic butterflies may notice your presence, but they cannot flee. You usually have ample time to set up

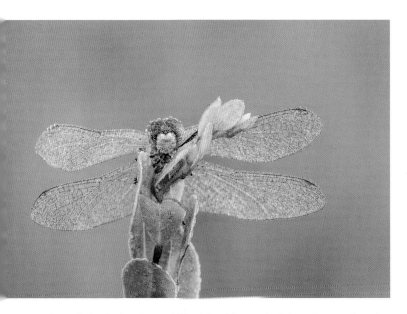

Remembering that insects are cold blooded and thus easy to photograph on a cool morning, this dew-laden dragonfly remained perfectly still for at least 30 minutes and did not begin to move until the sunshine warmed it. Canon 10D, 180mm, 1/1.4, f/16, ISO 100, Auto.

and shoot. Barbara and I have for decades enjoyed making images of dew-laden butterflies in the meadows around Munising in Michigan's Upper Peninsula. Year after year, our August workshop students, both first-timers as well as many repeaters, make many memorable butterfly images during the crack o'dawn field trips to the nearby meadows.

HOW TO FIND BUTTERFLIES AND DRAGONFLIES

Certain species of stunning butterflies and dragonflies like to roost on the shrubs, grasses, and flowers that grow in the meadows. They can be found by searching the small meadows that border ponds and lakes as well as meadows that have forest growth along one or more sides. Dragonflies are aquatic creatures most of their lives and are more commonly found in meadows near bodies of water. Moreover, a steady source of water encourages the growth of wildflowers, which in turn attracts butterflies. Tall trees along the meadow borders are helpful because they block the early morning sun from warming the insects and to some degree moderate the awakening of the morning breezes. The meadow air can remain completely still for a couple of hours after sunrise before the sun finally warms the meadow, livening the butterflies, arousing the breezes, and sending wiser photographers who recognize the impossible shooting conditions to a nearby restaurant.

If the morning wind is light or calm and the temperature is low enough for heavy dew formation, begin your search at the first hint of light. The light will usually be bright enough to find subjects, although you will probably have to wait until about 15 minutes before actual sunrise for adequate shooting light. By then you should have found several photogenic subjects in locations that you've marked with inexpensive fiberglass electric fence posts or colorful ribbons tied to a nearby plant. Don't use your hat. I used to do that until I had lost every hat I owned and I'm now alarming the insects with reflections from my increasingly shiny forehead.

Walk slowly when scouting for insects. It might seem fruitless at first, but keep working at it. Your score will improve.

Walk eastward while looking intently at all of the plants in the meadow because the dew-laden subjects are softly backlit by the brightening eastern sky and thus are easier to spot. Walking westward has the subjects front-lit and visually blending into their backgrounds, making them more difficult to see. When walking to the east, nicely backlit subjects like dragonflies and spider webs can often be seen from 20 yards away. On a cool morning with heavy dew, diligent searching can easily turn up dozens of nice webs and dragonflies in a mere 20 minutes of searching. Concentrate on looking for bright spots near the tops of the plants as you look toward the east. Usually the source turns out to be an odd-colored leaf, but sometimes it turns out to be a photogenic gem.

Not so very translucent, butterflies are more difficult to spot than dragonflies and spider webs, but you may sometimes locate them with a careful search. Finding a couple of butterflies each morning is a good average. Some mornings you will be skunked like a frustrated fruitless fisherman, and other

The dewdrops and strands of spider web are typical on a dewy morning. Canon 5D Mark III, 180mm, 1/13, f/18, ISO 100, Sun.

mornings, especially after a big butterfly hatch, you'll be awash in photogenic beauty.

It's well worth repeating that you should arrive at the meadow as soon as there's enough light to see. The more time spent searching, the greater the likelihood of finding the best photo opportunities. I recall an incident worth repeating. One of our workshop students made the mistake of setting up to shoot the first and only dragonfly he discovered that morning. He had never before seen a dew-coated dragonfly, was oblivious to its being in poor condition with damaged wings, but he was so enthralled that he spent most of the morning shooting the one bedraggled dragonfly. Suggestions that he find other specimens fell on deaf ears, and he was as happy as the proverbial clam with his images—until he disappointedly saw what the other students had photographed when they projected their images later in the week. Other students were working only a few yards away on two splendid pristine dragonflies wonderfully arranged on a single Gray-headed Coneflower blossom. They made images vastly more engaging than those of the overly hasty shooter. The moral of the story is to look first, find the best subjects, and then shoot them thoroughly.

FIND THE OPTIMUM SUBJECTS

Look first and shoot later. Let's expand on that. We can't overstress the importance of this rule. Having critiqued zillions of images over the years, Barbara and I can assure you that your insect portfolio will be far more enhanced by a few excellent images than by many mediocre ones. Excellent shots come from excellent subjects, not from a host of different angles and exposures of a tired and shopworn subject. That being said, when you do find a truly worthwhile subject, by all means shoot it every which way you can think of. Do not shoot it just one way as so many "got it" shooters do. Shoot it from the front, the rear, from down low, from up high, from the right and the left. Also consider using frontal light, back light, and side light. Use reflectors and diffusers. Use fill-flash, main flash, and always mix the flash with ambient light. Experienced close-up shooters will meticulously work a good

Checkerspots are a colorful group of small butterflies. The back lighting and the fill-flash to reduce the contrast work nicely here. Nikon D4, 200mm, 1/6, f/22, ISO 200, Cloudy, fill-flash with a Nikon SB-800.

Always look for other interesting compositions. Since this checkerspot is cooperative, Barbara changes her shooting angle to create a completely different image. Nikon D4, 200mm, 1/6, f/22, ISO 200, Cloudy, fill-flash with a Nikon SB-800.

subject from beginning to end, exercising as many creative ideas as they can bring to mind in their relentless pursuit of gorgeous images.

A SUCCESSFUL MORNING

Suppose your diligent morning search is so successful that you discover five dew-laden butterflies and seventeen dewy dragonflies. Which specimens should be photographed first? Consider all of the factors. Suppose further, that two of the butterflies are Monarchs, two are Atlantis Fritillaries, and one is an uncommon Coral Hairstreak. Both Monarchs are in excellent condition because they recently emerged from their chrysalis. One is roosting on an unattractive brown plant stem, and the other is on a pristine Gray-headed Coneflower blossom. Both of the Atlantis Fritillaries are roosting on coneflowers, but one is less colorful because it has been flying longer and has lost numerous wing scales and has a few tears in the wings. The Coral Hairstreak, a handsome fellow indeed, is roosting on a fern leaf close to the ground in a difficult location for photography. Most of the dragonflies are roosting near the top of the grass seed heads, though two are sleeping on flowers. One is on a coneflower in the middle of the meadow. Another is perched on a purple Spotted Knapweed blossom. If you have approximately 90 minutes before the rising sun generates breezes and ugly contrast, which evaporates the dewdrops and wakes the subjects, which should be shot first?

Give thought to first shooting the Monarch on the coneflower blossom. The bright yellow coneflower complements the orange butterfly and adds an attractive element to the image. The nicer of the two Atlantis Fritillaries is also a good choice. The Monarch on the coneflower and the perfect Atlantis Fritillary should be your first two photo subjects. For a third choice, consider the Coral Hairstreak butterfly. Although it's roosting in a difficult spot, here is where you can use the sharp pointed scissors in your camera bag to clip the leaf on which it is sleeping and move it to a better spot. Pick a spot that not only allows better camera access, but also provides a favorable height, an uncluttered background, shadow-free ambient

light if available, and, if not, unfettered access for a reflector, diffuser, or flash. If it's cool enough, and you move very slowly and very gently, it's easy to move the slumbering butterfly to an optimized location, photograph it, and return it unharmed to its former location. Often, though, the prize subject warms up and flies away before you are finished photographing it. When you find an opportunity with such a beautiful subject, shoot it thoughtfully and thoroughly, as you may never again find another.

Let's address our seventeen dewy dragonflies. We found so many dragonflies because they are more numerous than butterflies in northern Michigan meadows. So we prioritized the butterflies, and now we can consider the two "dragons" that are sleeping on flowers as they each offer an opportunity to make an exquisite image. Does it matter which to shoot first? Yes. It has often been said that size matters, but sunlight matters too. The dragonfly in mid-meadow is likely to be first to receive contrasty light from the rising sun and be first to warm up and flit away. Shoot it first. The other dragonfly, protected to some degree by the tall trees, will be shielded

This Coral Hairstreak is heavily coated with dew and roosts on a Bracken Fern. Canon 10D, 180mm, 1/2, f/11, ISO 100, Shade.

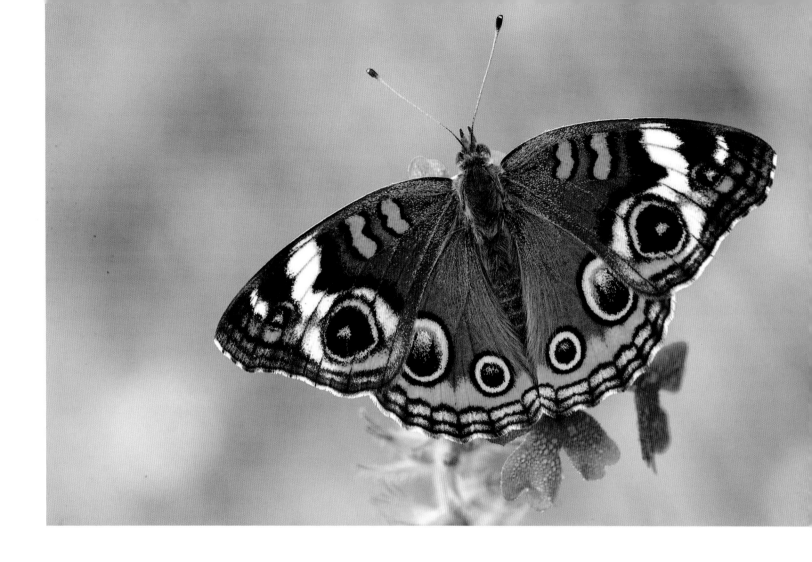

from direct sunshine and its harsh shadows. This dragonfly will remain dormant until much later because it remains shaded longer. Photograph it later.

The subject ranking game plan can be applied to any group of insect subjects found in your diligent search of the meadow. We call it the *shoot into the shadows* strategy. It's best implemented by beginning on the west side of the meadow because the rising sun illuminates that side first. Then gradually move eastward, striving to remain in the shadows for as long as practicable. It's a good system for meadows with trees or a tall hill on the east side. We're always mindful of where we find those meadows so we can go back often.

Texas is blessed with a huge variety of butterfly species. This Buckeye basked in the dawn sun only for a minute or two before it flew away on a warm morning. The cooler the morning, the more time there is to photograph naturally chilled insects. Nikon D3, 200mm, 1/13, f/20, ISO 200, Cloudy, Aperture-priority, fill-flash.

Remember that we've talked a lot about naturally chilled and slumberous insects, but if you're awaiting a butterfly to spread its wings, set up on a target where the sun will soon rise. Many butterflies spread their wings and face them toward the sun to warm up. This basking warms them up quickly. But, if you are in position ahead of time when they spread their wings, it is often easy to shoot gorgeous images of them for a few minutes before they sail away on gently flapping wings.

PHOTOGRAPHING THE MONARCH

There may be no single correct way to photograph a butterfly, but there are certainly some excellent ways. Here's how Barbara and I approach it: We always use a long macro lens, such as the Canon 180mm f/3.5, the Nikon 200mm micro f/4, or the Sigma 180mm f/2.8. These long focal length lenses offer large working distances that reduce the likelihood of alarming the subject, narrow angles of view giving good background control, rotatable tripod collars for convenient camera orientation, and they are optically optimized for close-up photography.

Let's assume the Monarch is hanging from the edge of the coneflower in a way suggesting a horizontal (landscape) composition. We see that the coneflower, being 2 or 3 feet tall, is gently swaying in the slightly moving air. We stabilize it by employing a light stand or electric fence post, or some other stake, where we attach one end of a Plamp. The other end is attached to the coneflower's stem as close as possible to the Monarch without intruding into the frame. Voila! We're well along the road to a tack-sharp image, but be especially

Monarch butterflies regularly roost on Gray-headed coneflowers. The natural dewdrops on the flower and the butterfly add considerable interest. When the butterfly warms, it will spread its wings and angle them toward the sun for a couple of minutes before launching into flight. A Plamp is attached to the flower's stem to hold the butterfly perfectly still. Nikon D3, 200mm, 1/3, f/22, ISO 200, Cloudy, fill-flash.

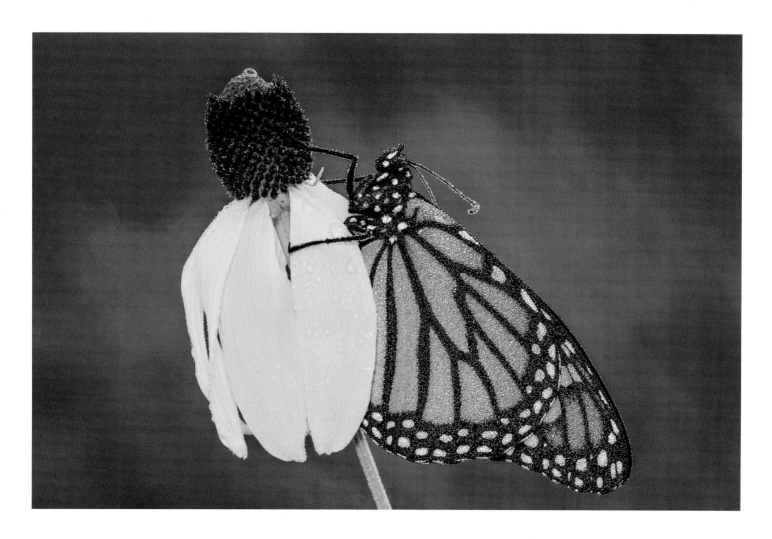

cautious when attaching the Plamp to the coneflower so as not to alert the sleepy butterfly, which may flick its wings and cast off the dewdrops. The keys to your success are the slow care and precision of the surgeon when deliberate and delicate movements are required.

The soft light occurring minutes before sunrise is low in contrast, but blue in color. If shooting JPEGs, we can set our white balance to Shade and eliminate most of the blue colorcast. If shooting RAW files, we can decide whether to ignore the color in favor of adjusting it in post-capture editing or using Shade WB to remove it in the camera. We set our aperture to f/18 as a reasonable compromise between good depth-of-field to avoid the image-softening diffraction effects of f/22 and f/32.

In the soft early morning light, we might opt to shoot toward the west for smooth frontal lighting. When the sun finally peeks over the horizon or trees, we immediately move to the other side and shoot to the east, taking advantage of the pretty back lighting on the translucent butterfly wings and the flower. If the butterfly is not readily accessible from both sides, your scissors can be used to clip a leaf that blocks the view! Don't overdo it! Clipped leaf stems that appear in the image detract from it. If the contrast is too high when shooting into the back light, it's time for some light modification. We can use a reflector, perhaps a gold one if we want warmer light, or we can use our flash. Although Barb and I used reflectors for this task over many years, we've recently been relying more on our flash units for adding extra light. Either way, we have good control over fill light. We can adjust it by varying the position and/or angle of the reflector. If using a flash, varying the angle of a flash burst, adjusting the flash compensation control, or diffusing the flash are all effective ways to modify the light.

CORAL HAIRSTREAK

The tiny Coral Hairstreak is only the size of a nickel and we don't find them very often, making it the next subject on our list. Their diminutive dimensions make them difficult to spot in the meadows where we photograph. This Coral Hairstreak (see page 166) was found roosting nearly at ground level on

non-native unprotected and invasive Bracken Ferns, so once again we can use our pointed scissors to cut a small portion of the Bracken Fern leaf and move it to a better shooting location. In a shaded spot, we can attach the severed fern leaf to a Plamp at a convenient shooting height. We make sure that the background is of a reasonably constant color and tonality and is far enough away that even at our shooting aperture of f/18, it is blurred and featureless without distracting detail.

To shoot the butterfly, we use a series of steps to create sharp images and light them well. Here's the sequence.

1. Mount the camera securely on a sturdy tripod.
2. Compose the image by looking through the viewfinder. Though many students compose with the Live View display, we find it is easier looking through the viewfinder.
3. Next activate the Live View display and magnify it by 10x for critical manual focusing.
4. We use a reflector or more often the flash to alter the contrast and improve the color.
5. Trigger the camera with a remote release or the self-timer.

Some butterflies do not spread their wings to bask. Sulfurs are lateral baskers that angle their wings to be at a right angle to the sun. Nikon D4, 200mm, 1/30, f/22, ISO 200, Cloudy, fill-flash.

6. Confirm the lighting by examining the image on the rear LCD panel.
7. Confirm the exposure with the RGB histogram, and observe if any *blinkies* appear in the image when it is shot.

When we've photographed it until we can think of no other way to do it, we just leave it in place until the rising sun awakens its dormant slumbers and it happily flies away. If we need to use the Plamp right away, then we gently move the fern leaf with the butterfly to a safe place among the ferns. Don't bother waiting for it to spread its wings because this species will not—it just keeps its wings closed while sporadically reorienting itself to optimize absorption of the sun's warmth. Butterfly mavens call this behavior *lateral basking.*

ATLANTIS FRITILLARY

Our hypothetical meadow search turned up two Atlantis fritillaries. The one with the missing wing scales, we'll just ignore. The prime specimen gets all of our attention. If in a good spot for composition, for access, and for lighting, we'll shoot it in place. Often, we'll have to lie on the ground. Even though Barb and I are members of AARP (an organization for retired people), we're a long way from retirement—such a long way that we're still limber enough to lie on the ground. Many of our workshop students can't get up once down on the ground! Our smiling offer to provide a fork-lift truck generally results in a dirty look. If you are one of the few that can't get down, or can't get up, or both, just gently and safely move the butterfly to a better location. Of course, the more you fuss with the perch the subject is on or with nearby vegetation, the greater the chance the photo will be ruined.

WHEN THE BUTTERFLY SPREADS ITS WINGS

The lethargic chilled butterflies must come up to a higher temperature to be able to fly, and butterflies are well adapted to absorb heat. Some species—sulfurs and whites—have wings folded above the thorax, and they orient their wings to be perpendicular to the rays of the sun. This maximizes the wing area exposed to the sun's warming rays. This is the lateral basking behavior we've mentioned, and when up to a comfortable temperature, the butterfly promptly takes flight and goes about its daily business.

Other species, including Monarchs, most fritillaries, and Mourning Cloaks, spread their wings flat and orient them to maximize heat absorption from the sun. In this position, the rate of heat rise increases because the exposed area of both wings is twice that of the single wing surface presentation of the sulfurs and whites.

The spread wings of the butterfly are wonderful photographic targets with exquisite colors and details. Fortunately, butterflies demonstrate a certain lack of concern with a slowly moving nearby photographer and may remain spread for several minutes before launching into flight. You must be alert and ready to shoot immediately upon seeing the wings spread. The exposure, lighting, approximate composition, and focus must all be set. Using a remote release, shoot as soon as you set precise focus and the final composition to accommodate the spread wings. Keep shooting and continue making fine adjustments from shot to shot until the butterfly takes flight. Slow movements are absolutely crucial when the butterfly spreads its wings. *Any fast movement of the hand or the arm will often instantly spook the butterfly into flight.* Be sure you understand and abide by the last sentence or you will ruin many wonderful opportunities. Butterflies are petrified (I think) of fast-moving objects! Move slowly when a butterfly spreads its wings. Noise, however, does not seem to bother them, so feel free to talk.

Speaking of trigger devices, Barb and I began in 2012 to use two PocketWizard Plus III radio transceivers to trip the shutter. They are easy to use and very reliable even over long distances and around corners. One unit is attached to the camera hotshoe and connected via a dedicated electrical cord. The other is in a pocket and easy to reach at any instant we want to trip the shutter. They're admittedly expensive, and a simple wired electrical release works well for most close-up operations. We have used wired cable releases for years and currently still do with great success. Lately, though, I have been using the release button (REL) on the Canon 600 EX-RT flash (Menu 2) when this flash is set to radio control and Slave and the Speedlite Transmitter ST-E3-RT is used.

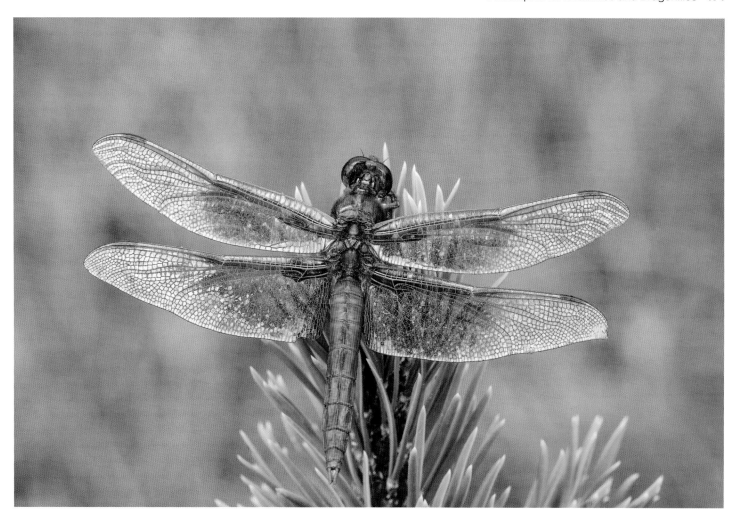

When a butterfly does flush, observe whether it alights nearby. Occasionally they'll just continue their basking on another nearby perch, allowing another opportunity for the photographer who can unobtrusively move tripod and camera into a new position and resume shooting. Of course, if you're shooting handheld, it may be easier to pursue a butterfly hither and yon as it seeks new perches. Irrespective of whether you are handholding or using a tripod, let me nag you once more that one must, absolutely must, move very slowly and very gently to avoid spooking the butterfly into flight! Butterflies will react to any quick movements, although if you very slowly cast a shadow over the catnapping chromatic creatures, they might

Gorgeous Red Skimmer dragonflies are abundant in the thermal areas of Yellowstone National Park during September. Canon 5D Mark III, 180mm, 1/2, f/18, ISO 200, Cloudy, fill-flash.

assume you're just a passing cloud and obligingly spread their wings to soak up a few more rays.

WHAT ABOUT THE DRAGONFLIES?

Have we forgotten the two dew-drenched dragonflies sleeping on flowers and begging to be photographed? Once again, carefully attach a Plamp to the flower stem to stabilize the

flower and its four-winged guest. Work the subject thoroughly using the best techniques for capturing sharp, well-composed, and well-exposed images. Use our *shoot into the shadows* scheme, first shooting the one in mid-meadow and probably first to be impacted by the rising sun. Then shoot the one remaining in the shade with its advantageous low-contrast light.

The dragonflies' translucent wings, especially when bejeweled with dew, photograph best when backlit. Shoot toward the rising sun, but be aware of possible lens flare. Often, a slight change of shooting angle of the camera can minimize the flare, and be sure to use a proper lens hood. Even when the sun has not risen or is blocked by trees, the eastern sky still creates a soft back light. Dragonflies can have more than one plane that needs proper focus, and when they are immobilized by a cold morning, they're a great subject for successful focus stacking.

Insect photographers are probably a hundred percent aware that it's better to shoot in the cool air of dawn. For butterflies that roost in meadows, the technique is very effective. But what about the many species that do not roost in meadows? What about the ones that roost in dense bushes, in trees, and like certain politicians, in undisclosed locations? We're acutely aware that we've never found a Mourning Cloak or a Western Tiger Swallowtail butterfly roosting in a meadow. Let's discuss how to find those elusive entomological critters.

Butterfly life revolves around air temperature. Sunny warm days will find virtually all butterflies flitting freely about the landscape. If a thunderstorm passes through, the rain will bring all the frenetic activity to a swift and unceremonious halt. If the storm is associated with a cold front with a significant temperature drop, the butterflies will remain perched and wait out the storm. They're too cold to fly in that state and will willingly pose until eventually warmed. When the temperature finally does rise, they'll fly about in a less frenzied pace, often pausing for a basking session to warm up and once again offer another good opportunity for the observant photographer.

It is also productive to search meadows in the evening. Even if the light is unfavorable for shooting, a beautiful benumbed

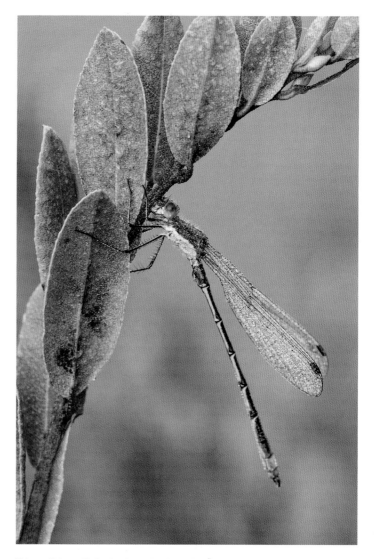

This small damselfly is sleeping on leatherleaf. Damselflies are related to dragonflies, but hold their wings high above their backs, rather than flat like Red Skimmers. Nikon D70, 200mm, 1/8, f/13, ISO 200, Auto.

butterfly will be right there in the better light of the coming daybreak. Keep in mind though, that a gorgeous setup crying out for you to return by the dawn's early light can be rendered photographically futile when you awaken to the discouraging sounds of blustery winds and drenching rain.

This Twelve-spot Dragonfly is in pristine condition. Nikon D4, 200mm, 1/3, f/22, ISO 200, Shade.

The dewdrops make this Twelve-spot Dragonfly interesting, but the poor condition of this individual is bothersome. Notice the many missing wing sections. Canon 5D Mark III, 180mm, 1/2, f/18, ISO 160, Cloudy, fill-flash.

ATTRACTING BUTTERFLIES WITH FLOWERS

Our own gardens are filled with flowers—both cultivated and wild—specifically planted to attract butterflies. Our lawn is tiny because we leave most of our 27 acres undeveloped to provide wildflowers for the native creatures and us to enjoy. Besides, those flowers bring hummingbirds every year that we very much like to photograph. Each spring we carefully scrutinize the flower and seed catalogs, and we visit commercial greenhouses to find new plants that we'd like in our garden. Some flowers are excellent butterfly attractors, including asters, mistflowers, goldenrod, sunflowers, sage, thistles, coneflowers, blazing stars, and especially the aptly named butterfly weed.

PROVIDE BUTTERFLY FOOD

Some butterflies are strongly attracted to rotting fruit like bananas and apples. Those foods entice certain species to loiter about, making them good subjects. Surprisingly, some butterflies shun flowers, preferring tree sap or animal dung. Bad news. Tree sap is sticky to work with and not good news for camera gear. What about animal dung? Well, we have three canine family members, so doggie doo is easy to find, but what cultivated connoisseur of tasteful nature photography would appreciate the aesthetics of such severely scatological images?

MUD

Yes, mud, just plain mud. Butterflies obtain plenty of moisture from their natural food sources, but wet dirt is a major attractor. When we water our small lawn in Idaho, our dirt driveway gets thoroughly soaked. On warm summer afternoons, dozens of butterflies that may include Western Tiger Swallowtails, blues, coppers, fritillaries, checkerspots, sulphurs, and whites land on the salty and mineral-laden damp soil. During these "puddling parties," many are so oblivious to human presence that they ignore our viewfinder filling intrusions. Even if they do flush, they merely circle around and land again. And I have found that we can actually befriend a butterfly! If we keep approaching and working on the same butterfly, occasionally one will become more accepting of our presence as it comes to realize we mean no harm and may ignore us altogether.

It's easy to photograph butterflies on mud. They're on wet ground so the background is not too distracting even though so close that selective focus can't blur it completely. That same closeness allows flash to be as effective on the background as it is on the butterfly in providing smooth lighting. Not to worry if you don't have a driveway—any natural damp area can offer similar benefits. After a rainfall, pay close attention to puddles on dirt roads for the same activity, and keep an eye on the wet sandy areas along stream banks.

PHOTOGRAPHING PUDDLING BUTTERFLIES

Many butterflies seem mesmerized by damp soil, and they can be quite easy to photograph when engrossed in serious puddling. Approach slowly from the rear while crouching down so as not to cast a shadow on the butterfly and cause it to flush. If you need shade to improve the light, move slowly to attempt to emulate a passing cloud and let your shadow gradually envelop the unsuspecting butterfly. Once the butterfly is fully shaded, move in gradually while looking through the viewfinder. As the butterfly comes into focus, adjust the magnification and composition as necessary and focus carefully on the point where the wings join the thorax. Be sure to hold that focus while shooting multiple images. It is a good idea to put your camera into a high-speed continuous shooting mode and shoot as many images as you can to increase the chances of getting some in perfect focus. The limited depth-of-field at these magnifications makes hitting critical focus crucial because, in this case, wings are the largest part of the butterfly, so it is essential that they be as sharp as possible.

PHOTOGRAPHING ACTIVE BUTTERFLIES IN THE WILD

As we've often repeated, butterflies are best photographed when dormant in chilled slumber. When the sun warms them, they're quickly off to the races, or wherever it is that

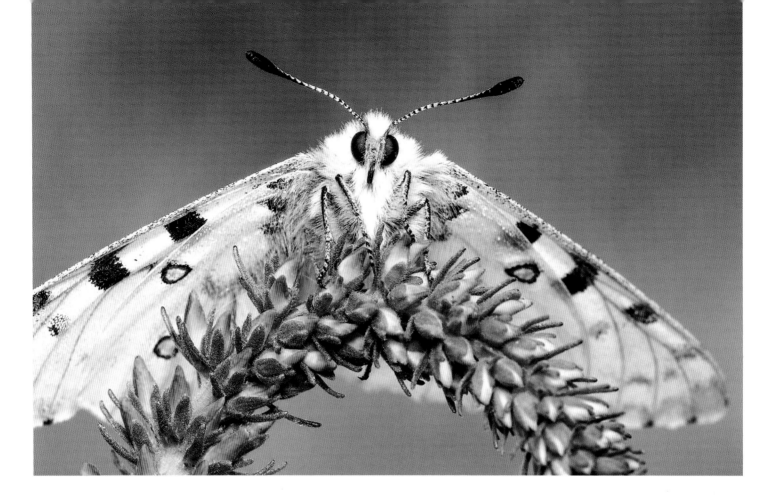

This Rocky Mountain Parnassian is slowly moving about its perch. It is impossible to use a tripod if the subject never holds still, so it is photographed handheld. Many shots were taken and only two were sharp. Nikon D4, 200mm, 1/125, f/16, ISO 800, Cloudy, fill-flash.

butterflies go when doing their day's work. When the sun is invigorating butterflies, it's casting harsh shadows over the environment and generating breezes—a duo making critical focus difficult. If you stop your lens down to achieve good DOF, even at a reasonably high ISO 800, you may not have enough shutter speed to stop the blurring motion of the rapidly beating wings.

Many shooters see the fix for the motion problem in the use of flash. Many believe that the flash will provide lots of light and that the short flash duration is enough to stop the butterfly's motion. Yes, both are true, but Barbara and I don't agree it's the best way. We rarely use flash as the only light source.

Instead, we prefer to mix the flash with ambient light because of four crucial factors:

1. One or perhaps two flash units will surely freeze a butterfly's motion while it is feeding on the nectar of a flower that's swaying in the breeze. However, the rapid light falloff with increasing distance due to the Inverse Square Law means that we'll probably get the black backgrounds that we dislike so much. After all, butterflies are diurnal creatures rarely seen in the dark of night—making black backgrounds intuitively seem unnatural.

2. Not only are black backgrounds unappealing to many, a very dark insect or one with dark regions around its wing edges or the black antennae can merge into a black background causing the outline of the insect to disappear.

3. Many of our students instinctively use direct frontal flash, but we think frontal lighting can make butterfly wings look "flat" by muting the colors and hiding the texture of some very pretty wings.

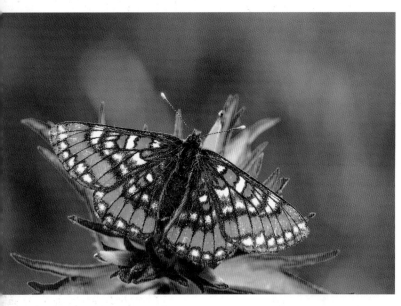

Gillette's Checkerspot is a gorgeous and rare butterfly that fortunately is rather common around our Idaho home. The green background complements its color and reveals the dark edges. Canon 5D Mark III, 180mm, 1/2, f/18, ISO 100, Cloudy, fill-flash.

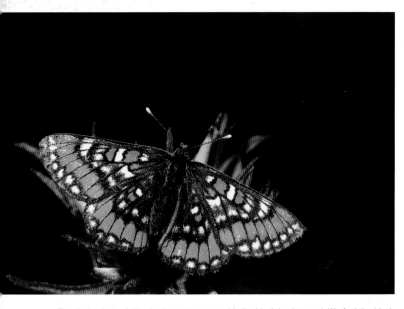

The dark edges of the checkerspot merge with the black background. We feel the black background makes the image look artificial. After all, this butterfly would never spread its wings at night. All of the light is from a single Canon 600EX flash. Canon 5D Mark III, 180mm, 1/15, f/18, ISO 100, Flash.

4. Flash is unwelcome with some butterfly enthusiasts. Some believe that flash scares the butterfly, an opinion we do not share. We have used flash to light hundreds of butterflies, and not one has indicated any sign of alarm—by flushing or by any other reaction. Some claim that the heat from the flash might harm the butterfly, but we know that isn't true. Moreover, even though we often use two flashes to light one butterfly, we've never been accused of entomological pyromania and have yet to see a butterfly burst into flame. Okay, that's silly, but we'd bet that if you'd fire your field flash pointed at your hand from the same distance you use in close-up photography, you would not even feel a hint of warmth.

BUTTERFLY HOUSES

The greatest variety of butterfly species is found in tropical regions where the temperatures are warm and vary little throughout the year. Travel is expensive these days. Not all butterfly photographers are able to visit the tropics. Butterfly houses are quite popular around the world. Searching the Internet may lead you to one located near you. This is especially true in the United States where they are incredibly popular.

Butterfly houses buy and raise butterflies from all over the world and release them into the temperature and humidity-controlled environment that is landscaped with plants on which butterflies usually roost and feed. These butterfly houses are filled with large varieties and massive numbers of butterflies. Many are exquisitely colored and they're a sight to behold. Even the most nonchalant of butterfly photographers can't help but be delighted by the unlimited shooting opportunities.

However, butterfly houses can be difficult for close-up photography. Many butterfly houses disallow or only conditionally allow tripods on the allegation that they're hazardous to other visitors. If so restricted, you must shoot handheld. That's not a major headache as you've probably already learned to do that when chasing butterflies in the wild. Here we can offer a few ideas on how to produce consistent quality butterfly images when limited by the rules and the dim lighting of a typical butterfly house. Fortunately, modern photographic

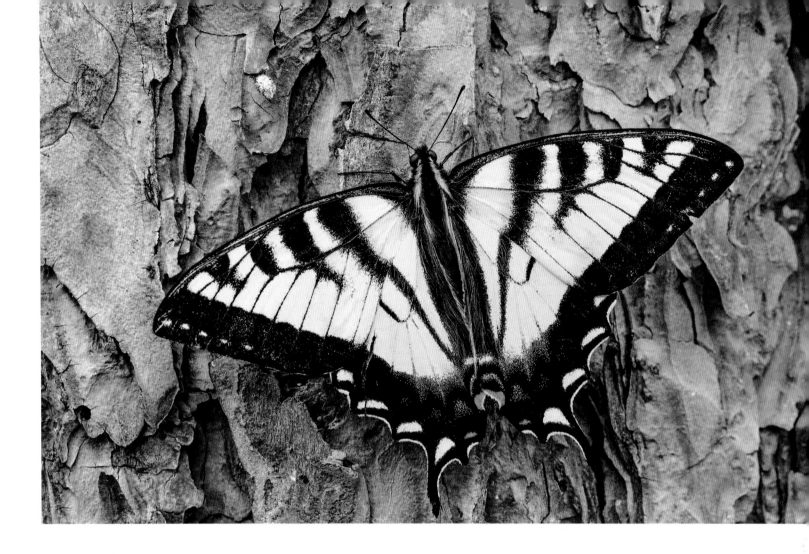

gear helps a great deal. Consider the list below and then we'll discuss the items individually.

- High ISOs can deliver good image quality
- Macro lenses are faster these days
- Some macro lenses offer image stabilization
- Automatic flash is much more sophisticated and easier to use
- Multiple digital images do not add additional cost

Let's contemplate each item.

HIGH ISO OPERATION

The latest wave of new digital cameras offers a gratifying ability to use high ISO numbers and still provide low-noise

Eastern Tiger Swallowtails fly in the spring and are gone by mid-summer. Why this individual is roosting on the trunk of a pine tree during our Michigan fall color photo workshop remains a mystery. The butterfly is 5 feet up a tree, so a borrowed Sigma 180mm macro lens that has image stabilization is used along with fill-flash to capture a sharp image handheld. Canon 5D Mark III, 180mm, 1/60, f/11, ISO 400, Cloudy, fill-flash.

and high-quality images. One can easily use ISO numbers of 400, 800, and even 1600 to produce excellent quality, especially when using a camera with a full-frame sensor. That's because large sensor cameras tend to have larger pixels that produce less digital noise due to a more favorable signal-to-noise ratio than cameras with smaller pixels. Both my Canon 5D Mark III and Barbara's Nikon D4 shoot ISO 800 images with remarkable quality. These higher ISO sensitivities allow

higher shutter speeds for arresting motion, allow smaller apertures for better DOF, or some combination of both.

FASTER MACRO LENSES

Modern macro lenses often have apertures of f/4 or f/2.8. Why does this matter when we've already counseled you to consider f/18 as a good compromise between sufficient DOF and softness-inducing diffraction? Here is the reason: Most likely you're not going to shoot at those wide apertures. You're still going to shoot at f/18 or thereabouts most of the time. It's just that those big and bright apertures are marvelous for clear viewing, for easy composing, and especially useful for quick and precise manual or autofocusing which is so crucial in close-up photography. Remember, the lens aperture doesn't actually stop down to the shooting aperture until you push the shutter release. Even though the aperture is set to f/18, you still see the subject at the widest aperture on the lens.

IMAGE STABILIZATION

Canon may call it IS (Image Stabilization) and Nikon may call it VR (Vibration Reduction) and others may call it something else—the name of your stabilization system is unimportant. What's important is that they're a tremendous benefit to the handheld shooter. The systems typically cause internal lens elements to physically move in a manner that compensates for camera movement—not subject movement—and aids in producing sharp images for the handholder. An old rule of thumb is that the minimum shutter speed for handholding is the reciprocal of the lens focal length. For example, if using a 100mm macro lens, the minimum shutter speed would be 1/100 second. If your manufacturer claims your stabilization system offers a 4 stop improvement, you could presumably handhold 4 stops below 1/100 second, which is 1/6 second. Please recognize the possible presence of marketing puffery, and always test your own equipment to learn its limits. One way to check a stabilization system is to tack a magazine page to the wall and shoot the fine print while handheld with the stabilization system turned on. Find the lowest shutter speed at which you can repeatedly achieve sharp images. My own testing of a Sigma 180mm image-stabilized lens has proven that stabilization is a very valuable aid in handheld shooting. I was able to shoot acceptably sharp images handheld at 1/100 second with the 180mm lens, but could not do so at slower shutter speeds because I am super critical about sharpness. Still, being able to use 1/100 second is an enormous advantage for handheld photography.

Even with stabilization, it always pays to shoot at the highest shutter speed that is reasonably feasible, especially at higher magnifications where camera shake is magnified as much as the subject is magnified.

FLASH

Flash is a great aid in shooting sharp images. The flash duration will probably be less than 1/700 second and will produce a very sharp image when the lens is precisely focused on the subject. The key to shooting sharp handheld images is to ensure that all useful factors are employed for every shot:

- Use a high ISO to allow a fast shutter speed.
- When using Manual exposure, set the ambient light exposure about 1 stop underexposed to allow a contribution from the ambient light. This will help avoid black backgrounds.
- If the ambient light is changing rapidly, then use the Shutter-priority exposure mode to lock in the shutter speed that is needed for sharp results. Some cameras even allow the shooter to lock in both the shutter speed and the aperture while allowing Auto ISO to adjust up or down for changing ambient light conditions. This works incredibly well for all handheld and low light photography.
- When using any automatic mode, set the exposure compensation to slightly underexpose the subject.
- Use your LCD display to confirm the desired exposure compensation.
- Now use flash as the main or key light and set whatever flash exposure compensation (FEC) is necessary to produce an optimally exposed final image.
- Be sure to use your RGB histogram to ensure proper exposure. Check to see that no color channel is seriously overexposed.
- Set the shutter speed at or below your camera's maximum sync speed if you're not using a high-speed sync mode. Most likely you

won't accidentally try to shoot with too fast of a shutter speed because your camera will likely detect a flash being used and automatically defaults to the sync speed for flash. By the way, although high-speed sync does make the flash less powerful in lighting the subject, it works well in close-up photography because flash to subject distances are short.

- What is the key advantage of using flash as the main light? The short flash duration will freeze and render the subject sharp during its portion of the exposure. If the ambient light portion of the image is slightly soft due to camera shake or subject movement, it might not be as objectionable as it would be if the image consisted totally of a slightly soft ambient light exposure.

- When all camera parameters are set to your satisfaction, ensure that your plane of focus is parallel to the most important plane of your subject and that your stance is balanced and steady with elbows firmly to your sides. Hold the camera just as still as possible, inhale a big breath, exhale part of it, hold it there, and gently and smoothly release the shutter.

- Shoot as many images as possible to better your chances of perfect sharpness, but don't shoot any faster than your flash can recycle for another shot.

- Many will choose to shoot using ambient light only. In this case, activate image stabilization if you have it and use ISO 800 or perhaps ISO 1600—if necessary. Don't stop down as much—perhaps f/8— and align the plane of focus carefully with the most important plane in the subject. Use the same camera holding strategy as just described earlier, and shoot a lot of images. As a minimum shutter speed, try to keep the shutter speed to at least 1/focal length of the lens.

- Although we greatly prefer using manual focus when shooting on a tripod, automatic focus makes perfect sense when handholding. Your shooting distance will change slightly and continuously as you handhold. Using continuous autofocus to adjust for this does help capture sharp images. Although we normally use autofocus on the back-button for tripod work, putting the autofocus on the shutter button for handheld photography may be easier for most shooters. Why? There is one less thing to do as the button on the rear of the camera does not need to be held down when autofocus is relegated to the shutter button, which is the camera's default.

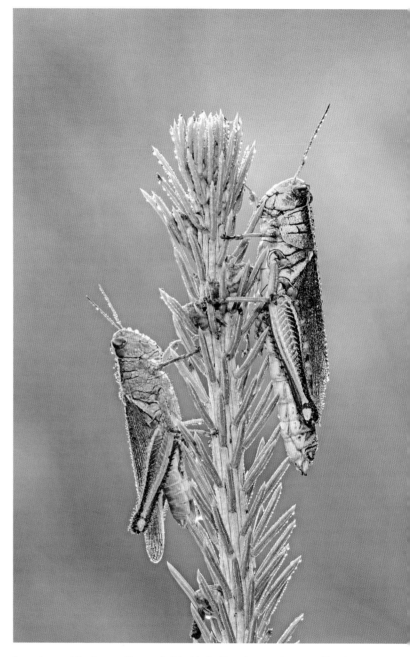

It pays to spend the time working wonderful subjects. These two grasshoppers, although dew covered, were not frozen in place. They crawled up and down this conifer twig. After several minutes, the two paused in the perfect position so both could be sharply focused. Canon 5D Mark III, 180mm, 1/1.7, f/20, ISO 100, Sun, fill-flash.

DIGITAL IMAGES ARE FREE

Well, sort of free anyway. The premise assumes that you have forgotten the initial cost of cameras, lenses, your vast collection of accessories, and computer costs! After all, you already own the gear, so does it matter economically how many pictures you shoot? The reasonable answer is no. So, good reader, when you're pursuing the bewitchingly beautiful butterfly, don't skimp on the number of images you shoot. Later, in the leisurely comfort of the evening, you can sort the good from the not-so-good—retaining only those super-sharp keepers that generate an involuntary "Wow!"

Oh, one more thought—we don't use camera straps when shooting on a tripod and generally counsel our students to avoid them for several reasons. But they are valuable for steady handheld camera support.

Handheld photography of free-flying butterflies takes some thought and some practice, but is certainly possible. Which reminds me that even that one annoyingly skeptical student of ours reluctantly admits that diligently applying the guidelines we've covered here can make one's success rate improve by leaps and bounds.

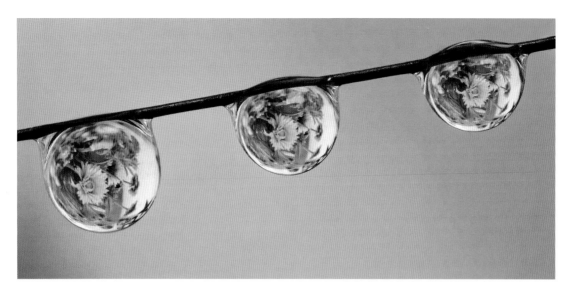

Barbara discovered horsehair has a surface texture that enables water drops to readily cling to it. Shooting indoors to avoid all air movement, she placed the water drops on the horsehair with an eyedropper. Then she placed a potted flower a few inches behind the water drops. Reflections in water drops are instantly appealing. On dewy mornings, always look for reflections in the natural dew drops! Nine images were combined with Zerene Stacker to acquire the depth of field needed to do justice to this tiny subject. Canon 5D Mark III, Canon 65mm macro, ISO 500, f/8, 4 seconds, Cloudy WB.

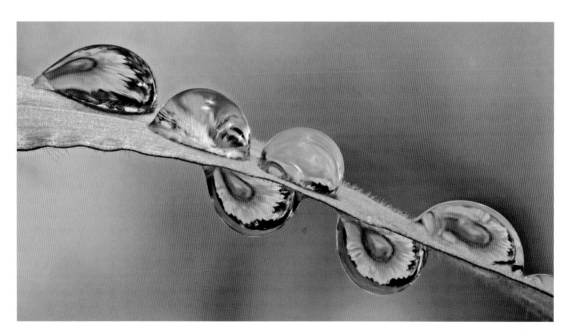

Barbara added water drops to the grass and placed some flowers closely behind them. Although she normally shoots Nikon, she borrowed my Canon camera and 65mm macro lens because it is optimized for high magnification. Barbara shot sixteen images using a Kirk focus rail to change the focus from the front to the rear of the subject in tiny increments. When shooting images at life-size magnification or greater, the focus rail is the optimal way to change the focus. The sixteen images were combined with Zerene Stacker in order to achieve a depth of field not possible with a single exposure. Canon 5D Mark III, Canon 65mm macro, ISO 400, f/9, 2.5 seconds, Cloudy WB.

What's in Our Camera Bags?

Aside from the occasional granola bar, we carry the close-up and macro gear that time has proven valuable over and over in our fieldwork as well as in our greenhouse macro studio. Barbara and I photograph a plethora of close-up subjects that require different kinds of equipment. Moreover, to ensure the highest quality images for instructional programs, our books and DVDs, and for other users of our images, we always insist on using only the best quality gear available. We try to operate on the "buy once–cry once" principle, which mandates that we initially buy the best gear available even if we're not happy with its cost. That way, we don't have to keep trading up over and over again to get to a total higher cost for gear we should have bought initially. Should you want to limit your equipment budget, however, please trust that you can absolutely make fine images with almost any reasonably priced gear that you use with good photographic techniques.

Okay, with all that said and always considering ladies first, here's what Barbara likes to carry in her camera bag:

BARBARA'S BAG

CAMERA

- Nikon D4, with attached custom Kirk Enterprises L-bracket, a well-charged battery, and adequate memory for the shoot

No book is complete unless Boo makes an appearance, according to Barbara. Nikon D3, 200mm, 1/320, f/8, ISO 400, Cloudy, and Aperture-priority.

Our three horses (left to right) include Toby, Teton, and Bandit. They help us reach remote alpine and subalpine meadows where we shoot many close-up photos. Thanks to them, some of our discoveries appear in this book. Nikon D4, 24mm, 1/250, f/18, ISO 400, Sun.

- Nikon SU-800 Remote Commander, for remote control of the SB-800s
- Nikon R1C1 Wireless Close-Up Speedlight System

LENSES

- Nikon 200mm f/4 D ED-IF Micro lens with a Kirk quick-release lens plate attached to the tripod collar
- B + W circular polarizing filter, 62mm, to fit the 200mm lens

FLASH EQUIPMENT

- Two Nikon SB-800 flash units, each with four fully charged AA batteries
- Eight fully charged extra AA batteries

TRIPOD AND HEAD

- Gitzo #GT3541LS carbon-fiber tripod legs
- Kirk Enterprises BH-1 ball head

ACCESSORIES

- Kirk Enterprises focusing rail
- Kenko extension tube set for Nikon, with 36mm, 20mm, and 12mm tubes

- Two Pocket Wizard Plus III Transceivers (radio remote flash controllers)
- Nikon electrical remote release
- Sharp pointed scissors
- Notebook and pen
- Photoflex MultiDisc 5-in-1, 22 inch multi-surface reflectors and diffuser
- Large Giotto-Rocket blower, microfiber cloth, lens-cleaning fluid and tissue
- Plastic ground sheet
- Knee pads

CAMERA BAG

- ThinkTank Photo Airport Acceleration V2.0

JOHN'S BAG

CAMERA

- Canon EOS 5D Mark III with attached Kirk L-bracket and a fully charged battery
- 2 extra fully charged batteries
- 4-32GB SanDisk CF cards

LENSES

- Canon MP-E 65mm f/2.8 1x-5x macro, with Kirk quick-release plate attached to the tripod collar
- Canon 90mm f/2.8 tilt-shift lens
- Canon 180mm f/3.5 macro, with Kirk quick-release plate attached to the tripod collar
- 72mm B + W circular polarizing filter for the 180mm macro lens

FLASH EQUIPMENT

- Two Canon 580II Speedlites, each with four fully charged AA batteries
- One Canon 600 EX-RT Speedlite, with four fully charged AA batteries
- One Canon ST-E3-RT radio flash controller
- Two extra sets of batteries, eight in all, housed in plastic battery holders
- Canon ST-E2 Speedlite Transmitter, for wireless flash control

- One spare 2CR5 battery for the ST-E2 transmitter
- MT-24EX twin flash with four fully charged batteries

TRIPOD AND HEAD

- Gitzo #1325 carbon-fiber tripod legs
- Kirk BH-1 ball head

ACCESSORIES

- Kirk Enterprises focusing rail
- Canon 25mm extension tube
- Kenko extension tube set for Canon, with 36mm, 20mm, and 12mm tubes
- Canon electrical remote release
- Sharp pointed scissors
- Notebook and pen
- Photoflex MultiDisc 5-in-1, 22 inch multi-surface reflectors and diffuser
- Large Giotto-Rocket blower, microfiber cloth, lens-cleaning fluid and tissue

CAMERA BAG

- Lowepro Trekker II

WHY DO WE USE THIS GEAR?

We've discussed much of this gear before, but now having listed it all in one place, let's review the reasons we have selected these particular items.

LENSES

The Canon 65mm macro lens is absolutely first-class for shooting very high-magnification images from 1x all the way to 5x! Do you want a full-frame image of that attractive horsefly eye? This is the lens for you!

The Canon 90mm tilt-shift lens is a special purpose tool allowing one to obtain seemingly large depths of field (DOF). No actual increase in depth-of-field is achieved, but realignment of the plane of focus permits an optimized utilization of the ordinarily available DOF and thus excellent focus over large

segments of the image. This is a tremendous advantage when shooting planar subjects like an angled shot of a butterfly's wings or the surface of a dense field of flowers, a spread of lichens on a flat rock and so on. An entire discussion is beyond the scope of this book, but interested techno-geeks might look up *The Scheimpflug Principle* on the Internet. (Note: focus stacking has made the need for this lens much less.)

Finally, the Canon 180mm macro lens and the Nikon 200mm micro lens are the workhorse lenses offering excellent working distances for wary insects. The pleasingly small angles of view are superb for good background control, and the rotatable tripod collars make shooting vertical images on a tripod easy.

While both of our camera bags contain polarizers, we normally don't use them for macro work because most macro subjects aren't very reflective and the filters absorb about 2 stops of light. For any given aperture, this forces longer shutter speeds or higher ISOs, neither of which is desirable. Also, the polarizer dims the viewfinder by about 1.5 to 2 stops of light, which makes manual focusing more difficult and prone to error.

FLASH EQUIPMENT

Occasionally Barb and I use two flashes for a given shot. Therefore, we each carry two flashes even though the bulk of our work requires only one flash. Besides, it's never a bad idea to have a spare when working in the field. That said, they're unarguably expensive, so don't feel at all under-equipped or deprived if you have only one.

I like the Canon 580II because it features wireless evaluative through-the-lens (ETTL) metering and emits plenty of light. However, I love being able to fire the camera remotely with the release button on the Canon 600 Speedlite, so I use it most of the time and will probably get another 600 Speedlite soon and add my 580 Speedlites into my hummingbird flash setup. Barb likes her Nikon SB-800s. They're discontinued now, but are slightly smaller and lighter than the newer Nikon SB-910s, and Barb is never one to ignore a convenience if the function is equally good!

We nearly always mix ambient light with our flash. One must first determine the proper exposure for the ambient light and then adjust the flash for the desired effect. In doing so, the flash must be suppressed while checking ambient exposure. One can inhibit an optically controlled flash by merely hiding it behind one's back, but a radio-controlled flash probably needs to be turned off. The radio-controlled flash is superb, though, for shooting from inside a blind, which is not done in close-up work, for firing a Remote flash at a distance greater than its optical cousins can handle, and for firing a Remote flash where line-of-sight between the controller and the Remote flash is not available.

Special purpose close-up flash units are available by both Nikon and Canon. The Canon MT-24EX Twin Flash and the Nikon R1C1 Wireless Close-Up Speedlight system each feature two small flash heads mounted at the front of the lens. These heads can be adjusted at various angles and the light output from each is independently adjustable, allowing creative lighting effects. They work well for tiny subjects, and for handheld shooting. These are generally excellent light sources, although Barb and I have such a preference for mixing ambient and flash illumination together that we prefer conventional flashes. Keep a lookout for the pitch-black backgrounds that can occur when using any flash without consideration of ambient light. Some photographers like black backgrounds, but we generally do not. Regardless of background preferences, whether the Canon or Nikon macro-flash systems will do well for you is your call. There is no wrong answer as it's entirely up to your own personal preferences.

FOCUSING RAILS

Focusing rails are an important accessory and practically a necessity when shooting images at life-size (1x) or greater. The bottom of the focusing rail attaches to the tripod head and the camera and lens mount to the top of the rail. The rail allows tiny fore-and-aft adjustments by a rotatable screw or a rack-and-pinion system. Major focusing is done by tripod placement and lens control. Fine adjustments are made by moving the entire focusing rail, which is supporting the

camera and lens, back and forth in the very tiny but well-controlled amounts allowed by the rail. It is practically an essential tool when doing focus stacking, although as always, you get what you pay for. Inexpensive focus rails may be sticky and have annoying adjustment backlash, so buy once and cry once!

SHARP POINTED SCISSORS

Scissors will come in handy. Sometimes the close-up shooter must do a little gardening or housekeeping to remove offending blades of grass, twigs, and dead leaves from intruding into the image frame. Besides, it is occasionally good to be able to cleanly clip a twig upon which a caterpillar is dozing to place it into a more favorable location. We avoid trampling a bush and at the same time obtain a lovely background for our caterpillar shot while allowing room to use our reflectors and diffusers. When done with the shot, we promptly return the caterpillar unharmed to its bush.

REMOTE RELEASES

It is hard not to keep calling these gadgets *cable releases*, but in the interest of keeping up with technology, they're better termed *remote releases*. The cable release of yesteryear was a mechanical plunger, but today's remote releases can be wired electrical switches, infrared triggers, or even wireless radio triggers.

We almost invariably use one to trip the camera. It prevents us from touching the camera at the instant of exposure, thus preventing our unavoidable bodily wiggles and shakes from moving the camera even a smidgen and making fuzzy images.

Wired electrical switches connect to the camera and have a flexible electrical wire terminated in a thumb-operated push-button switch. They are available for most cameras—the Nikon MC-30 and Canon Remote Switch RS-80N3 are but two examples. Some cameras have handheld optical receivers built into the body, which makes the handheld optical remote trigger convenient, and our PocketWizard transceivers that usually operate Remote flashes can do double duty as wireless

radio-operated camera triggers. All of the releases are generally available from camera manufacturers, and while not our own preference, that one irritatingly irreverent student of ours (a.k.a. Al Hart) has pointed out that relatively low-cost equivalents of each type are often found on eBay.

GIOTTO-ROCKET BLOWER, LENS-CLEANING FLUID AND TISSUE, AND MICROFIBER CLOTH

Every camera bag should include the necessities for keeping camera and lenses impeccably clean. Even a tiny bit of lens dust can cause contrast-reducing flare in an image, so lenses should always be immaculately clean. Camera bags need to be cleaned of dust and debris, too.

We always recommend the large Giotto blower because it's been shown to be reasonably free of oils and rubber particles, making it suitable for cleaning your camera's sensor as well as lenses and the camera body itself. *Caution:* Even beyond oils, rubber particles, and other debris being expelled from an unsuitably cheap blower, there have even been reports of one blower that when vigorously squeezed would actually expel its entire nozzle, a powerful plastic projectile potentially destructive to an open camera! Submariners and breaching whales blow often and blow hard, but photographers must blow carefully.

Lens fluid and tissues have been used for untold eons to keep lenses clean, and we continue the tradition. Be sure to use brand name fluid and tissues specifically designed for camera lenses as the important coatings on your lenses are not content when unmercifully attacked by inferior materials.

Microfiber cloths are widely used to clean camera lenses, and we do use them regularly. Everyone uses them except for that nonstop-nuisance of a student of ours who argues that careless users might inadvertently let a microfiber cloth pick up a grain or two of sand or other abrasive dirt and damage an expensive lens. Always keep the cloth free of grit.

NOTEBOOK AND PEN

As a photography instructor, I routinely write down notes of in-field photographic techniques and subject biology. I heartily

recommend that my students record similar matters to later compare with their images.

EXTENSION TUBES

Extension tubes, whether made by the camera manufacturer or a third party, fit between the lens and the camera body. They allow closer focusing that provides greater magnification. Every close-up shooter should own at least one—perhaps 20 or 25mm or thereabouts. That's a good general purpose length, although sets of tubes of different lengths, like the three-tube sets sold by Kenko, are very useful.

22 INCH PHOTOFLEX MULTIDISC 5-IN-1

This accessory includes four different 22 inch reflector surfaces in white, silver, gold, and soft-gold. Until more recently we used to reflect light into the shadow areas to lower the contrast of subjects or occasionally to raise subject contrast. The set contains a neutral white diffuser to soften shadows of ambient light. More recently, we've cut down on our use of reflectors. Instead, we favor flash, but for those who don't use flash so much this is a splendid system of reflectors.

PLASTIC GROUND SHEET

The physical milieu of the close-up shooter is largely in the dirt or the mud. We spend a lot of time on or near the ground, and often it is wet! What a comfort it is to lie on the plastic ground sheet and stay relatively clean and dry! I don't use it all that much because we macho-men don't mind being wet, but Barbara, with her charming lady-like leanings prefers being clean and dry. Our "got a better idea" student Al Hart dislikes plastic sheets and extols the benefits of the lightweight Mylar space blankets available inexpensively at many outlets. Some shooters just wear lightweight chest waders to stay dry, although some find them excessively hot on warm days and some object to the blocking of pocket access.

RUBBER MUCK BOOTS AND RAIN PANTS

Okay, you trapped me! These Muck boots aren't really in our camera bags, but they are always in a plastic tub in our car. They're great in damp and dewy meadows on dew-drenched mornings when we're shooting insects and plant life. We always wear rain pants and knee-high rubber muck boots for wet meadow photography. When we are done each morning, the wet pants and boots are put in the plastic box. When they dry, the sand and other debris falls off into the box, which is easy to discard.

KNEE PADS

Barb's knee surgery virtually mandates these comfort-promoting accessories. They are inexpensive, widely available, and many photographers swear by them. I personally don't use them because my knees are just fine. But, who knows, with advancing years I may yet change my mind.

TRIPOD AND HEAD

Barb and I both use Gitzo tripod legs. They're strong and reasonably light. They don't have center columns, leg braces, and other mechanical nonsense. The legs can splay out so that our camera gear can get very low to the ground. Our tripod legs have now been replaced by later but similar models. The Gitzo brand continues to be the gold standard of the outdoor and nature photographer.

Our tripods are each equipped with the Kirk BH-1 ball head. Mike Kirk and I became friends in the late 1970s when he built custom flash brackets for me and many other nature shooters. Mike was a skilled machinist and eventually launched Kirk Enterprises, specializing in designing and manufacturing equipment for nature photographers. Mike has sadly and prematurely passed away, but his very capable son, Jeff, continues to successfully manage the firm that is located in Angola, Indiana.

We use the larger BH-1 because our wildlife work involves larger and heavier lenses. The smaller and less expensive Kirk BH-3 model is excellent for close-up shooting. Alas, we'd be

remiss if we were to ignore the observation of that perpetually disorderly student of ours who never overlooks any opportunity to quibble. He unquestionably concedes the excellence of Kirk's products and of Gitzo's. He uses Kirk and Gitzo equipment himself, but claims that his own Really Right Stuff (RRS) ball head is also excellent.

CAMERAS AND L-BRACKETS

As of January 2014, all of my close-up work is done with my Canon EOS 5D Mark III, and Barbara swears by the many virtues of her Nikon D4. These two cameras each offer a wide set of features that we find just right for our close-up and macro shooting. They're each full-frame cameras with adequate sensor resolution to make large prints, and there is no lack of resolution for considerable cropping of the images. Each has high ISO capabilities at low noise figures that are great for dim light operations. We especially appreciate their ease of operation and find that their great flexibility in setup configuration is virtually unmatched. Should a newer version of these cameras become available, we would quickly upgrade in order to discover the new features that we could incorporate into our shooting workflow.

The cameras we shoot are expensive, but we shoot images for a living, and our success depends on capturing the finest quality images possible. To be honest, the advanced features on our cameras are more applicable to wildlife photography than close-ups. Any digital camera works fine for close-ups, so you don't have to spend a lot of money to acquire a suitable camera.

All of our cameras are fitted with dedicated L-brackets. The ones we use are made by Kirk Enterprises. With lenses having no rotatable tripod collar, the L-brackets permit easy rotation between horizontal and vertical shooting, while maintaining a favorable center of gravity. Not having to flip the camera to one side to shoot vertical images on a tripod is an advantageous feature!

CAMERA BAGS

It's a standing joke among all kinds of photographers that each has at least one large closet crammed full of idle camera bags that were acquired in a never-ending search for the perfect bag. Yet here, kind reader, we're going to tell you the closely held secret of the perfect bag. Here it is: *The perfect camera bag is one that you like.* I like my Lowepro Trekker II and Barbara likes her ThinkTank Photo Airport Acceleration. Each thinks that our bag is almost perfect, although there are many others from which to choose. Most bags have a zillion features, but make sure that yours carries all the necessary gear into the field in an organized manner that makes it easy to find a specific lens, battery, or other piece of equipment. Don't be seduced by the bigger-is-better syndrome. Getting a bag that's larger than necessary may be far too heavy to comfortably carry into the field when fully loaded.

DON'T OVERDO THE EQUIPMENT

There is plenty of gear available for purchase that enables you to capture outstanding close-up and macro images. What we use and described above works well for us. However, you certainly don't need to have everything we use and your choices—especially if you use another camera system besides Canon and Nikon—will be different. This entire chapter is meant only to be a guideline to help you decide what needs to be purchased now or in the future. We think having high quality close-up gear is important, but it is not as important as using the best techniques possible. To be honest, the quality of your images depends more on mastering technique rather than the equipment. Typically, it is the photographer's lack of attention to detail that results in unsharp, poorly exposed, or badly illuminated images. It is not the fault of the equipment. Having good equipment does indeed make it easier to become a skilled close-up photographer mainly because it is easier to use and automatically solves many problems you will encounter.

Claret-cup cactus are simple to photograph because the blossoms are stiff and remain motionless in all but the strongest breezes. Helicon Focus combined the twelve images used to capture the depth of field in these blossoms. Canon 5D Mark III, 180mm macro, ISO 100, f/11, 1.3 sec., Shade WB.

Appendix: Resources

CUSTOM MACRO ACCESSORIES

Kirk Enterprises www.kirkphoto.com

We have used the equipment of this innovative company for decades. They offer L-brackets, custom quick-release plates for cameras and lenses that have tripod collars, a wonderful focusing rail for high magnification photography, flash brackets, ball heads, and many other accessories.

Wimberley www.tripodhead.com

Wimberley is famous for the *Wimberley Gimbal Tripod Head* that revolutionized how big lenses are used today. They also make many accessories that are useful for close-up photographers, including the indispensable plant-clamp (Plamp). In our opinion, all close-up photographers need at least two Plamps with them at all times. No other device has made capturing excellent close-up images easier than the Plamp.

Really Right Stuff www.reallyrightstuff.com

Although we have no personal experience with their equipment, many of our workshop clients do and it is rated quite highly among the photographic community. They make their own tripods and heads, along with many other accessories, including a focusing rail that moves forward and backward and side-to-side for precise framing.

Photoflex www.photoflex.com

This company specializes in making light modifiers for improving the light. We continue to use their popular 22 inch 5-in-1 MultiDisc that includes a diffuser and four colored reflecting surfaces.

PHOTOGRAPHY WORKSHOPS

Gerlach Nature Photography Workshops www.gerlachnaturephoto.com

Our business web site describes our various field workshops and indoor seminars in detail. Many of our most popular instructional photography articles are posted here. We do send out an E-newsletter from time to time. Subscribe to our free newsletter on the web site.

Please visit our Facebook page at Gerlach Nature Photography Workshops. We post a new image every day that includes photo tips to explain how we did it. Facebook is the best way for us to share our new images and the cutting-edge photographic ideas that come to us.

Charles Cramer www.Charlescramer.com

Charles teaches a superb workshop using Photoshop to produce exhibition quality prints. Barbara attends his workshop at least once every two years to learn the latest techniques. This is an intensive class that requires the student to be familiar with Photoshop and to run through a detailed instructional program ahead of time to prepare for this exceptional class with this master printer.

PHOTO STACKING SOFTWARE

Helicon Focus www.heliconsoft.com

This software program is designed by Danylo Kozub and specializes in combining sets of images where the focus has been varied from image to image. Using stacking software is the best way to obtain maximum sharpness in a subject where it is not possible to align the focusing plane with the plane of the subject. Contact Danylo directly at dankozub@gmail.com

Zerene Stacker www.zerenesystems.com

This superb software program by Rik Littlefield is excellent at stacking large sets of images. We use this one and Helicon Focus ourselves and teach their use in our field workshops. Like Helicon Focus, it is highly recommended. Go to both web sites to view the tutorials!

BOOKS

The first three books describe the shooting workflow we have developed over forty years of full-time nature photography. Of course, our workshop clients have a lot to do with the shooting system we use because they often ask crucial questions that lead us to a whole new way of taking photographs.

Gerlach, John & Barbara, *Digital Nature Photography—The Art and the Science.* Focal Press, 2006.

Gerlach, John & Barbara, *Digital Landscape Photography.* Focal Press, 2010.

Gerlach, John & Barbara, *Digital Wildlife Photography.* Focal Press, 2013.

Other quality close-up photography books:

Davies, Adrian, *Close-up and Macro Photography.* Focal Press, 2010.

WEB SITES

There are numerous web sites that offer outstanding information on photography. Listed below are some of the most popular. These web sites are especially good for asking specific questions about close-up photography techniques.

Naturescapes: www.naturescapes.net

Nature Photographers Network: www.naturephotographers.net

Luminous Landscape: www.luminous-landscape.com

MAGAZINES

Nature Photographer www.naturephotographermag.com

I have been a regular columnist for this colorful magazine since its inception. This magazine is especially good at showcasing lots of incredible images and features many helpful articles on nature photography.

Outdoor Photographer www.outdoorphotographer.com

This fine outdoor photography magazine has been published since the mid-1980s. It excels at describing the new equipment and software that becomes available each year and includes many instructional photo articles and images.

Popular Photography www.PopPhoto.com

This is a popular general photography magazine that offers detailed equipment and software reviews, along with teaching articles. Sometimes helpful close-up articles are included.

PHOTOGRAPHIC EQUIPMENT

CAMERAS

Canon www.canon.com

Nikon www.nikon.com

Olympus www.olympus.com

Sony www.sony.com

Pentax www.pentaximaging.com

LENSES

Tamron www.tamron.com

Tokina www.tokinalens.com

Sigma www.sigmaphoto.com

EXTENSION TUBES

Kenko www.kenkoglobal.com

They offer sets of extension tubes for Canon, Nikon, Olympus, Panasonic, and Sony Alpha. These tubes preserve autofocus and automatic metering.

TRIPODS

Gitzo Tripods www.gitzo.com

Manfrotto www.manfrotto.com

CAMERA BAGS

We have used photo bags from these companies for years. Both companies offer a large selection of well-designed bags to accommodate anything you might wish to put into them.

Lowepro www.lowepro.com

ThinkTank www.ThinkTankphoto.com

CAMERA AND FLASH RADIO TRIGGERS

PocketWizard www.PocketWizard.com

The PocketWizard Plus III transceiver is terrific for firing your camera remotely by using radio signals. They are also suitable for firing a Remote flash. In each case, two units are necessary. One is set to be the transmitter and the other is set to the receiver mode.

GREENHOUSES

A small greenhouse is ideal for shooting close-up and high magnification macro images because it is easy to control the light and stop all subject motion that can be caused by the slightest air movement. For studio flower photography and for focus stacking applications where the subject must be completely still from one image to the next, a greenhouse works incredibly well. We bought a "cute" one—according to Barb—and had it delivered to our Idaho home in 2012. This 9 × 12 foot greenhouse, which we use as a photo studio, has proven to be an extremely valuable addition to our property and business. We should have one installed years ago! All

close-up photographers, and especially those who enjoy flower photography should consider getting one. With the use of a small greenhouse, it is possible to shoot superb close-up images anytime during the day and the weather doesn't matter.

There are many styles, sizes, and makes of greenhouses that fit all budgets. A good place to discover what is available is to search for greenhouses on the Internet. Another excellent source of information is the thirty-six-page *The Greenhouse Catalog.* Contact: www.GreenhouseCatalog.com

Index

Note: Page numbers in *italics* refer to figures.

50mm macro lenses 25
65mm macro lens *25,* 25–6
100mm macro lenses 23–5
180mm macro lenses 23, *24*
200mm macro lenses 23, *24*

accessories: choice of 184–5; custom macro 191–2
Acmon Blue butterfly 21
A/D (analog-to-digital) converter 42
Adobe RGB 1998 color space 14
A (aperture-priority) exposure mode 48, 55, 58; with fill-flash 125; with main flash 129–30, 132–3
Alpine Spring Beauty *101*
Alpine Sunflower *70*
ambient light 111; with fill-flash 123–4, *124*; with flash 122; "killing" of 127
analog-to-digital (A/D) converter 42
angle of view *20,* 20–1
aperture 39, *52,* 53–4; and sharpness 79, *79*
aperture-priority (A) exposure mode 48, 55, 58; with fill-flash 125; with main flash 129–30, 132–3
aperture-value (Av) exposure mode 48, 55, 58; with fill-flash 125; with main flash 129–30, 132–3
Arca lens plate 72, *72*
Atlantis Fritillary butterfly 166, 170
autofocus 7, 12–13, 22, 76–7
automatic exposure: adjusting ambient light exposure with 57, *57*; changes in subject size with 58–9; in difficult operating conditions 59; exposure compensation control with 57, *57*; light through viewfinder with 58; Program (P) mode for 54; with remote release of

two-second self-timer 59; trouble with 55–7, *56, 57*; using Live View *59,* 59–60
automatic white balance (AWB) *93,* 94–5
available light 111
averaging histogram 13, 40–2, *40–2,* 44–5
Av (aperture-value) exposure mode 48, 55, 58; with fill-flash 125; with main flash 129–30, 132–3
AWB (automatic white balance) *93,* 94–5

back-button focusing 12–13, 77
backgrounds: with 50mm macro lens 25; and angle of view *20,* 20–1, 186; aperture and 79, 129–30; artificial 141, 152; with balanced flash 114–15, *114–15, 134,* 134–6, *135;* black 84, 122, 130, *133,* 137, 175, *176,* 186; for butterflies and dragonflies 166, 168, 169, 170, 175, *176;* with Canon macro 65mm lens 26; compensating for dark 136; with cross-lighting *128;* darkening of *7, 113,* 114; depth of field and *117;* diffused *10–11,* 11–12; diffusers and 105; and environmental friendliness 83–4; exposure compensation control and 132; with fill-flash *124, 126;* for flowers *75,* 143, 144, *144, 148,* 148–9; focal length and 144–5; with focus stacking 78, *84,* 156; holding object behind subject for better 83; and Inverse Square Law 130, 137; with Live View 60; with main flash *70, 113,* 114, 127–8, 129; with manual focus *75,* 155; and RGB histogram *44,* 44–5; sensor size and 23; shutter speed and 132; tilting subject for better 83
back lighting *99,* 100, *101;* main flash for 129, *133,* 133–4

balanced flash 134–6; applications of 114–15, *114–15*; with bright background 114, *134*, 134–6, *135*; with dark background 114–15, 136; defined 114, 134; FEC control for 114; primary light with 115
ball heads for tripods *71*, 71–2, 188–9
batteries 17; for flash 116; rechargeable 17, 116; safe carrying of 60
battery packs 17
bees *38–9, 126*
beetle *25*
bellows 35
Bergamot *158*
birds: flash for *110–11, 121*; teleconverter for *33*
black background: with butterflies 175, *176*; due to flash 84, 122, *133*, 186; Inverse Square Law and 130, 137
blinkies 40–1, *47*
blue colorcast 92–3
books 192
bracken ferns *50*
bracket-mounted flash 136–8
Bracted Lousewort *113*
breeze: with bellows 35; breakfast 8; with butterflies and dragonflies 162, 163, 166, 175; cable release vs. self-timer with 7, 76; control for 151–2; with flowers 151–2; and focus stacking 152, 157; greenhouse to prevent *3*, *4*, 152; Plamp for 82–3; and sharpness 5, 73; and shutter speed *49*, 130; tilt-shift lens for 157; tripod for 145; warming air and 8
brightness histogram 13, 40–2, *40–2*, 44–5
bubble images *3*, 4
Buckeye butterfly *167*
bulb (B) setting 51
butterflies 161–80; Acmon Blue 21; active 54, 174–6, *175, 176*; Atlantis Fritillary 166, 170; attracting 174; background for 137; back lighting of 100, 133, *133*, 134; balanced flash for *114–15*; Buckeye *167*; in butterfly houses 136, 176–7; camera straps for 180; challenges with 161–2; checkerspots *165, 176*; color of 92, 169; cool weather for 163; Coral Hairstreak 166, *166*, 169–70; cross-lighting for *128*; Eastern Tiger Swallowtail *177*; elusive 172; extension tubes for 31; false eyespots on swallowtail larvae of *2*; finding optimum subjects for *165*, 165–6; flash for *114–15*, 169, 175–6, 178–9; Great Spangled Fritillary 46, *74, 81*, 91; Green Comma 162, *162*; habitat of 162–3; handheld photography of 180; high ISO numbers for 177–8; Hoary Comma *103*; how to find 6, 163–5, *164*; image stabilization for 178; lateral basking by *169*, 170; LCD display of *40*; light for 91–2, *99*, 100–1, *103*; losing highlight detail with 46;

macro lenses for 23, 168, 178; marking location of 6, 163; Monarch 166, *168*, 168–9; Mourning Cloak 55, *56*, 57; number of images for 180; parallel subject and sensor planes for 80–1, *81*; Plamps for *168*, 168–9; puddling 174; reflectors for 169; relocating 166, 169; Rocky Mountain Parnassian *133, 175*; shooting angle for 169; shooting priority for 166, *166, 167*; skimming light for *124*; sulfur *28, 169*; tilt-shift lenses for 26; trouble with automatic exposure modes for 55, *56*, 57; Two-tailed Swallowtail *124*; Variegated Fritillary *128*; Weidemeyer's Admiral *114–15*; with wings spread 167, 170–1; working distance for 21
butterfly houses 136, 176–7

cable release *see* remote release
camera(s) 11–17; back-button focus of 12–13; batteries for 17; build-in wireless flash control of 16; choice of 183, 185, 189; color space of 14; crop factor vs. full-frame 11–12, *12*, 23; features to look for in 12–14; image size on LCD of 14; live histogram of 13–14; live view of 13; megapixel count of 12; memory cards for 17; mirror lock-up of 16; resources for 193; reversing exposure control dials of 14–15; reversing exposure indicator inside viewfinder of 15; RGB histogram of 13; small sensor 11–12, 23; taking advantage of options with 14–17; two-second self-timer in 16
camera bags 185, 189, 193
camera motion 68, 73–6; due to firing of camera 74–6; with flash 115–16; with high magnification 68–9; due to mirror vibration 76; due to soft ground 74; due to water 73–4; due to wind 73
camera-mounted flash 136–8, *137*
camera strap 16–17
Canon 65mm macro lens *25*, 25–6, *185*
Canon 90mm tilt-shift lens 185–6
Canon 180mm macro lens 186
Canon 580II flash 186
Canon 600 Speedlite 186
Canon EOS 5D Mark III 189
Canon MT-24EX Twin Flash 186
Canon Remote Switch RS-80N3 187
Canon ST-E2 Speedlite Transmitter 119–20
center-weighted metering 46
CF (Compact Flash) memory cards 17
checkerspot butterflies *165, 176*
clipping 13, 44, *56*; on left 45–6
close-up lenses 27–8, *28*
close-up photography 19
cloudy white balance setting 95
color 92–4; fill-flash to improve 113–14, *126*; white balance settings to improve 94–8

colorcast: blue 92–3; white balance settings for 94–8
color channels display 13
color contrast 102
Color Matrix metering 46, 48
color space 14
color temperature white balance setting 98
Commander flash 119
Common Whitetail dragonfly *112*
Compact Flash (CF) memory cards 17
coneflower 7, *126, 153–4, 168*
consumer-grade lenses 27
continuous shooting lock 75
contrast 102–8; diffusers for 105; fill-flash to reduce 112, 112–13; flash to add *131*, 131–2; reflectors for 102–5, *103*, *104*; shading for *101*, 105–8, *106*
Coral Hairstreak butterfly 166, *166*, 169–70
Cramer, Charles (Charlie) 14, 192
crop factor cameras 11–12, *12*, 23
cross-lighting 101, *103, 128*
custom macro accessories 191–2
custom white balance setting *97*, 97–8

dahlias *41, 146*
damselfly *172*
daylight white balance setting 95
dedicated flash cables *118*, 118–19
dedicated flash controller 119–20
dedicated L-brackets *72*, 72–3, 189
delphinium *45, 82*
depth-of-field (DOF) *52*, 53; for focus stacking 152, 153–4; and magnification 69, 80, *80*
dewdrops 4–8; on beetle *25*; on dragonfly 7, 28, 114, 134, *134, 163, 173*; extension tube and teleconverter for 31, 34, *34*; as highlights 41; light through viewfinder with 58; on spider web *5*, 21, *77*
dial direction reversal 63
diffraction 53; focal length and 79, *79*; and focus stacking 153–4
diffused light 100
diffusers: to control contrast 105; with flash 138; to modify light direction 100; Plamps for 83
digital stabilization 85
diopters 27–8, *28*
DOF (depth-of-field) *52*, 53; for focus stacking 152, 153–4; and magnification 69, 80, *80*
download for focus stacking 156
dragonflies 171–2, *171–3*; angle of view for *20*; back lighting of 100, 172; balanced flash for 114, *134*, 134–6; close-up lenses for 28; Common Whitetail *112*; cool weather for 163, *163*; damselfly *172*; dew-laden 7, 28, 114, 134, *134, 163, 173*; extension tube for *24*;

fill-flash for *112*; finding optimum subjects for 165–6; habitat of 5; how to find 5, 6, 163–5, *164*; marking location of 6, 163; Plamp for 6, 171–2; Red Meadow *7*; Red Skimmer *171*; shooting priority for 166–7; Twelve-spot *134, 173*

dynamic range 102

Eastern Tiger Swallowtail butterfly *177*

EC (exposure compensation) control 57, *57*; for fill-flash 125

eggs *51*

electrical release *see* remote release

environmental friendliness 83–4

environment and tripods 73–4

equipment 4, 183–9; accessories as 184–5; in Barbara's bag 183–5; camera bags for 185, 189; cameras as 183, 185, 189; extension tubes as 188; flash 184, 185, 186; focusing rails as 186–7; Giotto rocket blower as 187; in John's bag 185; knee pads as 188; L-brackets as 189; lens cleaning fluid and tissue as 187; lenses as 184, 185–6; microfiber cloth as 187; notebook and pen as 187–8; Photoflex Multidisc 5-in-1 as 188; plastic ground sheet as 188; remote releases as 187; resources for 193; rubber muck boots and rain pants as 188; scissors as 187; tripod and head as 184, 185, 188–9

ETTR (exposure to the right) rules 45–6

Evaluative metering 46, 48

exposure 39–64; automatic 54, 55–7, 59–60; averaging histogram and highlight alert for 40–2, *40–2*; avoiding common mistakes of 40, *40*; brightness of image on LCD monitor and 40, *40*; clipping on the left in 45–6; and depth-of-field 52, *53*; f/stop and aperture for 39, *52*, 53–4; good 54; ideal JPEG *43*, 43–4; ideal RAW 44; ISO number for 39, 48–50, *49*; JPEG and RAW image considerations for 42–3; and law of reciprocity 54; and loss of highlight detail 46, *47*; manual 7, *7*, 55, 60–4; and metering modes 46–8; RGB histogram and *44*, 44–5, *45*; shutter speed for 39, *50*, 50–3, *51*; standard 54; and stops 48–54

exposure compensation (EC) control 57, *57*; for fill-flash 125

exposure control dial reversal 14–15, 63

exposure indicator reversal 15

exposure modes 54–5; aperture-priority (A or AV) 48, 55, 58; automatic 54, 55–7, 59–60; and changes in subject size 58–9; in difficult operating conditions 59; and light through viewfinder 58; manual (M) 55; and metering modes 55–9; program (P) 54; with remote release or two-second self-timer 59;

semi-automatic 54–5; shutter-priority (S or Tv) 48, 54–5

exposure scale 15, 62, *62*

exposure to the right (ETTR) rules 45–6

extension tubes 29–31, *32*; choice of 188; combined with teleconverter 32–4, *34*; for dragonflies *24*; resources for 193; for shells *30*

feathers *19, 97*

FEC control *see* flash exposure compensation (FEC) control

ferns *50*

field of view: with crop factor cameras 11; with extension tubes 30; focal length and 20–1; with macro lenses 7, 23, 25, 26; sensor size and 23

fill-flash 112–14, 123–7; aperture-priority and 125; applications of 112–14; FEC control for 123, 125, 127; flash angle for 125; to improve color 113–14, *126*; and LCD display 125; manual exposure for ambient light with 123–4, *124*; primary light with 115; procedures for 123–7; to reduce contrast *112*, 112–13; TTL system for 126–7

filters 29, *29*

firing of camera 74; with remote release 74–5, *75*; with self-timer 75–6

flash 111–38; adding contrast with *131*, 131–2; advantages of 4, 7, 112; aperture-priority exposure with 129–30, 132–3; balanced 114–15, *114–15*, 134–6; basics of 117–22; batteries for 116; for butterflies *114–15*, 169, 175–6, 178–9; camera-mounted 136–8, *137*; choice of equipment for 184, 185, 186; close-up techniques with 122–3; color of 112; Commander and Remote 119; dedicated cables for *118*, 118–19; diffusion of 138; duration of 115; fill-flash 112–14, 115, 123–7; for flowers *148*, 148–9, *149*; freeze camera and subject movement with 115–16; for fungi *129, 131*; ghost images with 115–16; handheld 136; with high-speed sync 117, *117*; Inverse Square Law for 130–1; and live histogram 60; main *113*, 114, 115, 127–34; manual exposure with 132–3; Master and Slave 119; mechanisms of 116–17; off-camera 118; pop-up 16, 117–18, *118*; positioning of 125, 129; recycle time of 116; setting ambient light exposure for 122; for sharpness 84; shutter speed with 116–17, 132; for side lighting and back lighting *133*, 133–4; skimming light with *124*; storage capacitor of 116; synchronization (sync) speed and 116–17; with tripod 122–3; used as controller 120; use of term 112; voltage converter of 116; wireless 119, *120*

flash angle: for fill-flash 125; for flowers 148; for main flash 129

flash bracket 136–8

flash cables, dedicated *118*, 118–19

flash controller: dedicated 119–20; optical 119, 120, *121*; programming pop-up flash as 119; radio 120–2, *121*, 186, 193; terminology for 119; wireless 16, 119, *120*

flash exposure compensation (FEC) control 57, *57*; for balanced flash 114–15; on camera vs. flash 129; for fill-flash 123, 125, 127; for flowers 148; for main flash 128–9, *129*; and shutter speed 132

flashgun 112

flash tube 116

flash white balance setting 95–7

flowers 141–59; Alpine Spring Beauty *101*; Alpine Sunflower *70*; to attract butterflies 174; averaging histogram for 41; background for *75*, 143, 144, *144, 148*, 148–9; balanced flash for *135*; Bergamot 158; Bracted Lousewort *113*; bubble images of *3*, 4; close-ups of *142, 158*; color of *93*; coneflower *7*, *126*, 153–4, *168*; control of breeze and light with 151–2; dahlias *41, 146*; delphinium *45, 82*; favorable weather for 143–4; fill-flash for *117, 126*; flash for *148*, 148–9, *149*; focus stacking for 152–9; frost on *147*; Goat's Beard seed heads *68, 88–9*; Indian Paintbrush *91, 135*; kindness to 151; larkspur *147*; light modification for *101*; lily *75*; Live View for 76; long focal length lens for 144–5; looking for best 144; lupine *76*; main flash for *113*; manual exposure for *61, 147*; manual focus for 147, *147*; multiple exposures for *155, 156*; orchids *61, 146*; Plamps for 81–3, *82, 140–1, 146*, 146–7; RGB histogram for 45; Scarlet Gilia *141–2*; shooting strategy for 143–52; with "something extra" 142–3, *143*; sundew *12*; tripod for *70*, 145; tulips *93, 142, 145*; viewpoint for 144; water drops on *90, 144, 149*; Wine Cup blossom *117*; working the subject for 149–50

focal length: angle of view and 20–1; and aperture 53; for butterflies 168; of close-up lens 28, *28*; and depth-of-field 76; and diffraction 79, *79*; with extension tubes 31; for flowers 144–5; with macro lenses 19–20; for multiple exposures 151; sensor size and 23; shutter speed and 51, 85; with stacking lenses 35; with teleconverters 32; and tripod collar 21–2; working distance and 21, *96*; of zoom macros 27

focusing 67, 76–8; automatic 7, 12–13, 22, 76–7; back-button 12–13, 77; in dim light 92; with extension tubes 29, 31, 188; on flowers 147, *147*, 154–6; with handheld shooting 137; Live

View for *59*; with macro lenses 19, 25; manual 7, 13, 69, 77–8, 147, *147*; with tripod heads 72; with zoom macros 27
focusing distance 145; with extension tubes 31
focusing plane 157, 192
focusing rails *34*, 34–5, 78; choice of 186–7; for focus stacking *154, 155,* 155
focusing range 22, *22,* 31
focusing ring for focus stacking 155
focus limiter switch 22, *22*
focus stacking 152–9; appropriate subject for 152; depth of field for 152, 153–4; download for 156; focusing rail for 78, *154, 155,* 155; with HDR software 158; how to shoot sets of images for 152–4, *153–4*; manual exposure for 152; manual focus for 154–5; with panoramic images 157–8; for sharpness 68, 84, *84,* 157; software for 156–7, 192; vs. tilt-shift lenses 157; turning focusing ring for 155; usefulness of 152, 157–9, *158*
food for butterflies 174
frogs *24, 42, 52*
front light *99,* 99–100
frost *1,* 15
f/stop 39, *52,* 53–4
full-frame cameras 11–12, *12,* 23
full-size sensor 11–12, *12,* 23
fungi: flash for *129*; tilt-and-shift lens for *27; see also* mushrooms

Gerlach Nature Photography Workshops 192
ghost images 115–16
Giotto rocket blower 187
Gitzo #1325 carbon fiber leg tripod 188
Goat's Beard seed heads *68, 88*–9
good exposure 54
grasshoppers *76, 96, 179*
Great Spangled Fritillary butterfly 46, *74, 81,* 91
Green Comma butterfly 162, *162*
greenhouses *3,* 4, 152, 193–4

handheld flash 136
handheld shooting: of butterflies 171, *175,* 176, *177,* 180; camera-mounted flash for 136, *137,* 186; camera straps for 17; of flowers 143; focusing for 137; image stabilization for 23, 85, 178; minimum shutter speed with 51, *51*; sharpness with 85–6, 178–9
Hart, Al 71, 108, 122, 187, 188
Hart's Law of Photography 122
hat trick 100
Helicon Focus 84, 152, *153,* 156, 192
high dynamic range (HDR) software 158
highlight alert 40–1, *47*
highlight detail: back lighting for *99,* 100, 101; balanced flash for 114, *115, 134, 135*; fill-flash

for 123, 125; for flowers 144, 147, 148, 149; ideal JPEG exposure for 43, *43*; loss of 46, *47*; main flash for 132; native ISO and 61
highlight overexposure 44, 56
high-speed sync 117, *117*
histogram: averaging (luminance, brightness) 13, 40–2, *40–2,* 44–5; live *13,* 13–14, *59,* 59–60; RGB 7, 13, *44,* 44–5, *45*
histogram display, calibration of *63,* 63–4
Hoary Comma butterfly *103*
hollyhock 90
horizontal images 14
horse fly 25
hummingbirds *110–11*

image noise 49
image processing 4
image size on LCD 14
image stabilization (IS) 23, 85; for butterflies 178
imaging sensor 11–12, *12*
incident light 55–6
Indian Paintbrush *91, 135*
insects: bees *38*–9, *126*; beetle 25; grasshoppers *76, 96, 179*; horse fly *25*; magnification of *35*; *see also* butterflies; dragonflies
intensity of light 92
Inverse Square Law 124, 130–1
IS (image stabilization) 23, 85; for butterflies 178
ISO number 39, 48–50, *49*; for butterflies 177–8; native 48–50, 61
ISO standard settings 49

JPEG files 14, 42–3; automatic white balance for 94; ideal exposure for *43,* 43–4

key light 114, 127
"killing the ambient" 127
Kirk, Mike 188
Kirk BH-1 ball head 188–9
Kirk Enterprises 191
knee pads 188

landscape images 14
larkspur *147*
lateral basking *169,* 170
law of reciprocity 54
L-brackets, dedicated *72,* 72–3, 189
LCD (liquid crystal display) monitor: exposure and brightness of image on 40, *40*; with fill-flash 125; image size on 14
leaf(ves) *10–11, 12, 18, 50*
lens(es) 17–36; angle of view of *20,* 20–1; bellows for 35; choice of 184, 185–6; close-up (supplementary, diopter) 27–8, *28*; consumer-grade 27; extension tubes for *24,* 29–31, *30, 32,* 32–4; filters for 29, *29*;

focusing rails for *34,* 34–5; limit controls of 22, *22*; macro 4, 7, 19–26; and magnification 18–19, *19*; minimum focusing distance of 19; perspective control (tilt-shift) 26, *27*; resources for 193; and sensor size 22–3; stacking *35,* 35–6; teleconverters for 32–4, *32–4*; tripod collar on *21,* 21–2; working distance of 21; zoom 27
lens aperture 39, *52,* 53–4; and sharpness 79, *79*
lens cleaning fluid 187
lens cleaning tissue 187
lens flare 29, 100–1, 172, 187
lens-mounted macro flash system 136–8, *137*
lens plates *72, 72*
lichen *79–80*
light and lighting 89–108; ambient (natural, available) 111; back *99,* 100, 101; color of 92–8; and contrast 102–8; cross-lighting 101, *103, 128*; diffused 100; direction of 98–101, 112; with flowers 151–2; front *99,* 99–100; incident 55–6; intensity of 92; key 114, 127; qualities of 92; quantity vs. quality of 91; role of 91–2; and shadows 101–2; side *99,* 100; skimming *90, 124*; through viewfinder 58
lily *75*
limit controls 22, *22*
Limit switch 22, *22*
liquid crystal display (LCD) monitor: exposure and brightness of image on 40, *40*; with fill-flash 125; image size on 14
live histogram *13,* 13–14; automatic exposure using *59,* 59–60; and flash 60
Live View 4, *5,* 7, 13; automatic exposure using *59,* 59–60; focusing with 78; for sharpness 76
Lowepro Trekker II camera bag 189
luminance histogram 13, 40–2, *40–2,* 44–5
lupine *76*

m *see* magnification (m)
macro lenses 4, 7, 19–20; 50mm 25; 100mm 23–5; 180mm and 200mm 23, *24*; angle of view of *20,* 20–1; for butterflies 23, 168, 178; Canon 65mm *25,* 25–6; choice of 184, 185–6; custom accessories for 191–2; limit controls of 22, *22*; tripod collar on *21,* 21–2; working distance of 21; zoom 27
macro photography 19
macro slider *34,* 34–5
magazines 193
magnification (m) 18–19, *19*; with bellows 35; for butterflies 174; and camera-mounted flash *137*; with close-up lenses 27, 28, *28*; with combined extension tubes and teleconverters 32–4, *34*; and depth of field *52,* 53, 69, 80, *80*; extension tube for *24,* 25, 29–31, *30, 32,* 186; and focusing handheld 137; with focusing

rails 34, 78, 155; and focus stacking 152, *153, 157*; and image stabilization 178; and limit controls 22, *22*; Live View with 13; with macro lenses 19–26, *25*, 185; parallel subject and sensor planes with 80; with stacking lenses 35, *35*; with teleconverters 32, *32*; with tilt-shift lenses 26; and tripods 68–9, 123; and working distance 21; with zoom macros 27

magnification factor 11, 23

main flash 127–34; to add contrast *131*, 131–2; aperture-priority and 129–30, 132–3; applications of *113*, 114; FEC control for 128–9, *129*; for flowers 148–9; Inverse Square Law for 130–1; manual exposure with 132–3; primary light with 115; procedures for 127–9; shutter speed with 132; for side lighting and back lighting 129, *133*, 133–4; when to use 127

manual (M) exposure 7, *7*, 55; for ambient light with fill-flash 123–4, *124*; calibrating histogram display for *63*, 63–4; in difficult operating conditions 59; exposure scale for 62, *62*; for flowers 147; for focus stacking 152; reversing exposure dials for 63; speeding up process of 61–2, *62*; techniques for 60–4, *61*, *62*

manual focus 7, 13; for butterflies 169; with Canon 65mm lens 26; with dark viewfinder 77–8; for flowers 147, *147*; for focus stacking 154–5; with Live View *59*; for sharpness 67; tripods with 69

markers 6, 163

Master flash 119

Matrix metering 46, 48

megapixel (MP) count 12

memory cards 17

metering modes 46–8; and exposure modes 55–9

M exposure *see* manual (M) exposure

MFD (minimum focusing distance) 19

microfiber cloth 187

micro lenses 20

middle tonality 56–7

mid-toned object 56–7

minimum focusing distance (MFD) 19

mirror lock-up *15*, 16, 76

Monarch butterfly 166, *168*, 168–9

moths *47*

Mourning Cloak butterfly 55, *56*, 57

MP (megapixel) count 12

mud: to attract butterflies 174; movement due to 74

multiple exposures for flowers *155*, *156*

mushrooms: controlling contrast with 102, *104*; flash for *131*; RGB histogram for *44*; two-second self-timer for *16*; wide-angle lens and focus stacking for *84*

native ISO rating 48–50, 61

natural light 111

Nature Photographer (magazine) 193

Nikon 200mm micro lens 186

Nikon D4 189

Nikon MC-30 remote release 187

Nikon R1C1 Wireless Close-Up Speedlight system 186

Nikon SB-800 flash 186

Nikon SB-910 flash 186

notebook 187–8

off-camera flash 118

open shade 92, *96*

optical flash control 119, 120, *121*

optical stabilization 23, 85

orchids 61, *146*

Outdoor Photographer (magazine) 193

overcast 81

overexposure 40–1, *41*

panoramic images, focus stacking with 157–8

pan-tilt head for tripod 71

parachutes as diffusers 105

partial metering 46

pen 187–8

pendulum effect 22

perspective control lenses 26, *27*

Photoflex 192

Photoflex Multidisc 5-in-1 188

photography workshops 192

pine needles *15*

Plamp (plant-clamp) 81–3, *82*; for butterflies *168*, 168–9; for dragonflies 6, 171–2; for flowers *140–1*, *146*, 146–7

plastic ground sheet 188

P (program) mode 54

PocketWizard 120–1, 170, 193

polarizing filter 29, *29*, 186

"pop" 127, 129

Popular Photography (magazine) 193

pop-up flash 16, 117–18, *118*; programmed as controller 119

pop-up reflectors 102

program (P) mode 54

ProPhoto color space 14

protected species 83

protection filters 29

radio flash controller 120–2, *121*, 186

radio link system for remote release 75, 170

rain pants 188

Rain-X *2*, 4, *155*

RAW files 1, 14; automatic white balance for 94; exposure considerations with 42–3; ideal exposure for 44

Really Right Stuff (RRS) 191

Really Right Stuff (RRS) ball head 189

rechargeable batteries 17, 116

reciprocity, law of 54

recycle time of flash 116

Red Meadow dragonfly *7*

Red Skimmer dragonfly *171*

reflectance 55–7, *56*

reflectors 7; for butterflies 169; choice of 188; to control contrast 102–5, *103*, *104*; to modify light direction 101; negatives of 103–5; Plamps for 83; pop-up 102; types of 102–3

Remote flash 119

remote release 7; automatic exposure with 59; choice of 187; purpose of 74; radio link system for 75, 170; to reduce camera motion 74–5, *75*; resources for 193; types of 74–5

reproduction ratio 18

resources 191–3

RGB histogram 7, 13, *44*, 44–5, *45*

Rocky Mountain Parnassian butterfly *133*, *175*

RRS (Really Right Stuff) 191

RRS (Really Right Stuff) ball head 189

rubber muck boots 188

Salty Lightfoot crab *107*

sand, movement due to 74

SanDisk Extreme CF cards 17

Scarlet Gilia *141–2*

Scheimpflug Principle 26, 186

scissors 187

seashells *29*, *30*

Secure Digital memory cards 17

self-timer 7, 16, *16*; automatic exposure with 59; to reduce camera motion 75–6

sensor plane parallel with subject plane 80–1, *81*

sensor size 22–3

S (shutter-priority) exposure mode 48, 54–5

shade: and aperture size 69; butterflies and dragonflies in 167, 174; and light color 93; and light through viewfinder 58; open 92, *96*

shade white balance setting 7, 95, *96*

shading 105–8; with back light 100; to control contrast *101*, 105–8, *106*; of viewfinder 145

shadows: with back light 100; balanced flash for 114, 134, *134*; cross-lighting for *128*; with diffused light 100; fill flash for *112*, 113, *117*, 123–7, *126*; flash angle for 125; flash for 7, 60, *90*, 96; with flowers 148, *148*, 149; front light for 99; and highlight detail 46; with Live View 78; main flash for 114, 127; from mid-day sun 89, 95, 102, *107*; minimizing noise in 39, *47*, 61; modifying light direction due to 101; native ISO with 61; over butterflies and dragonflies 171, 174; reflectors for 7, 102, *103*, *104*, 188;

and shape 101–2; shoot into the 167, 172; with side light 100; with two flashes 138

sharpness 67–86; camera motion and 68; flash for 84; focusing for 67, 76–8; focus stacking for 68, 84, *84*, 157; with handheld shooting 85–6; image stabilization for 85; Live View for 76; optimum apertures for 79; parallel subject and sensor planes for 80–1; shooting looser for 80; subject motion and 68, 81–3; tripods for 68–76

sheets as diffusers 105

shells *29, 30*

shift 26, *27*

shooting angle 6; for flowers 144

shooting loose 27, 80

shooting workflow 4

shoot into the shadows strategy 167, 172

shutter-priority (S) exposure mode 48, 54–5

shutter speed(s) 50–3; in Aperture-Priority (A or AV) mode 55; available 51; and backgrounds 132; and breeze *49*, 130; with Bulb (B) setting 51; with changes in subject size 59; in close-up photography 51–3; defined 50; dial for adjusting 14–15, 62, *62*; and exposure 39, *50, 50–3, 51*; with extension tubes 31; with flash 116–17, 132; and focal length 51, 85; and ghost images 115–16; with handheld shooting 51, 85; and image stabilization 85; and intensity of light 92; and Inverse Square Law 130; and ISO number 49–50, *49*–51; and law of reciprocity 54; in manual exposure (M) mode 55, 61; and metering modes 46; and mirror lock-up *15*, 16; in Program (P) mode 54; in Shutter-Priority (S or TV) mode 54–5; and stops 48, 50–3; with tripod 6, *68*, 69, 145

side lighting *99*, 100; main flash for 129, *133*, 133–4

skimming light *90, 124*

Slave flash 119

slider *34*, 34–5

small sensor cameras 11–12, 23

snow, soft ground due to 74

soft-box with flash 138

soft ground, movement due to 74

software for focus stacking 156–7, 192

specular highlights 41

speedlight 112

spider(s) *49, 66–7, 137*

spider web: back light for 100; dew-laden *5, 77, 143*; Live View for 78; teleconverter and extension tube for *34*; working distance for 21

spot-metering 46, 48

stacking lenses *35*, 35–6

standard exposure 54

standard RGB (sRGB) color space 14

ST-E2 Speedlite Transmitter 119–20

step-up ring 28

stones *106*

stops 48–54; and depth-of-field *52*, 53; f/stop and aperture as *52*, 53–4; ISO number and 48–50, *49*; and law of reciprocity 54; shutter speed and *50*, 50–3, *51*

storage capacitor of flash 116

strap for camera 16–17

strobe-light 112

subject motion 68; with flash 115–16

subject plane parallel with sensor plane 80–1, *81*

subject size changes 58–9

sulfur butterfly *28, 169*

sundew *12*

sunlight, color of 95

sunrise and sunset images, automatic white balance and 94–5

sun white balance setting 95

supplementary lenses 27–8, *28*

swallowtail larvae, false eyespots on *2*

swan *33*

synchronization (sync) speed 116–17, *117*

teleconverters (TCs) 32, *32, 33*; combined with extension tubes 32–4, *34*

tele-extenders *see* teleconverters (TCs)

tents as diffusers 105

ThinkTank Photo Airport Acceleration camera bag 189

third-party radio flash controller 120–2, *121*

three-way pan-tilt head for tripod 71

through-the-lens (TTL) metering: for fill-flash 125, 126–7; with radio flash control 121

tilt-shift lenses 26, *27*; vs. focus stacking 157

time-value (Tv) exposure mode 48, 54–5

tonality, middle 56–7

tonality contrast 102

top lighting 129; main flash for 129, *133*

tripod(s) 6, 68–76; center column of 69; choice of 184, 185, 188–9; and environment 73–4; with flash 122–3; for flowers 145; height of 69; with high magnification 68–9; and image stabilization 85; leg sections of 70; to lock in composition 69; with manual focusing 69; popular brands of 70–1; reasons for using 68–9; requirements for 69–70; resources for 193; for shooting low to the ground 69; sturdiness of 69; as third hand 69

tripod collar 7, *21*, 21–2

tripod heads *71*, 71–2; choice of 184, 185, 188–9

TTL (through-the-lens) metering: for fill-flash 125, 126–7; with radio flash control 121

tulips *93, 142*

tungsten white balance setting 98

Tv (time-value) exposure mode 48, 54–5

Twelve-spot dragonfly *134, 173*

two-second self-timer 7, 16, *16*; automatic exposure with 59; to reduce camera motion 75–6

Two-tailed Swallowtail butterfly *124*

underexposure 40, *40*

Variegated Fritillary butterfly *128*

vertical images 14

Vibration Reduction (VR) 85; for butterflies 178

viewfinder: light through 58; manual focus with dark 77–8; reversing of exposure indicator inside of 15; shading of 145

viewpoint for flowers 144

voltage converter of flash 116

VR (Vibration Reduction) 85; for butterflies 178

water, vibration due to 73–4

weather conditions 5, *6*

web sites 192

Weidemeyer's Admiral butterfly *114–15*

West, Larry 89, 91

white balance (WB) settings 94–8; automatic *93*, 94–5; cloudy *93*, 95; color temperature 98; custom *97*, 97–8; flash 95–7; most useful 98; shade 7, 95, *96*; sun or daylight 95; tungsten 98; white fluorescent 98

white fluorescent white balance setting 98

wildflowers *see* flowers

Wimberley 191

Wimberley, Clay 81

wind *see* breeze

Wine Cup blossom *117*

wireless flash 16, 119, *120*

wireless flash controller 16, 119, *120*

working distance 7, 21, 145

workshops 192

x-sync speed 116–17

Zerene Stacker 84, 152, 156, 192

zoom lenses 27